Impressionism

Impressionism

BELINDA THOMSON and MICHAEL HOWARD

Exeter Books

NEW YORK

A Bison Book

For our children Rupert
and George; Maxim and Cordelia

First published in USA 1988
by Exeter Books
Distributed by Bookthrift
Exeter is a trademark of Bookthrift Marketing, Inc.
Bookthrift is a registered trademark of
Bookthrift Marketing, New York, New York

ISBN 0-7917-0187-5

Printed in Hong Kong

Pages 2-3: *Wild Poppies* by Claude Monet

Contents & List of Plates

Introduction

Looking at Impressionist painting is one of the great joys of the modern world. The very word 'Impressionism' conjures up a brightly colored, modestly sized picture of a light-filled landscape or cityscape painted with broken brushwork. It is our very familiarity with such paintings that sometimes gets in the way of a fuller understanding and appreciation of them. What do they signify to us today? What did they mean to those artists who painted them over a hundred years ago? It is easy to forget that, when they were first exhibited, many of these pictures were rejected by the public and by the critics. It is hard to conceive how such apparently open and reassuring images as those contained in this book could once have been controversial, even unacceptable as art. Yet these artists were intimately connected with a style of painting that has been recognized as one of the major turning points in the development of European art; perhaps even the beginning of modern art as we know it today.

There were eight Impressionist exhibitions held between 1874 and 1886. Many of the artists who showed there are household names today; many are not. This historic series of exhibitions began inauspiciously enough when thirty artists participated in an exhibition at Nadar's photographic studios on the Boulevard des Capucines which opened on 15 April 1874 for one month. The exhibition went under the grand-sounding title *Société anonyme des artistes peintres, sculpteurs, graveurs, etc.,* which translates as the Limited Company of Painters, Sculptors, and Engravers. Subscription was 60 francs a year; there was no jury and all the members enjoyed equal rights. Exhibition spaces were determined by lot and there were no prizes or medals to be awarded to any of the contributors. Most importantly of all, although various academic and amateur artists were invited to participate, it was completely independent of the state-controlled Salon system. It was, therefore, essentially a show place where independent artists could sell their wares directly to the public. By the time the show closed a month later on 15 May 1874, the participants had been baptized by the press as Impressionists. The name first appeared in a review of the 1874 show in which the journalist Louis Leroy used the term in reference to Monet's *Impression, Sunrise.* The respected art critic Castagnary, reviewing the exhibition for *Le Siècle,* gave his readers a working definition of the term, a definition that is still valid today. 'Once the impression is captured, they declare their role terminated . . . one would have to create the new term *impressionists.* They are *impressionists* in the sense that they render not the landscape, but the sensation produced by the landscape.'

Although the term Impressionism is the one that has come into common usage, it was not until their Third exhibition in 1877 that the painters involved accepted this designation. Until that time, they were also known as the *intransigeants,* that is, radicals, or, as they preferred themselves, *indépendants.* In exhibiting independently, they were following the example of Gustave Courbet, a known socialist and revolutionary, who, in 1855, had set up a one-man exhibition directly outside the Galerie des Beaux-Arts at the Exposition Universelle. Twelve years later, at the next

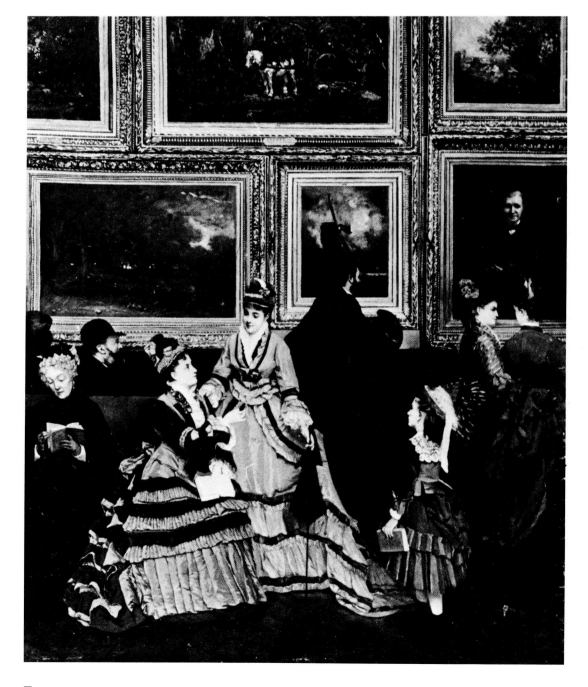

Below left: *The Salon of 1874* by Jean Béraud. The Salon was a popular and chic annual event, with pictures tightly packed on the walls. By the 1870s modern subjects outnumbered historical themes.

Below: Boulevard des Capucines *c.* 1895, typical of the Parisian scenes that the Impressionists painted.

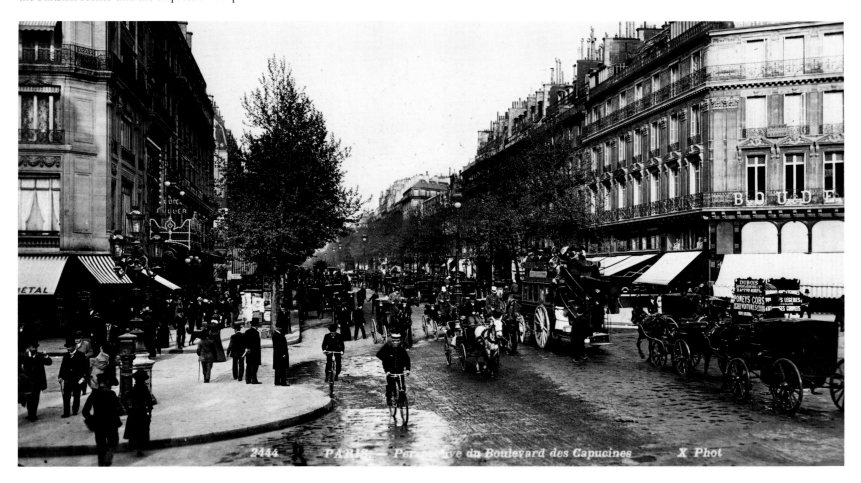

Exposition Universelle, a similar gesture of artistic independence had been made by Édouard Manet. More general dissatisfaction with the Salon had led, in 1863, to the setting up of a Salon des Refusés, but this idea of an 'official' alternative to the Salon had not been repeated.

When the Impressionists made their first attempt to side-step officialdom in 1874, there were political and historic reasons why they met with suspicion and opposition. France was in the process of recovering from the humiliation of her defeat at the hands of the Prussians in 1870-71. Paris, in particular, was still shadowed by the aftermath of *l'année terrible*, as the debacle of the Commune was known, when Parisians had rebelled against the Prussians and the government troops; the ensuing struggle had left a death-toll of 20,000 French men, women, and children. Art was seen as an indicator of the moral health of the nation and was therefore expected to play its part in the reconstruction of the French nation. To be seen as working outside the officially sanctioned channels of art practice was to run the risk of being branded as a revolutionary or worse.

There was never any manifesto or group statement marking the objectives of these artists. History has singled out the names of Monet, Sisley, and Renoir as the creators of the typical Impressionist painting. However, a visitor to the exhibition at Nadar's studio would have found it difficult to isolate the features now seen as common to the Impressionist style. There was no sense of a unified approach to either subject matter or style. Presiding over one of the rooms was a bust of the arch-representative of conservative academic principles, Ingres. And, though the majority of artists showed modern subjects, this practice was not uniformly adhered to; one of the works exhibited was a sketch by Brandon of *Saint Bridgit Showing her Wounds to the People of Rome, 1355*. The titles *César* and *Jupiter*, however, that appeared in the exhibition catalogue, did not, as one might suppose, refer to historical subjects but to a couple of portraits of griffon dogs shown by an aristocratic dog breeder, comte Lepic.

The subjects and styles of those artists that we now call Impressionists were equally diverse. For example, although Claude Monet exhibited mainly landscapes painted directly from nature *en plein air*, by no means were all his paintings of outdoor subjects. For his part, Edgar Degas, who executed relatively few landscapes in his career, repeatedly stressed the studio basis of his work. The landscapists and figure painters were united in their ambition to take up the challenge of Charles Baudelaire's call for a painter of modern life, for a painter whose work would encapsulate and project a distinctively modern sensibility. This plea first appeared in his Salon review of 1845 and was repeated and refined over the years in his critical writings until his death in 1867.

The works of the Impressionists were not so much subjective recordings of a neutral subject matter as some critics at the time and since have argued; rather they were conscious attempts to paint the modern world in a sincere, unaffected and appropriate manner. Such a program gave scope for each artist to follow an individual path; as Renoir said, 'each one sings his own song if he has the voice.'

The fact that they worked at a precise historical period, in a particular place, when the world in which we live was being formed, may account for their great popularity today. In the twenty years between 1850 and 1870, Paris had undergone a radical transformation, changing from what many considered to be, in retrospect, an almost medieval city into the first recognizably modern urban center – a city tailor-made for the middle class. As a major force, perhaps *the* major force, in society, this class as yet had no art that it could recognize as corresponding directly to its new

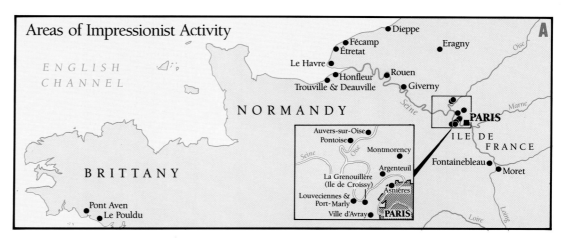

Areas of Impressionist Activity

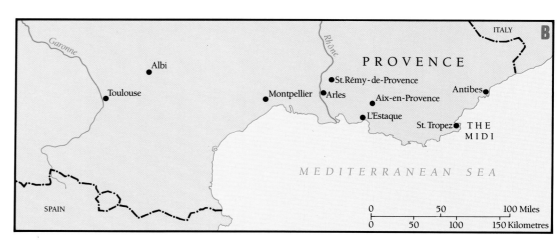

Below: *Ville d'Avray, les maisons Cabassud*, 1835-40 by Camille Corot. Corot's early style had an immense impact upon the artists of the Impressionist circle. Here the main subject is set in the mid-distance; the perfect harmony of silvery tones, matched by Corot's use of a limited palette, creates a fusion of atmospheric effects.

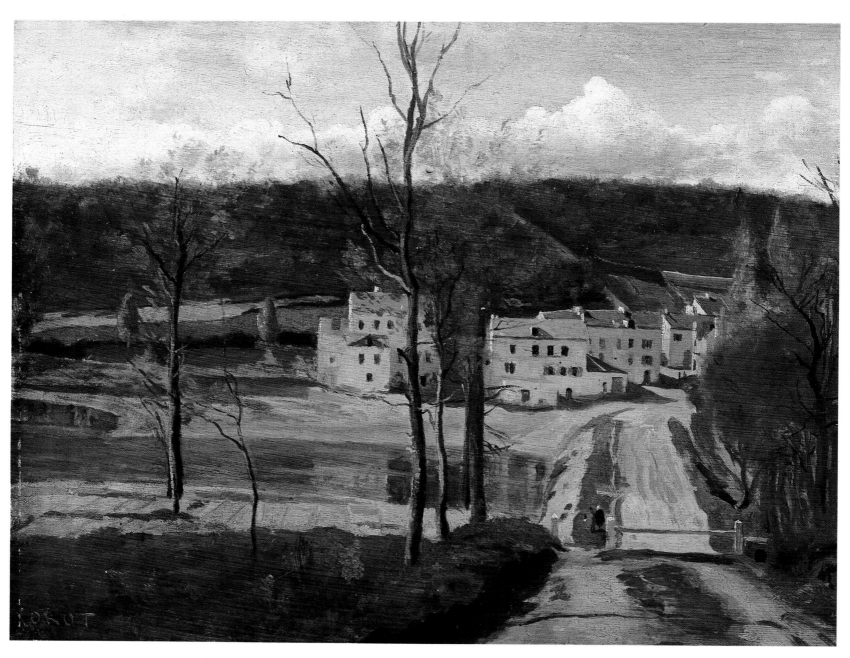

Below: *The Gleaners* by Jean-François Millet. Exhibited at the Salon of 1857, this scene of rural labor provoked an outcry from the critics. By the time the Impressionists were painting, Millet's reputation was secure. His painted explorations of the drudgery and dignity of peasant life were of importance to Pissarro and Seurat, among others.

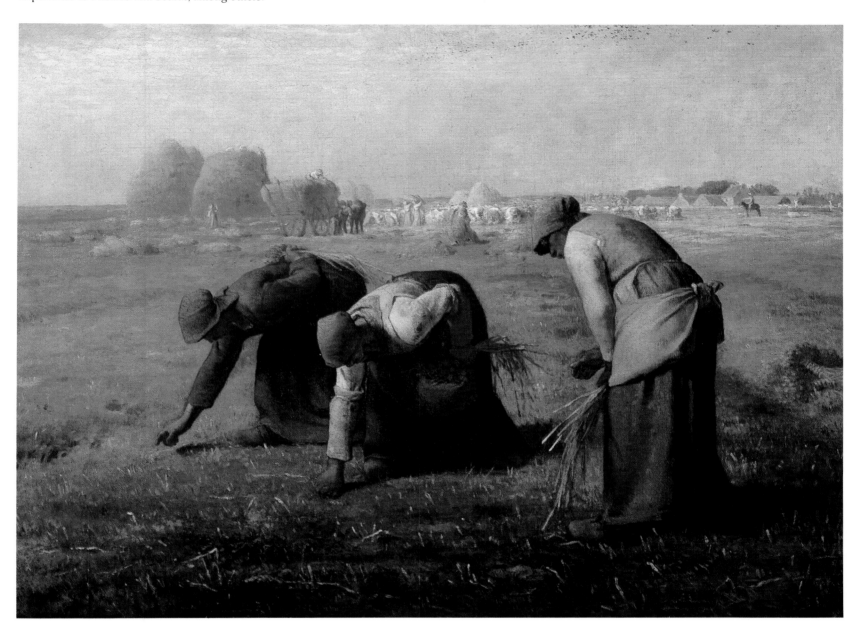

position. The inhabitants of the city were for the most part second or third generation city-dwellers, unsure of themselves in their new surroundings and eager for images of stability and nostalgic sentiment, images such as the picturesque rural landscapes that lined the walls of the annual Salons. By the 1870s, even the formerly controversial peasant paintings of Jean-François Millet were seen as reassuring. The realistic, unsentimental approach to modern life that was found in the work of the Impressionists (and their literary counterparts such as Emile Zola and Guy de Maupassant) did not fulfill such expectations and therefore could be disconcerting, at times profoundly shocking, to bourgeois sensibilities.

The new art was, to varying degrees, supported and nurtured by the critical writings of such men as Zola, Edmond Duranty, and Joris-Karl Huysmans, the key novelists of the naturalist school. Their writings, coming in the wake of Baudelaire, promoted the idea of the city as the most fertile and fitting subject for modern art. The Impressionist vision springs directly from the experience of the city, its suburbs, and the surrounding countryside. In Impressionist paintings we find images of holiday beaches and suburban spots, ideal for picnics or romantic encounters, together with the spectacle of the city, the parks, the ballet, the dance-hall, the theater, the circus, the cafés, even the brothels. We encounter the lounger, the tourist, the middle-class family at lunch or at leisure, the young clerks and milliners enjoying their free time in the cafés and restaurants in the immediate environs of the capital. The painters' interest is not confined to the consumers of the modern city but takes account of those paid to service their needs. Just as significant are the new and apposite viewpoints adopted by the painters which invite the viewer to partici-

pate actively in the scenes portrayed. So we find ourselves looking down from the upper windows and balconies of the new city apartments, gazing across tables in cafés, or peering between the heads of fellow spectators in a theater or music-hall. Such scenes and ways of looking, which have become the archetypal image of nineteenth-century Paris, are to a large extent the creation of the Impressionist painters.

It is important to realize the difficulties faced by the painters of the urban scene. For the landscapists there were the precedents established by the Barbizon school of painters, who, building upon the seventeenth-century Dutch tradition, handed on a ready-made set of conventions to develop for painting the countryside. The freely painted, on-the-spot oil study had had a significant role to play in the work of Théodore Rousseau, Jean-François Daubigny, and Camille Corot. The last, who had trained in the classical landscape tradition,

offered the example of broad tonal painting using a blond palette and insisted on the importance of being true to one's first impression.

Much more problematic was the forging of new means to represent the city. The elements of the new style were found in a variety of sources. Sometimes the Impressionists painted with an eye to the great museum art of the Louvre, sometimes they relished the *modernité* of the popular print, the fashion plates, or the latest advances of photography which, as the century developed, became an increasingly powerful and influential way of showing the world. From these sources they developed a set of conventions appropriate to the modern city, a city which at the time seemed to many a brutal place, new, faceless, and heartless:

Le vieux Paris n'est plus (la forme d'une ville. Change plus vite, hélas! que le coeur d'un mortel): . . . Paris change! mais rien dans ma mélancholie N'a bougé!
The Paris of yesterday is no more (alas, the face of a city changes more quickly than the human heart): . . . Paris is changing! but nothing of my melancholy has shifted!
Charles Baudelaire, *Le Cygne*, 1859.

Our experience as city-dwellers, as interpreted by Baudelaire, is given form in a large number of Impressionist paintings: the bustle of a street scene, the glimpse, caught for a second, of somebody whom we will instantly lose to the vastness of the urban sprawl.

It was some time before the majority of critics and collectors recognized that Impressionism was the art singularly in step with modern existence and that the

summary nature of the Impressionist style was not the result of a sloppiness or deficiency of technique, a Courbet-inspired plot to insult public taste. It was not until the late 1880s that the more prominent Impressionists could consider themselves financially secure, and some of them never reached that position. This is difficult to appreciate today when their works reach such fabulous prices in the salesrooms of the world and when their stock of imagery and style is regularly plundered by advertising companies and the media to sell us our dreams. Just as Impressionist pictures never refer directly to great political events and seldom refer to that great supplier of imagery for western European art, the Church, they rarely reveal the hardships that a number of the artists endured. Some of Monet's sunniest pictures, for example,

Below: The elderly Monet, smoking the perennial cigarette, at work in his studio at Giverny on one of his monumental late waterlily paintings.

Bottom: Monet in the water gardens he constructed and lovingly developed at Giverny. Behind him, the oft-painted Japanese bridge.

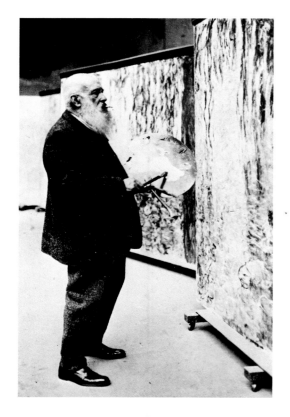

were painted at a time when he was suffering terrible deprivations.

Claude Monet was the linchpin of the Impressionist movement. He was born in Paris in 1840 but had spent his youth in the coastal port of Le Havre. There he had met Eugène Boudin, a painter who had dedicated his life to painting the crowds of people who flocked to the Channel coast. Boudin's obsessive interest in recording the ever-changing light effects and subtleties of the atmosphere made a great impact upon Monet, and prepared the way for the younger artist's development as one of the most innovative of modern painters. From the very beginning, Monet had admired the landscapes of Rousseau, Daubigny, and Corot and it was to this genre that Monet dedicated his long life. Arriving in Paris in 1859, he had refused to try to get into the École des Beaux-Arts, attending instead the life-drawing studio known as the Académie Suisse where he probably made the acquaintance of Camille Pissarro. Three years later, he entered the studio of Charles Gleyre where he met Frédéric Bazille, Pierre-Auguste Renoir, and Alfred Sisley, and the nucleus of the Impressionist movement was complete. Although Gleyre was a respected academic artist who believed in the traditional values of the art establishment, many of the technical aspects of his teaching may be found in the future work of these artists. Another important figure for the young Impressionists was Eugène Delacroix, whose use of color and painterly innovations were still considered by mainstream commentators to be an adverse influence on art students pursuing a traditional training. Even while he was a student, Monet declared himself dissatisfied with the conventional ideas of art training, and in April 1865 he went to Chailly to begin a large canvas, a *Déjeuner sur l'herbe* 'in the spirit of Manet, but actually painted out of doors.'

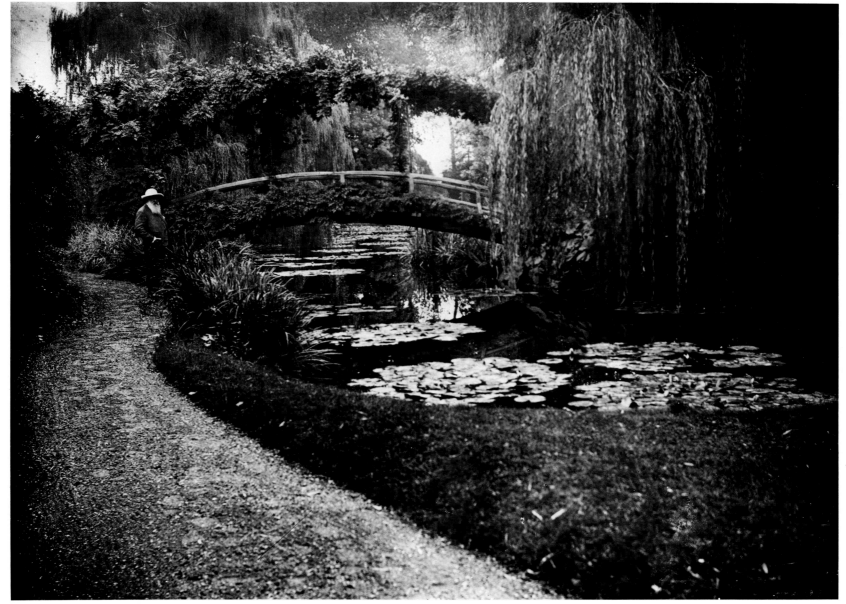

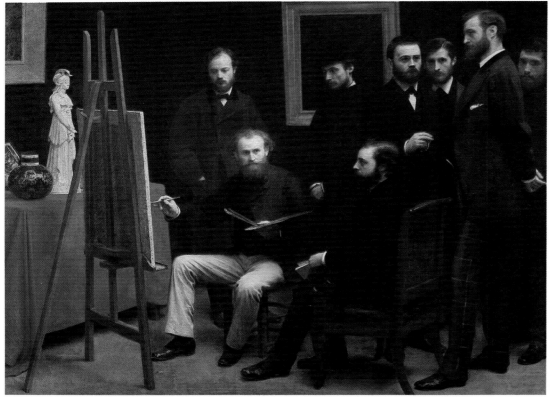

Left: *L'Atelier des Batignolles* (Manet's Studio), by Henri Fantin-Latour. From left, Scholderer, Manet, Renoir, Astruc, Zola, Maître, Bazille, Monet.

Below left: *Jacob Wrestling with the Angel,* 1854-61, by Eugène Delacroix. One of the two murals at Sainte Sulpice that inspired a generation of artists.

The friends at the Gleyre studio worked together under the twin influence of Gustave Courbet and Édouard Manet. Courbet's example, like Manet's, was as much to do with his personality as his art. From the start of his career in the 1840s, Courbet had based his art on his own experiences, stressing the importance of his own individuality and the necessity of basing the act of painting on the observation of the material world. The elegant and sophisticated *boulevardier* Édouard Manet earned their allegiance by his promotion of the ideas of Baudelaire and the anti-establishment nature of his art. His paintings were closely related to contemporary issues, both in subject matter and style directly confronting

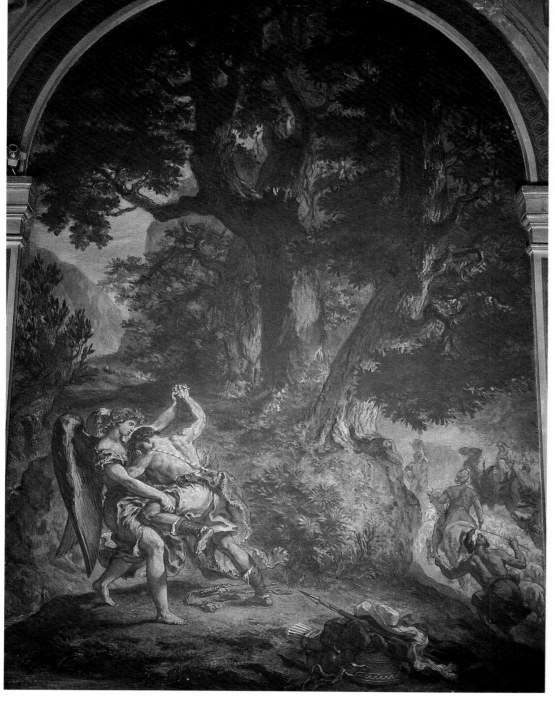

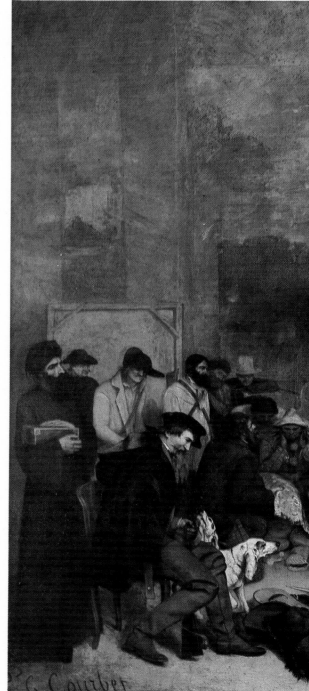

Right: *At the Café,* 1874, by Manet. This lithograph perfectly catches the casual atmosphere of the Impressionists' early café meetings.

Below: *The Studio of the Painter. A Real Allegory,* 1855, by Courbet. A grandiose proclamation about artistic independence and sincerity to experience.

and subverting the academic clichés of the day. In his own *Déjeuner sur l'herbe* of 1863 and his *Olympia*, painted the same year but exhibited in 1865, he had made a multilayered attack on the works of artists such as Alexandre Cabanel and others, whose officially sanctioned idea of *la grande tradition* justified the display of acres of female flesh at the annual Salons by the paltry inclusion of a classical tag. Manet was at the center of a circle of habitués who met at the Café Guerbois, discussing and exchanging ideas – given the widely different personalities involved, their meetings must have been lively.

Although he was born in Limoges in 1841, Pierre-Auguste Renoir had spent his

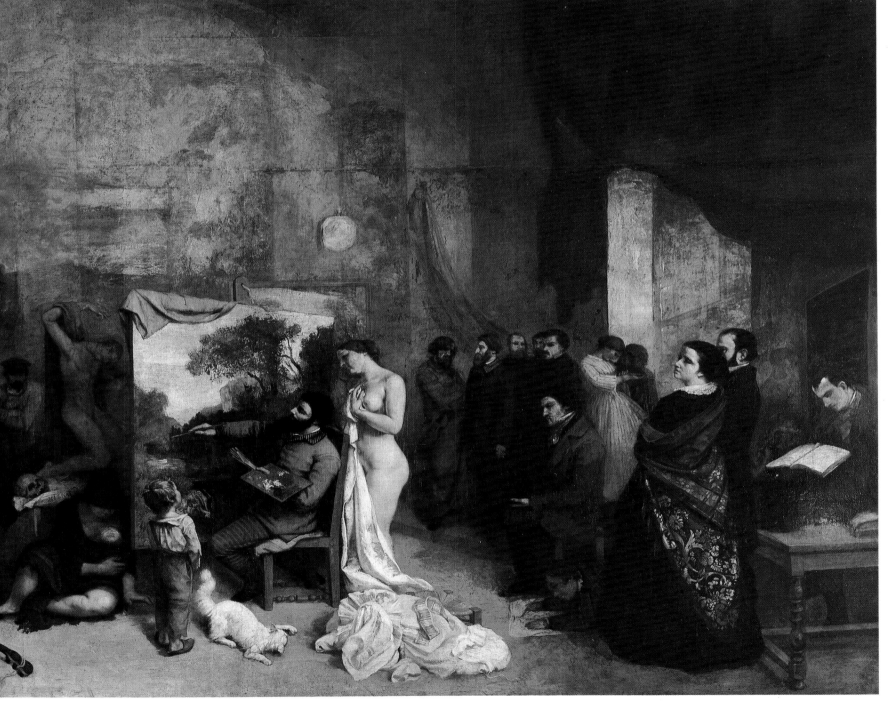

Below left: Sketch for *Le Déjeuner sur l'herbe,* 1865-66, by Monet. The final version was destroyed and only two fragments survive.

Bottom: *Birth of Venus,* 1863, by Alexandre Cabanel. Unlike Manet's derided *Olympia,* nudes with classical tags were acceptable at the Salon.

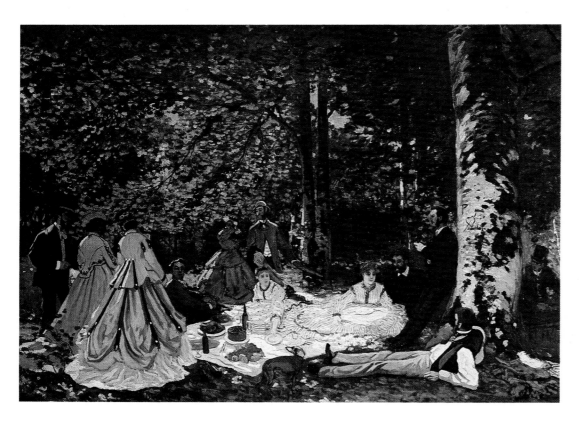

childhood in Paris, and his early career was dedicated not to Fine Art but to working as a decorative painter of porcelain and ladies' fans. In time, with the little money he managed to save, he devoted himself entirely to painting. He entered the

École des Beaux-Arts in 1862 and subsequently enrolled in the studio of Gleyre where he met the other Impressionists-to-be. Although he was enthusiastically involved with his colleagues' experiments with out-of-doors painting, and joined in

their outings to Fontainebleau and later to La Grenouillère, he never forgot his deep love for the art of the past and especially for the art of the eighteenth century. The Impressionist dedication to the landscape never quite overwhelmed his desire to paint the human, or perhaps more exactly the female, figure. In many ways the enigma of the group was Frédéric Bazille, a painter full of talent whose untimely death in 1870 during the Franco-Prussian War robbed Impressionism of one of its most interesting protagonists.

The work of the unfortunate Alfred Sisley was stylistically the closest to Monet and, critically, has often suffered because of it. He was born in France of wealthy English parents, but his father's business collapsed as a result of the Franco-Prussian War, forcing Sisley to rely upon his art and upon his more fortunate friends for support. He was one of the great figures of Impressionism. Like his mentors, Monet and Corot, he was a dedicated practitioner of *plein-air* painting. His works are identifiable by his choice of a few favored sites, his sensitivity to delicate light effects, and his penchant for creating balanced, almost classically restrained compositions. Beautiful though his paintings are, he

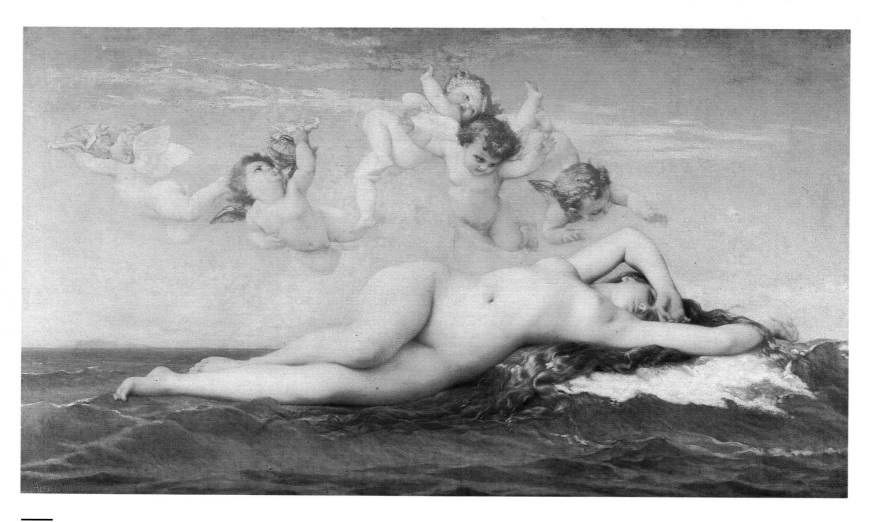

Right: Renoir, *c.* 1900, working *en plein air* on a fashionable portrait commission of *Mme G. Bernheim.*

Below: *Bazille's Studio,* 1870, by Bazille. This informal gathering of Bazille's friends includes the artist presenting his work for Manet's approval.

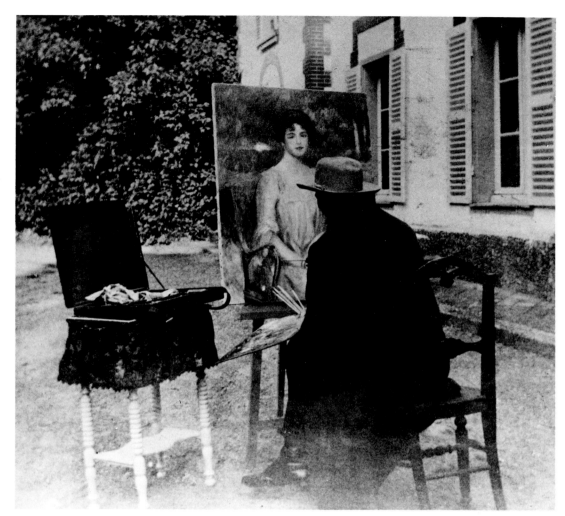

never gained the financial success that was eventually to be enjoyed by his *confrères.*

Gustave Caillebotte, who joined the Impressionists in 1876, following his rejection at the Salon of 1875, was wealthy enough never to have to concern himself with sales; on the contrary, on many occasions he helped out his friends by buying their work. One possible result of his freedom from financial concerns was the arresting and uncompromising *modernité* of both his subject matter and his compositions. The considerable importance of Caillebotte's art and of his contribution to the Impressionist movement is still in the process of being re-evaluated.

Berthe Morisot, who was born in 1841, shared a similarly privileged family background. She first met Manet, through their mutual friend Fantin-Latour, while working as a copyist in the Louvre in the 1860s. The two artists enjoyed a close working and family relationship; Morisot sat to

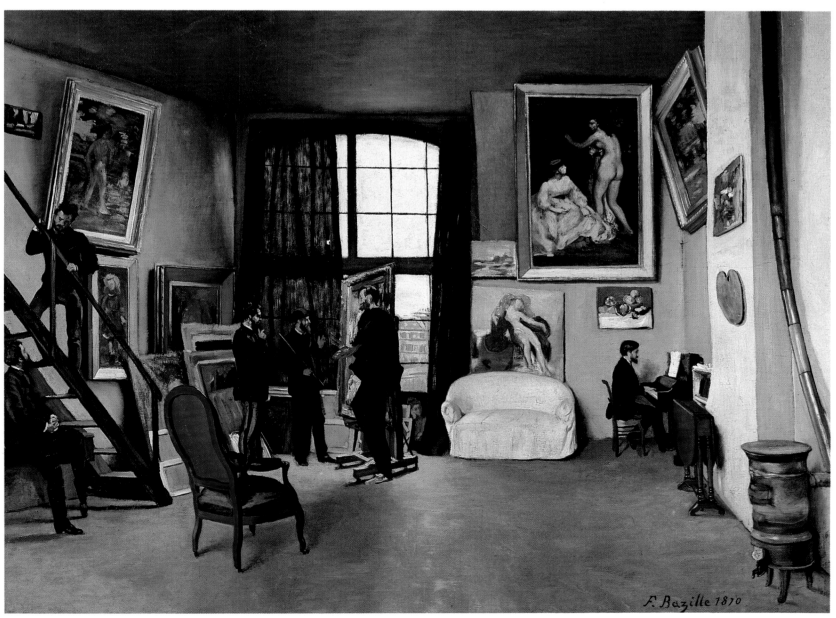

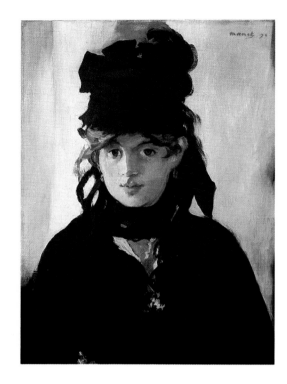

Right: *Berthe Morisot with a Bunch of Violets,* 1872, by Manet. Manet's virtuoso handling captures the elegance and intelligence of this sensitive painter.

Below: *Sisley and his Wife,* 1868, by Renoir. At once intimate and formal, this portrait echoes the work of Courbet, Manet and Degas.

Manet on a number of occasions around 1870 and later married his younger brother. She courageously opted to exhibit with the Impressionists in 1874, becoming one of the most loyal members of the group, despite the protestations of her teacher Joseph Guichard and the often derogatory remarks of the critics.

Older than the others were the figures of Edgar Degas and Camille Pissarro. Degas, for whom the designation Impressionist is something of a misnomer, came from an aristocratic family, and began his career as a history painter. Gradually, in the 1860s,

he became aware of the difficulty of continuing this tradition and turned to the depiction of modern life subjects. He never forgot his classical training, however, and as his career developed, his work became more generalized, focusing ever more rigorously on a few chosen themes as he explored the endless expressive potential of line, form, and color.

Camille Pissarro was born in 1830 on the island of Saint Thomas in the Antilles. He came to France in 1855, and immediately fell under the spell of the work of Courbet and Corot. He lived at first on the outskirts

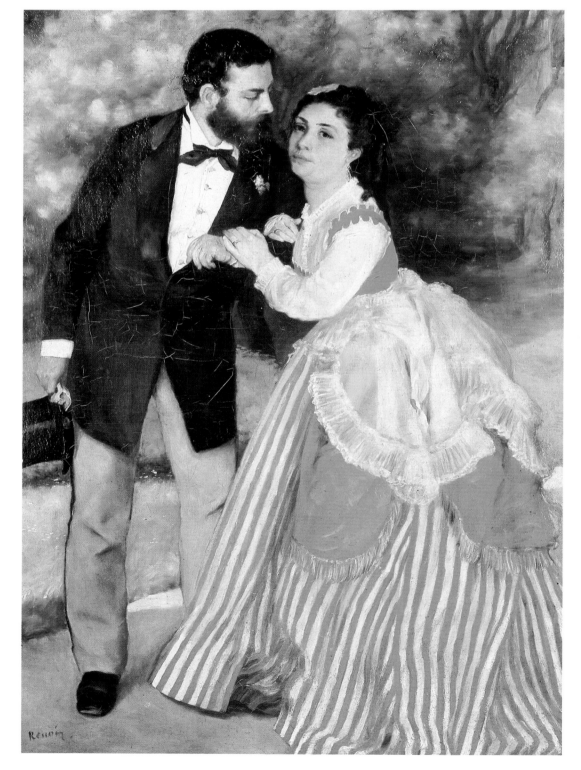

of Paris, later settling farther from the capital, and produced paintings based on the close observation of the Ile de France countryside. Early on in his solid, well-crafted paintings, he often used a palette knife to lay on clearly defined tonal areas that lock together to form powerful compositions. Younger landscape painters gravitated toward Pissarro, and in the early 1870s he exerted a beneficial influence on Paul Cézanne, turning him away from his early melodramatic manner that was based on the paintings of Veronese and the Baroque paintings of Spain and Italy, and toward an art based on the close observation of the natural world. Cézanne was born in Aix-en-Provence, far away from the cosmopolitan atmosphere of Paris, and the Provençal landscape formed the major stimulus for his art. He had grown up in the company of Émile Zola and he never forgot their idyllic youthful escapades bathing in the pools and rivers around Aix. Later in his life they form the *raison d'être* for his meditations on the theme of the nude in the landscape.

Clearly, even in the 1870s, at the period when their work seems to be in closest harmony, the attitudes of the individual Impressionists to their art were very different. Even their opinion of the benefits of exhibiting independently varied from artist to artist. Manet never renounced the idea of exhibiting at the Salon, believing that the battle for the new art should be fought in the enemy camp; and it was against Manet's advice that Berthe Morisot, whose work had never been rejected by the Salon, joined forces with the Impressionists. While Monet and Renoir equivocated, Degas and Pissarro were united in their staunch opposition to the Salon system. There were wide divergences in their political ideas. By the 1890s, Degas and Pissarro were at opposite

Below left: The elderly Pissarro and his family with the 'Rolling Studio' at Eragny, 1890s.

Below right: *Édouard Manet at the Races, c.* 1865, by Degas. The artist is portrayed as a seemingly dispassionate observer of contemporary life. To his left is a sketch of a woman with binoculars.

Bottom left: *Portrait of Cézanne, c.* 1874, by Pissarro. Pissarro portrays Cézanne as an unruly Bohemian.

Bottom: Cézanne in the vicinity of Mont Sainte-Victoire, *c.* 1900. He died six years later, after working in the rain on the same motif.

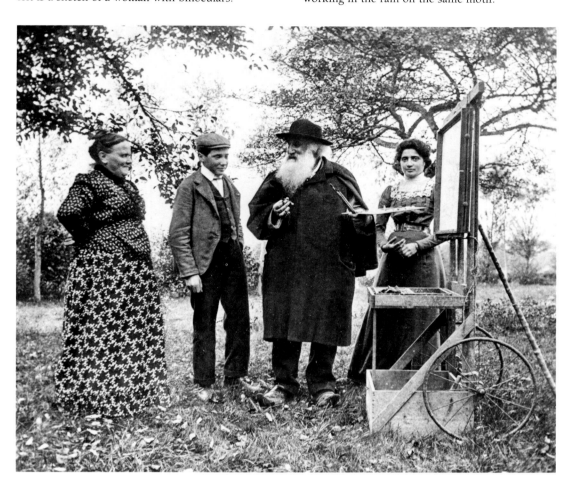

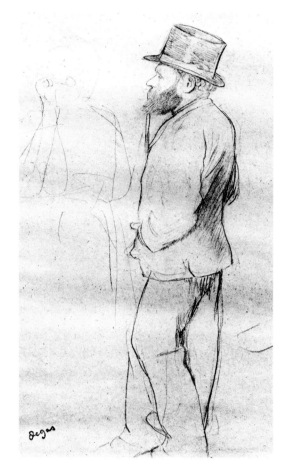

ends of the political spectrum, Degas a right-wing reactionary, Pissarro an ardent supporter of the anarchist cause. Manet was a staunch republican, whereas Renoir seems to have been completely uninterested in politics. Equally, their backgrounds, tastes, ambitions, and lifestyles were diverse. In letters and discussions, some waxed eloquent, others, such as Cézanne and Degas, preferred to keep silent. And, despite the radicalism of their artistic stance, friendships could and did

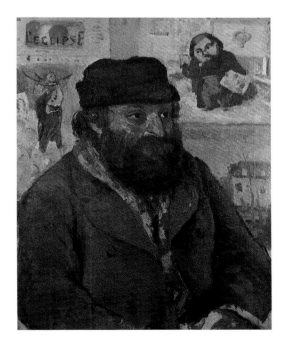

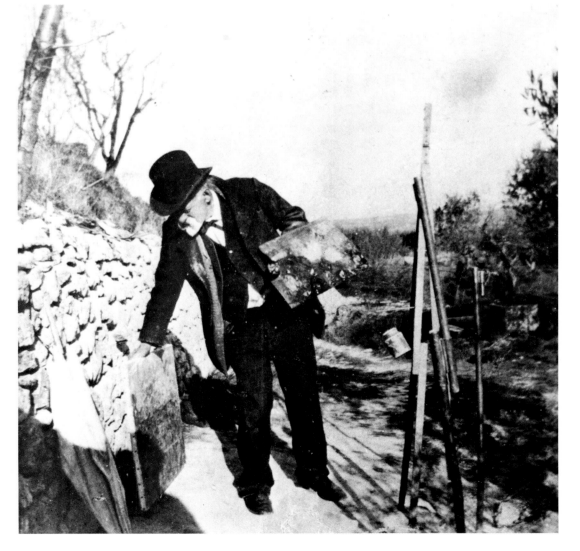

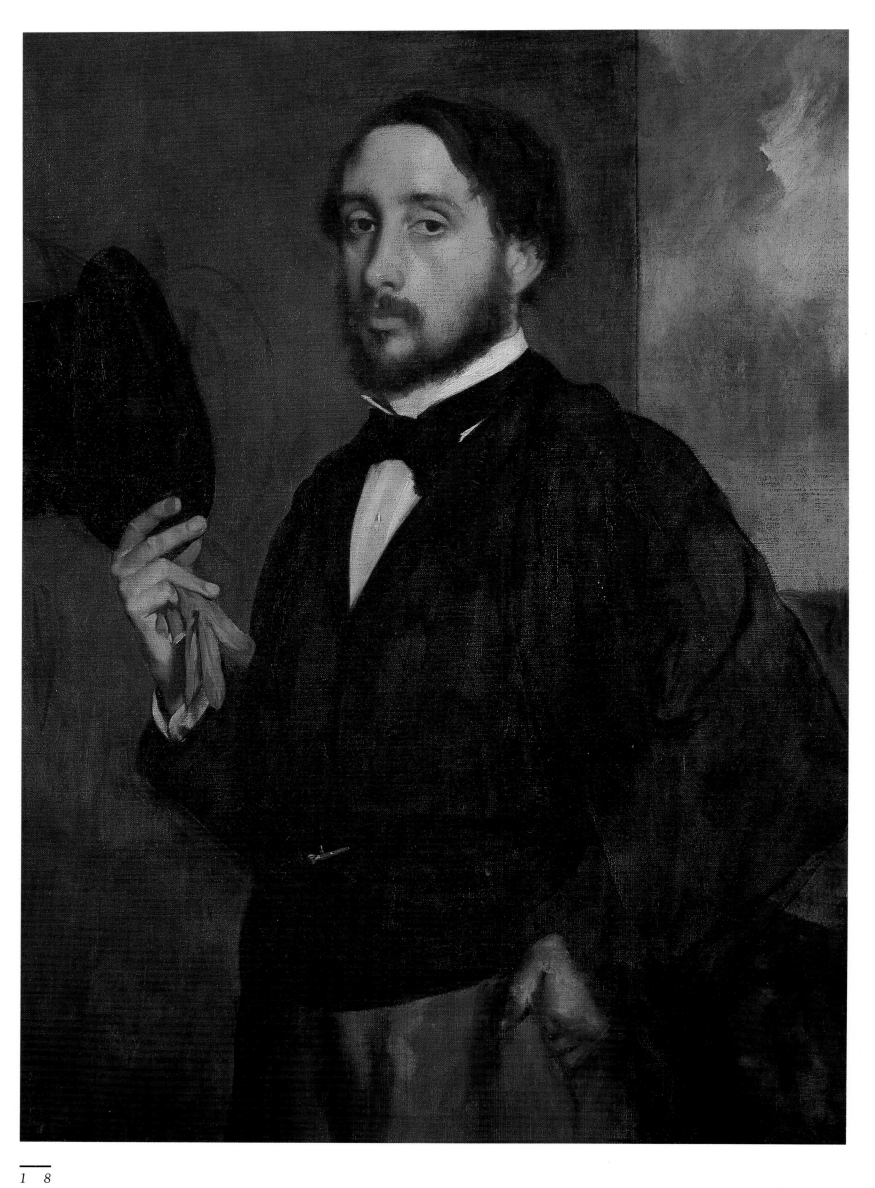

Left: From *Self-Portrait, c.* 1863-65, by Degas. A somber and ironic self-image which gives nothing away. He salutes the viewer dolefully.

Below: *Semiramis Founding Babylon,* 1861, by Degas. A representative example of Degas' history paintings that preceded his interest in modern life.

exist across the avant-garde/academic divide. Especially interesting was their association with such wealthy and respected figures as the Belgian Alfred Stevens, a modish painter of highly detailed and glamorized images of the wealthy women of the Second Empire. There were also social contacts with Puvis de Chavannes, the painter of monumental, classically inspired allegories, who kept up a friendly correspondence with Berthe Morisot.

In the summer of 1869, Monet and Renoir worked together on a series of pictures at the popular bathing place on the Seine known as La Grenouillère. Begun as sketches, these paintings came to be considered by the artists as finished works in their own right and thus established the prototype of the Impressionist style. The hallmarks of this style involved painting in a manner reminiscent of the academic sketch, contravening the polished finish expected at the time. The use of a high tonal scale of relatively pure color, laid on with rapid, broken brushwork, created an image that also went against conventional ideas of composition as taught at the École des Beaux-Arts and the various academic studios. The composition and subject matter of the Impressionists emphasized a

sense of the informal, the figures in the paintings, who were often the artists' own family or friends, being shown in attitudes of relaxed candor. In the 1870s, the artists abandoned the large-scale canvases they had favored in the previous decade and which were essentially dictated by the need to make an impact at the Salon. Instead they confined themselves to smaller canvases that involved less investment of time and effort. This move was of practical importance in view of their by now almost exclusive practice of painting in the open air: small canvases were easier to handle and carry about. The gradual introduction of portable collapsible tubes of oil paint in the 1850s was another factor that made open-air painting in this medium a feasible proposition.

The move to smaller canvases was not just a matter of practical convenience. In desperate need of sales, the artists realized that work on a more modest scale was more commercially viable. At the outset of their careers, like any other artists, they were ambitious for recognition. However, throughout the 1870s and 1880s, they suffered much adverse and often vicious criticism from the press that was only occasionally offset by sympathetic reviews. If their work was accepted at the Salon then

it was often badly hung. For sales they had to rely upon their more wealthy friends such as Bazille and Caillebotte, and a few enlightened patrons, such as Choquet and the actor Faure. They also relied heavily upon the existence of a dealer, such as Durand-Ruel, who was prepared early on to invest in their potential. Indeed, without the development of independent art dealing as a feature of modern Paris, the Impressionist enterprise would have been very different.

Such differences as existed at the outset of the group's formation became increasingly marked. As time went on, the divisions between the landscapists on the one hand and the figure painters grouped around Degas on the other became difficult to reconcile. In 1879 and 1880, Renoir, Cézanne, and Monet broke faith with the original commitment of the group to avoid the official arena and sent work to the Salon. Although Cézanne's submissions were rejected, Renoir and Monet assured themselves places by sending paintings that were suitably finished and therefore palpably different from the works they had shown with the Impressionists. Renoir's *Madame Charpentier and Her Children* was acceptable on two levels, firstly because of its higher level of finish, and secondly

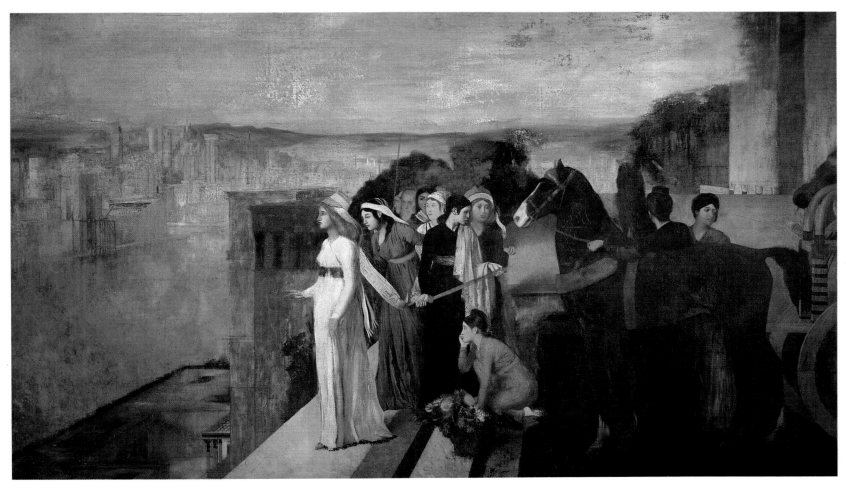

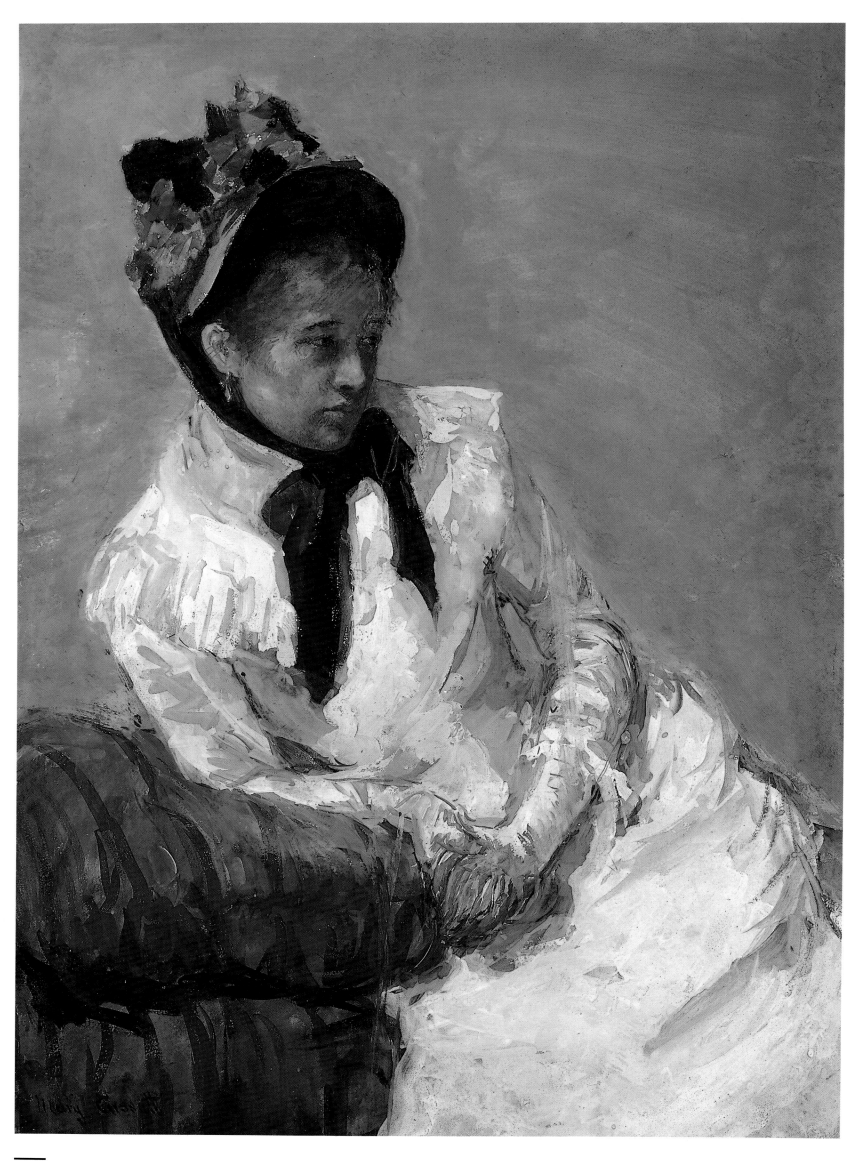

Left: *Portrait of the Artist, c.* 1878, by Mary Cassatt. She is shown in pensive mood, wearing one of the stylish bonnets that attracted Degas' admiration.

Below: *Portrait of Gauguin* by Pissarro and *Portrait of Pissarro* by Gauguin, *c.* 1883. This unusual sheet shows the artists' distinctive drawing styles.

because the sitter was a prominent society figure. Such compromises went against the grain for Pissarro and Degas, the most anti-authoritarian members of the group. And yet Degas, for his part, was seen by some as an *agent provocateur* due to his apparently indiscriminate support for those figure painters who shared his own interest in modern urban subjects, irrespective of whether they shared common ground with the Impressionists at a stylistic level. The Impressionist attitude to the direct recording of one's sensations before nature was in any case scarcely a characteristic of Degas' working method. The introduction of artists such as Jean-Louis Forain, Mary Cassatt, and Jean-François Raffaëlli markedly altered the character of the Impressionist exhibitions of 1880 and 1881 in which they participated, especially given the absence of Monet from the first of those shows. Monet was reported later as saying he had rather lost faith in the group idea at this time because the 'little church' seemed to be opening its doors to all comers.

The new personalities who began to make an impact on the Impressionist group around 1880 included Jean-Louis Forain, who joined the group as a young man of twenty-five in 1879 and quickly earned himself a reputation as a satirical commentator on contemporary city life. He was closely allied to Degas whom he

greatly admired. Mary Cassatt, who first showed in 1879, was the daughter of a well-to-do Pennsylvanian family. Having trained at the Philadelphia Academy of Art for four years, in 1866 her parents allowed her to come to study art in Europe. She was taught in Paris by two contrasting masters, Jean-Léon Gérôme and Charles Chaplin, the former a painter of historical and oriental genre scenes in a coldly precise classical style, the latter a successful painter and pastelist in a rococo manner. To these influences, Cassatt added her own enthusiasms for the Old Masters and an awareness of the work of Manet. She had traveled widely in Europe, pursuing her interests in contemporary rural genre, and her study of Spanish painting marks her early work. Degas, who introduced Cassatt to the Impressionist group, had been struck by the truth and simplicity of one of her portraits exhibited at the Salon, sensing her to be someone who felt as he did.

Paul Gauguin joined the Impressionists on Pissarro's recommendation. When he first exhibited, as an amateur, in 1879, he was earning a handsome living on the stock market. Combative by nature, even before he had decided to pursue an artistic career on a full-time basis, he was making his voice heard within the Impressionist group. Gauguin's early work equivocated between the landscape and the figure as he

underwent the influence of Pissarro and Degas. It was to be some time before his contribution was able to strike a decisively personal note, marking a new departure for avant-garde art.

By contrast with the shows of 1880 and 1881, the Seventh Impressionist exhibition of 1882 was totally dominated by the landscapists, Degas having stood down in protest against the exclusion of the unpopular Raffaëlli, and other figure painters having followed suit. But it was four years later, at the Eighth and final show of 1886, that more marked divergences began to assert themselves. Camille Pissarro, like a number of his colleagues, had been growing increasingly dissatisfied with the lack of disciplined method in the Impressionist manner. He no longer worked so exclusively out of doors and, around 1880, gave a new attention to drawing and to printmaking. In his work of the early 1880s, peasant figures are given greater prominence and he made new efforts at unifying the surface of his paintings with small, choppy brushwork. He was the first to lend wholehearted support to the new initiatives made by Georges Seurat and his follower Paul Signac. Seurat belonged to a younger generation and, unlike most of the original Impressionists, had joined the independent artists after following a full academic training at the École des

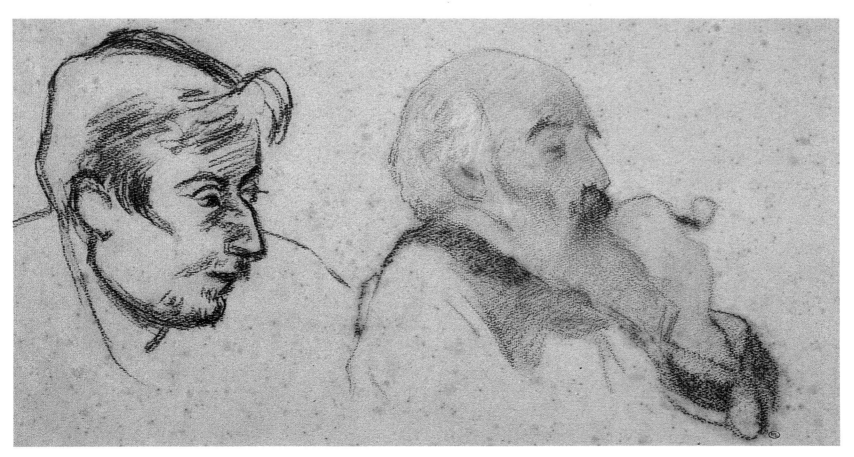

Right: *Portrait of Seurat,* 1883, by Ernest Laurent. Despite being a friend of the sitter since their time at the École des Beaux-Arts, Laurent's portrait is as enigmatic as Seurat himself. This drawing, a study on the effects of candlelight, is built up in a series of cross-hatched marks on rough paper in a manner that parallels Seurat's own drawing style.

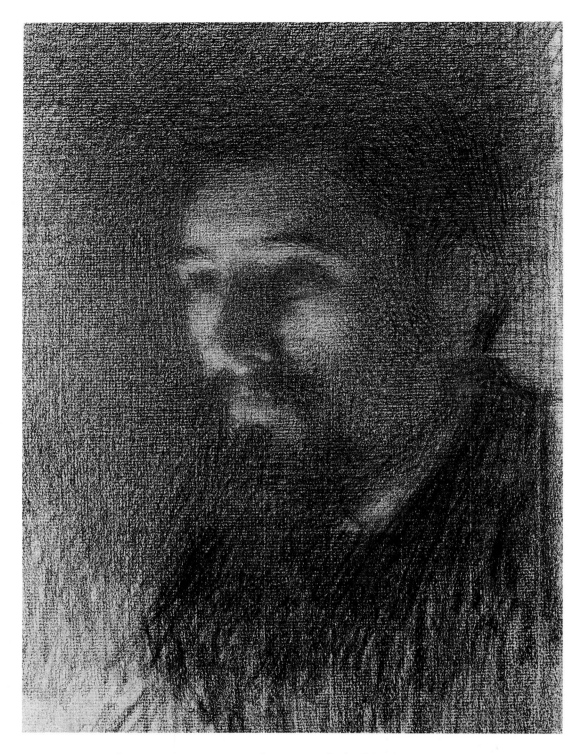

Beaux-Arts. His paintings of 1884-85 show a debt to the Impressionists' modern life subjects and an interest in the theories underlying their coloristic innovations, theories which he began to develop into a more systematic 'scientific' division of tone. Pissarro's enthusiastic endorsement of Seurat's innovations led to a schism within the original Impressionist group and provoked the immediate withdrawal of Monet, Renoir, and Caillebotte from the proposed Eighth exhibition, of which Pissarro was one of the prime organizers. In the longer term, it revealed the fact that the group unity of the Impressionists, always fragile, had finally foundered. Pissarro was angry at the unreceptive attitude adopted by his old colleagues whom he now described as the 'romantic Impressionists,' arguing, 'Seurat brings a new element that these gentlemen are incapable of appreciating, for all their talent . . . personally I am convinced that with this art lies the way forward, that it will produce, in time, extraordinary results.'

The schism extended further, taking in Gauguin, Armand Guillaumin, and Degas, all of whom maintained an equivocal and even, in Gauguin's case, an openly hostile attitude to the experiments of Seurat. Seurat and the Neo-Impressionists made such a profound impact on a whole generation of younger artists and critics that in 1886, as Gauguin observed, the very notion of Impressionism was being questioned. For his part he turned his back on the solutions to the crisis within Impressionism offered by Seurat, and found instead new sources of stylistic and literary inspiration. At first, in company with the young painter Émile Bernard, he was drawn to the primitive art forms and traditions of Brittany. Later he abandoned Europe for the remoter cultures of Oceania. As the critic Félix Fénéon was probably the first to realize, the several new stylistic avenues extending out from Impressionism in the later 1880s were a direct outcome of this renewed concentration of creative energies. Although separate and distinct, the path of scientific method and order followed by Seurat and the Neo-Impressionists ran parallel to the path followed by Gauguin and Bernard toward a more synthetic, symbolic art. Both signified a return to an art of premeditation and order that was to replace the notion of the direct, instinctive, and untheorized Impressionist sensation before nature. In the brief but intense career of the Dutchman Vincent van Gogh, be-

tween 1886 and 1890, one witnesses the simultaneous and combined exploration of both these alternatives.

In the 1890s the original members of the Impressionist group were increasingly thrown back on their own resources, tending to exhibit separately with their faithful dealer Durand-Ruel or, in the case of the reclusive Cézanne, with the new dealer Ambroise Vollard. They were by now happy to follow their individual careers, to hand on the wrangling over primacy and position in the avant-garde to a new generation. For the first time Renoir, Monet and, to a lesser extent, Pissarro, were able to reap the financial rewards for the many years of hardship they had endured. Degas' late career produced some of his most remarkable work which he had no interest in exhibiting, preferring to keep himself well away from the public eye. Something of his approach to modern subject matter was taken up, with economy and biting irony,

in the highly idiosyncratic work of the aristocratic Henri de Toulouse-Lautrec and, in a more light-hearted decorative vein, by the young Nabis, Pierre Bonnard, and Édouard Vuillard. Their obvious admiration may have provided Degas with some solace in his caustic old age. By the 1890s the nature of Monet's investigations into the changing nature of light led him to see his work as a continuing succession of momentary effects, to be recorded not as single paintings but as a series of decorative compositions. To this end he established his remarkable gardens at Giverny, where the waterlily ponds and Japanese bridge provided him with constantly changing motifs. His work was now reaching an appreciative audience especially in America, where his dealer, Durand-Ruel, had for some time been promoting the Impressionists' work. It took rather longer for Renoir, who in his later career had returned almost exclusively to painting the

Right: *Self-Portrait 'Les Misérables,'* 1888, by Gauguin. The reference is to Jean Valjean, the secular saint and outcast hero of Hugo's novel. The profile to the right is of Émile Bernard.

Below: *Self-Portrait,* 1887, by van Gogh. Radiating brushmarks project a powerful sense of energy.

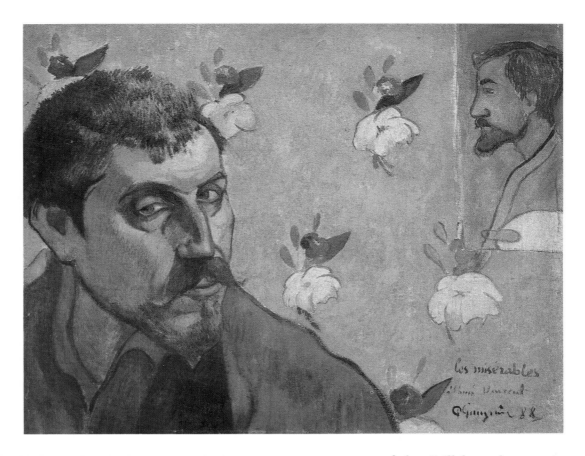

figure, to gain a comparable following.

In 1909 Mary Cassatt warmly congratulated a Bostonian whom she had helped to interest in a painting by Manet, explaining, 'It has been one of the chief interests of my life to help the fine things across the Atlantic.' The American middle-class art buyers, who were already hungry consumers of French Salon painting, quickly became major purchasers of Impressionism, attracted by the freshness, by the modernity, and, not least, by the very 'Frenchness' of the new painting. In Europe, in-built prejudices, age-old conventions, and academic traditions slowed down the acceptance of the Impressionists – one case in point in Paris was the muddle and delay attached to the Louvre's

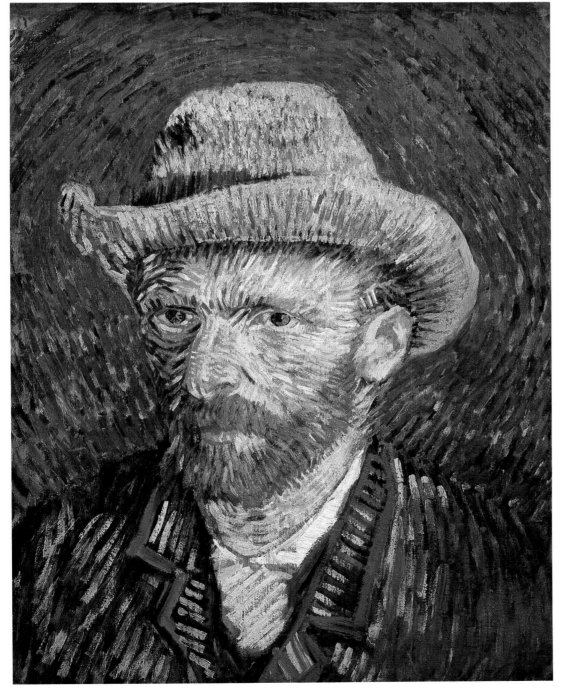

acceptance of the Caillebotte bequest in the 1890s. If that fiasco represents the nadir of the official recognition of the Impressionists, then the queues outside the exhibitions that celebrate their achievement in galleries throughout the world are living proof of their popularity and continuing significance to us today.

THE PAINTINGS

Any selection of paintings by the Impressionists must inevitably include those generally recognized as being either milestones in an artist's career, or masterpieces by any definition of the term. For example, no account of this period in French painting would be complete without Manet's *Olympia*, Monet's *Impression, Sunrise*, or Renoir's *Moulin de la Galette*. Beyond these, any method of selection and exclusion is bound to a degree to be controversial, personal, and arbitrary. In making our choice of 120 paintings, we have followed a number of priorities. As far as possible we have selected works which were exhibited at one or other of the eight Impressionist exhibitions held between 1874 and 1886. A few of the artists we have included did not exhibit with the Impressionists but profoundly influenced or were influenced by them. We have chosen representative works that give some sense of the development of an artist's oeuvre. At the same time, we have chosen images which give an indication of the key themes that run across the movement and give it its historical cohesion. These common themes form a visual argument, a range of comparisons and contrasts that we hope will add to the reader's understanding and enjoyment of the Impressionist venture.

Frédéric Bazille

F r e n c h 1 8 4 1 - 7 0

The View of the Village, 1868

Oil on canvas
51×35 inches (130×89 cm)
Montpellier, Musée Fabre

Frédéric Bazille belonged to a wealthy family who supported his wish to become a painter, and so, unlike most of the other Impressionists, he never had to worry about financial matters; indeed, he did all he could to support his friends in their difficulties. He met Monet and Renoir at the studio of their academic teacher, Charles Gleyre, and through them was introduced to Manet. In his brief working life he developed many of the ideas and preoccupations of his friends into a number of memorable canvases. A few days before his twenty-ninth birthday he was shot dead at the battle of Beaune-la-Rolande, during the Franco-Prussian War.

Berthe Morisot wrote to her sister Edma in 1869:

Our good Bazille had done something which I admire very much: it is [a portrait] of a little girl in a very light colored dress, in the shadow of a tree beyond which is visible a small town. There is much light, sunshine. He is seeking what we all have often sought: how to place a figure in outdoor surroundings; this time, I think he has really succeeded.

The 'town' referred to is the village of Castelnau and the girl who looks so solemnly out of the painting was the daughter of the gardener who tended his parents' estate at Méric, near Montpellier in the South of France. In the painting, Bazille has continued his exploration of the themes of his earlier paintings. Aspects of Manet's *Déjeuner sur l'herbe* and Monet's *Women in the Garden* have clearly inspired Bazille in this work, and yet despite these influences, the atmosphere of the painting is hauntingly original.

A year previously he had painted, *en plein air*, a large family group known as *The Family Reunion*. Despite its studied air of informality the result was a rather stiff and formal group portrait. In *The View of the Village* he has drastically simplified his task by condensing the idea of a multi-figure composition down to the study of a single person.

The young girl turning toward the viewer is convincingly placed within the landscape setting. Her physical presence is suggested by careful modeling and drawing; compared with Monet's *Women in the Garden* his treatment of shadows and reflected light is remarkably restrained. Bazille has used her sash and ribbons to introduce a note of high color into the painting and to enhance the illusion of her presence on this tufted rise of land overlooking the valley of the River Lez. Her slightly melancholic expression, perhaps due to the strain of posing for the son of her father's employer, gives the painting a certain poignant edge.

The barrier of trees and the river in the mid-ground lead our eyes to the sunlit village cradled in the gentle landscape. The pine tree to the right of the seated figure gives the work a solid construction, its branches and rather sparse foliage spreading out at the top of the painting to break up the blue of the sky and setting the rest of the painting into the distance. Bazille made this image the subject of his only etching.

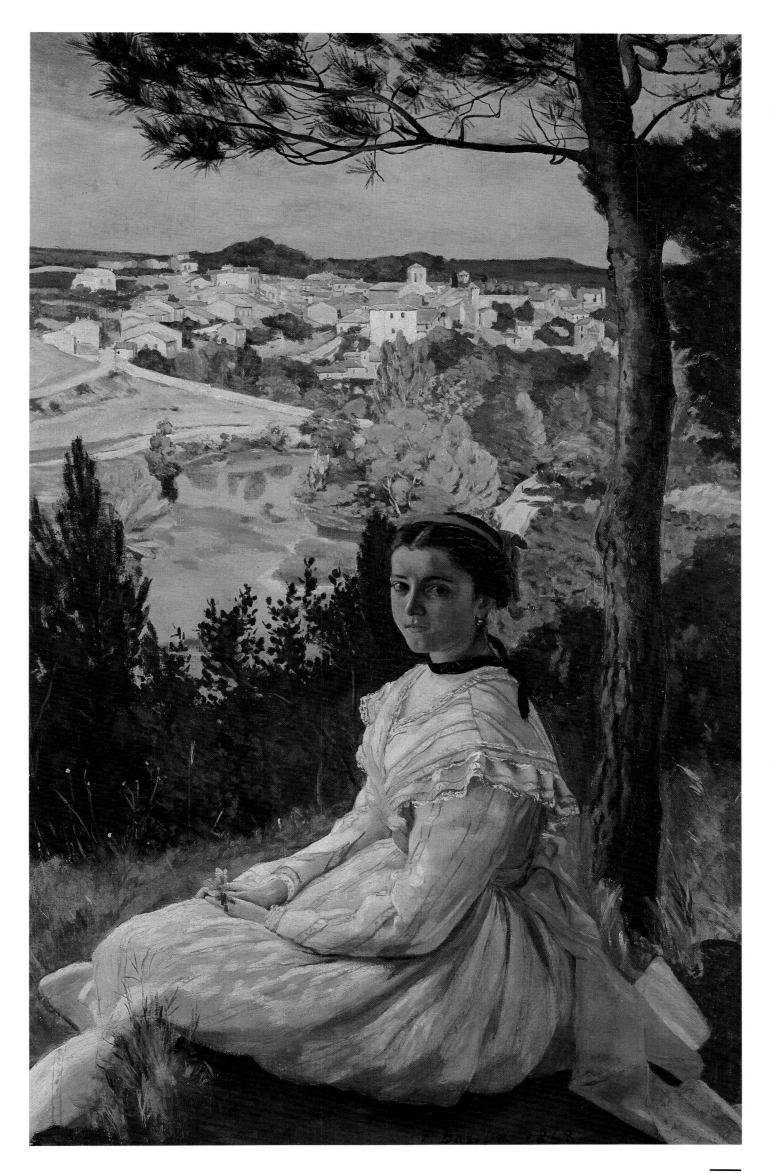

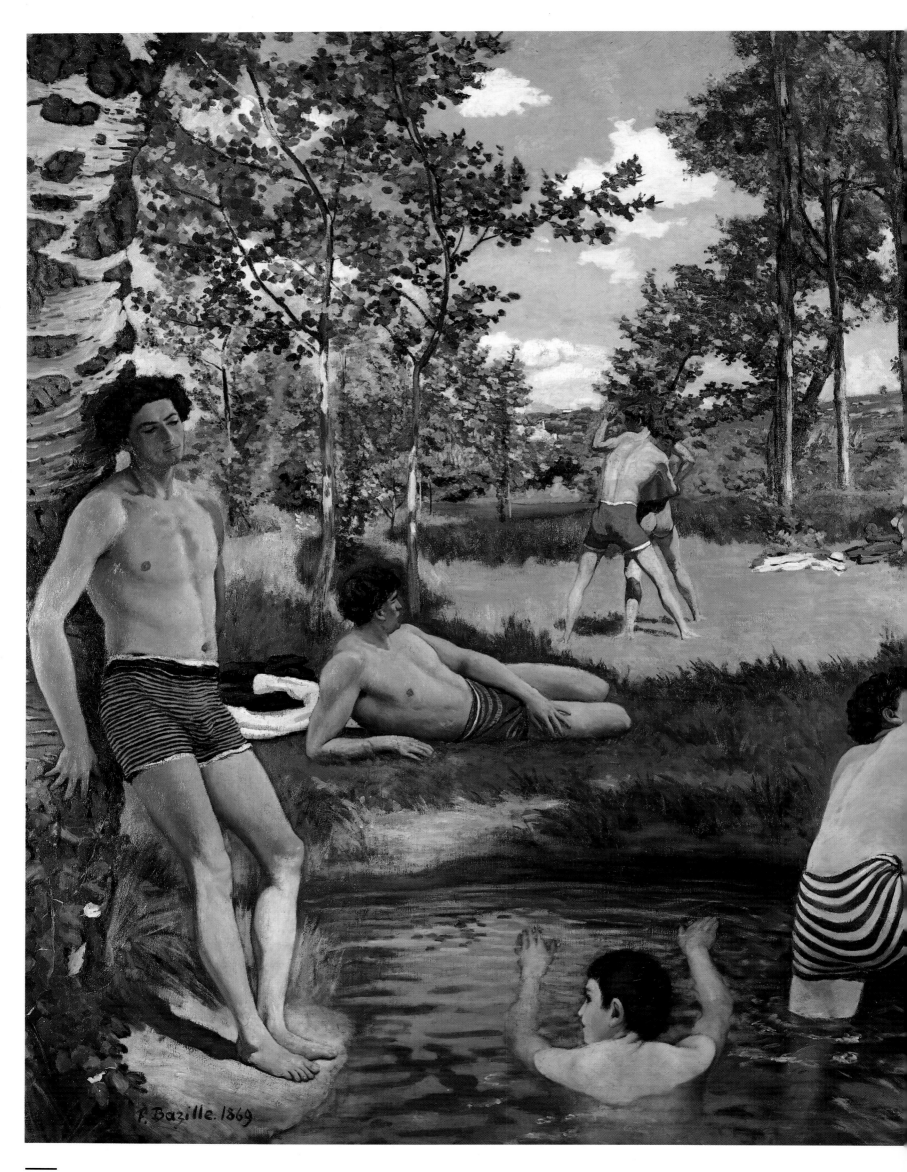

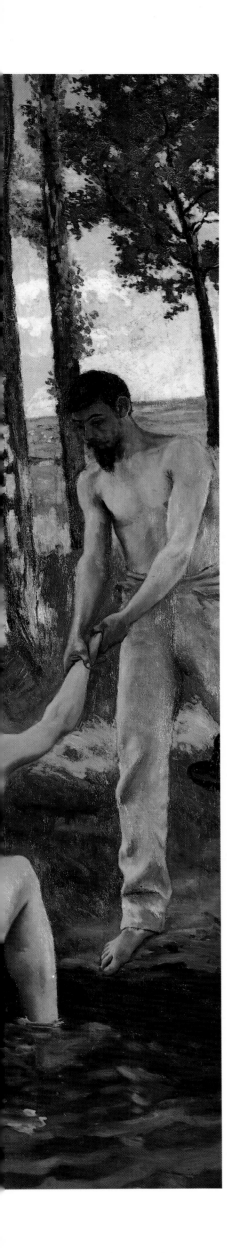

Summer Scene, 1869

Oil on canvas
62¼×62½ inches (158×159 cm)
Cambridge, Mass., Fogg Art Museum

Bazille sent two paintings to the Salon of 1870, *La Toilette*, which was rejected, and *Summer Scene*, which was accepted. An unusual painting, *Summer Scene* sets out to unite closely observed and almost academically considered studies of the male nude and transpose them into an open-air setting. It would appear that Bazille is here responding in a highly original way to two works of 1853 by Courbet, *The Wrestlers*, which was kept in Courbet's studio and is now in the Szépmüvészeti Museum, Budapest, and its more familiar female counterpart, *The Bathers*, now in the Musée Fabre, Montpellier. Certainly there are undeniable debts to these and to Manet's *Déjeuner sur l'herbe*, but in choosing a male as opposed to female bathing scene, he has given this perennial theme an original twist.

Summer Scene has a very strong visual impact and reveals Bazille's interest in academic art. He has not been completely successful in his bold attempt to reconcile the opposing camps of establishment art with the experiments of his friends, the Impressionists. Instead of being a fully integrated whole, the painting seems like a collection of separate incidents; the figures appear frozen in their poses and have rather the air of models in the life room than of young men fooling about on the banks of a river. Bazille's failure to weld all the elements of his painting into a convincing single unit may be partly explained by the unexpected presence of the very contemporary bathing costumes which unassailably sets this scene within the context of the latter part of the nineteenth century. He wrote:

I have constant migraines, I am in a moment of deep discouragement. I have just started a painting I anticipated doing with great pleasure. But I don't have the models I need. It is not going well, and I don't know with whom to be angry.

The frustration evident in this letter, however, should not blind us to Bazille's achievement in producing an extraordinary work, the ambitious nature of which links his *Summer Scene* with Seurat's work of the 1880s, notably his *Bathers at Asnières*. Although Bazille's painting is very different from Seurat's, both artists shared a breadth of artistic taste which allowed them to make use of the monumental paintings of Puvis de Chavannes. Puvis was one of the most challenging academic artists of the day, frequently under critical attack in the 1860s. His paintings often used the motif of a riverside landscape to act as a foil for his classically conceived figures. Perhaps, if he had lived longer, Bazille might have been able to produce works which would have united the vividness of Impressionist technique to the grandeur of the art of the past.

Émile Bernard

F r e n c h 1 8 6 8 - 1 9 4 1

Breton Women with Umbrellas,

1892
Oil on canvas
31½×41 inches (80×105 cm)
Paris, Musée d'Orsay

During the winter of 1887-88, in company with some fellow students from Cormon's studio, Anquetin, Toulouse-Lautrec and van Gogh, Émile Bernard developed the technique of cloisonnism. Visible in somewhat muted form in this picture of 1892, the cloisonnist technique involved the use of heavy black outlines and flat areas of dense color. Encouraged by van Gogh, Bernard had made a point of visiting Gauguin in Pont-Aven during his walking tour of Brittany in the summer of 1888. In Gauguin's own recent work similar stylistic tendencies toward simplification had been emerging. Although at their previous meetings Bernard and Gauguin had found little in common, this time the two artists, despite their opposing temperaments and a large age gap, succeeded in striking up a fruitful working relationship which led to the production of a group of key paintings, including Bernard's *Breton Women in the Meadow* (private collection) and Gauguin's *Vision after the Sermon.* Gauguin was forcibly impressed by the younger artist's stylistic innovations, his crude childlike drawing, his suppression of modeling, frank use of flat color, and decorative treatment of Breton costume. Gauguin undisguisedly built on ideas taken from Bernard's *Breton Women in the Meadow* in his painting of the *Vision.* Having exchanged it for a work of his own, he took Bernard's painting with him to Arles in October that year where it was copied in watercolor by van Gogh.

When on the point of embarking for Tahiti three years later, Gauguin was hailed by the critics as the undisputed genius of Symbolism. Bernard's contribution as a crucial catalyst to his development was entirely overlooked. Justifiably hurt, Bernard launched a concerted and rancorous attack on Gauguin in the press. Writers continue to this day to argue over the relative merits of each artist's claim to supremacy. Bernard had unquestionably broken new ground in treating Breton motifs with brutal, caricatural simplicity, yet his pictures had made no attempt to suggest a profound mystic dimension of the kind that in Gauguin's *Vision* so inspired the admiration of the Symbolist writers. Although a pioneering and exciting artist in his youth, one of the great talents of his generation, Bernard's subsequent development did little to substantiate his claims to being the overlooked progenitor of pictorial Symbolism.

In *Breton Women with Umbrellas,* painted four years after the disputed collaboration, Bernard once again tackled the subject of Breton women gathered in a meadow, perhaps for the traditional pardon festivities. He presents a relatively straightforward account of a group of women, four dressed in traditional local costume, and one, under the reddish umbrella, in the contemporary style of the day. The composition is less flat and schematic than in his works of around 1888. The treatment of the landscape in parallel brushstrokes reflects Bernard's considerable and growing admiration for the work of Cézanne while the decorative use of shadow and the stiff profile poses of the seated women hark back to Seurat's *La Grande-Jatte.*

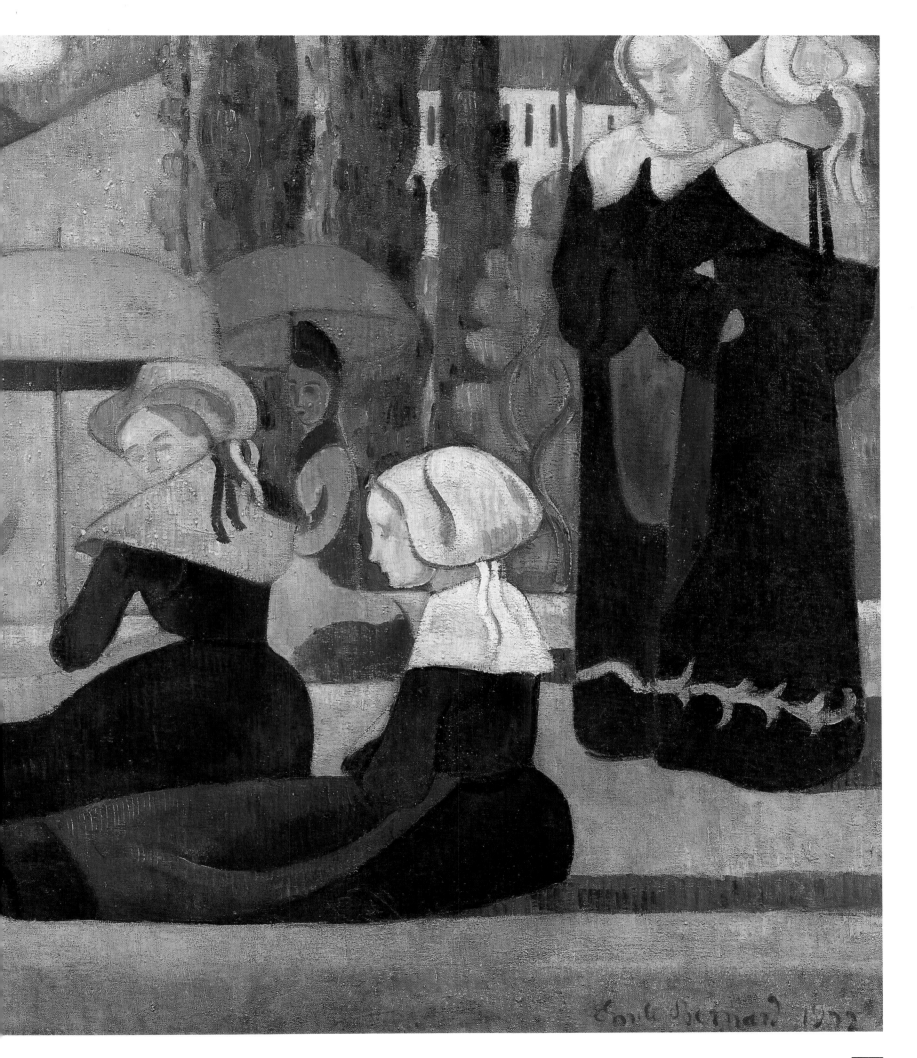

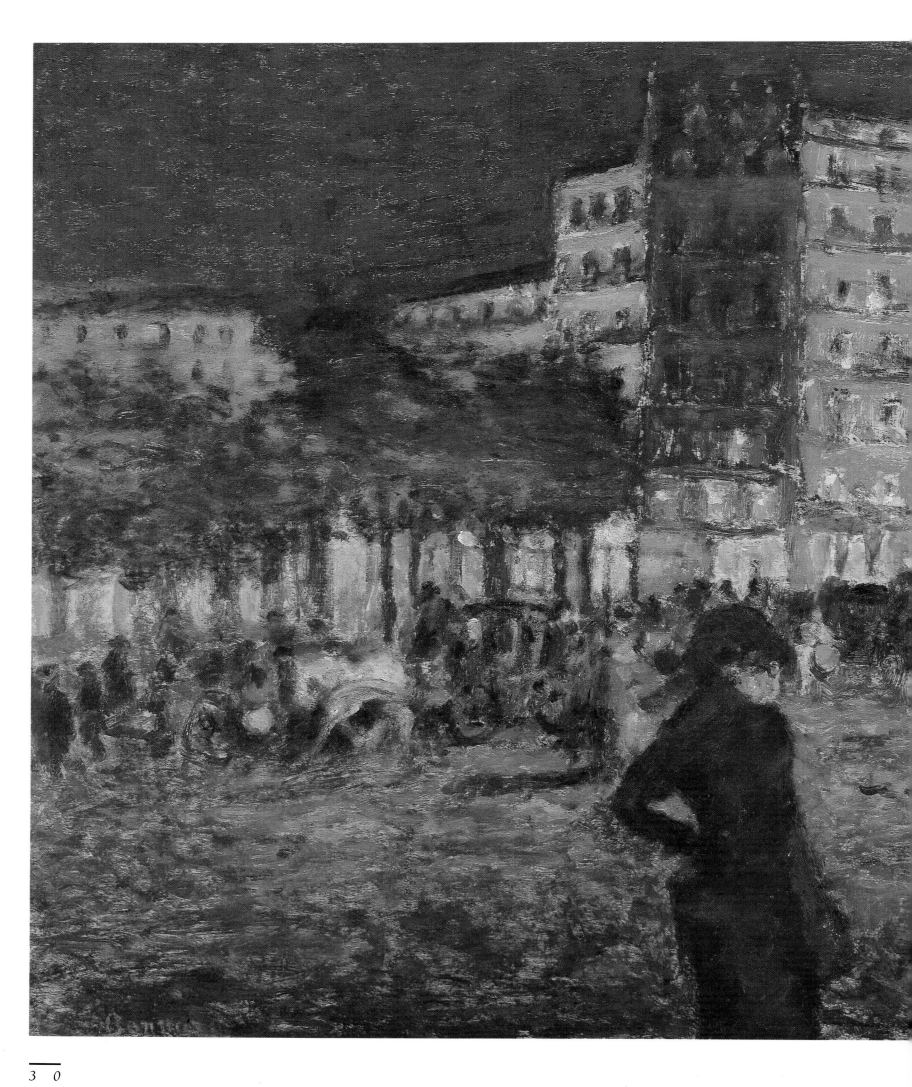

Pierre Bonnard

F r e n c h 1 8 6 7 - 1 9 4 7

Place Pigalle, At Night, c. 1905-8

Oil on wood panel
22¾×27 inches (58×69 cm)
New Haven, Yale University Art Gallery

Pierre Bonnard belonged to the generation of talented artists who came to the fore in the 1890s, having learned a great deal from the Impressionists, and Gauguin in particular. Although a member of the Nabi group, a major force within the Symbolist avant-garde from 1888 onward, Bonnard retained a certain skepticism and kept apart from some of the more esoteric interests of his friends. They dubbed him the '*Nabi très japonard*' because of his intense love of Japanese art. In his aptitude and enthusiasm for poster design and lithography, and attraction to subjects from the modern city, he had much in common with Toulouse-Lautrec.

Bonnard's work is characterized by an economy of statement. The son of *haut-bourgeois* parents, he abandoned a career in law to become a painter and pursued his path with a somewhat bohemian dedication and idealism. His work of the 1890s concentrated either on the comfortable interiors of the bourgeoisie or on the streets and spectacles of Paris. Around the turn of the century he began using rather more subdued colors and a complex handling of paint which was entirely his own, although it owed much to looking at Monet and Renoir. Stylistically he was out of step with any system then in vogue, be it the disciplined, even touch of the Neo-Impressionists or the synthetic drawing and flat, arbitrary coloring of Gauguin and his Symbolist followers.

In *Place Pigalle*, Bonnard's touch is loose and free yet not exactly Impressionistic. He does not use a visible flecked brushstroke; rather he rubs the colors into the surface, suggesting the sense of movement and instability that characterize modern life by keeping contours soft and fluid. Place Pigalle was at the heart of the Paris entertainment district, noted for its circuses, café concerts, and brothels. Bonnard treats the subject in a broad way as a nocturnal cityscape, something Lautrec never attempted. Although Renoir had painted Place Clichy twenty-five years earlier, and Pissarro had tackled one or two night views in his series of paintings of the Paris boulevards, the city at night had hitherto been of little interest to the Impressionist painters. It was a theme that came to the fore at the turn of the century in the painting of Bonnard and also in the works of young newcomers to Paris, notably van Dongen and Picasso.

The elegant, unmistakably modern figure of the woman in black moving across the foreground of Bonnard's composition is kept anonymous, perhaps to emphasize her isolation from the bright, busy scene of cabs, pedestrians, and cafés behind her. Yet there is no suggestion of threat or alienation in Bonnard's vision which is always lightened by a gentle humor and wit. His interest seems to have been inspired by the combined effects of the lights and their reflections on the wet pavements and the strong geometric shapes of the new apartment blocks seen against the skyline.

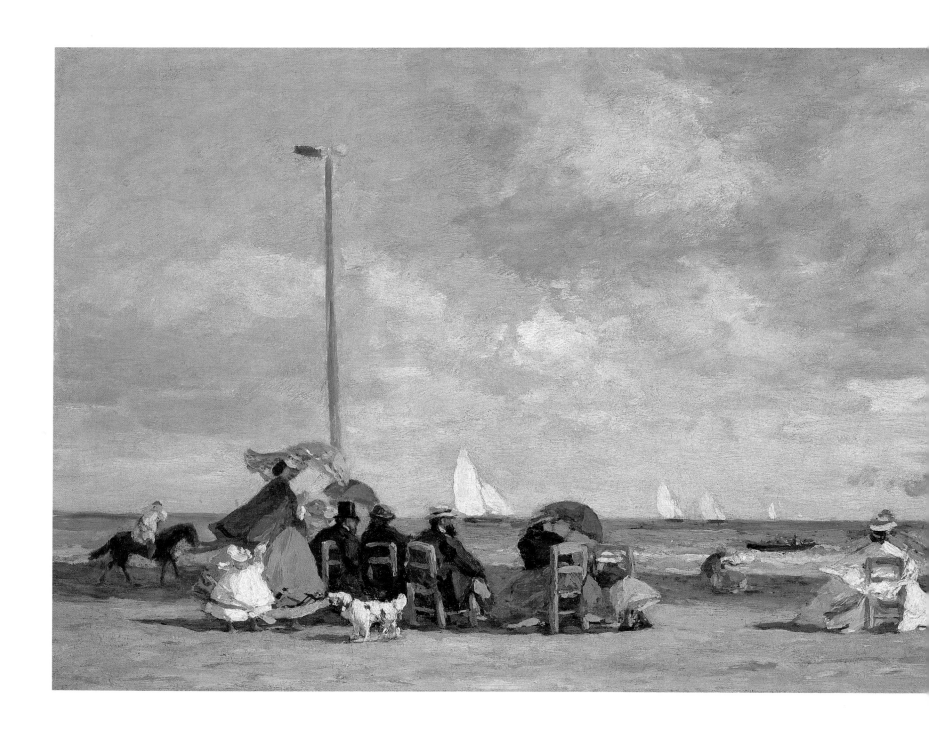

Eugène Boudin

F r e n c h 1 8 2 4 - 9 8

The Beach at Trouville, 1864-65
Oil on wood
10¼×19 inches (26×48 cm)
Washington D.C., National Gallery
of Art

Boudin's paintings are some of the most original works of the nineteenth century. He was born in Honfleur in 1824, the son of a ship's captain, and he spent most of his life exploring the combination of land, sea, and sky that can be found in the landscape of the Channel coast. 'The romantics have had their day,' he wrote. 'Henceforth we must seek the simple beauty of nature . . . nature truly seen in all its variety, in all its freshness.' He found that the vicinity of Le Havre and the resorts of Trouville and Deauville contained all he needed to occupy him for a lifetime of painting.

Visits to the seaside had become a popular and fashionable pastime during the period of the Second Empire. The Emperor's half-brother, the Duc de Morny, leader of fashion and entrepreneur par excellence, had taken a leading role in exploiting the natural resources of this area, creating splendid beaches that were now, thanks to the railway, within easy traveling distance of the capital. Boudin, mistakenly, thought that he had struck a 'gold mine' in choosing to paint scenes of the upper middle classes enjoying themselves on the Normandy beaches. He nevertheless persevered, pursuing his own vision despite little encouragement from the very people he chose to paint.

As in this example, Boudin often shows his subjects indulging in an open-air version of their sophisticated Parisian social round. They are rarely shown doing anything as energetic or vulgar as bathing. Instead, they gather in informal huddles swapping gossip, discussing stock-market holdings, or simply delighting in seeing and being seen by their social equals at these fashionable resorts.

The intrepid visitors brave the bracing wind to chart the progress of a number of distant yachts being put through their paces. Boudin's fine sense of composition can be seen in the measured movement across the painting that leads us from the group on the left of the canvas to the figures standing by the edge of the sea on the right. Two flagpoles relieve the overall horizontality of the painting. Subtle contrasts of light and shade focus our attention on specific elements of the composition, such as the encounter between the horse and rider, who holds his hat firmly on his head, the young child and the dog, and the woman seated apart, her figure brilliantly lit by the sun. 'The peasants have their painters of predilection,' said Boudin, '. . . do not these men and women . . . have a right to be fixed on canvas?' His paintings capture the most ephemeral of things, the movement of the clouds and the sea, the casual pose of a fashionable lounger seated on a chair precariously balanced on the sand, or the sudden billowing of a flag or dress.

Baudelaire wrote that Boudin's paintings were 'prodigious enchantments of air and water;' Corot called him 'the King of the Skies,' and the exactness of Boudin's tonal relationships reveals a careful study of that gentle artist's work. However, his genius for the placing of groups of figures against the open vastness of the sea and sky is all his own.

Boudin was one of the great mentors of the Impressionist group; he it was who introduced himself to the young Monet, at that time uncommitted to art, and invited him to come painting with him. Monet later revealed:

I must confess I wasn't thrilled by the idea. Boudin set up his easel and began to paint. I looked on with some apprehension, then more attentively and then suddenly it was as if a veil was torn from my eyes; I had understood, I had grasped what painting could be; the sole example of this painter's absorption in his work and his independence of effort were enough to decide the entire future and development of my painting.

Gustave Caillebotte

F r e n c h 1 8 4 8 - 9 4

Le Pont de l'Europe, 1876

Oil on canvas
49¼×70¾ inches (125×180 cm)
Geneva, Musée du Petit-Palais

Caillebotte showed this large painting at the Impressionist exhibition of 1877 together with five other works including his *Paris: a Rainy Day.* His paintings of the city were personal and ambitious attempts to give visual form on a grandiose scale to the new capital that had sprung into being during the period of the Second Empire. Artists at the Salon, illustrators in the popular magazines, and avant-garde artists alike were fascinated by these developments and wished to record them. There was no doubt that there existed a large and greedy public eager to devour images of the new technological feats of which the Pont de l'Europe was a prime example. Manet and Monet had also depicted this celebrated piece of engineering, but neither of them had given so much emphasis to the sheer physicality and massiveness of the structure upon which six newly built streets converged.

Caillebotte has not shrunk from expressing the raw newness of this edifice. The brilliant sunlight causes the gigantic steel grid work of the bridge to cast blue-gray shadows on the ground, crisply defining the figures and enhancing the effect of the exaggerated perspective. A dog, hindquarters to the viewer, tail erect, follows its nose toward the Place de l'Europe, while a workman dressed in his traditional blue smock leans over the parapet of the bridge and looks down on the railroad yards of Saint-Lazare. Farther along the bridge an anonymous man walks on, the sunlight beating on his back. Closer at hand, centered over the very spot where the lines of perspective converge, is a young man about town, engaged in an ambiguous encounter with, as one contemporary commentator pointed out, 'an elegant woman, exquisite beneath her flecked veil.' The nature of the transaction is not necessarily certain; but it is clear from what he goes on

to write that they were not to be seen as man and wife, '. . . a common little vignette that we have all observed with a discreet and benevolent smile.'

The uniqueness of Caillebotte's painting can be assessed fully by comparing it to Renoir's painting of the Pont Neuf; unlike Renoir's use of a relatively distant viewpoint, reminiscent of contemporary photography, Caillebotte hurls us with unsettling abruptness into a picture space that plunges disquietingly into the far distance. It is a painting that contains the shock of real experience.

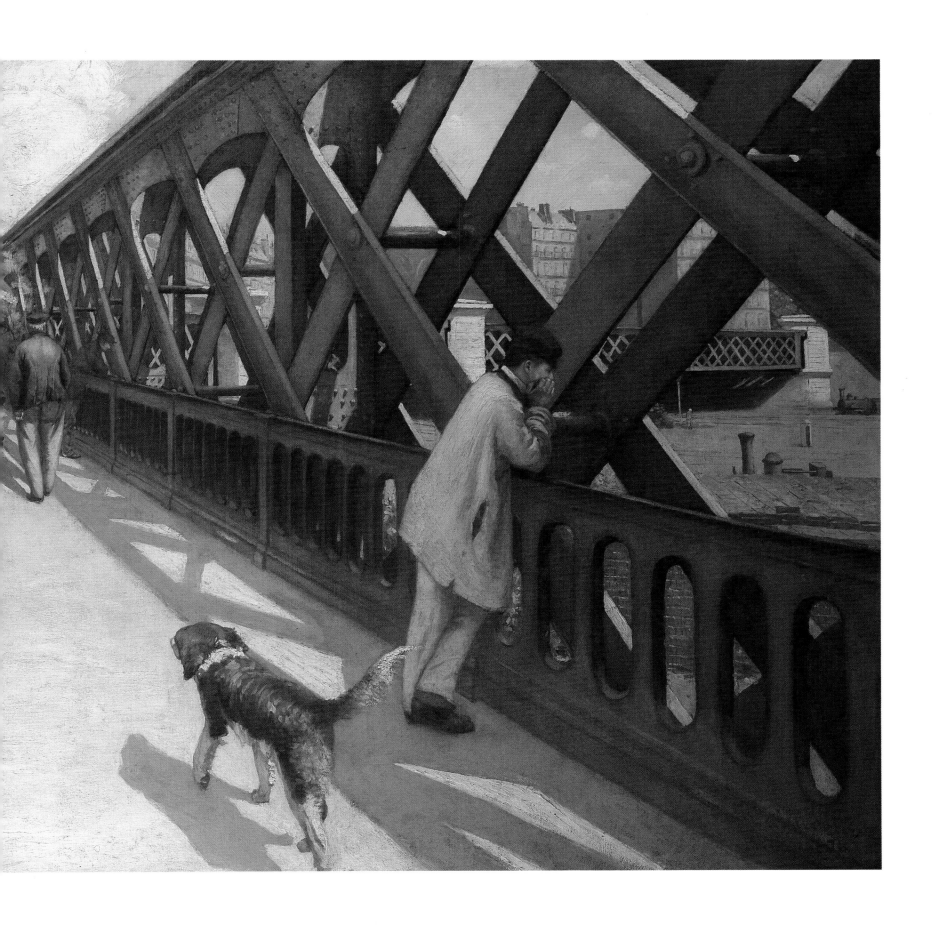

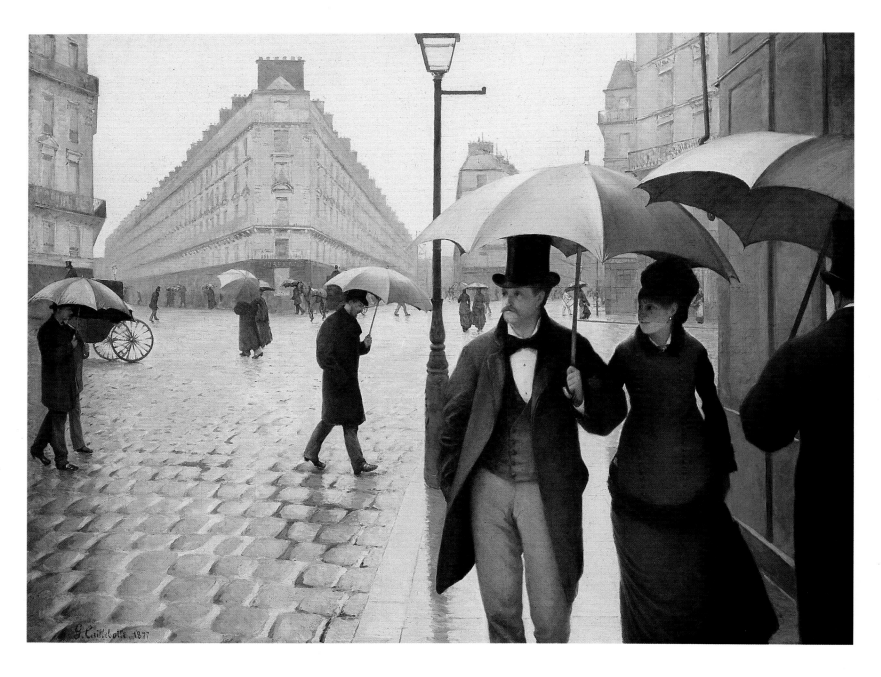

Paris: a Rainy Day, 1877

Oil on canvas
83½×108¾ inches (212×276 cm)
Chicago, Art Institute

This large painting (the figures are life-size) depicts a precise spot in a newly completed quarter of Paris; the two pedestrians pictured strolling nonchalantly before us are heading into the rue de Turin just before it crosses the rue de Moscou, less than five minutes away from Manet's studio and very close to the Gare Saint-Lazare. The painting was exhibited at the Impressionist show of 1877 together with Renoir's *Moulin de la Galette* and Monet's paintings of the Gare Saint-Lazare.

Caillebotte was a man of some wealth who supported his more unfortunate colleagues with gifts of money and purchases of their work. On his death, he left his considerable collection of paintings to the Louvre. It included masterpieces by all the Impressionists but, unbelievable to us today, it was turned down by the French government. Eventually they were persuaded to accept approximately half the collection; the rest was dispersed throughout the world.

Caillebotte's work has been until recently seriously underrated. He never adopted an Impressionist palette or technique, but experimented with striking and original images of the new urban landscape and the people who inhabited it. 'Caillebotte is an Impressionist in name only,' wrote an anonymous reviewer in 1877. 'He knows how to draw and paints more seriously than his friends.' The painting invests the almost deserted city streets with a sense of solemn grandeur, and yet another reviewer felt that 'the subject lacks interest, as do the figures, as does the painting. Caillebotte sees a gray, confused world. Nothing is more emptied of character and expression than these faces.' Perhaps it is precisely for these reasons that the painting seems to a modern audience so eloquent of city life. Caillebotte has exaggerated the width of the streets to enhance the effect of massiveness already created by the looming perspective. The umbrellas, roofs, and cobblestones reflect the silvery sheen of the drizzle. The sun is hidden behind the featureless leaden sky

but just enough of its light filters through the clouds to animate the scene. The two major figures, though walking arm in arm, seem unaware of each other's presence, so absorbed are they in their own thoughts. Their insouciance is such that an imminent collision of umbrellas and bodies seems likely. The size of the canvas, Caillebotte's accomplished use of perspective, and his inclusion of the pedestrian walking into the painting encourage us actively to extend the pictorial area he has created beyond the confines of its frame into our own space. The painting could almost be an illustration for Duranty's *La Nouvelle Peinture* of 1876, in which he writes, 'In real life views of things and people are manifested in a thousand unexpected ways . . . our point of view [does not] always exclude the large expanse of ground or floor in the immediate foreground.'

Recent art historians have noted that it is possible that the young Georges Seurat may have seen this painting in 1877 and remembered it when, seven years later, he began work on his own monumental painting, *Sunday Afternoon on the Island of la Grande Jatte.*

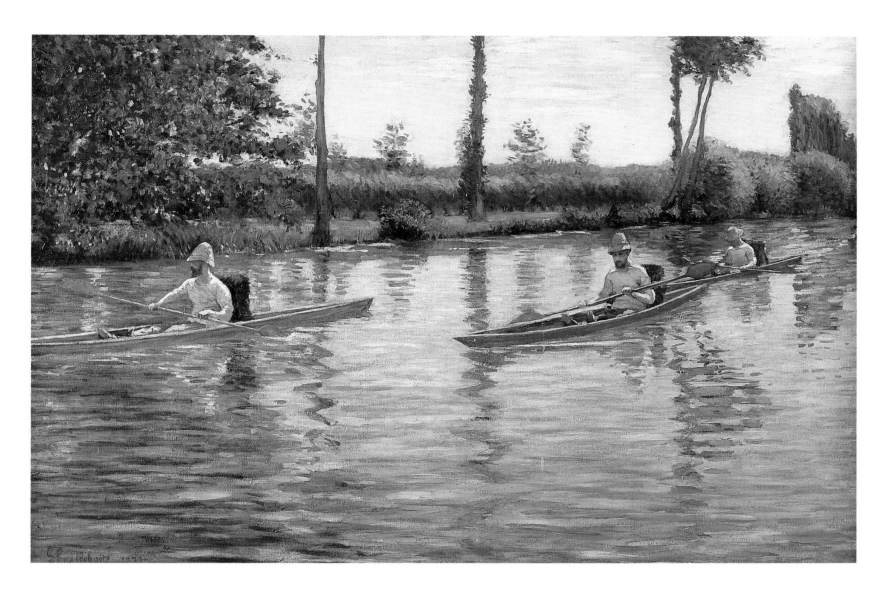

Périssoires sur l'Yerres, 1877

Oil on canvas
40¾×61½ inches (104×156 cm)
Milwaukee, Art Museum

At the Fourth Impressionist show, Caillebotte exhibited a number of boating scenes. Among them were three paintings of three men paddling their *périssoires* or sculls down what is probably the River Yerres. Boating of all types was extremely popular at this time, and these pictures were only a few of many such scenes produced by Caillebotte and his Impressionist friends. In 1881, Gauguin complained that scenes of boating at Chatou were becoming too much of a trademark of the Impressionists.

It is an unusually large painting for such an informal subject. The composition is equally informal; the boatsmen, all dressed in similar outfits, are pictured traveling laterally across the canvas, breaking the verticals of the reflected poplar trees as they do so. Unlike Monet's versions of poplar-lined river scenes, Caillebotte has introduced closely observed and clearly detailed human figures whose forms are treated with more precision than the details of the water and landscape. The large blue area of water takes up approximately two-thirds of the painting, and

reacts markedly against the powerfully realized shades of green, and white touches that describe the landscape and figures.

Caillebotte has here followed the traditional practice of painting in detail that which is of the most significance in the picture and using a more summary technique for subsidiary elements, such as the landscape. This procedure is in contradiction to the practice of his Impressionist colleagues, whereby the various elements of a particular scene are treated with the same degree of emphasis. There are two other versions of this subject: one is now in the Mellon Collection, on loan to the National Gallery of Art, Washington; the other belongs to the Musée de Rennes. They were all painted within two years of each other and, seen together, they have the immediacy of a broken sequence of stills taken from a movie recording some long-forgotten sporting expedition.

Mary Cassatt
A m e r i c a n 1 8 4 4 - 1 9 2 6

In the Loge, 1879
Pastel and metallic paint on paper
26¾×32½ inches (66×82 cm)
Philadelphia, Museum of Art

It was on Degas' invitation that Mary Cassatt, a talented, independent American from Pennsylvania, joined forces with the Impressionist group. In 1879 Mary Cassatt exhibited eleven works at the Fourth Impressionist exhibition, including two pastels entitled *At the Theater,* one of which may have been the present example.

The model for the young woman seated in the theater box was, as usual, the artist's sister Lydia. The subject of the theater or the theater audience inspired several other Impressionists around this time, notably Degas and Renoir. In late nineteenth-century Paris, the theater audience was quite as much a part of the spectacle as the performers on stage. House lights were not dimmed, and as one of Degas' theater paintings reveals, it was standard procedure for the gentlemen in the stalls, a part of the theater often barred to women due to the narrowness of the aisles, to train their opera glasses onto the more attractive women in the boxes instead of onto the actors. This practice accounts for the air of poised self-consciousness characteristic both of Cassatt's and Renoir's elegant young models.

Mary Cassatt's use of color and lighting is both bold and subtle here, refined by her familiarity with the properties of pastel. The daring composition is evidence of the artist's high ambition, her determination to be judged on equal terms with her predominantly male peers. Cassatt produces a startling effect by setting the wide-open fan, patched with metallic paint, parallel to the picture plane and masking the lower half of the model's face. Much to the delight of Cassatt and her family, her works earned almost unanimous praise from the critics in 1879. This particular pastel was later acquired by Degas, a sure sign of his unequivocal approval, and the purchase must have given Cassatt cause for self-congratulation.

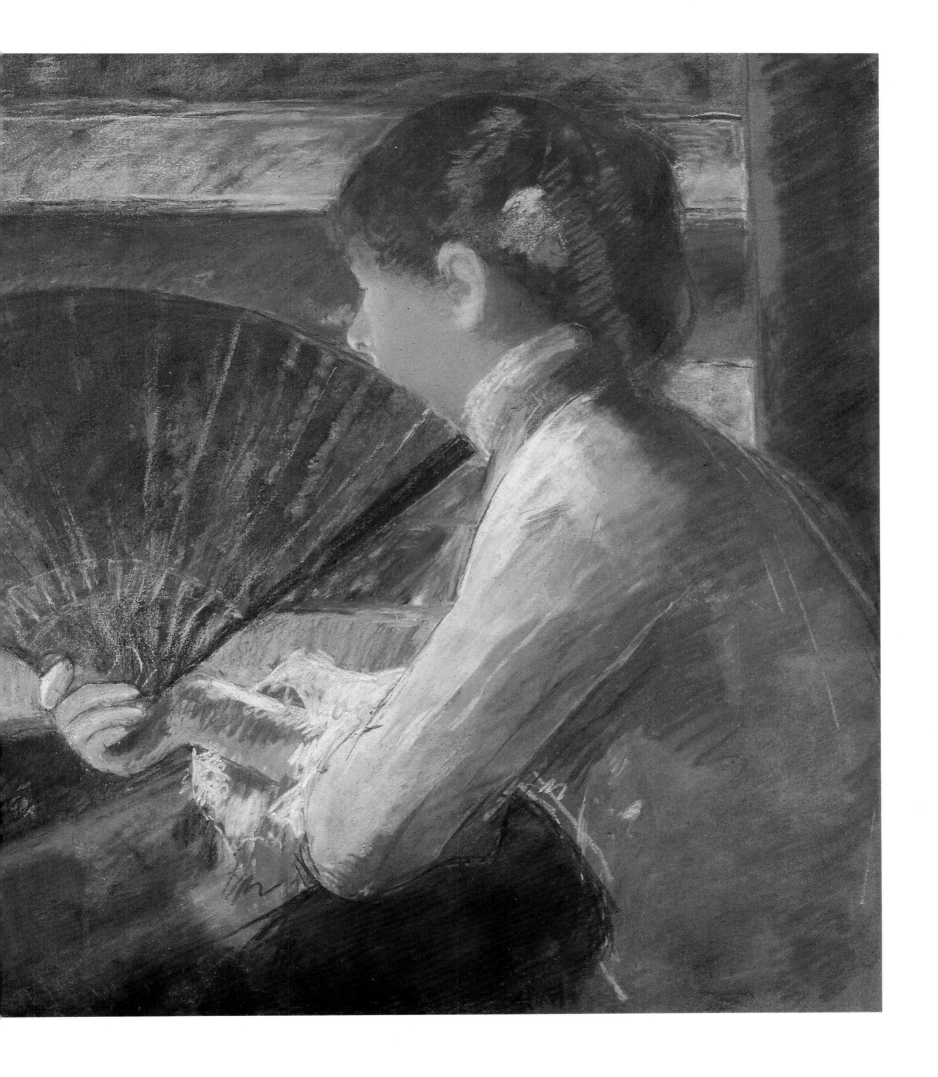

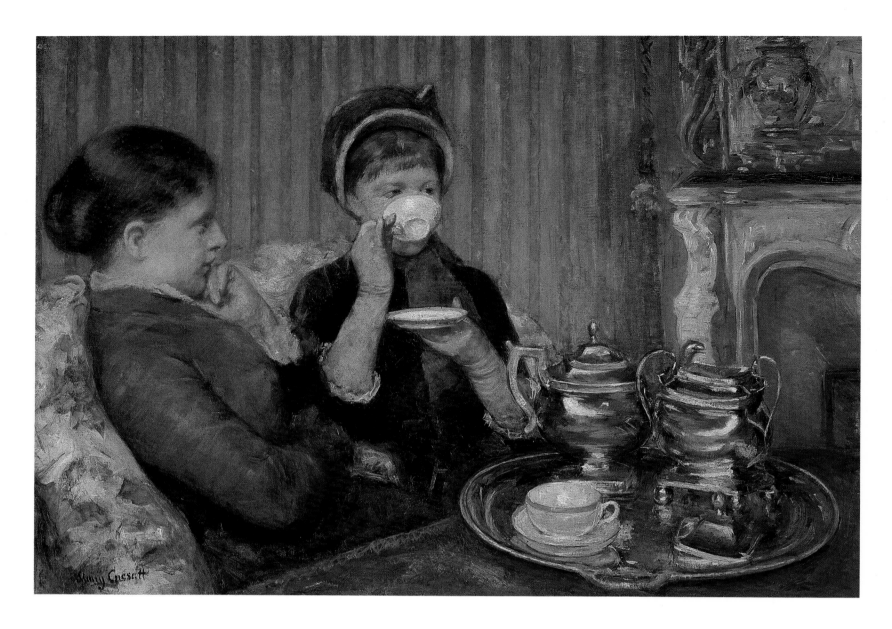

Five o'Clock Tea, 1880
Oil on canvas
25½×36½ inches (65×93 cm)
Boston, Museum of Fine Arts

In view of the success of her first exhibition with the Impressionists and the delight of many critics in identifying Anglo-American qualities in her subject matter, Cassatt seems to have been emboldened to assert her nationality more openly the following year. She sent *Five o'Clock Tea* to the Fifth Impressionist exhibition in 1880. With its untranslatable title, the painting can be seen as a celebration of this bourgeois Anglo-Saxon ritual which so intrigued the French. Although the elegant setting was probably that of the Cassatts' Parisian apartment – the artist's family had joined her in Paris – the models were not taken for Parisiennes by most critics and the handsome early-nineteenth-century tea service was recognizably not French.

The tea service and fine china, together with the marble fire surround and gilt picture frame, all of which reflect the light, provide a foil for the painter's skill as a still-life painter and combine to give the setting an air of comfort and opulence. The artist's viewpoint and her positioning of the two young women is calculatedly intriguing. One of them is evidently a guest who has dropped in but who has not removed her street attire of bonnet and gloves; the hostess, in the brown dress (once again Cassatt's sister Lydia), is entertaining at home. Although seated close together on a sofa, they appear not to be talking to each other, rather to be listening to a third person, another partaker of tea, who is out of sight to the right. In this carefully constructed composition, we too, as spectators, can imagine ourselves seated at the table.

It was in 1880 that Mary Cassatt and Berthe Morisot exhibited together for the first time. Morisot's translucent tones and vaporous brushstrokes were generally felt to be more appealingly 'feminine' than Cassatt's robust and precise draughtsmanship. But for Huysmans it was Cassatt who had the upper hand; 'Miss Cassatt has . . . a curiosity, a special attraction, for a flutter of feminine nerves passes through her painting that is more poised, more peaceful, more capable than that of Mme Morizot [sic], a pupil of Manet.' The two women painters succeeded in overcoming their initial feelings of rivalry and established a firm and lasting friendship based on mutual respect and admiration.

The Bath, 1891-92
Oil on canvas
29¼×36¼ inches (74×92 cm)
Chicago, Art Institute

In this charming scene of a mother washing her child's feet, one can detect the influence of Mary Cassatt's practice as a printmaker. The subject itself, notably the idiosyncratic coloring of the woman's fashionable striped dress, coupled with the plunging viewpoint which has the effect of flattening the figures and emphasizing their contours, are directly comparable to her print *Woman Bathing* of 1891 and both can be related to prints by Japanese artists such as Outamaro. Her experiments in the field of color etching were indebted to Japanese examples from which she learned to use outline economically, to use spare blocks of color, and to keep her motif simple yet bold. When tackling the motif in the medium of oil, Cassatt uses unexpected and somewhat jarring color contrasts to more naturalistic effect; her use of red underdrawing, clearly visible around the fingers and toes, not only echoes the rich reds of the patterned carpet but gives a warm, living quality to the representation of the child's naked body.

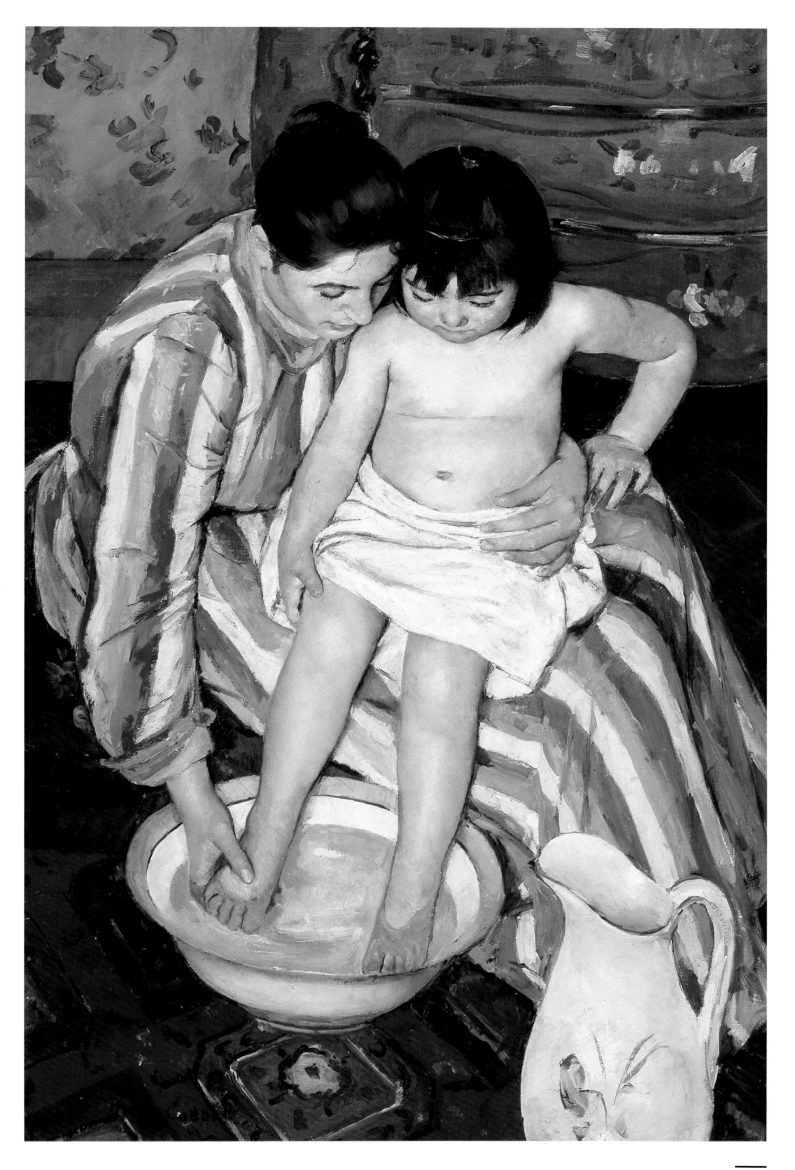

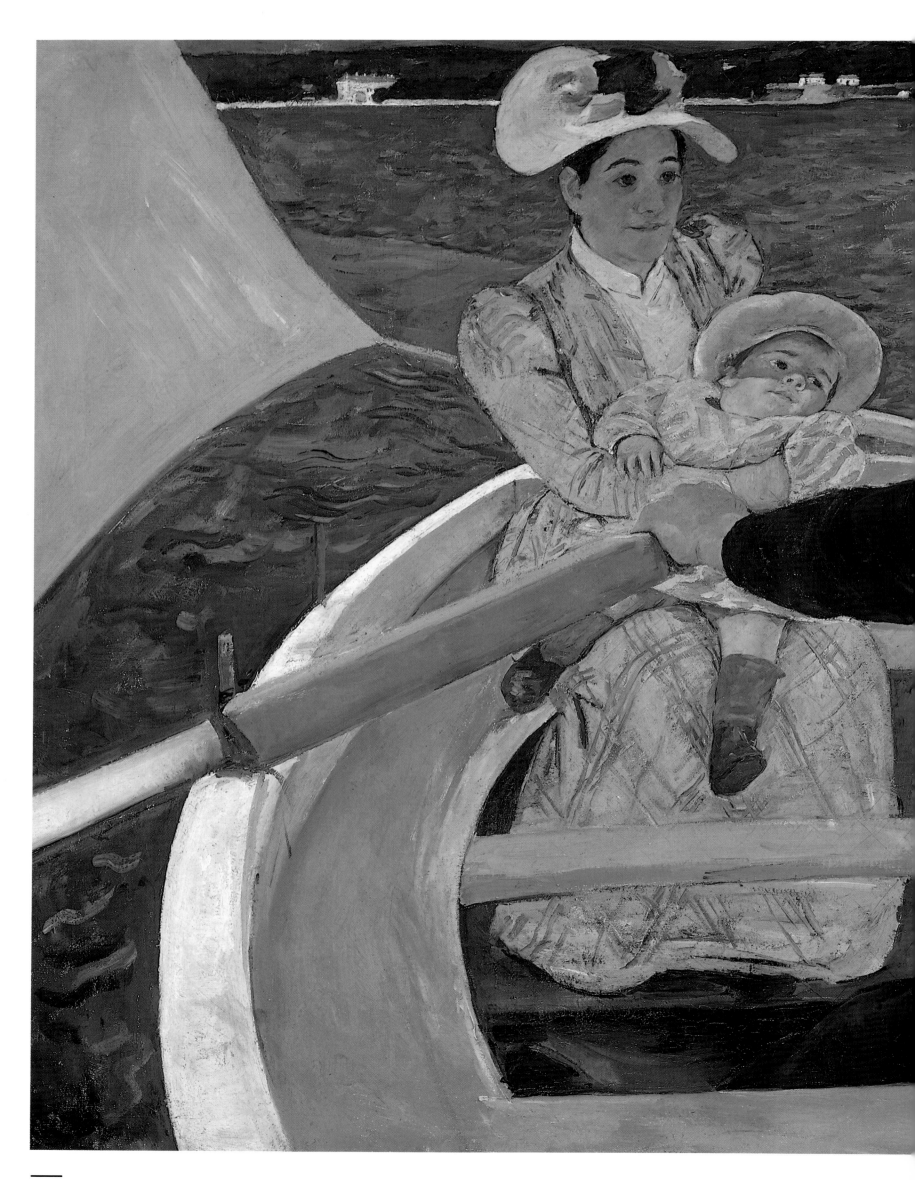

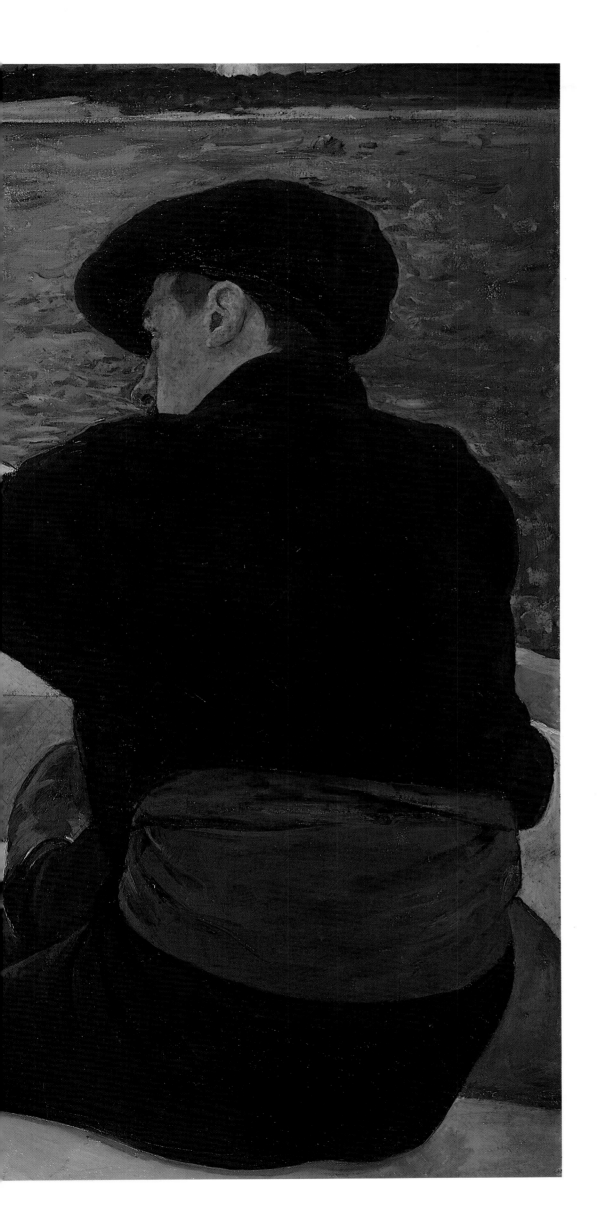

The Boating Party, 1893-94

Oil on canvas
35½×46 inches (90×117 cm)
Washington D.C., National Gallery of Art

In *The Boating Party*, Cassatt departs from her more usual intimate interior subjects and places three figures, a man, a woman, and child, in the confined space of a small sailing boat. There is apparently no wind, because the man has taken to the oars. The composition truncates the lines of the boat and brings the figures close up to the surface of the picture in such a way that the spectator is implicitly placed, like the artist, in the stern. A similarly arresting viewpoint had been pioneered earlier by Manet in *Boating at Argenteuil* and by Gustave Caillebotte.

In her bold use of color, Mary Cassatt seems to make little attempt at naturalism; the flat, unbroken slab of blue for the water, repeated in the bright blue of the oarsman's midriff, contrasts sharply with the bright lemon yellow of the oars and interior woodwork of the boat. The brilliance of the blue was inspired by her experience of the Mediterranean; the artist was staying at Antibes when she undertook this canvas. Similarly bold experiments with color and flattening effects were being made by the members of the Nabi group at this date and they too had been in part inspired by Japanese prints.

The more conventional accomplishment of Cassatt's figure drawing, however, and use of perspective prevents the image reading as a series of flattened shapes. Moreover, her sensitive study of the facial expressions of the three figures adds an implicit narrative and psychological dimension to the image. As so often in Cassatt's work, the spectator's attention is drawn in by the interplay of directional glances. The tautly braced oarsman eyes his elegantly dressed passenger; she, primarily absorbed in the physical effort of containing the struggles of the restive infant on her lap who threatens to rock the boat, nevertheless boldly returns his look.

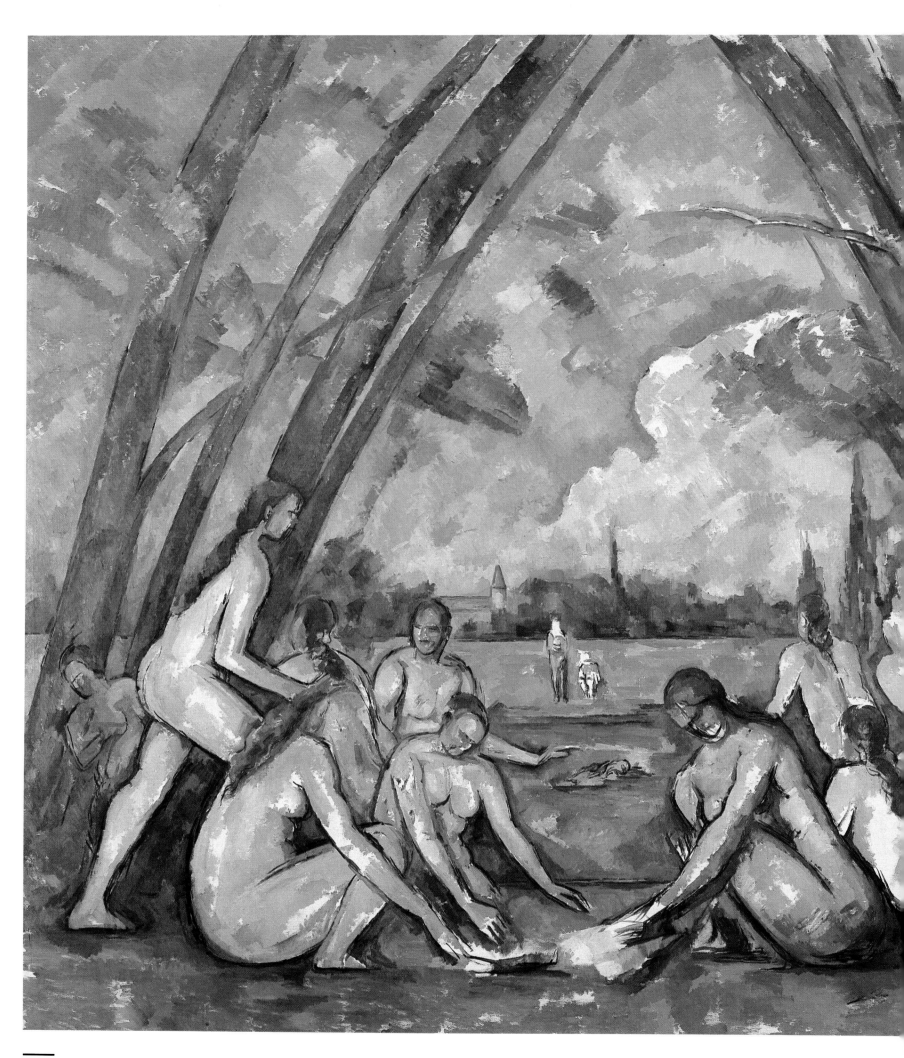

Paul Cézanne

F r e n c h 1 8 3 9 - 1 9 0 6

The Large Bathers, 1899-1906,
possibly 1906
Oil on canvas
82×99 inches (208×251 cm)
Philadelphia, Museum of Art

When Picasso was asked what quality he most admired in the work of Cézanne, he replied that it was his anxiety. Cézanne was in his eighties when he began a series of three monumental compositions of female bathers seen in a landscape setting. An important element in the work of Cézanne is his immense regard for the work of the Old Masters, and it is evident in these late works that he was taking up the challenge of 'museum art.' Comparisons with the work of Courbet, Manet, Bazille, Seurat, and Renoir make it evident that these are no ordinary bathers, and, despite what seems like a contemporary building in the background, for Cézanne these women are mythical creatures from the world of Giorgione, Titian, or Poussin. They possess a grandeur and monumentality that go beyond mere logic; Cézanne was never a 'logical' or 'scientific' artist; neither was the purpose of these paintings to give a convenient genealogy to Cubism. The Philadelphia *Bathers* is the latest of a series of three large paintings of bathers, and was probably painted in the last months of the artist's life. It is relatively thinly painted and parts of the canvas have been left without paint. Unconcerned with traditional notions of finish, he was, however, preoccupied by the notion of completion, writing to the young painter Émile Bernard in 1905 that:

The colored sensations which create the light produce abstractions which do not allow me to cover my canvas, nor pursue the delimitation of objects where their points of contact are fine and delicate: hence my image or picture is complete.

The subject of the painting may make reference to the legend of Diana and her nymphs as related in Ovid's *Metamorphoses*. But there is no sense of narrative contained within the picture, no central incident to disturb the meditative power of the painting. *The Large Bathers* should be seen as an attempt to weld together figures and setting into a single unified composition, expressing at once the artist's strong identification with nature and his deep love of the classical values and order that he admired in art. Perhaps this is what Picasso may have meant when he referred to Cézanne's 'anxiety.' In his paintings of *Bathers*, whether finished or otherwise, Cézanne reveals to the viewer the difficulties of making art in general and of painting in particular, while at the same time producing works that are paradoxically both mystifying and satisfying.

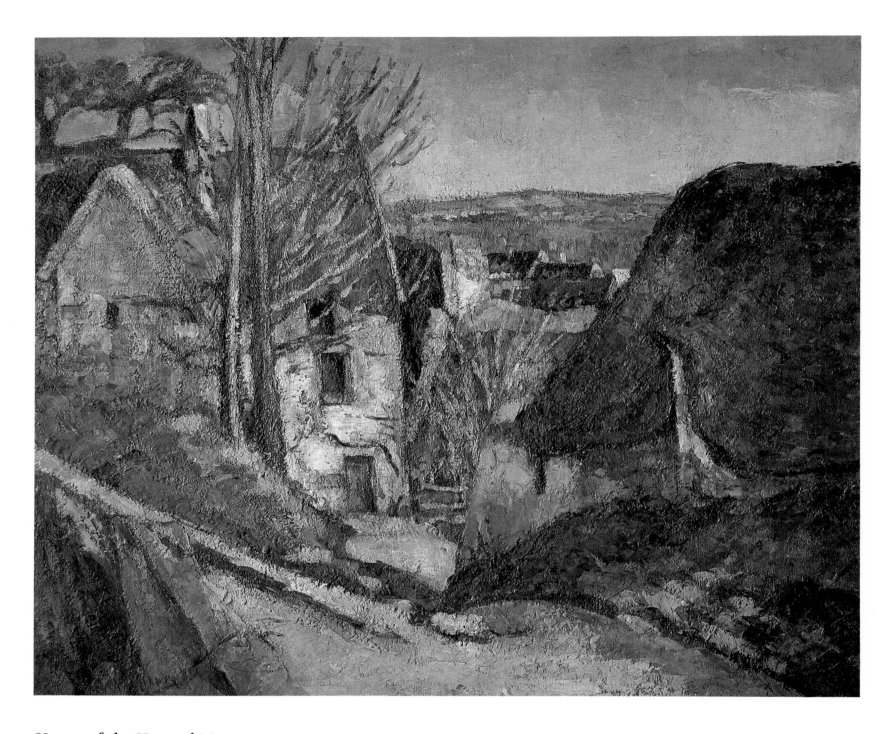

House of the Hanged Man, 1873

Oil on canvas
22×26 inches (56×66 cm)
Paris, Musée d'Orsay

Cézanne exhibited this painting at the First Impressionist exhibition in 1874, and it was probably painted in the spring of 1873. It was one of the few paintings by the artist to be exhibited during his lifetime.

Painted under the influence of Pissarro, the painting shows the village of Auvers-sur-Oise where Cézanne met Dr Gachet, who, seventeen years later, would look after the ailing van Gogh. Pissarro's influence may be seen not only in the subject depicted but also in the painting's light tonality, its fractured brush and palette-knife work, and its solid, almost marquetry-like construction. Gone are the dark dramatic works influenced by the masters of the baroque tradition, and in their place is the result of a patient and prolonged study of a prosaic corner of a village in the Île de France. In this painting we see signs of struggle. Every inch of the canvas is covered with a crusty surface of thick opaque paint, evidence of overpainting and of Cézanne's use of the palette knife.

Clearly noticeable in the painting is Cézanne's desire to build a strong surface structure that locks the objects into place and creates a tension with the far horizon just visible between the roofs of the foreground cottages. His treatment of the branches of the trees suggests the beginning of his ability to capture in a medium that is physically fixed a sense of movement and atmosphere.

The scene could almost be a Corot or Pissarro; an entry to a village, an image of comfort and security, was also a subject beloved of the seventeenth-century Dutch painters. Out of that potentially gentle subject, Cézanne creates an image of great tension. At the point where the road disappears into the village, the viewer is forced to cut a visual pathway through the densely packed architecture of the streets to the landscape beyond.

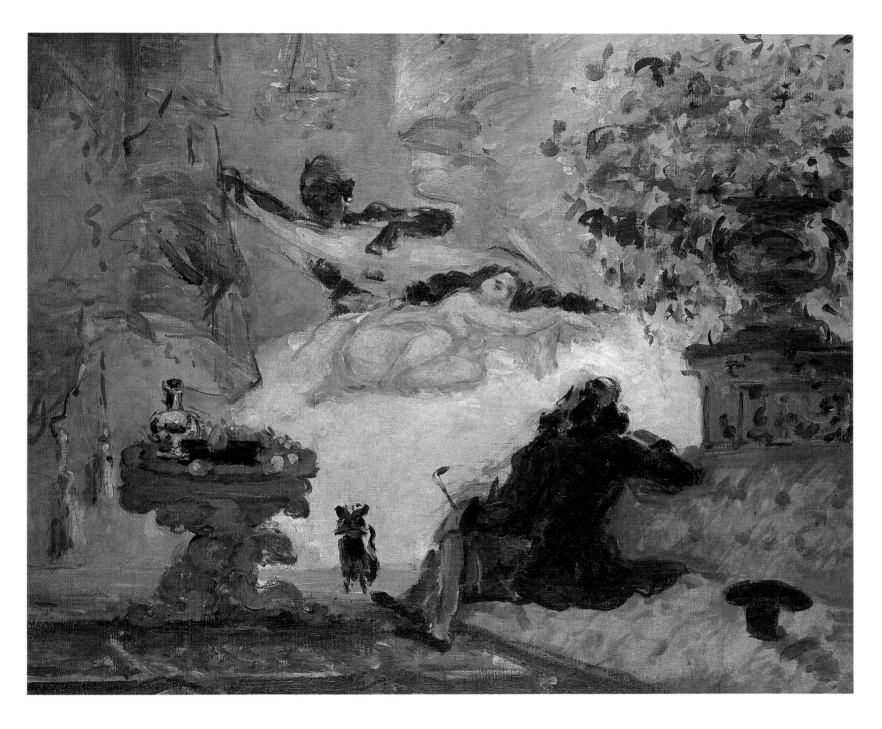

A Modern Olympia, 1873-74

Oil on canvas
18×22 inches (46×56 cm)
Paris, Musée d'Orsay

This charming little oil sketch is one of the
many homages paid to Manet's great
masterpiece, *Olympia*. In it, Cézanne has
made many changes which tell us a great
deal about his own art and much about his
attitude to the original. It is very lightly
painted and the story is related that M.
Chocquet, one of the few early collectors of
Impressionist paintings, saw Cézanne
working on this small painting and, realiz-
ing the artist's tendency to overwork his
canvases, snatched this one away from him
before the artist could spoil it.

Once compared with the Manet, it
becomes immediately apparent that
Cézanne's version is a parody of the
original, delicately laced with gentle
humor. Instead of an ice-cool painting,
here we have a passionate one; the black

maid, instead of offering her mistress a
bouquet of flowers still wrapped in their
paper, is given the much more dynamic
role of revealing her mistress's beauties to
the seated male. The balding, bearded man
is Cézanne, who has included himself in
the painting, gazing fervently, cane in
hand, at this bounteous vision. The profes-
sional hauteur of Olympia is rejected in
favor of an inviting and openly erotic nude
of Rubensian proportions. The Baudelai-
rean black cat, the symbol of lascivious-
ness and promiscuity, has been exchanged
for a beribboned lapdog, a reference to the
original source of Manet's painting,
Titian's *Venus of Urbino*, in which a dog is
used as the symbol of faithfulness.

In the context of Cézanne's painting
career, this painting marks the shift in his
work from the angst-ridden images of sex-
ual frenzy, drunkenness, and violence, to
an art dedicated to the expression of his
relationship with perceived reality, which
would be at the same time equal in profun-
dity to the art of the Louvre.

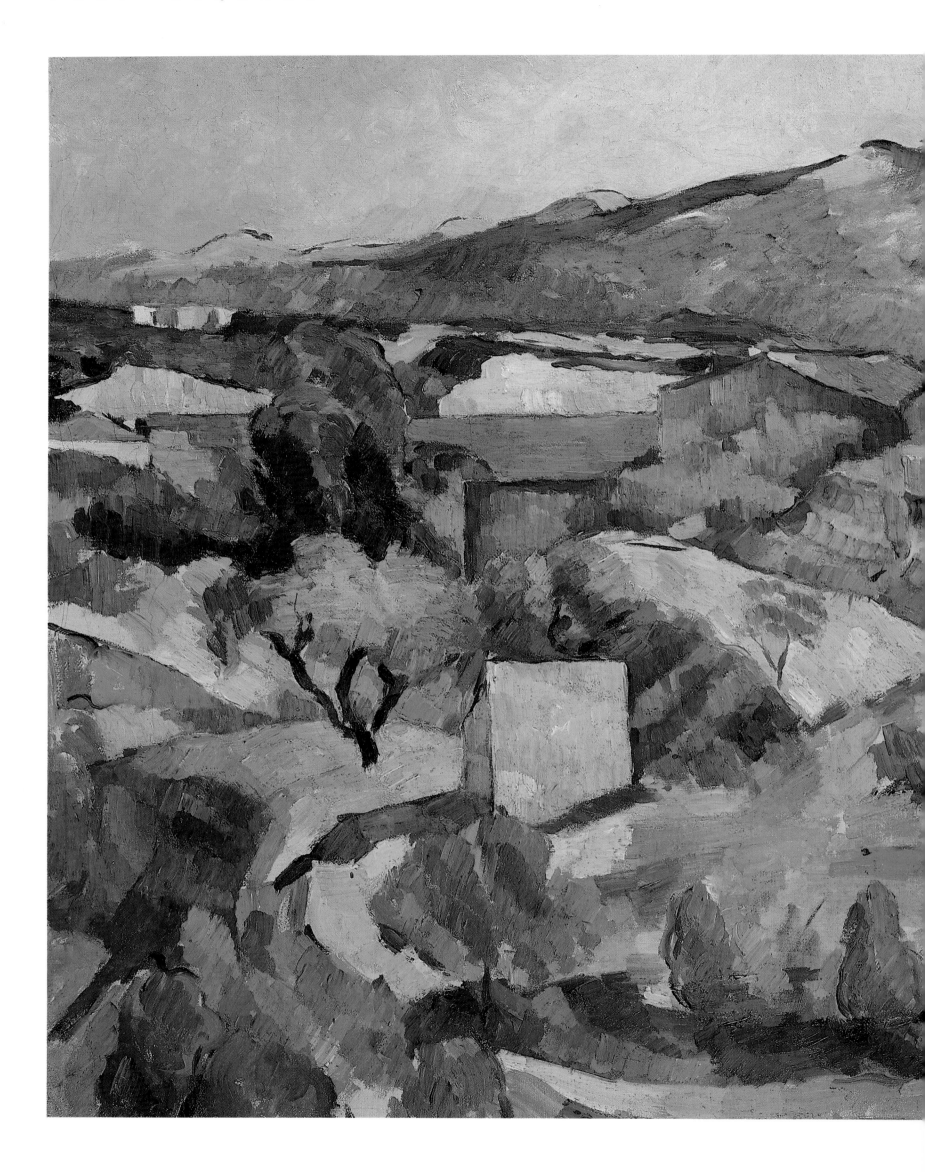

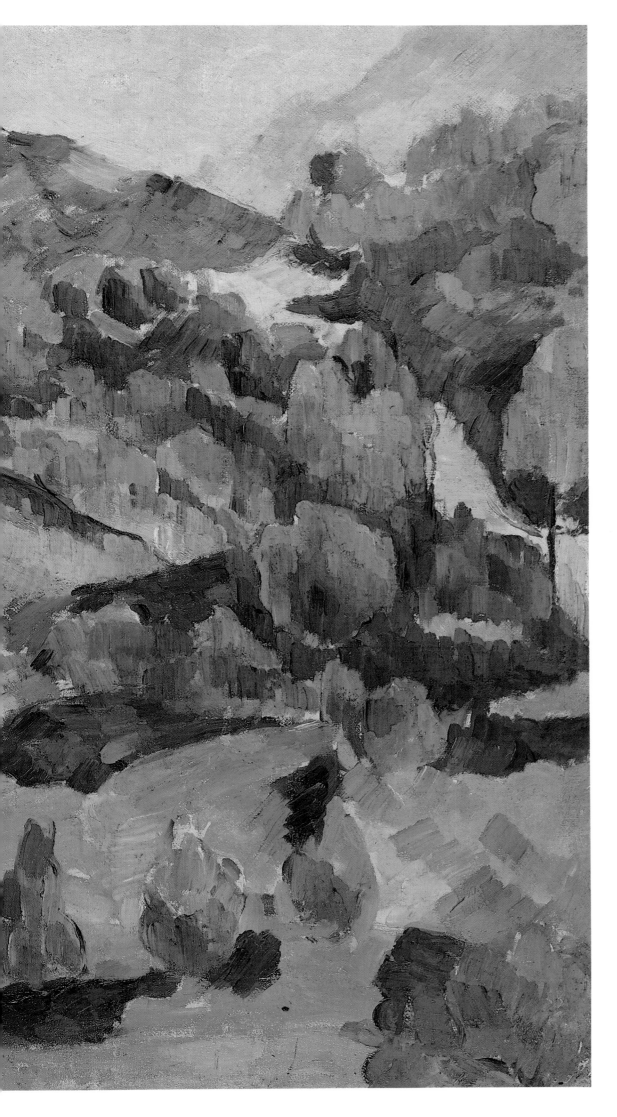

Mountains seen from l'Estaque,

c. 1879
Oil on canvas
21×29 inches (53×74 cm)
Cardiff, National Museum of Wales

In this painting, Cézanne has caught all the heat and glare of a Provençal landscape. The composition is solidly constructed within the rectangle of the painting area and, through a system of steps as carefully charted as anything Poussin invented, the artist leads us down the roadway, behind the building, and on into the distant countryside via a series of related arcs that take us into the depths of the landscape. Instead of the thickly applied paint seen in *House of the Hanged Man* Cézanne now favors a thinner paint and separate brushmarks, both of which add to the structure of the painting's composition, giving a solid, well-constructed feel. The light falls across the painting from upper right to lower left, giving a strong emphasis to the diagonal movements of the landscape, which zig-zags from the curve of the road at the bottom of the canvas through the landscape until the eye rests on the form of the mountain in the distance.

Despite Cézanne's use of clear, bright colors and generalized forms, the landscape is easily comprehensible, each separate element linked to the whole by a subtle balance of repeated shapes and echoing forms. As with the work of so many of the Impressionists, part of the picture's fascination rests in the desire of the viewer to read the scene naturalistically and at the same time to appreciate the rich surface pattern of color and texture formed by the manipulation of the paint on the surface of the canvas. In the area of the sky the paint is washed on thinly, allowing the canvas to show through, while in other areas the paint is thick, dragged on in strokes that echo the form and solidity of the thing depicted, as in his treatment of the foliage of the trees. Cézanne was intensely aware that nature rarely stands still, and that the human eye does not record a split second of frozen time, but that things are seen in a state of continual flux. Cézanne's techniques give a freshness, a lightness, and a sense of breathable space to his pictures which go hand in hand with the monumentality of their composition.

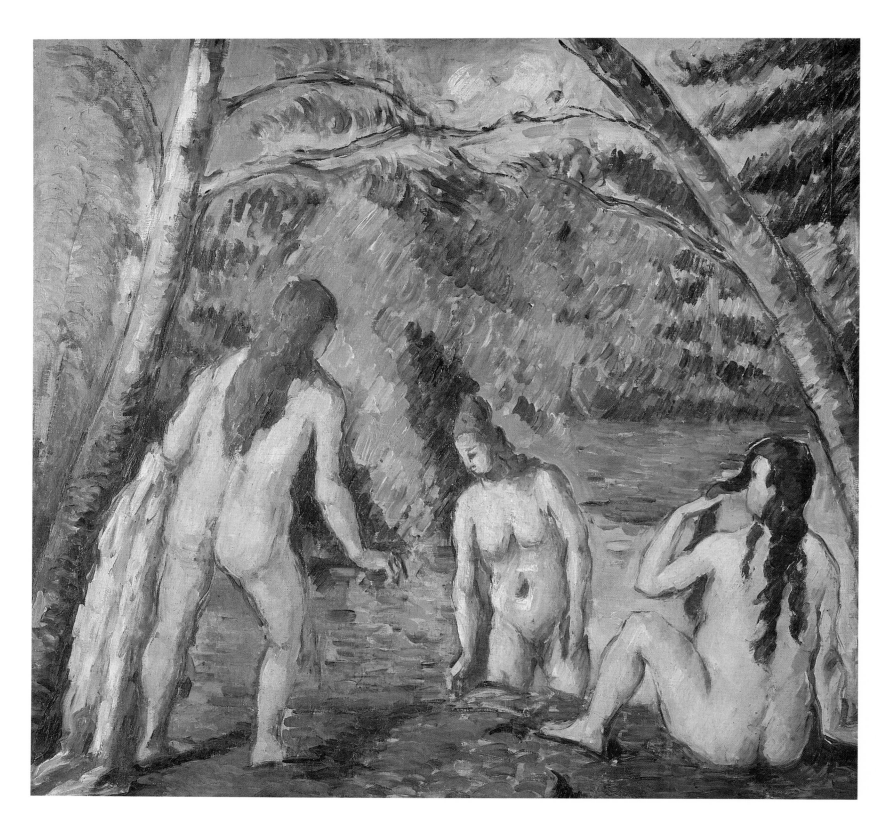

Three Bathers, 1879-82

Oil on canvas
22×20 inches (56×51 cm)
Paris, Petit Palais

Henri Matisse, one of the greatest artists of the twentieth century, bought this painting with part of his wife's dowry in 1899. In 1936, he gave it to the City of Paris, and it now hangs in the Petit Palais. He accompanied his gift with a letter to Raymond Escholier, the Director of the museum. 'I have drawn from it my faith and perseverance . . . it is rich in color and surface, and seen at a distance it is possible to appreciate the sweep of lines and the exceptional sobriety of its relationships.'

It was painted about 1879-82. Given that

part of Cézanne's reputation rests upon his many paintings of the nude, it may come as a surprise that he felt profoundly ill at ease in the presence of the naked model. Most of his mature work in this genre was done from old sketches and drawings after the Masters. The painting is far removed from the open eroticism of his earlier nudes, and marks his deep reverence for the Classical tradition; not the tawdry exploitation of that tradition by the academic painters like Cabanel or Bouguereau, but a profound and personal meditation through the act of painting on this, one of the perennial themes of European culture. Painting the nude was important to the painters of the Impressionist circle; Manet, Degas, and Renoir, each in their own way, paid homage to this great tradition.

Cézanne took up the theme of the single male bather in the 1870s and used the motif to give form to his memories of his adolescent adventures with his friend Zola in the countryside around Aix. In the final decade of his life, Cézanne began his series of monumental *Bathers* which would occupy him, alongside his still life and landscape painting, until his death. The powerful forms of the women are framed by the two leaning trees, and the modulated color and brick-like brushstrokes do not record the sensations of a perceived landscape, but are used to create a framework to support the sculptural mass of the three figures. By these means, Cézanne builds up a painting powerful and dynamic enough to give impetus to the equally innovative works of Matisse.

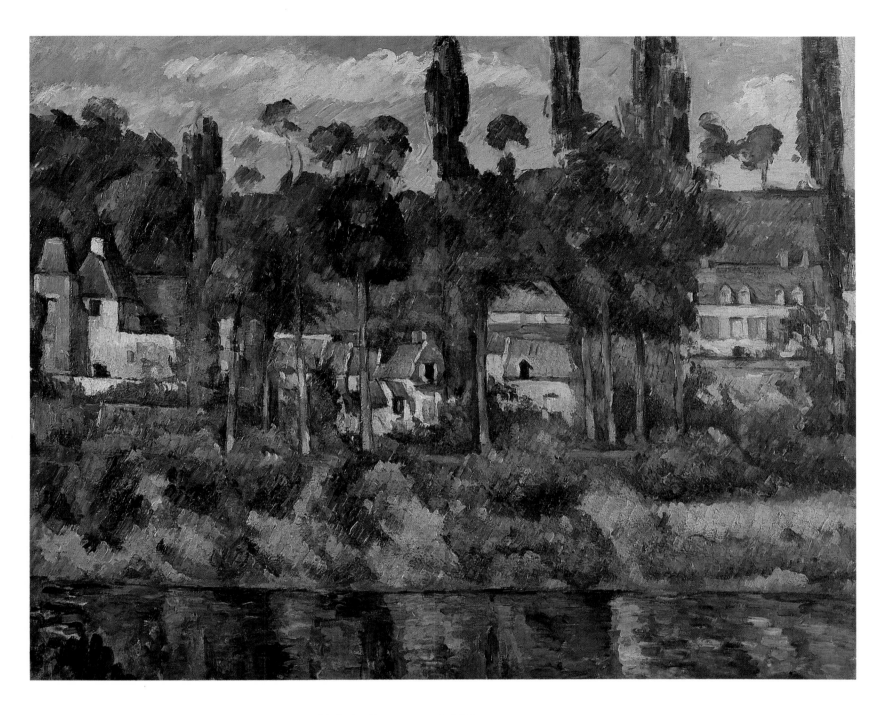

Zola's House at Médan, *c.* 1880

Oil on canvas
23×28 inches (59×72 cm)
Glasgow, Burrell Collection

Cézanne was a childhood friend of the novelist and critic Émile Zola. By the 1870s, Zola's realist novels about modern Paris had earned him the means to live in luxury at Médan, situated on the Seine to the northwest of the capital. Cézanne visited him there on a number of different occasions between 1879 and 1882 and in 1885. The scene is viewed from a small island situated in the River Seine; Zola's house is out of sight to the right.

In this painting Cézanne has taken one of Pissarro's favorite pictorial devices of the view of the buildings through a framework of trees and foliage; this device allows him to produce a composition based on bands of horizontals locked into place by the verticals of the trees.

Like the landscape referred to earlier, this painting once belonged to Gauguin.

Gauguin and his friend Bernard reacted against what they regarded as the limited art of Impressionism and found in the orderly structuring of Cézanne's canvases a means to create sonorous effects in their own works. Both artists admired Cézanne's use of close, parallel strokes of different-colored paint as well as his use of an almost geometrically rigorous composition relating to the sides of the canvas that give his paintings an aura of solemn hierarchical grandeur.

Cézanne first sketched in the landscape quite freely in thin paint and then began to impose his ordered brushwork upon particular areas of the painting. Gradually, as he continued to lay on the paint, areas built up to varying degrees of thickness, causing the contour lines to shift as he noted down his *petites sensations* before the motif. Cézanne's endlessly subtle modifications of color, tone, and texture create a satisfying effect not unlike that of a tapestry; a unified, harmonious, and strongly crafted object. *Zola's House at Médan* remains a source of constant delight.

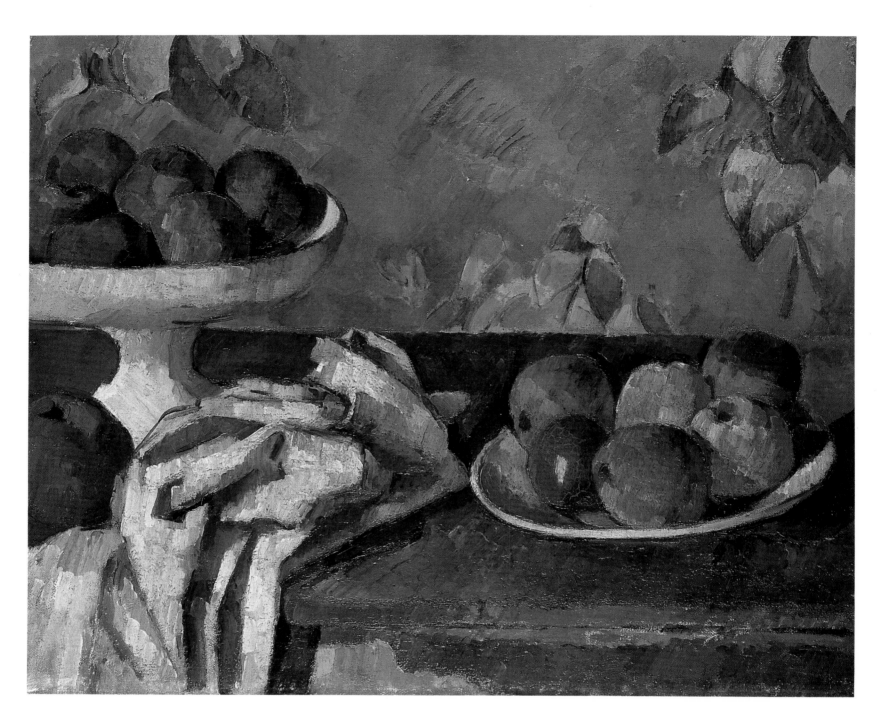

Still Life with Plate and Fruit-Bowl, *c.*1880

Oil on canvas
17¼×21 inches (43×54 cm)
Copenhagen, Ny Carlsberg Glyptotek

The still-life genre certainly suited Cézanne's artistic personality very well, allowing him to arrange the elements before him at his leisure to suit his sense of color and form. A still life raised none of the problems that a living model might present; fruit could not complain of long sessions, nor could it shift position. A confrontation with an apple did not give rise to the emotional problems he suffered in the presence of the naked model. Together with these advantages a still life presented him with a perfect testing ground for ideas.

Cézanne's painting is built up in a number of horizontal bands broken by the angular forms of the white napkin. A series of small diagonal strokes covers the canvas surface in a rich weave of texture and color.

Each brushmark consists of a separate dab of color relating to the visual sensation it arouses in the artist. Gradations of light and shade are not denoted by the means of an imagined tonal range but through the subtle modulation of color. The painting is not conceived as a copy or illusion of reality; instead, the artist presents us with an analogy of direct experience created through the manipulation of paint on canvas. The physical presence of these objects is so powerfully realized that one can almost fail to note that Cézanne has departed from the traditional rules of perspective. In order to make his painting a stronger and more cohesive whole the artist has not hesitated to distort the shape of the objects to bring a greater harmony between the various elements of the painting. Cézanne has manipulated their shapes in order to express their physicality. The fruitbowl's stand is set off-center and the ellipse that holds the fruit has been flattened out and drawn upward to enable the viewer to see into the bowl.

Still Life with Plaster Cast, *c.* 1895

Oil on canvas
28×22 inches (71×56 cm)
London, Courtauld Institute Galleries

By departing from the accepted rules of pictorial composition, Cézanne has created an image startling in its aura of actuality. The vertical form of the statuette of Cupid, viewed from an unusual angle, stretches almost the entire height of the canvas. A whole system of echoes and contrasts revolves round the lightness and form of the central area of the plaster cast. The plate repeats the shape of the base of the statuette, the canvas leaning against the studio wall frames it, the sharp perspective of the wall pushes the figure out from the canvas surface, while other elements – the sharply delineated contour lines of the painted drapery, the edge of the canvas resting against the wall – remind us of the inescapable flatness of the picture surface. The complexity of the composition is

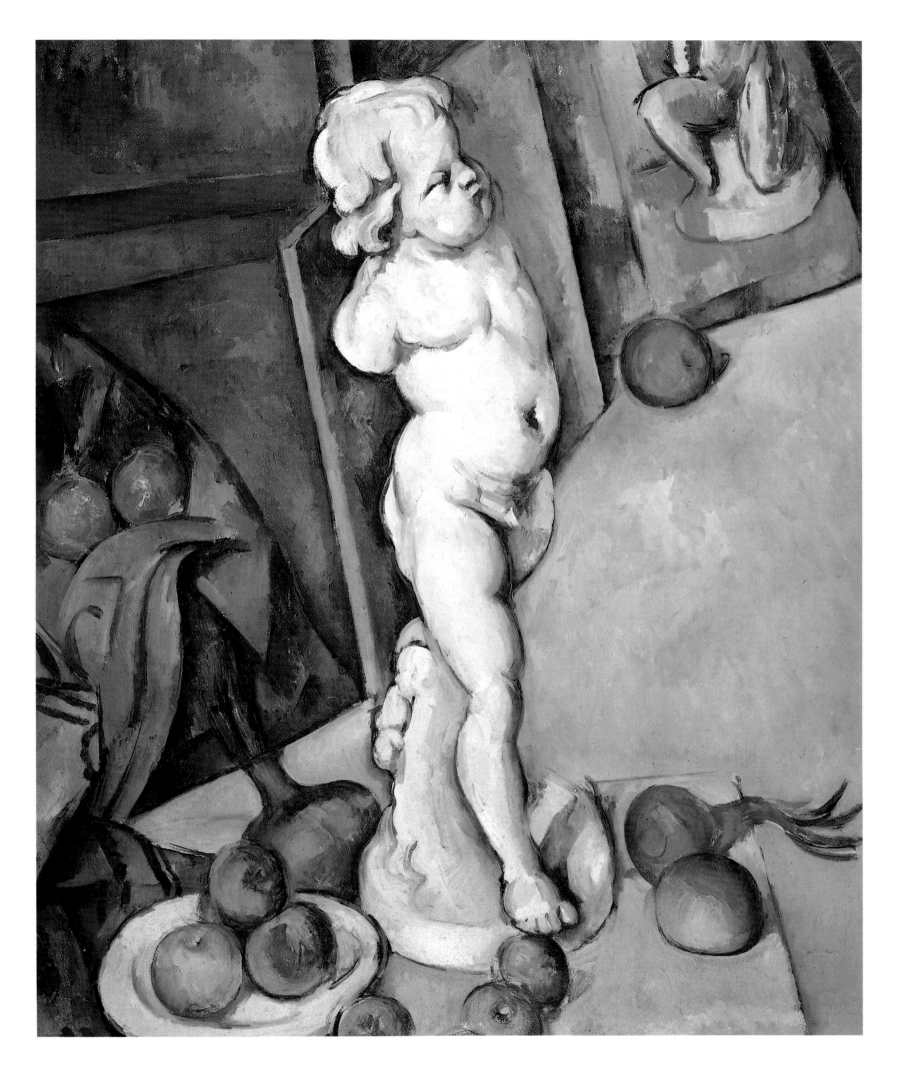

paralleled by the richness of allusion contained within the relationships of the objects depicted in the painting.

The color harmonies are especially subtle; the ripe reds and golds of the fruit sing out against the infinite variation of blues, tans, and ochers of the rest of the painting. Cézanne has created an image that parallels the complexity of our relationship with the exterior world.

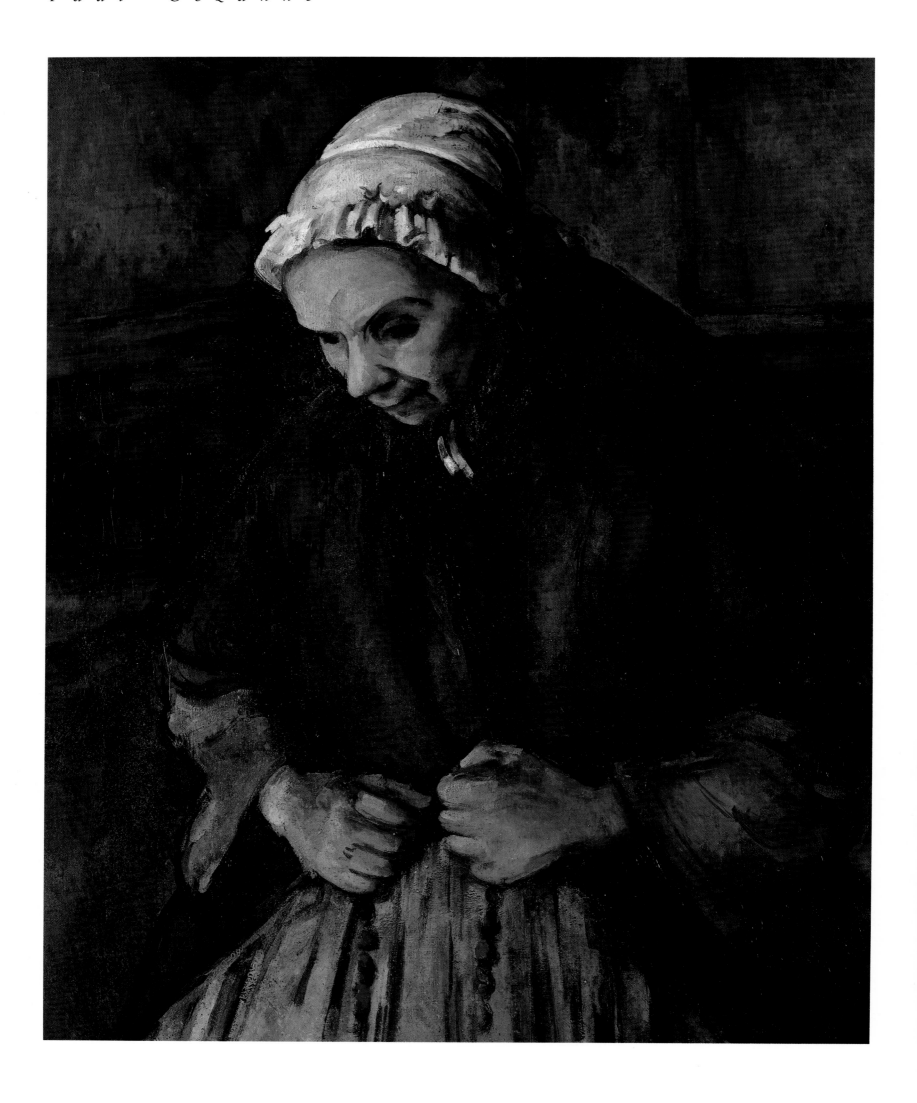

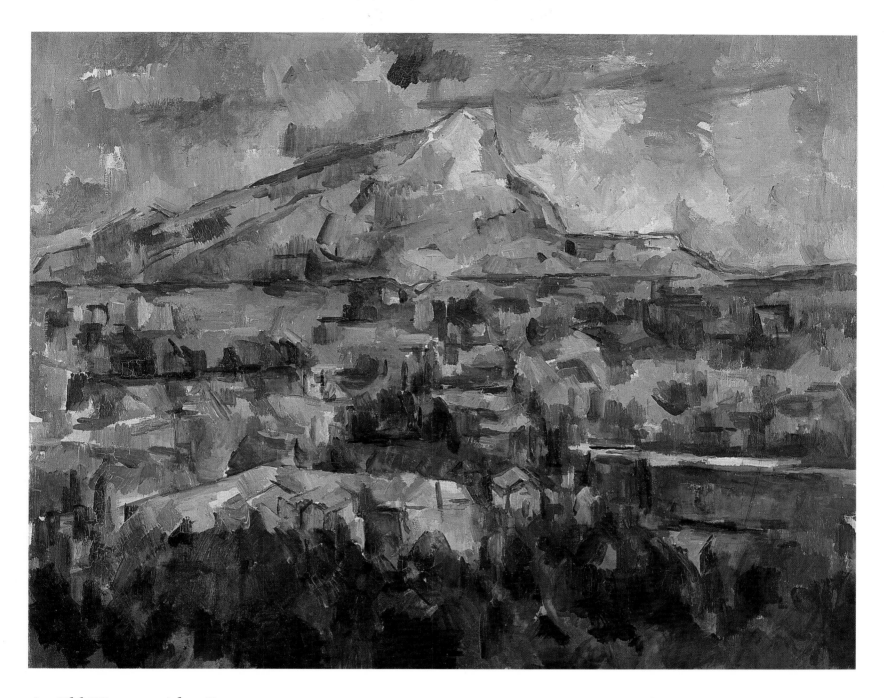

An Old Woman with a Rosary

c. 1896
Oil on canvas
32×25¾ inches (81×65 cm)
London, National Gallery

This wonderful harmony of blues represents an anonymous old woman, her head bowed as she stares fixedly at the floor, her massive hands clenched over her rosary. The painting has a power of expression and a sense of human presence that is comparable with the late work of Titian and Rembrandt, and it is considered to be one of Cézanne's finest achievements.

There is some controversy about the identity of the sitter. Joachim Gasquet, a poet friend of the painter's, wrote an article in 1896 which described her merely as a servant, but in a later piece of writing he referred to her as a nun who had lost her faith at the age of seventy and had left the convent. The artist had apparently come across the woman, worn-out and half-demented, in the vicinity of Aix and had given her shelter. She worked as a maid to

the Cézanne household and supplemented her income by ripping his linen and selling it back to the artist for use as rags to wipe his brushes. Gasquet discovered the painting covered in dust beneath a coal scuttle with a steam pipe dripping on to it.

Cézanne found it difficult to sustain relationships with outsiders and he may have found in this outcast a metaphor for his own awkward relationship with the outside world. The painting was worked over a long period of time and the difficulties it caused the artist are clearly visible on the canvas surface. This is most clearly evident in the thickness of the paint and, most spectacularly, in the series of ridges that mark the contour lines of her left shoulder as Cézanne shifted it up to its present position. This deformation adds to the monumental stature of the model and serves to lead the eye inevitably to the clenched hands. The picture's composition is based on a series of subtly modeled blues played off against the white of her cap and the rich coloration of her flesh. The head and shoulders suggest a triangle, the form of which is repeated by the shape of her dress.

Mont Sainte-Victoire, 1902-04

Oil on canvas
27½×35¼ inches (70×90 cm)
Philadelphia, Museum of Art

The famous profile of Mont Sainte-Victoire is celebrated again and again in the paintings of the last twenty years of the artist's life. In this densely worked surface, overlaid with patches of color, Cézanne has charted a successive series of encounters with external reality. The patches of color that describe the mountain also describe the air that surrounds it and the plain below. Cézanne is not painting a particular moment but catching the dynamism of nature herself in all her forms; the rock that makes up the mountain is expressed in the same manner and with the same force as the foliage. All the forms of existence are meshed together in a single dynamically charged rhythmic pattern. The result is a mystical expression of the unity and power of nature.

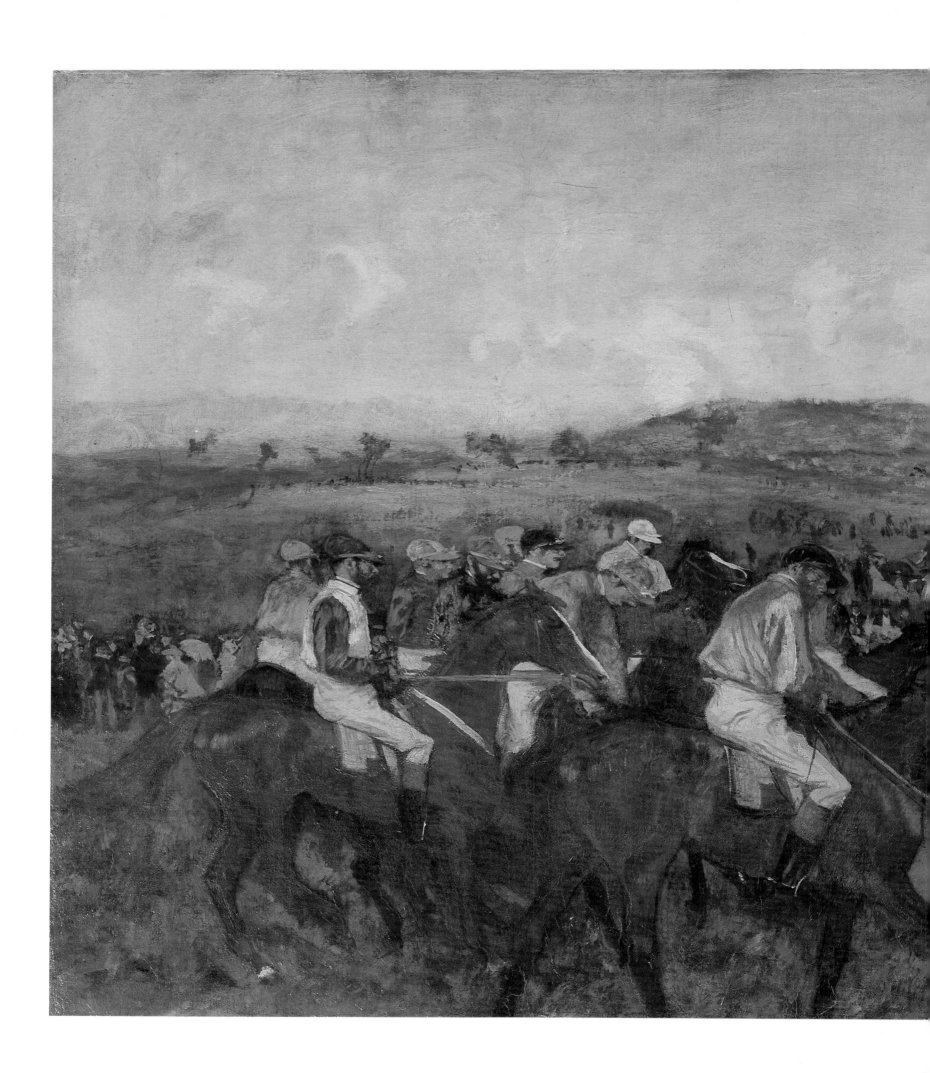

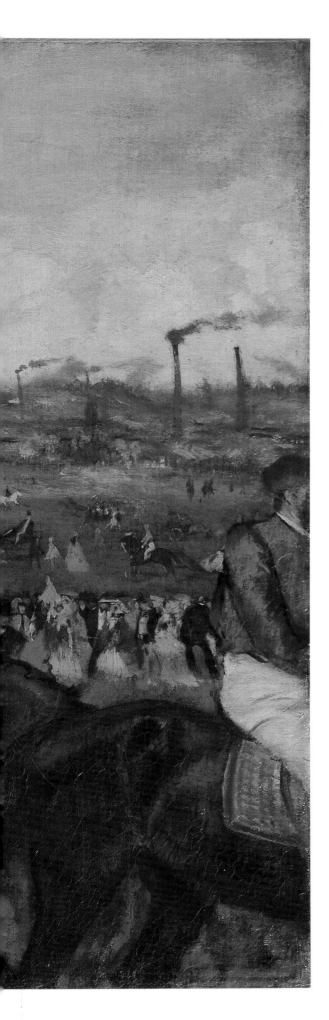

Edgar Degas

F r e n c h 1 8 3 4 - 1 9 1 7

Course de gentlemen, 1862
(reworked later *c.* 1882)
Oil on canvas
19×24 inches (48×61 cm)
Paris, Musée d'Orsay

The world of horses was a familiar one to Degas. His great friends the Valpinçons owned an estate near Haras-du-Pin in Normandy, one of the greatest horse-breeding centers in France, close to the Argentan racetrack. With Manet, he frequented the racetracks around Paris. Yet Degas is never recorded as being a horseman and apparently never painted his subjects directly from nature, but relied upon drawings made from life and studies made after the Masters and contemporary artists such as Meisonnier, John Lewis Brown, and Alfred de Dreux. Géricault had introduced the subject into high art with his painting of *The Race at Epsom* of 1821. Like Degas and most French painters of this fashionable subject, Géricault had used English sporting prints as the basis of his interpretations. It was only from 1879 onward that he could have made use of the information contained in Muybridge's photographic album *Animal Locomotion*. Equestrian subjects feature largely in Degas' work – in sculptures as well as paintings, like his figures of dancers.

Course de gentlemen is dated 1862, the period when Degas began to move away from his original desire to paint history paintings to follow his career as a painter of contemporary life. Its commencement date, in fact, coincided with the abandonment of his *Semiramis Founding Babylon,* but, like many of Degas' creations, it was subjected to repeated revisions to such an extent that, in this case, what we are really seeing is a work of the 1880s. Despite its completely convincing sense of actuality, the work stems from the artist's copies after the Italian Masters that he made during his stay in Italy in the late 1850s. Degas would often make use of such sketches as a basis for his paintings of modern subjects. It has been noted that the frieze-like processional composition of the painting relates to Benozzo Gozzoli's *Journey of the Magi* in the Palazzo Medici-Riccardi in Florence. He has transformed the courtliness of this Renaissance religious scene into a gathering of wealthy amateur jockeys – the latter-day equivalents of the rich Florentine banking dynasty depicted in the Gozzoli fresco. Jewels and fine brocades are exchanged for silk vests; the colors of most of the shirts are chosen quite arbitrarily to introduce specific color relationships into his picture, just as he added ribbons and bows to the dancers in his ballet scenes. The splendor of the rocky landscape through which the princes travel in Gozzoli's painting is converted into the gently rolling countryside of northern France. Evidence of the growing industrialization of the region is shown by a distant group of factory chimneys belching out smoke. This reworking of traditional motifs illustrates what Degas meant when he wrote in his notebook around 1868, 'Ah, Giotto, let me see Paris, and you, Paris, let me see Giotto.'

During the nineteenth century, racegoing had developed into an extremely fashionable pastime and, during the Second Empire, novelists and artists alike reflected this interest in a world where high society could mix and be confused with its shadowy counterpart, the *demimonde.* In this painting, Degas pays relatively little attention to the spectators and instead offers the viewer a close-up study of the riders as they rein in their horses at the starting line. Like the famous riders of the Parthenon frieze, they gather together, move apart, and wander out of the viewer's field of vision. Degas has audaciously cropped one of his equestrian figures and his mount as abruptly as the figures on the marble slabs of the Parthenon frieze are cut by the edges of the separate panels. From this brilliant amalgamation of sources, Degas has created a work of tense excitement and a coloristic display worthy of Delacroix, one of the artist's great heroes.

A Woman Ironing, c. 1873

Oil on canvas
21½×15½ inches (54×39 cm)
New York, Metropolitan Museum of Art

The subject had a special attraction for Degas, as it did for the novelist Émile Zola. The figure of the laundress and her environment typified for both of them something particularly significant about modern Paris. Zola admitted that he had studied Degas' paintings of the subject and had used them to great effect in his novel of 1876, *L'Assommoir*. Degas depicted the profession many times, sending pictures of laundresses to the Impressionist exhibitions of 1874, 1876 (at which show this example was probably exhibited), 1879, and 1881.

In his journal entry for February 1874, Edmond de Goncourt records:

Yesterday I spent the whole day in the studio of a strange painter called Degas. After a great many essays and experiments and trial shots in all directions, he has fallen in love with modern life, and out of all the subjects in modern life he has chosen washerwomen and ballet dancers . . . it is a world of pink and white, of female flesh, in lawn and gauze, the most delightful pretext for using pale, soft tints. He showed me, in their various poses and their graceful foreshortening, washerwomen and still more washerwomen . . . speaking their language and explaining the technicalities of the different movements in pressing and ironing.

Degas had been captivated by the world of the laundress since the late 1860s. Even the delights of New Orleans could not take his mind away from the subject: in 1872 he wrote, 'Everything is beautiful in this world of the people. But one Paris laundry girl, with bare arms, is worth it all for such a pronounced Parisian as I am.'

Paris was renowned throughout the world as a center of the laundry trade; people from as far afield as Poland sent their clothes to be cleaned and ironed in Paris. Artists, especially graphic artists like Gavarni and Daumier, had produced images of the profession and Degas must have considered it to be a perfect vehicle for his interest in modern life. The ironer was at the top of her profession, in complete control of a very complicated and wearisome craft. The milieu of the laundress offered interesting and unusual compositional and lighting opportunities to the artist, involving a series of often-repeated movements whose skill Degas obviously appreciated. Being involved with such a female-orientated world may have given Degas a certain frisson. In the nineteenth century, women in the laundry trade were frequently the subject of popular prints which stressed their supposed susceptibility to the advances of amorously inclined males. A passage in Zola's novel *L'Assommoir* conjures up this fascination: 'A man passing a laundry shop would glance in, surprised by the sounds of ironing, and carry away a momentary vision of bare-breasted women in a reddish mist.'

Degas shows his model absorbed in her task, silhouetted against the light and surrounded by veils of white linen. Unlike the popular prints of the time, Degas does not prettify the model or gloss over the arduous nature of her work. Her silhouette, etched against the light, suggests in the exactitude of its draughtsmanship and precision of pose the artist's appreciation of the exhausting nature of the woman's occupation.

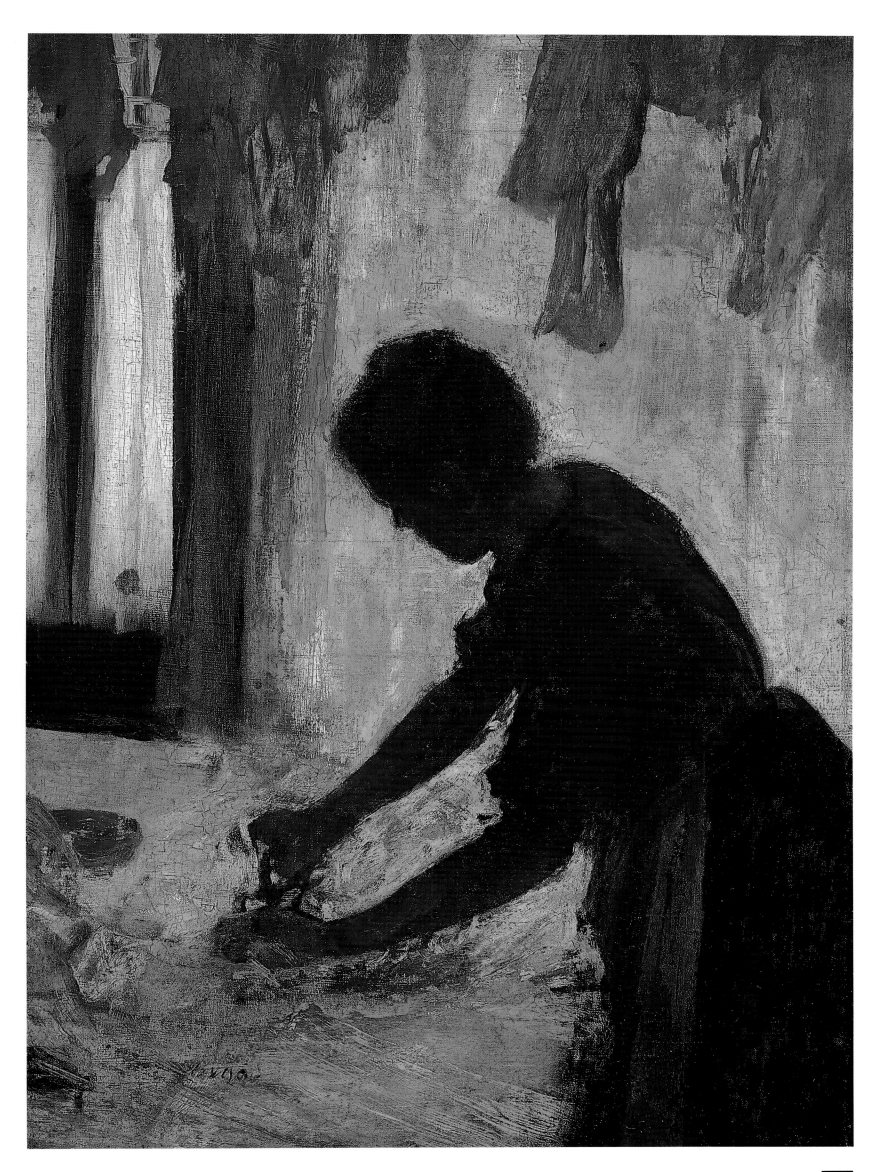

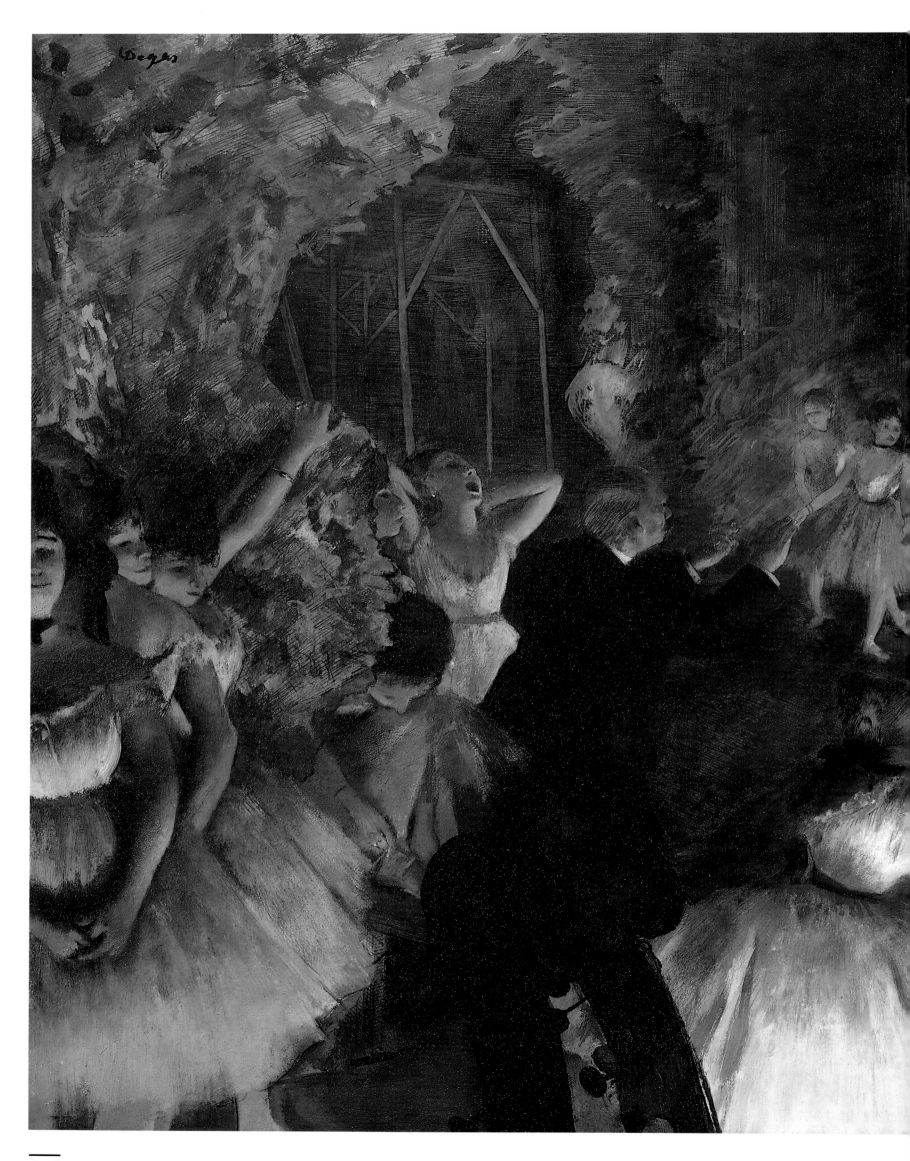

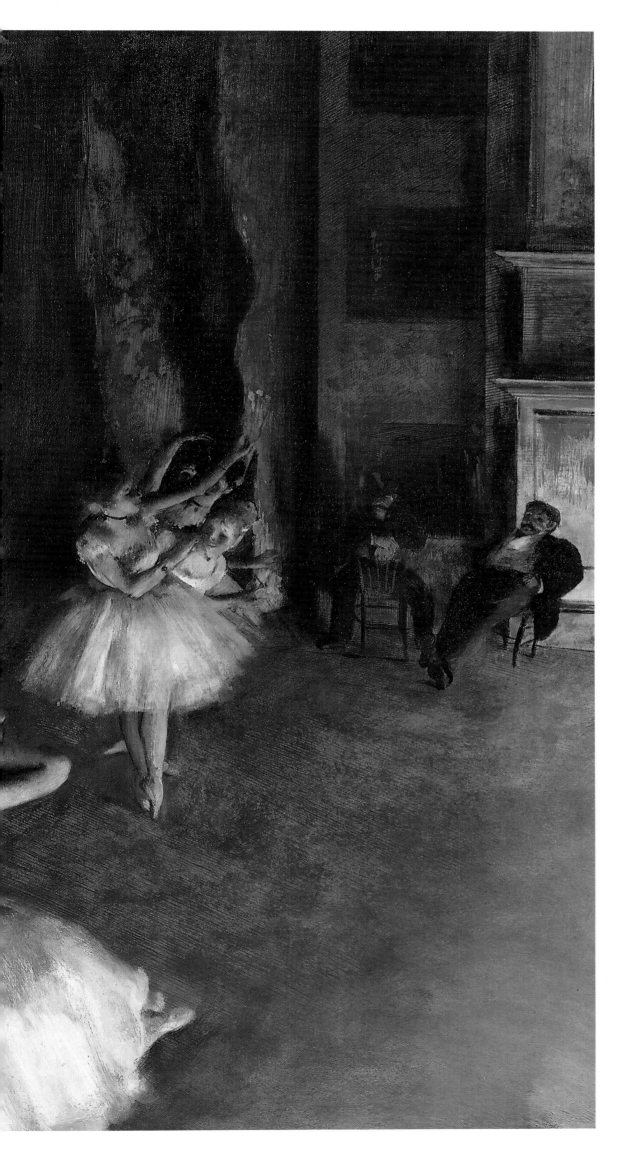

The Rehearsal of the Ballet on the Stage, *c.* 1874-75

Thinned oil paint, with touches of watercolor and pastel, on paper mounted on canvas
21½×28¾ inches (55×73 cm)
New York, Metropolitan Museum of Art

The artifice of the stage and the rigorous professionalism it demanded from those engaged in it attracted Degas as much as the visual effects and ambiguities such subjects offered to his sensibilities. When asked by an acquaintance why he painted so many ballet scenes, he replied, 'Because it is all that there is left of the synthesized movements of the Greeks.'

Degas made countless drawings of dancers at their daily practice, either at the opera or in his studio, and from these studies he would develop paintings such as the one reproduced here. Degas was more interested in the preparations for the ballet than in the actual performance; these pictures reveal the artifice of performance, the flats and wooden scenery supports and the tedium of the endless rehearsals.

Degas' dancers become, like the thoroughbreds he loved to paint, a symbol of his own art and a means by which he could explore the infinite possibilities of human movement. The awkwardness of each frozen gesture is organized into a completely harmonious composition. By these means the time-worn repertoire of gestures passed down from the classically inspired artists of the Renaissance and repeated mechanically by the academic artists of later times is radically investigated and given new life. The dancers stretch, yawn, scratch, and throw their bodies into various attitudes as they wait their turn to perform. Degas does not disguise the relative plainness of their features which, during the final performance, will transform as the dancers become endowed with beauty and grace.

Our view is a privileged one; like the *abonnés* or stagedoor johnnies that lounge on the chairs on the far side of the stage, we look across the open space of the stage, hardly aware of the necks of two cellos that start out abruptly from the base of the canvas. They merge into the figure of the *maître*, whose stance suggests his dominant role in the proceedings. Around him the other dancers wait, their poses familiar to us from other paintings and drawings on the same subject by the artist.

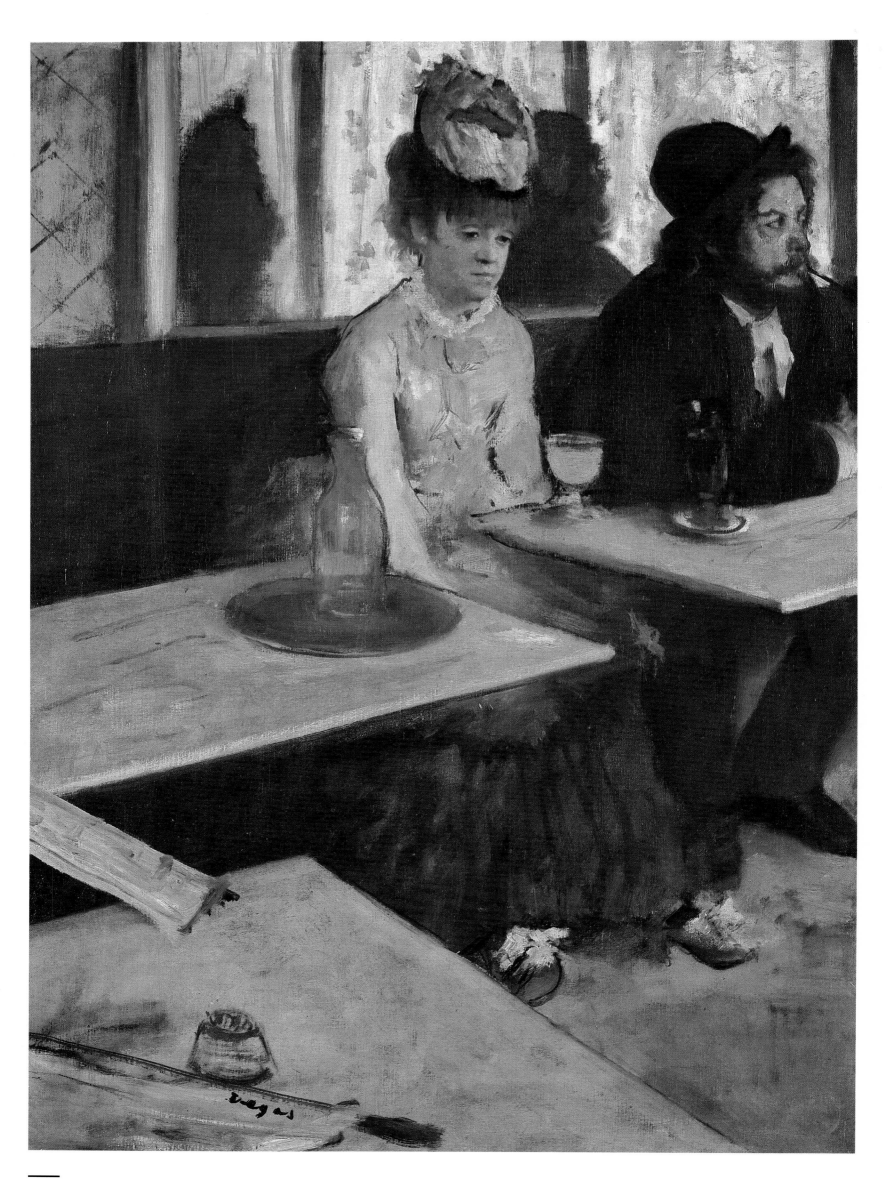

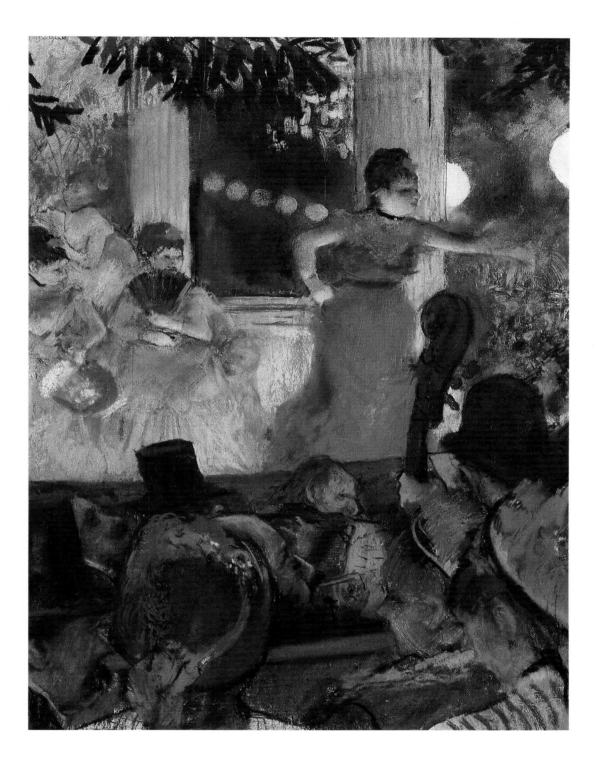

L'Absinthe, 1876

Oil on canvas
36×27 inches (91×69 cm)
Paris, Musée d'Orsay

This genre scene features two of Degas' friends, the painter and etcher Marcellin Desboutin and Ellen Andrée, an actress at the Elysée Montmartre. Depictions of the *habitués* of the cafés of Paris were familiar to people in the popular prints by artists like Gavarni and Daumier, but Degas was the first to present such an image in a medium associated with 'high art.' The two figures are shown seated together at a table and yet, despite their close physical proximity, there is no communication between them. The apparent hopelessness of their situation is suggested by Ellen Andrée's expressive pose. Her out-turned feet and unfocused gaze are finely described by Degas' precise draughtsmanship. Despite the apparent detachment of Degas' style, the viewpoint he has constructed intimately links the viewer with these figures. Our eyes glide toward them across the linking diagonals of the tables; bridging the gap between the two tables is a newspaper bearing the signature of the artist. Degas' study of Japanese prints is reflected in his daring omission of one of the table supports and summary handling of the mirror reflections. He has refused to develop the narrative content of the picture, and allows us no opportunity to stand in judgment over these people; instead, incident is presented to the viewer as a scene observed.

This refusal on the part of the artist to supply an easily comprehensible storyline or narrative caused people to supply their own. When the painting was exhibited at the Grafton Galleries in London in 1893, it was catalogued not under its former title *At the Café* but as *L'Absinthe*. Absinthe was an alcoholic drink made illegal in France in the early years of this century because of its lethal properties, and, by drawing attention to the drink before the woman, some kind of moral value was implied. Such a reading was given further credibility by the publication, in translation, of Zola's novel *L'Assommoir* or *The Dramhouse*, which allowed the painting to be connected to the story of its heroine, Gervaise, who drinks herself to death. For these reasons, the painting became the victim of one of the greatest outcries against a modern work of art in the nineteenth century.

Café-Concert at the Ambassadeurs, *c.* 1875-77

Pastel over monotype
15×11 inches (38×28 cm)
Lyons, Musée des Beaux Arts

A *café-concert* was a theatrical performance at the opposite end of the social spectrum from the polite environment described in Degas' earlier paintings of the Opéra. The *café-concert* was a particularly Parisian form of entertainment. It was mainly dedicated to, and enjoyed by, the working class. By the time Degas depicted it, such shows also included members of the middle class among their clientele.

Degas evolved a curious technique to create this work. The pastel is laid over a monotype – a medium that Degas made very much his own. As only one or two proofs of the print may be taken before the image is lost, monotype gave Degas a free-dom of expression and a powerful yet subtle tonal range over which he would lay brilliant color. The result here is a richly hued pattern of brilliant color to convey the gaudy opulence of the entertainment.

Degas depicts the clientele within his picture packed up against the picture plane in their vulgarly ostentatious outfits. He summarily captures the physiognomies of each of his types as they look up at the illuminated stage. Here, under the stage lights, the singers perform their 'idiotic songs . . . and other stupid absurdities.' Once again, Degas' encyclopedic knowledge of past art would allow him to snatch key gestures, half-familiar from the world of high art, which, being transposed into the world of low entertainment, were invested with a new evocative power. In the studio he would re-create the experience so vividly that, today, we can almost hear the songs and smell the smells of this raucous piece of street theater.

Beach Scene, 1876-77

Oil and essence on paper mounted on canvas
18×32 inches (46×81 cm)
London, National Gallery

Ambroise Vollard, who was Degas' dealer toward the end of the artist's life, recorded the following incident in his book *Degas: An Intimate Portrait*:

'How did you manage, Monsieur Degas, when you painted that *plein air* called *La Plage...*?' Degas replied, 'It was quite simple. I spread my flannel vest on the floor of the studio, and had the model sit on it. You see, the air you breathe in a picture is not necessarily the same as the air out of doors.'

The picture rewards close attention. Originally, the figure of the maid and the child made up the center of a composition painted on two pieces of paper joined vertically side to side. If one looks carefully at the tip of the girl's shoe, the edges of the two pieces are easily visible. At a subsequent date, Degas added the woman with the parasol and perhaps the man with the little dog.

It was shown at the 1877 Impressionist exhibition together with its companion piece, the intriguing *Young Peasant Girls Bathing at Night*. Degas was a very sensitive and able recorder of the natural environment, and in this painting he has produced a convincing evocation of space and atmosphere. *Beach Scene* may have been, like its pendant, a testing ground for Degas' own ideas and even perhaps those of his colleagues. It has been suggested that this painting was inspired by Manet's *Beach at Boulogne* of 1869 as well as by a Renaissance painting in the Louvre by Lorenzo Costa. Throughout his life, Degas was fascinated by reworking traditional themes in a novel manner, so it is hardly surprising that the two young bathers on the left of the painting wrapped up in their towels have a mock-classical ambiance, looking for all the world like some latter-day ancient Romans or Greeks. They are painted with the loose, rhythmic handling and fluid, sketchlike brushwork that we associate with Whistler's experiments of the 1860s. The strength of the painting lies in the two main figures, the girl's form superbly suggested by the thin, painted lines of her blouse. The action of the maid brushing her hair links the two figures, the maid's bulk contrasting with the young girl's supine pose.

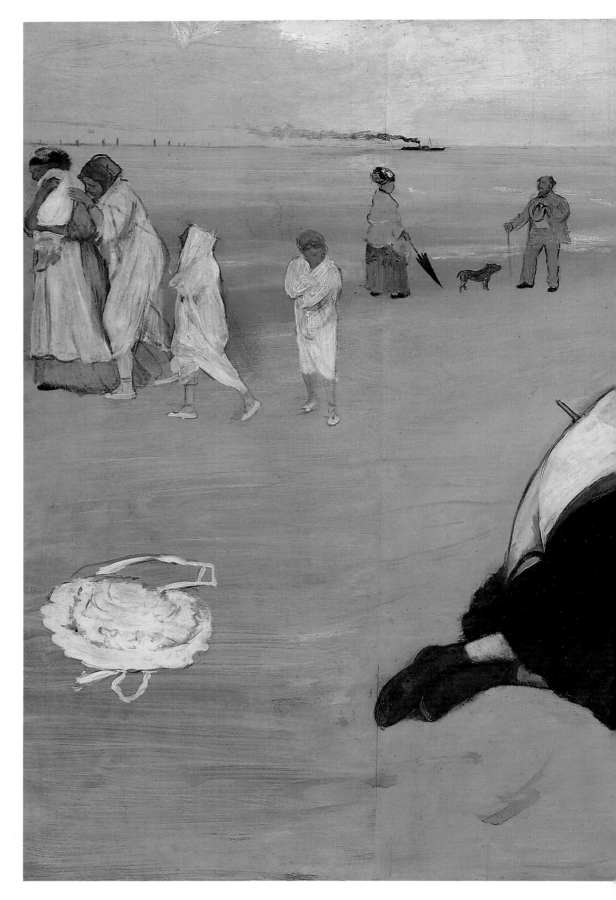

To their left, and seen from a completely different viewpoint, lies the girl's discarded bathing suit, laid out flat to dry in the sun, and her parasol. Like objects in a Japanese print they are separated out, flattened, and given an unexpected form that makes us look twice at these prosaic details. Part of the novelty of the painting lies in Degas' decision, possibly based on his knowledge of Japanese prints, to omit shadows from the painting. The harmonies of the picture, such as the red-browns, dull greens and yellow ocher, are set against crisp areas of white.

The painting now hangs in the National Gallery, London, close to a much later work, once owned by Matisse, of the same intimate domestic act of brushing hair. Degas' achievement relies upon the continual refinement this favored motif.

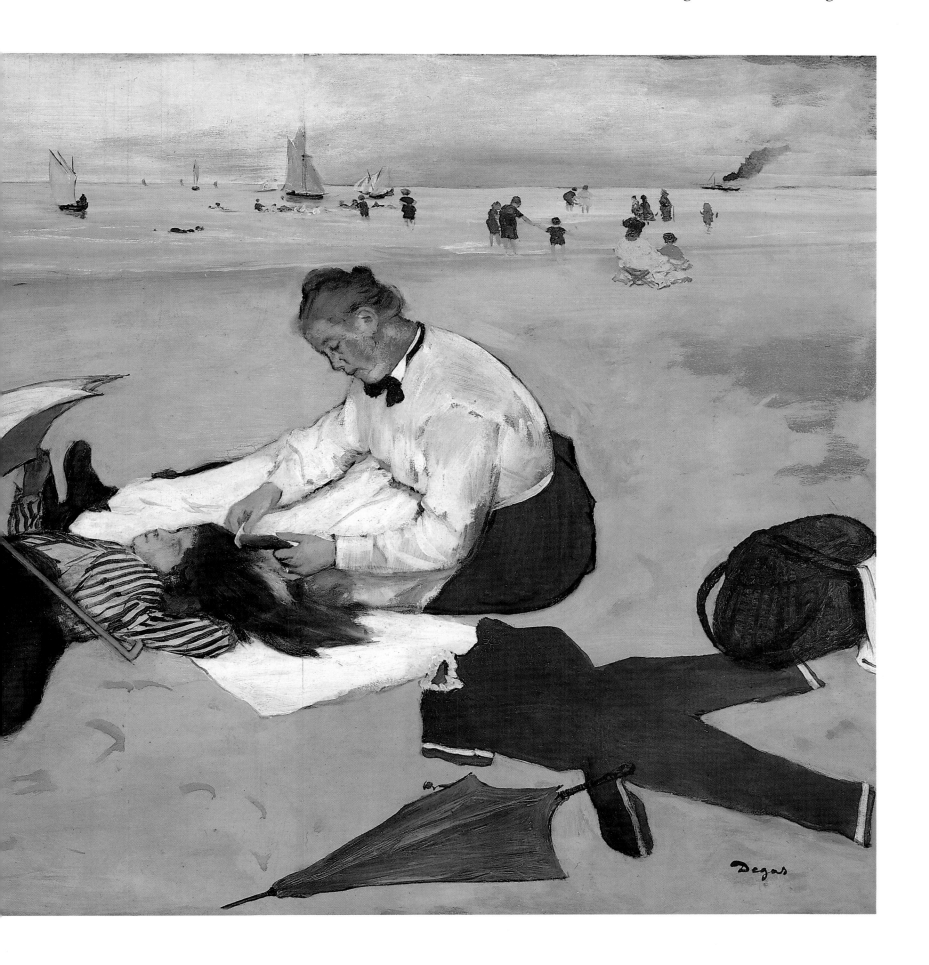

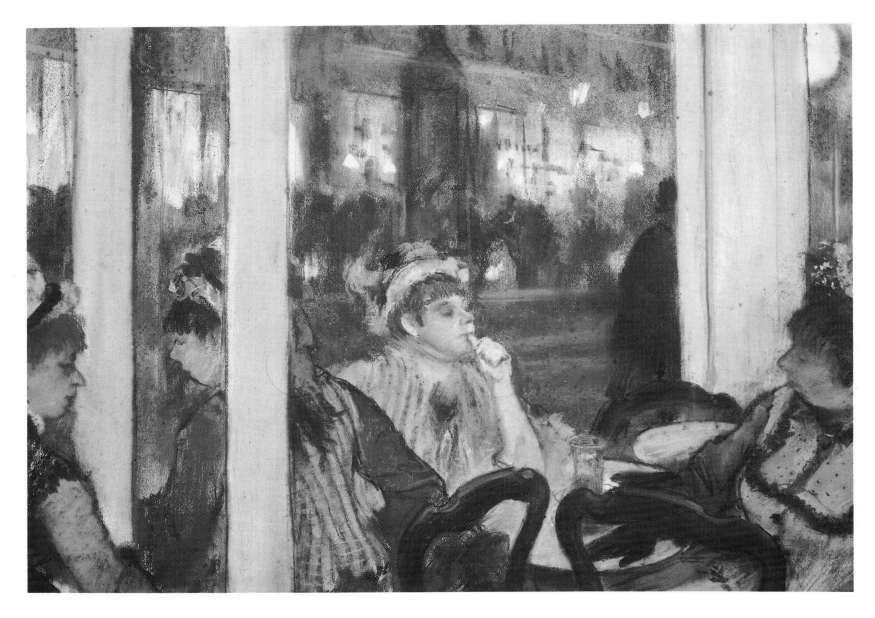

Women in Front of a Café, Evening, 1877

Pastel over monotype
16×24 inches (41×61 cm)
Paris, Musée d'Orsay

A group of prostitutes flaunt themselves in a public place, spilling out from the café on to the terrace adjacent to the pavement. The central figure makes crude gestures at the passers-by; others lose themselves in alcohol, daydreams or languid conversation. The art historian Eugenia Parry Janis quotes a reference, or rather a warning, in a contemporary guide to Paris written for Englishmen that sets this work into its context:

You cannot go into any public place in Paris without meeting one or more women that you will recognize at a glance as belonging to the class known in French society and fiction as the *demi-monde*. You will find them in the theaters, in the concert halls, in the cafés.

Throughout Europe, Paris had the unenviable reputation of being a center of vice and corruption. It has been estimated that in 1870 there were 145 brothels (*maisons de tolérance*) flourishing within the capital. Prostitution was a legal, though restricted, profession, subject to police surveillance and regular medical inspection. Clandestine prostitution was not allowed by law, but it flourished, especially among barmaids, milliners' assistants, and laundresses – many of whom could not survive on their legitimate wages. One of the few means by which they could supplement their income was part-time prostitution.

Academic artists, such as Couture, had tried unsuccessfully to treat the subject in an allegorical manner. It was writers, such as Baudelaire and Zola, and artists, such as Manet and Degas, who succeeded best in creating powerful and resonant images of a subject that seemed to many contemporaries to be linked in some mysterious way to the moral state of Paris and, by extension, to that of the nation.

As so often, Degas takes a cool and ironic attitude toward his subject and one of his most famous aphorisms could well have been made with this picture in mind. 'A picture is something that requires as much trickery, malice, and vice as the perpetration of a crime, so create falsity and add a touch from nature. . .'

The women are unaware of our presence and act accordingly. Seen under the brilliant illumination of the café, the women, depicted with precise draughtsmanship, contrast markedly with the shadowy evocation of the boulevard beyond where indistinct forms pass mysteriously to and fro. The work itself is technically very interesting. It is a monotype, created on an inky surface by drawing and wiping the ink away to create the desired image; the drawing is then passed through a press and a unique impression taken from it. Degas then worked over the black-and-white image in pastel, using the underlying darks and lights to suggest the garish quality of the artificial light of the scene.

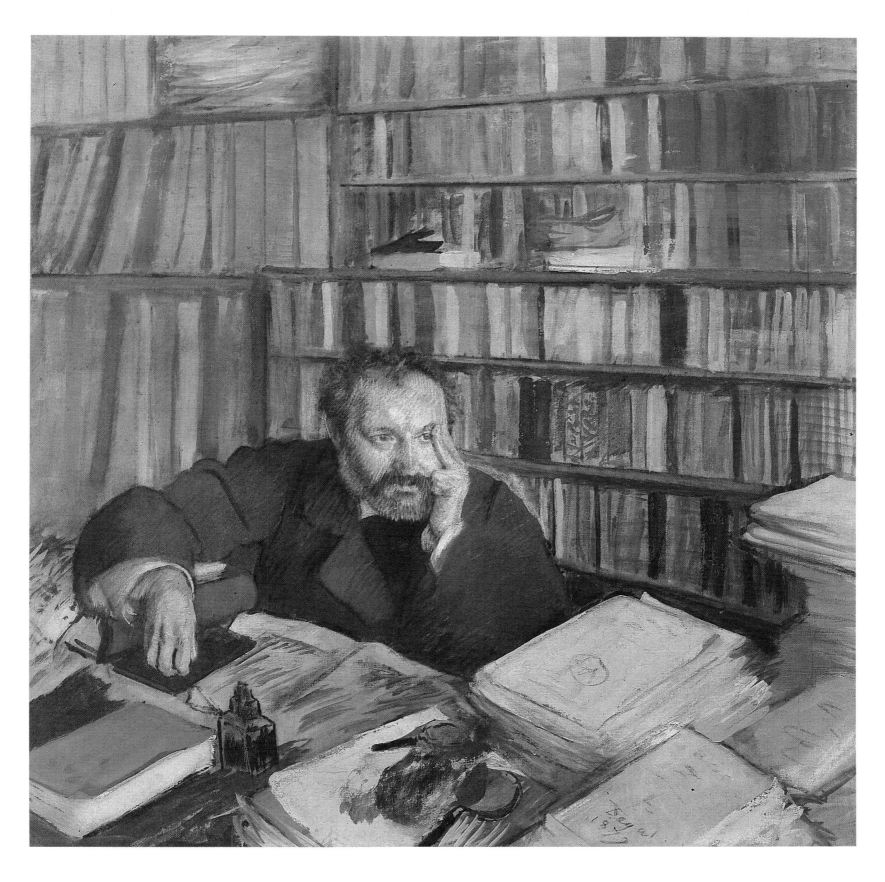

Portrait of Edmond Duranty,

1879
Distemper and pastel on sized but
unprimed canvas
40×39 inches (101×100 cm)
Glasgow, Burrell Collection

The novelist and art critic Edmond
Duranty was a close friend of Degas. He
was the editor of the short-lived review *Le
Réalisme*, in which he defended Courbet
and other realist painters and writers.
Degas probably met him around 1865 at
the Café Guerbois and remained friendly
with him until the writer's death in 1880.

Duranty's left hand is placed against his
forehead in the traditional gesture intimat-
ing intellectual acuity, although it is also a
pose that would enable the sitter to keep
his head relatively still during the long and
arduous hours of posing necessary for the
completion of the portrait. Another expla-
nation for the pose is that it was, presum-
ably, one that was characteristic of the man
and his profession. He is shown in the
midst of his study or library surrounded by
his books, the tools of his trade. Surpris-
ingly, the figure of Duranty takes up little
more than an eighth of the canvas area. As
in so many of his works, Degas has used an
extraordinary and idiosyncratic range of

techniques and has left the painting
unfinished in the traditional sense, but
completely realized to modern eyes. This is
particularly apparent in the detail of the
head, where ultramarine blue is used to
outline the fingers of the sitter and applied
in parallel hatchings under the nose to
denote not form but shadow. The mixture
of techniques and the constantly changing
means of expression throughout the pic-
ture add a fascinating dimension to what
was an already intriguing physiognomy.

Perhaps by way of reference to Manet's
earlier *Portrait of Zola*, the artist has placed
his signature on one of the books laid
down upon the sitter's desk.

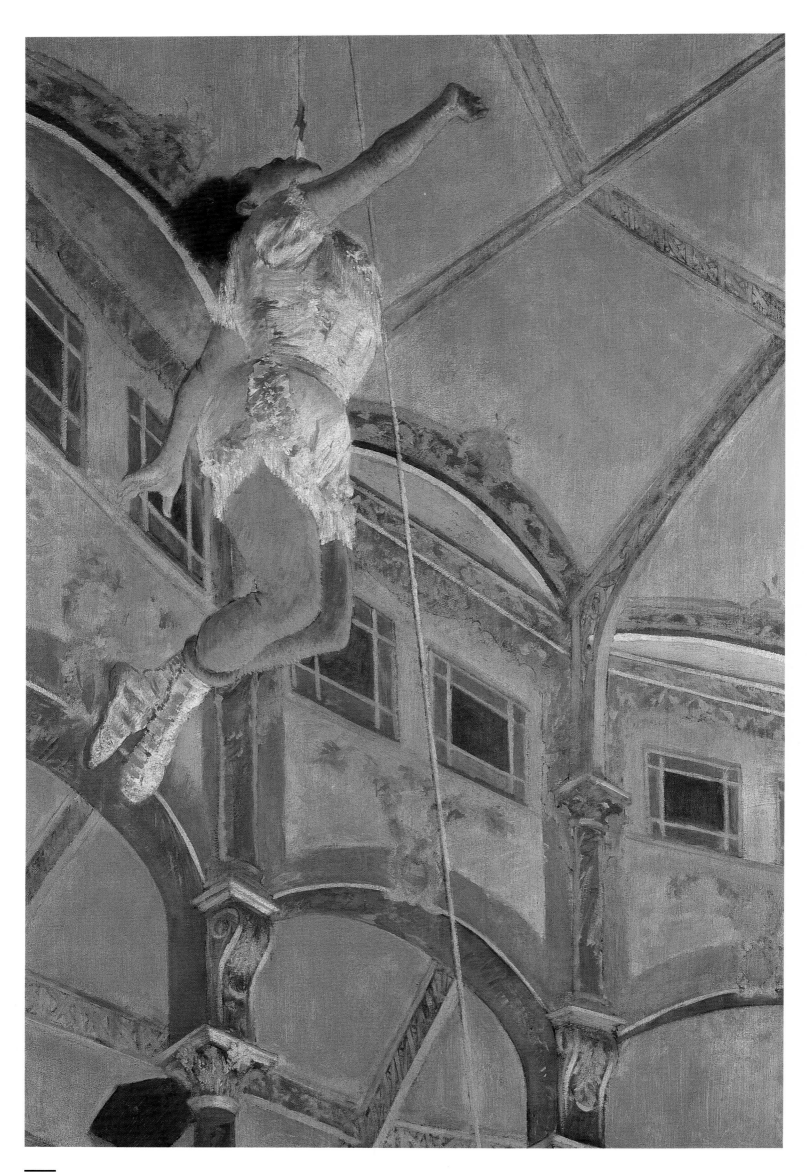

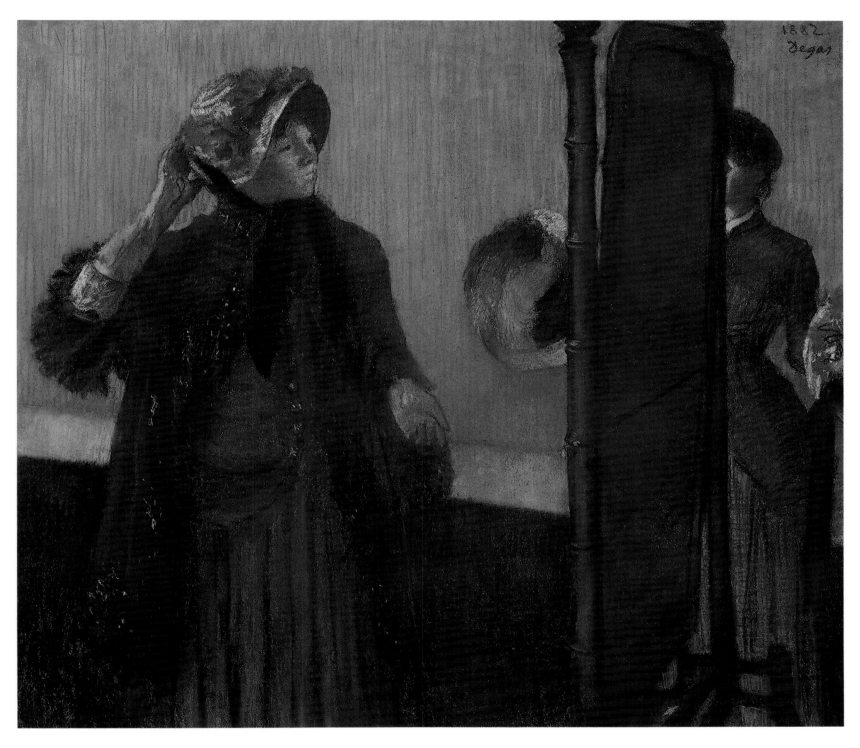

Miss Lala at the Cirque
Fernando, 1879

Oil on canvas
46×31 inches (117×79 cm)
London, National Gallery

In *Miss Lala*, Degas' fine appreciation of
the subtleties of color, his sharp awareness
of the characteristics of artificial light and
the effects to be gained by the use of
unusual perspectives are dramatically
expressed. Degas has situated his subject
asymmetrically in the top left-hand corner
of the composition. The rope forms a
strong diagonal through the painting,
emphasizing the space that surrounds her
and the danger of her isolated position.
The immediacy is further suggested by
excluding the audience. It was these qual-
ities of suspension, tension, and balance
that Degas was to explore in his sculptures
of dancers of the 1890s.

At the Milliner's, 1882

Pastel on paper
30×34 inches (76×86 cm)
New York, Metropolitan Museum of Art

In the early 1880s, Degas made a series of
ambitious studies in pastel of dressmakers
and milliners which resulted in a number
of ambitious pastels of the subject. *At the
Milliner's* is one of the most familiar and
intriguing of these works. Friend and fel-
low artist Mary Cassatt was the model.

The shop assistant is essentially seen as a
glorified hatstand. The full-length mirror,
or *psyché*, cuts her figure in two, divesting
her of the very features that would make
her an identifiable human being. The
woman before the mirror remains com-
pletely oblivious of the presence of the hat-
girl. Degas' pastel makes a comment on the
way our consumer society affects our rela-
tionships with those that serve our needs.

The pastel is a technical tour de force. A
wide range of marks is employed by the
artist, from the parallel crosshatching of
the shop assistant's dress to the swirls and
scribbles that describe the hats she holds
out before her. Degas suggests the effect of
an interior lit by artificial light by the use of
broken vertical striations of closely related
shades of yellow and orange which con-
trast markedly with the vivid blue of the
carpet. The white of the baseboard break-
ing between the orange and the deep blue
of the floor dramatizes the otherwise
drably colored figure of Mary Cassatt,
whose clothes pick up the ocher colors of
the background. The baseboard does
another important service to the picture,
by acting as a visible sign of the invisible
reflection that so absorbs the illuminated
features of the purchaser. Part of the conti-
nuing attraction of this pastel is the result
of the artist deliberately refusing to satisfy
our desire to see that mirrored image.

The Tub, 1885-86

Pastel on paper
23½×32½ inches (60×83 cm)
Paris, Musée d'Orsay

In his *Memoirs*, the Irish writer George Moore recalled Degas as saying:

Hitherto the nude has always been represented in poses which presuppose an audience, but these women of mine are honest, simple folk, unconcerned by any other interests than those involved in their physical condition. . . It is as if you looked through the keyhole . . . One day Degas said to a friend: 'See how different the times are for us; two centuries ago, I would have been painting *Susanna Bathing*, now I just paint *Woman in a Tub.*'

True to his ambition to paint aspects of modern life, Degas does not, like many of his colleagues, depict his nudes in timeless arcadian settings, but apparently in the intimacy of their Parisian homes. There has been much debate as to the exact social status of these women. Are they models, and, by extension, are the interiors they inhabit actually studio setups or inventions of the artist's imagination, or could this bachelor artist have had access to the bedrooms of wives of decent bourgeois? Some commentators, judging from the interiors Degas has chosen to portray and the activities he records, have interpreted these pictures as depicting prostitutes. Whatever the truth may be, it is a proof of Degas' powers to make radical reinterpretations of a clichéd subject, ones that still inspire controversy to this day.

In some mysterious way, Degas' pastel invites the viewer to identify or feel in sympathy with this anonymous, faceless figure, and the result, far from being an erotic work of art, is, like a Rembrandt nude, a work that plumbs the very depths of human feelings. It is a very different work from the overtly erotic *Bain Turc* painted by the octogenarian Ingres more than twenty years previously, and has more in common with Ingres' *Grande Odalisque* of 1821 that the young Degas had been instrumental in getting exhibited at the Exposition Universelle in 1855. Despite his great regard for the art of Ingres, the naturalism of the picture owes much to the detached, stylized depictions of courtesans in Japanese prints. To those elegant examples he has introduced his own astonishing skills as a draughtsman. He is looking down at the figure, whose features are hidden from the spectator, and

all his attention is focused upon the fall of light as it illuminates the model's back. The light falls from above, revealing the monumental nature of the human form, the strength of bone, and the soft sensual texture of the skin.

One Degas specialist has claimed that from his mid thirties onward Degas suffered from no less than four ocular disabilities, including amblyopia, which eventually caused him to lose the sight of one of his eyes. Combined with his other eyesight problems, this would have necessitated the use of certain visual strategies to make sense of even the most familiar of objects. Such procedures would have quickened his interest in close-up views of people and in seeing objects from a variety of unusual viewpoints in subdued lighting conditions, as occurs in this pastel.

As well as selecting such an unusual viewpoint, Degas has employed an extraordinary range of techniques; the floor areas are treated in a spirit of abandon; parallel strokes of blues and oranges surround the sculptural form of the bather, whose form is accentuated by the inclusion of the jugs on the sideboard. The pastel is laid down in a series of crosshatchings and scribbles, allowing the various layers of applied color to remain visible between the open weave of Degas' drawing. How much of this freedom of expression was the result of his visual disabilities and how much he was consciously using these methods to recapture the virtuoso coloristic effects of the great Venetian masters of the Renaissance must remain open to conjecture.

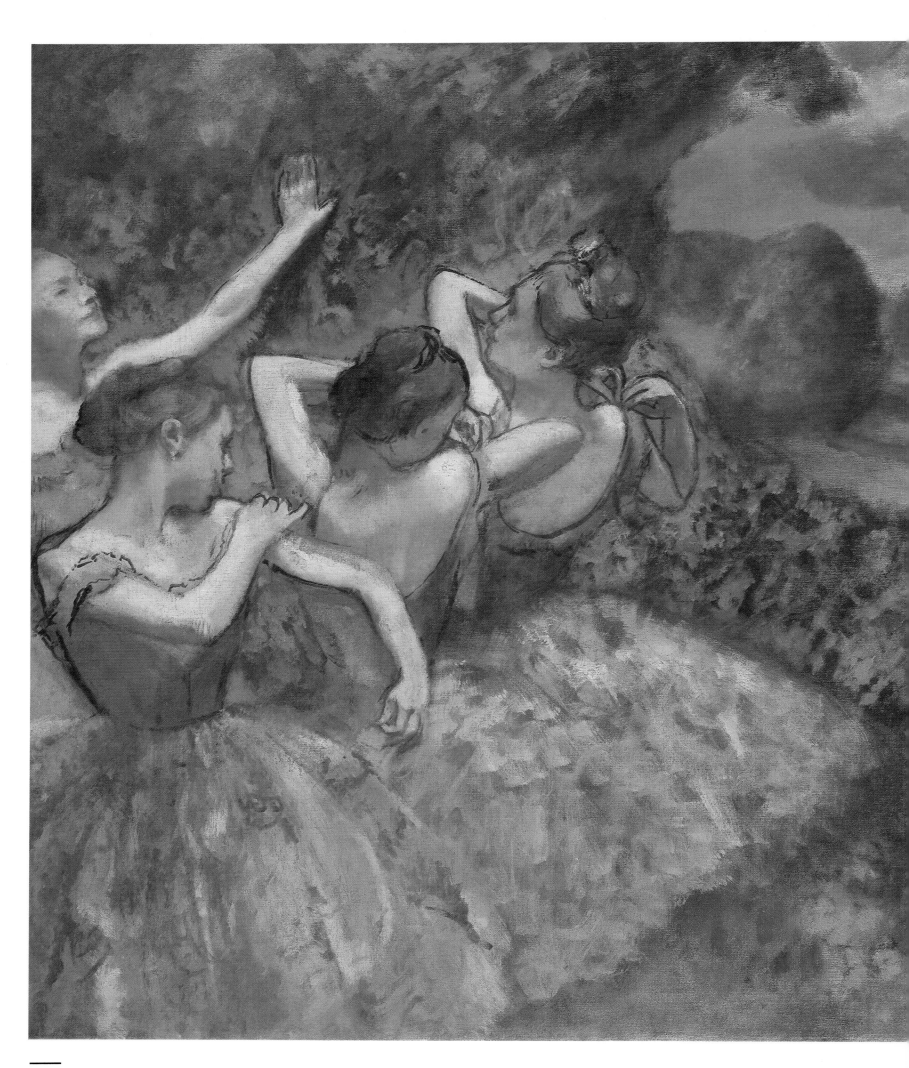

Four Dancers, *c.* 1899

Oil on canvas
59½×71 inches (151×180 cm)
Washington D.C., National Gallery of Art

As Degas grew older, so his work became increasingly focused upon a number of limited themes. Time and again, he reworked and reexamined motifs that had been of importance to him since the beginning of his career. The forms grow larger and more generalized and the impression that any of these works were finished in any traditional sense becomes irrelevant. Still prominent among his repertoire of subjects was the dance. There was now, however, no pretense that these dance images depicted any particular performance; rather they have become what, in a sense, they always were: a means of studying the human form. In this painting, Degas could easily be showing us the same model, seen at different moments, taking up a sequence of poses. Like Monet's, Degas' art is, among other things, a prolonged investigation into the mysteries of time and movement, his problem how to capture these transitory conditions in a still and fixed art form. One solution was, again like that found by Monet, to produce works in which the idea of sequence is important, a repeated or developmental set of poses that are continued either in one art work or in a series of related works.

In this painting, the figures are entirely absorbed in their own affairs; three of them form a diagonal that spirals into the illusory depth of the stage set. They are viewed with the same scrutiny and ease as if Degas had been turning one of his own sculptures around in his hand – and yet how natural he makes this contrived studio-based product appear. In his use of blurred edges and soft, *sfumato* technique, Degas' figures recall the academic paintings of the immensely successful Henner, a friend of Degas' from his student days of the 1850s. Ironically, despite his subject matter, Degas' works have nothing of the phony theatricality of Henner's work. The falsity of Henner's prop-filled classical stage is here replaced by a startling world full of ambiguities. Are we really expected to believe this is a scene in a real theater? The dancers are depicted standing before a stage flat beyond which is visible the painted backdrop. As in a painting by the twentieth-century artist, Giorgio De Chirico, strange and contradictory shadows fall across the mid distance, ominously sug-gesting an unseen presence of which the dancers seem unaware. The relationship of these self-absorbed dancers and the odd, dreamlike landscape is enhanced by the tension resulting from the extraordinary shape of the stage flat as it cuts vertically down the center of the painting. This feature reiterates the flatness of the canvas at the same time as the central dancer and her partnering extensions in space stress its imagined three-dimensional depth.

Together with these personal explorations of space, time, and movement, the painting explores the expressive properties of color. The colors are unusual, even for Degas. The dominant orange and green is shot through with an undercurrent of dull Prussian blue. This has been likened to the effect Degas would have noticed in his photographic negatives. Degas often used photography as an aid to his art, and, seen in certain lights, the negatives have a distinctly orange and white, sometimes green and white, cast. This may well have confirmed his own rather odd ideas about the color practices of the fifteenth- and sixteenth-century Venetian masters, and encouraged him to ever more daring coloristic experimentation.

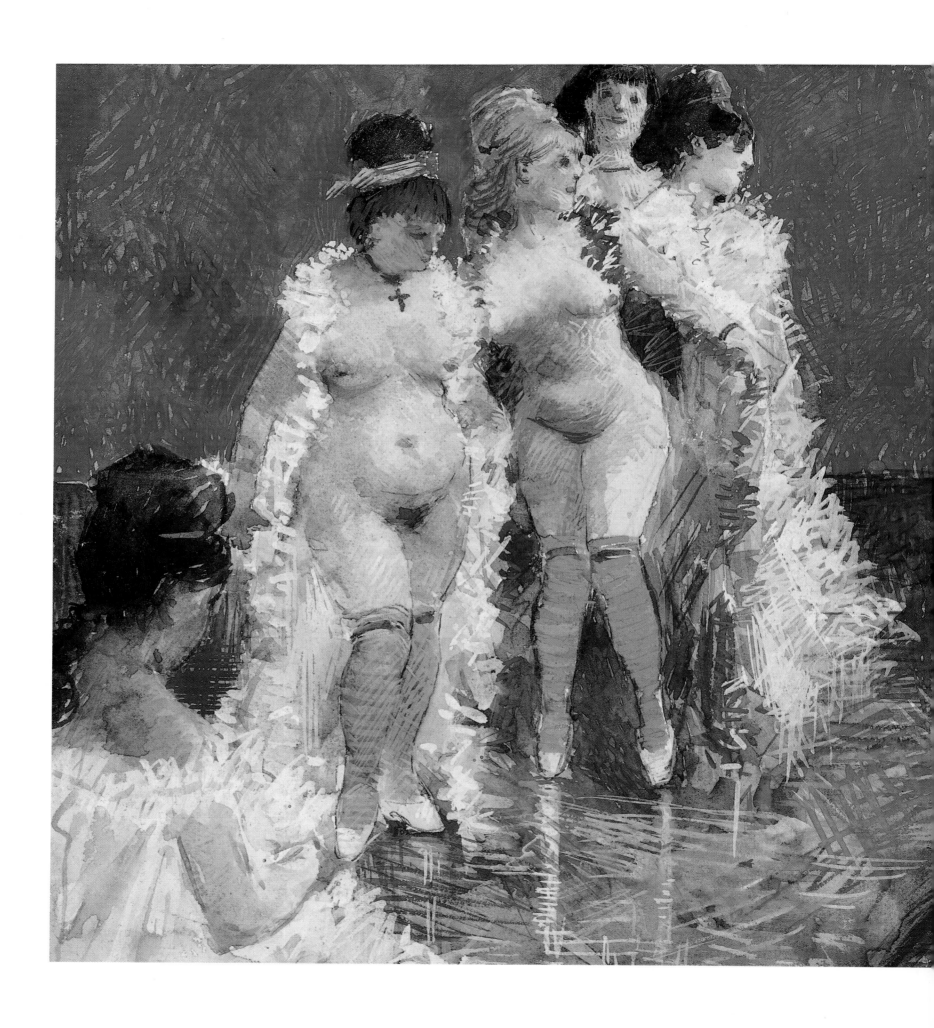

Jean-Louis Forain

F r e n c h 1 8 5 2 - 1 9 3 1

The Client or *The Brothel,* 1878
Gouache on paper
10×13 inches (25×33 cm)
London, private collection

Jean-Louis Forain first exhibited with the Impressionists in 1879 at their Fourth exhibition, and apart from 1882, when all the figure painters associated with Degas abstained, he showed regularly thereafter. Younger than the core members of the group, he had first come within the orbit of Degas and the Impressionists via the route of the cafés and literary circles; he was close to the poets Verlaine and Rimbaud and, like Degas, knew such society painters as Tissot and Boldini. Forain exhibited *The Brothel* at the Fifth Impressionist show in 1880, the year when the novelist and critic J-K Huysmans was so impressed by the modernity of Gauguin's *Study of a Nude.* Huysmans was quick to hail Forain as 'another curious painter of certain corners of contemporary life,' recognizing him as an artist in tune with the aims of the naturalist writers; indeed, much of Forain's work belonged to the realm of illustration; he made satirical drawings for the popular press alongside his paintings.

His drawing style harked back to Daumier, as a number of critics pointed out, and he also had a strong affinity with Degas, choosing to paint almost subject for subject the same aspects of modern urban life – café, ballet, theater, circus, and brothel – in some cases anticipating the exploration of such themes by the elder artist. His first group of exhibited works, some of which were owned by Huysmans, included a large number of small-scale watercolors or gouaches painted in bright contrasts of colors and tight, flecked brushstrokes of the *pourtours,* or balcony walks, of the Folies-Bergères. These predate by some two to three years Manet's more monumental treatment of the subject. Forain's so-called *The Client* or *The Brothel*, is also executed in this manner.

Forain's treatment of a subject of such questionable moral significance, which carried obvious erotic connotations, falls almost within the category of caricature; being of small scale and humorous, it seems not to have upset too many sensibilities. To the right of the composition, a well-dressed bourgeois in top hat, resting his chin on the handle of his umbrella, weighs up the relative charms of the four prostitutes who display themselves before him, rather as a modernized *Judgment of Paris.* Huysmans' description of the cheeky little painting stressed its prodigious realism, the unmistakable social identity of these women, and the pathos of their attempts to whet the client's jaded appetite. Having recently completed his own novel about the life of a prostitute, *Marthe, Histoire d'une fille* (1876), Huysmans was quick to weave a plausible story around the situation. 'The whole philosophy of paid sex is present in this scene; having entered of his own accord, urged on by some bestial desire, the gentleman reflects and, his ardor having gone cold, in the end remains insensible to the offers.' As this extract shows, Forain's work appealed to writers who were attracted by the provocative modernity of his subject matter, more than by any innovatory formal and stylistic qualities.

Paul Gauguin

F r e n c h 1 8 4 8 - 1 9 0 3

Study of a Nude: Suzanne Sewing, 1880

Oil on canvas
45×32 inches (114×81 cm)
Copenhagen, Ny Carlsberg Glyptotek

Gauguin's *Study of a Nude*, painted while he was still an amateur, was the first work that gave any indication of the seriousness of his ambitions as an artist. Shown at the Sixth Impressionist exhibition in 1881 where it attracted the attention of the critic J-K Huysmans, a disciple of Zola, it marked a decisive new departure, as Huysmans remarked, from the Pissarroesque land-scapes the artist had shown in 1880. Although Huysmans could not be aware of the fact, the subject gave an indication of the direction in which Gauguin's interests would go later in his career.

The model for the painting was the Gau-guins' maid, Suzanne (sometimes referred to as Justine), who had in her younger days sat for Delacroix. In view of the fact that Gauguin's Danish wife Mette was unhappy about the increasing attention he was devoting to art and no doubt resented his hiring the services of nude models, it is thought that she may have agreed to her maid posing on the understanding that she get on with some useful sewing jobs at the same time! The banality of the woman's pose and occupation – albeit a somewhat improbable situation – and the sincerity and candor of Gauguin's representation of the body and flesh, making no attempt to disguise its blemishes and imperfections, were interpreted by Huysmans in natural-ist terms. He contrasted Gauguin's admir-ably frank treatment of the nude theme with the artificial and titivating nudes that currently suited contemporary taste.

The picture remained unsold for eleven years but, in 1892, when Gauguin was in Tahiti, his wife succeeded in selling it to the Danish artist Philipsen for the sum of 900 francs. The following year it was exhi-bited in Copenhagen alongside the first selection of Tahitian paintings Gauguin sent back to Europe, and a Danish critic was impressed by this early example of Gauguin's figure painting:

His *Study of a Nude* . . . is equally excellent in the drawing, coloring, and characterization. There is a touching simplicity in what the pic-ture tells us, yet it is free of all sentimentality. She is not what one in ordinary terms would call beautiful, and yet she is appealing; a beauty all its own permeates the figure and makes this picture one of those the eye is most agreeably drawn to in the whole room.

From 1883, when he abandoned his finan-cial career in favor of an artistic one, Gau-guin had had extraordinary confidence in his own long-term marketability; indeed, it was one of the factors that sustained him through difficulties and deprivations. Con-sequently, it gave him considerable satis-faction, as he worked in isolation in Tahiti, to learn that his gamble was paying off, that his early works were beginning to sell and attract an appreciative public in Europe. It was a satisfaction that his contemporary van Gogh had been cruelly denied, due to the brevity of his career.

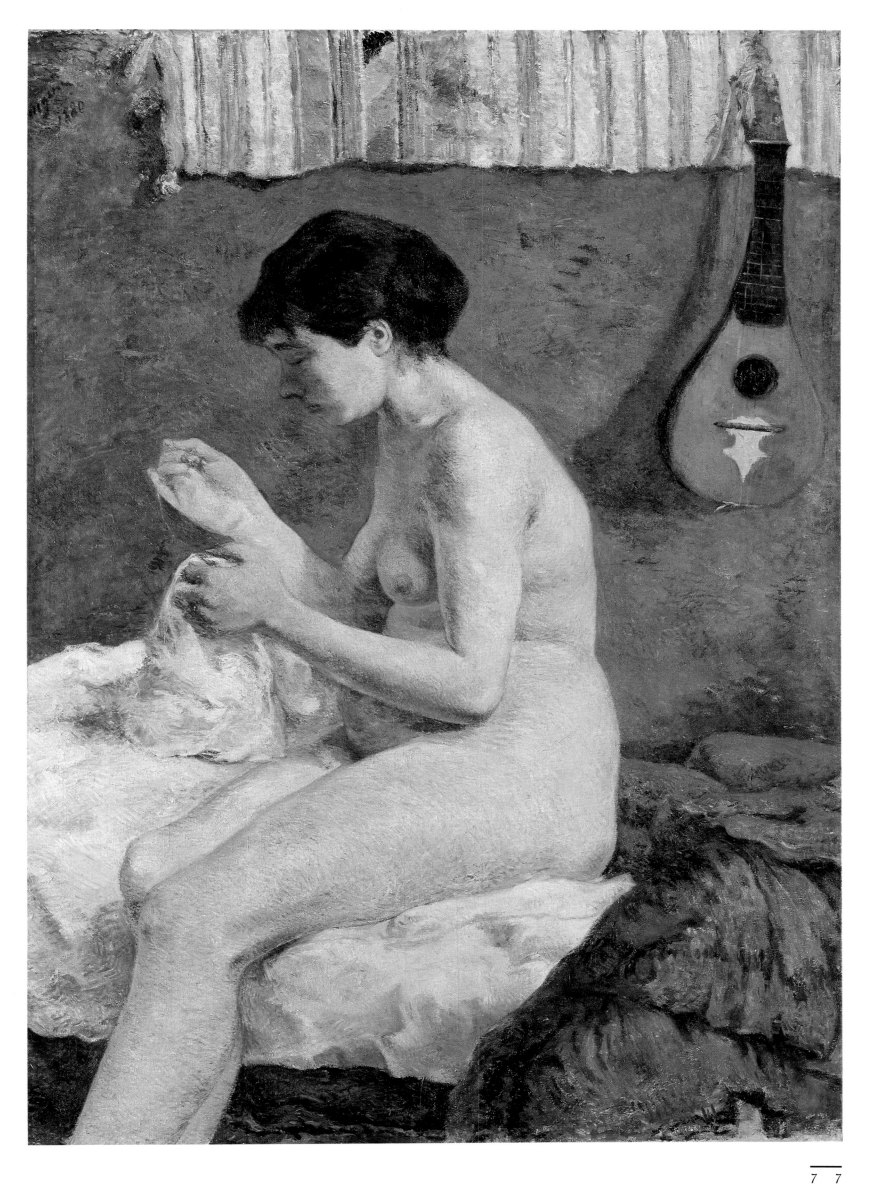

The Four Breton Women, 1886

Oil on canvas
28×35 inches (72×90 cm)
Munich, Neue Pinakothek

The difficulties and disappointments of his first years as a full-time painter, during which he made virtually no sales, led Gauguin to strike out alone in 1885-86, leaving his wife and children in Copenhagen under the wing of her Danish family. He made his first visit to southern Brittany in the summer of 1886, drawn there, like so many artists in his day, by the reports of cheap living and plentiful motifs. Picturesque representations of rural life and figures in folk costume had been popular themes for a number of years at the annual Salon, and Gauguin was not slow to realize the potential of Breton subject matter. This painting is one of the first in which he consciously cultivated a 'primitive' character, especially in the almost caricatural simplicity of the drawing of the geese and the sharp and decorative outlines of the women's costumes and coiffes. He featured the motif again in the decoration of a ceramic pot, and he would use a similar, though more simplified and flattened, composition and drawing style in his later Breton painting, *Vision after the Sermon, Jacob Wrestling with the Angel.*

In all likelihood, he painted *The Four Breton Women* in Paris after returning from his first prolonged stay in Pont-Aven. He had made drawings on the spot in pastel of the individual women and, by combining these studies, he was able to construct his composition in the studio, at a remove from nature. This synthetic method of working, getting away from the immediate response to the motif, marked a departure from Impressionist practice.

The same development can be seen in the work of Pissarro in the mid 1880s. Both artists were impressed by the example of Degas, whose naturalism was achieved by sophisticated artifice. Indeed, Gauguin's Breton women, drawn from behind or in profile, are remarkably close in pose and approach to some of Degas' dancers. They appear to be pressed forward toward the picture plane. By thus minimizing the treatment of the setting and cutting out the sky, Gauguin was able to break free from his hitherto somewhat hesitant attempts to integrate smaller figures into more realistic landscape settings.

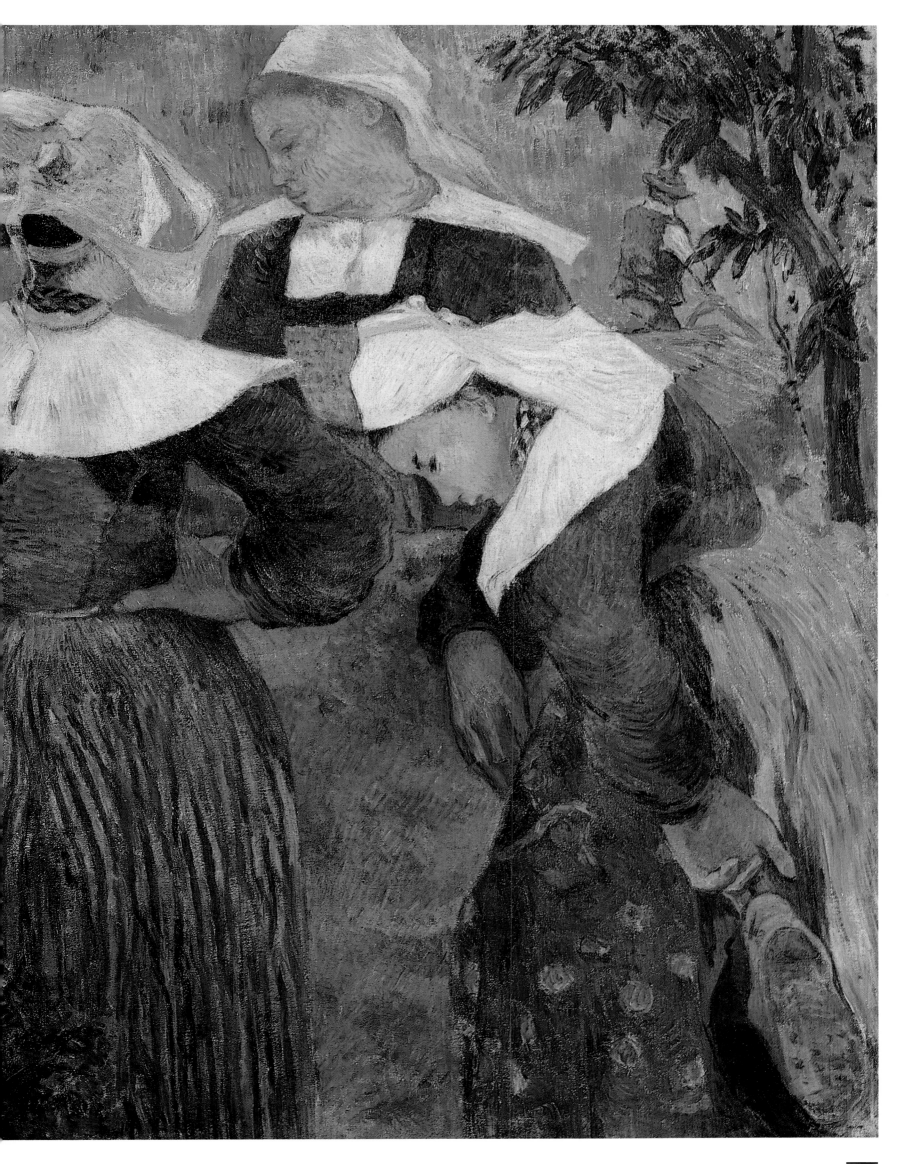

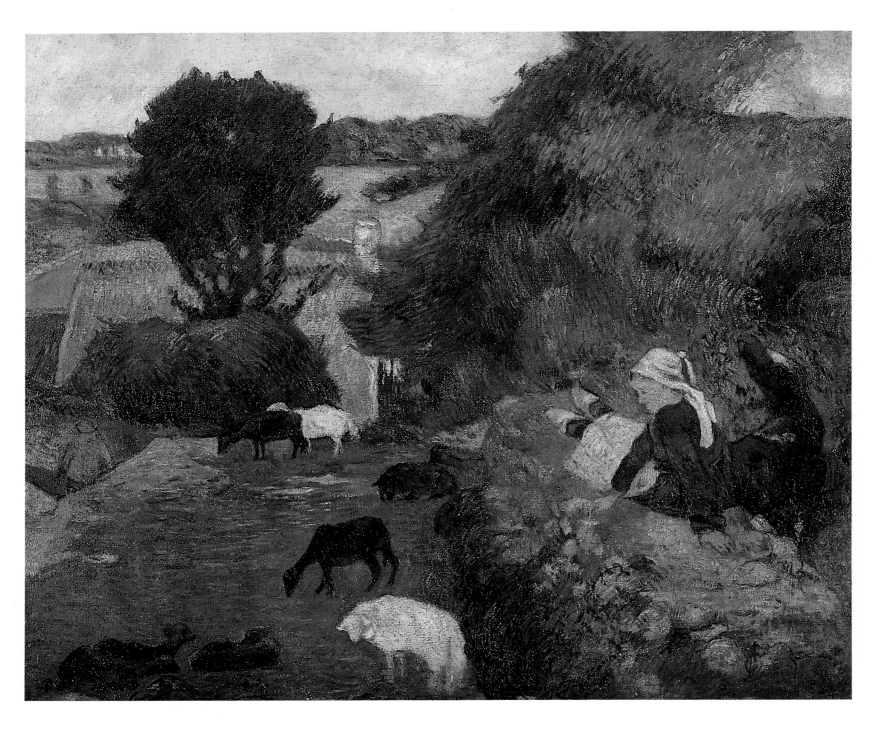

The Breton Shepherdess, 1886

Oil on canvas
24×29 inches (61×74 cm)
Newcastle, Laing Art Gallery

As an amateur painter, Gauguin had first sought the advice and assistance of Pissarro in the summer of 1879 and the fruits of the elder artist's example and teaching are clearly visible in his early landscapes. Thanks to Pissarro's encouragement and endorsement Gauguin had been invited to exhibit at the Fourth Impressionist show of 1879 and in 1880 had presented his first group of landscapes. During the early 1880s Gauguin had divided his time fairly evenly between landscapes and figure studies. After turning to art as a full-time career around 1883, like his mentor Pissarro before him Gauguin began attempting to integrate the figure and the landscape, as he does in this painting. Although in his choice of setting here – fields on the outskirts of the Breton village

of Pont-Aven – Gauguin was venturing into new territory, his choice of subject, a charming young shepherdess watching over her flock, can be compared to numerous works by Pissarro.

The steep slopes of the Aven valley presented difficult problems of angle of vision and foreshortening for the landscape artist, problems which Gauguin did not attempt fully to resolve here. He adopted a plunging viewpoint which led to the odd foreshortening of the shepherdess and her cow, and he applied to the whole surface of the canvas small, parallel flecked brushstokes which serve to counteract the illusion of depth, particularly in the right half of the picture. Gauguin made several preparatory drawings, notably of the animals and shepherdess, motifs he used in other works of the time. The clearly visible layer of directional brushstrokes was derived from his study of the landscapes of Cézanne, several of which he had acquired around 1880 at a time when he was enjoying financial prosperity.

Félix Fénéon was one of a number of critics who commented on the dense airless atmospheres characteristic of Gauguin's landscapes around this date, noting the artist's apparent predilection for certain strident color juxtapositions. In this painting the sky is reduced to a minimum and the strong greens of the grass and foliage are set against equally strong russets and golds. If such density was liable to be judged harshly in the context of the *plein air* aesthetic of Impressionism, Gauguin was soon to turn this 'defect' to good account in his synthetist paintings of 1888 onward, paintings in which flat, saturated color and airless atmospheres were cultivated for decorative and symbolic ends.

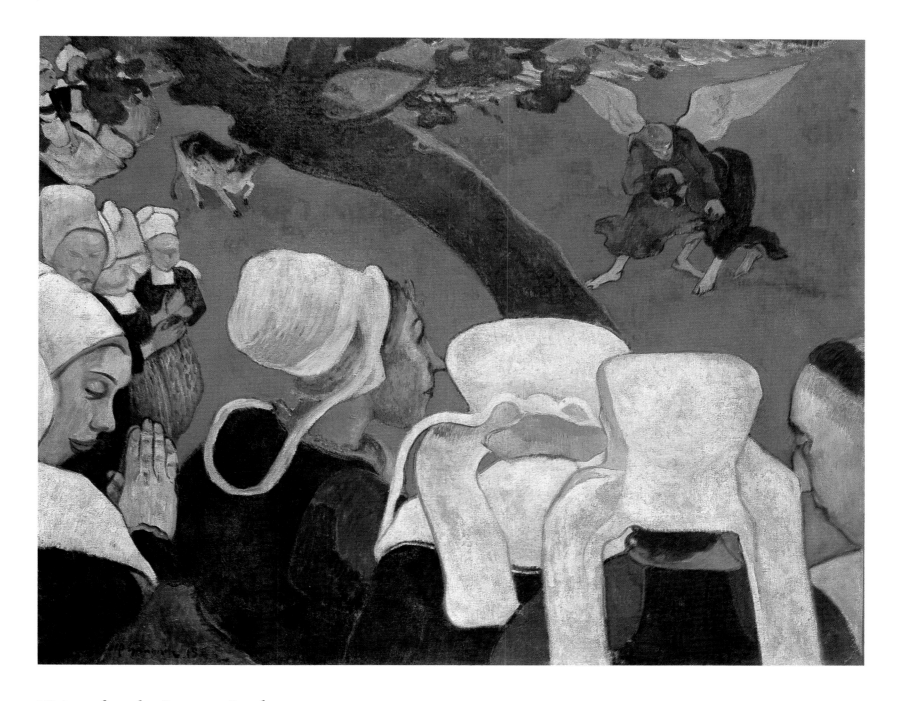

Vision after the Sermon, Jacob Wrestling with the Angel, 1888

Oil on canvas
29×36 inches (74×91 cm)
Edinburgh, National Gallery of Scotland

In the summer of 1888, when Gauguin returned to Pont-Aven after a brief stay on the tropical island of Martinique, his work began to show signs of a break away from Impressionism. He started to combine a crude, simplified outline style of drawing with a dense flat application of color, a process which involved the unnaturalistic treatment of space. Gauguin was increasingly fascinated by decorative, exotic, and 'primitive' art forms, such as Japanese prints, popular prints, children's illustrations, stained glass, and religious carvings. Such enthusiasms were shared by other artists in Paris – Vincent van Gogh, Louis Anquetin, and Émile Bernard. When the young Émile Bernard arrived in Pont-Aven in the summer of 1888 and stayed for some weeks, Gauguin was emboldened to pursue further some of his radical technical

experiments. Working side by side, he and Gauguin 'tormented Impressionism to death' as Gauguin himself was later to report, Bernard turning out his highly synthetic and innovatory *Breton Women in the Meadow*, while Gauguin produced his famous *Vision after the Sermon, Jacob Wrestling with the Angel* seen here.

Gauguin's painting, although heavily indebted to Bernard's in its arrangement of the figures, the decorative exaggeration of the head-dresses, and the liberties taken with color, perspective, and drawing, embarks upon a new realm of subject matter unexplored by the Impressionists. The struggle between Jacob and the Angel, famously interpreted by Delacroix in a monumental decoration at the church of Saint-Sulpice in Paris, is represented by Gauguin in a stylized manner in the top right-hand section of the composition. This struggle takes place in the imaginations of the praying women, stirred by the priest's sermon. The use of a flat plane of red served not only to contrast with the green foliage but also to remove the setting from reality, to symbolize the higher

spiritual plane, or so the Symbolist critic, Aurier, primed by Gauguin, was anxious to explain in his influential article 'Symbolism in painting – Paul Gauguin,' which appeared in the *Mercure de France* in 1891. This tendency toward symbolic abstraction alienated Gauguin's former mentor and champion, Pissarro. In 1891, at the time of Gauguin's departure for Tahiti amid a blaze of publicity, Pissarro was cynical about his former pupil being trumpeted by the media as an undiscovered genius. He felt Gauguin's notoriety had been achieved as much through cunning self-advertisement as through synthetic, anti-naturalistic paintings, such as *Vision after the Sermon*. He expressed his annoyance in a letter to his son Lucien, 'I do not blame Gauguin for having painted a vermilion background, two warriors fighting, and the Breton peasants in the foreground, I reproach him for having stolen this from the Japanese, from the Byzantine painters and others, I reproach him for not applying his synthesis to our modern philosophy which is absolutely social, anti-authoritarian, and anti-mystical.'

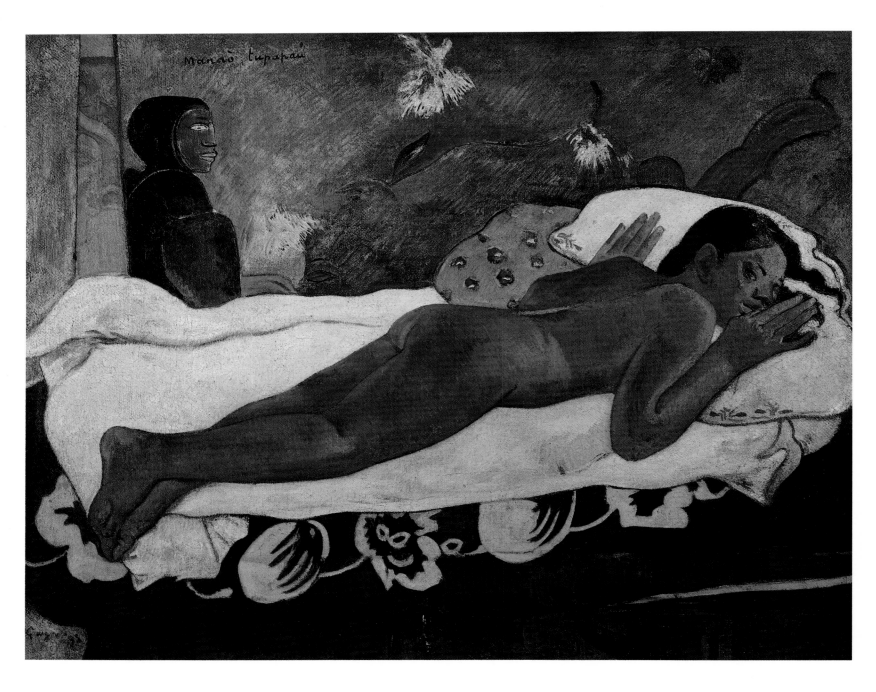

Manao tupapau (The Spirit of the Dead Keeps Watch), 1892

Oil on canvas
29×36 inches (74×91 cm)
Buffalo, New York, Albright-Knox Art Gallery

In this painting, with its stunning arrangement of colors, Gauguin works a variant on the concept of complementary contrasts widely applied by the artists of his generation. For the bed, he combines dark blues with a decorative pattern of orange-golds, and he sets the pale yellowish of the sheet against a background of mauves, pinks, and purples, and the rich golden browns of the girl's naked body. Gauguin's underlying theme here, as in *Vision after the Sermon*, was essentially the superstitious and visionary nature of simple, untutored women. The subject recorded a particular experience which Gauguin described in his partly autobiographical, partly fictional account of Tahiti, *Noa Noa*. Returning to his hut one night, Gauguin had found his young Tahitian bride Teha'amana, a girl of only thirteen, motionless on the bed, paralyzed by her fear of the spirits of the night. In the painting and the related woodcuts, Gauguin suggested her fear through gesture and facial expression and implied an other-worldly presence in the sinister black-hooded figure seated at the foot of the bed.

The scale and horizontal arrangement of Gauguin's Tahitian nude paintings recall Manet's equally controversial *Olympia*, and it is more than likely that Gauguin had Manet's painting in his mind. Shortly before leaving for Tahiti, he had made a painted copy of *Olympia* in the Luxembourg, the state collection of contemporary art, where Manet's masterpiece had finally been admitted following a campaign waged by Monet and others concerned to honor Manet's reputation. The picture was one of the first painted in Tahiti from a nude model. Initially, Gauguin had found the Tahitian women reluctant to pose for him, except when dressed in their Sunday best. Once Teha'amana was set up as the artist's 'wife,' with her family's full blessing however, she offered him undemanding companionship and became his favorite model. In 1893, *Manao tupapau* was exhibited both in Copenhagen (where it was seen alongside his much earlier *Study of a Nude*) and in Paris. Forced to explain and defend his subject matter to the critics, Gauguin claimed that the beauty of the Tahitian was incomparably superior to that of the white woman: she was an Eve free from the taint of shame or decadence associated with the European nude. Arguing that if he had painted a European woman in the same pose the picture would have been deemed indecent, Gauguin seems to have convinced himself that the color of the girl's skin served to make the painting innocent.

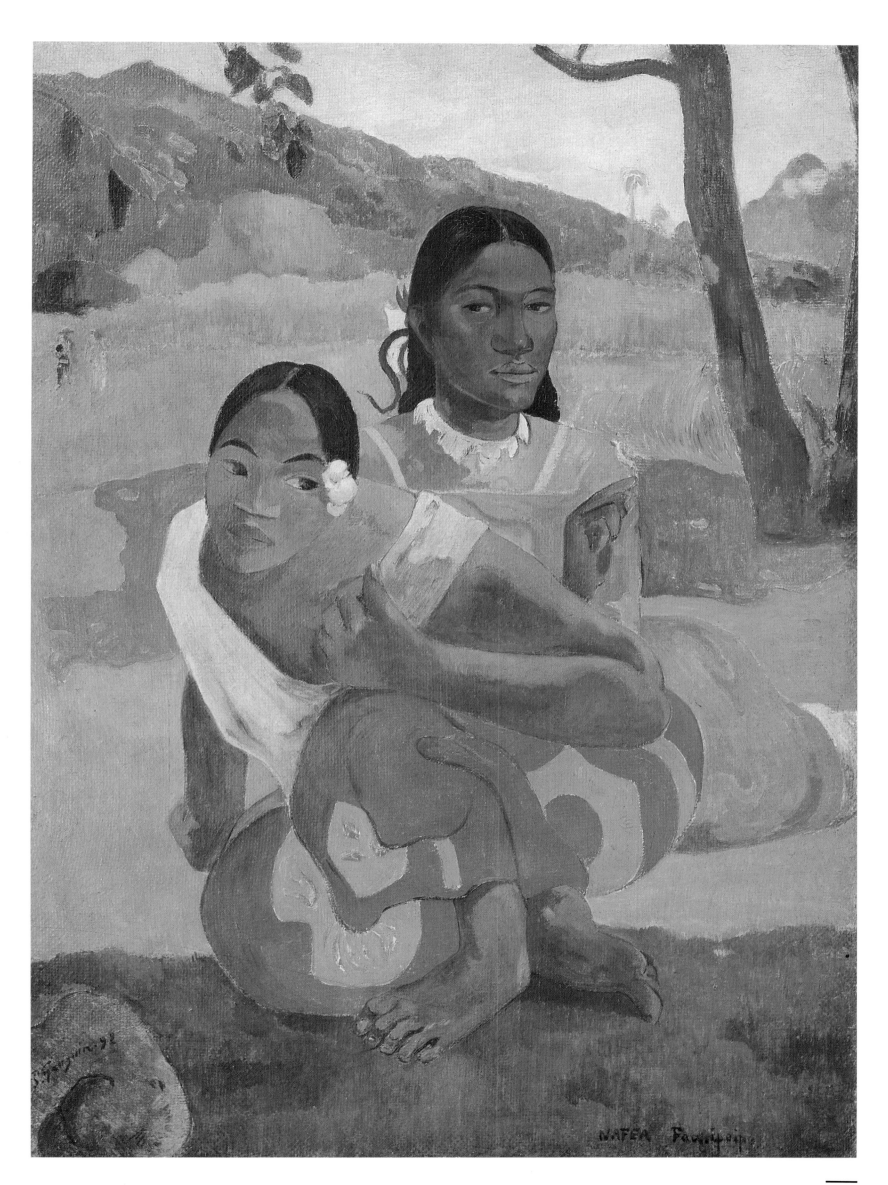

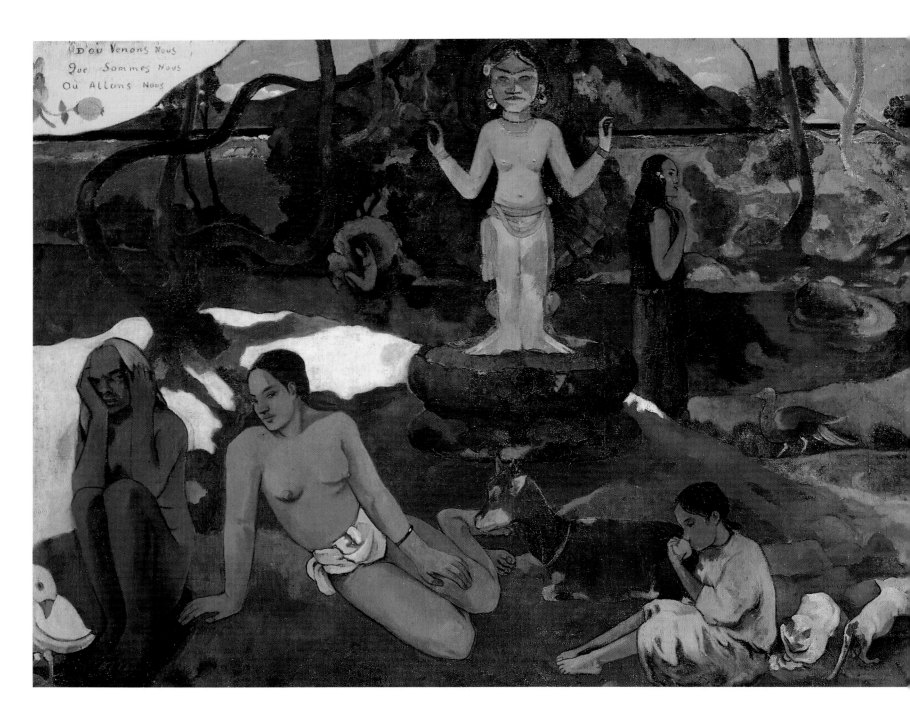

Previous page:

Nafea Faa ipoipo. When Will You Marry?, 1892

Oil on canvas
40×31 inches (102×79 cm)
Basel, Kunstmuseum

Gauguin painted a number of compositions in Tahiti involving two women, using interlocking poses to give balance and visual and sculptural interest. Such paintings would not have been done directly from the model or *en plein air* but in the studio Gauguin had rigged up for himself in his hut. There is a squared-up preparatory drawing for the foreground figure; her awkward crouching and leaning pose have been observed both in terms of simple outline shape and as a sculptural, modeled form. Although Gauguin's use of color and outline tended to assert the flatness of the picture plane, he continued to use strong modeling in his figures.

Gauguin freely combined opposing approaches in his organization of the landscape setting. Whereas the variegated hues of the mountains suggest distance and intervening heat-filled space in a conventional enough way, the areas of green, gold, and blue lower down seem to deny that sense of space and demand to be read as flat decorative bands.

The irony implicit in the questioning title was a favorite device of Gauguin's by this date. When required, for the purpose of an exhibition, to identify his works, he frequently invented poetic, suggestive titles. The use of Tahitian words, which he usually inscribed on to the canvas, contributed to giving the works an aura of mystery which he knew would appeal to his sophisticated Symbolist public in Paris. In this instance, the title may also have had an autobiographical significance. In *Noa Noa* Gauguin described, with some relish, the incomprehension his mode of existence aroused in the native Tahitians. They could not conceive of a man being content to live alone, in exile, without family or friends, and were eager to offer themselves, or to see him take a native woman as 'wife.'

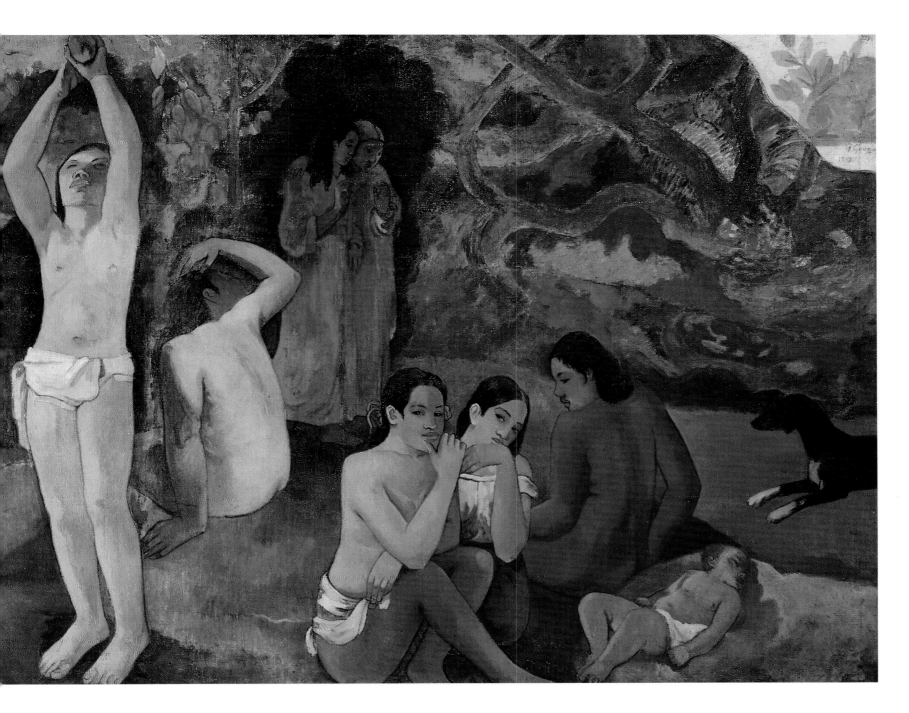

D'où venons-nous? Que sommes-nous? Où allons-nous?, 1897

Oil on canvas
54¾×147½ inches (139×375 cm)
Boston, Museum of Fine Arts

In this monumental canvas, painted just before he attempted to commit suicide, Gauguin set out to make a final statement, a last comment on the life he had discovered and enjoyed in Tahiti. The open-ended questions that form the title, and are painted on to the gold background in the top left-hand corner, ponder the profound mysteries of life and death. The philosophical nature of the painting's subject, as well as its overall formal conception, have come a long way from Impressionism. The arbitrary color scheme is dominated by its harmonies of sonorous blues and greens, broken up by the golds of the bodies and by the occasional brilliant notes of pink or orange of the fruit, flowers, and exotic bird. The figures are not integrated by means of brushwork into their surround-

ings, nor are we under any illusion that they have been naturalistically glimpsed. On the contrary, many were transposed, individually or in groups, from earlier works and rearranged here in a static, hieratic frieze. The brooding presence of the blue Buddha-like idol, which appears in several of Gauguin's other Tahitian works, represented his own imaginary version of the islanders' past pagan cults. Although, to Gauguin's dismay, under colonial rule no vestiges of that earlier religion had been allowed to remain, by studying written sources and ritual objects from other linked cultures, he had arrived at a suggestive approximation of the ancient Maori cults. The idol's fixed, symmetrical pose is only marginally more stylized than the gestures of the living figures, each of whom occupies a sealed-off space.

Gauguin's suicide attempt failed and he lived long enough to take an interest in the critical fate of his great masterpiece, which he dispatched by boat back to Paris. Aware that it was bound to provoke curiosity among the Paris audience, Gauguin

offered one or two of his contacts there clues as to the painting's meaning. He explained that although in terms of scale and significance the work could be set alongside the large decorations of the respected academic artists of the day, he prided himself that 'it does not smell of the model, of professional techniques and of so-called rules . . .' He had deliberately worked fast on it, using a coarse sackcloth as canvas, to produce a rough-and-ready but sincere artistic statement. The canvas reads from right to left, from the baby at the brink of life through the large central figure who plucks fruit from the tree of knowledge to the old woman, hunched in a fetal pose, who approaches death. She was derived from a Peruvian mummy Gauguin had seen back in 1889 in the Paris ethnographic museum, whose collection had played its part in inspiring Gauguin's radical decision to take his artistic quest away from Europe into the remote lands of France's new colonies. In so doing, he paved the way for a wave of similar 'primitive' quests in twentieth-century art.

Vincent van Gogh

D u t c h 1 8 5 3 - 9 0

Bridges at Asnières, 1887

Oil on canvas
20×26 inches (51×66 cm)
Zurich, Bührle Collection

Vincent van Gogh embarked late on an artistic career. He began by painting rural peasant subjects or typical working figures from urban life in a dark tonal manner not dissimilar to that of his contemporaries in the Hague school. Many of the naturalist and humanitarian concerns which he shared with and inherited from his Dutch countrymen, and from the English illustrators whose work he collected, were to remain constants throughout his career.

Bridges at Asnières was painted during van Gogh's two years in Paris between 1886 and 1888, where he stayed with his art-dealer brother Theo. To study life drawing and painting he enrolled as a student at Cormon's *atelier.* There he came into contact with a new generation of ambitious artists such as Toulouse-Lautrec, Anquetin, and Bernard, who, like himself, were eager to learn from and build upon the achievements of the Impressionist avant-garde. This was a period of rapid assimilation, and van Gogh's Paris works show him experimenting with a wide range of new stylistic ideas, responding not only to Impressionism but also to the latest technical experiments of Seurat and the Neo-Impressionists. *Bridges at Asnières* was painted during the summer of 1887, when he began to explore Asnières, a suburb to the west of Paris, in the company of Émile Bernard, who lived there with his parents. Van Gogh became fascinated by the wealth of motifs to be found on his walks around and beyond the city's north-western boundaries; the poetic potential of the suburbs had been vaunted by naturalist authors, notably in a recent collection of prose poems, *Parisian Sketches,* by Zola's disciple Huysmans. Van Gogh was a great reader of naturalist fiction, and many of his ideas for pictures were inspired by such literature. For a painter interested in the modern city as subject, the suburb of Asnières offered intriguing juxtapositions – its verdant riverbanks and riverside restaurants were a focus for bourgeois leisure pursuits, yet the new road and rail bridges and factories of Clichy on the opposite bank of the Seine were inescapable reminders of the rapid advance of technology and industry. The site and its social ambiguities had recently been brought into focus in Seurat's two monumental figure paintings, *Bathers at Asnières* and *Sunday Afternoon on the Island of la Grande Jatte.*

In this painting, van Gogh makes somewhat cautious use of Seurat's divisionist technique, breaking areas of local color into coarse, separate touches. His choice of viewpoint, which offers a more casual glimpse of the location's social and environmental ambiguities than Seurat's, harks back to the works of Monet in the previous decade. In the foreground are the rows of skiffs, presently idle. Although his figures on the riverbank are small and inconspicuous, van Gogh's juxtaposition of an incongruously elegant woman, with pink dress and parasol, with a working man's blue smock is noteworthy. The prominent inclusion of a steam train crossing the first of the two bridges, bound for the terminus of Saint-Lazare, seems deliberately to recall Monet, whose paintings during the previous decade had so frequently featured boats, trains, and bridges.

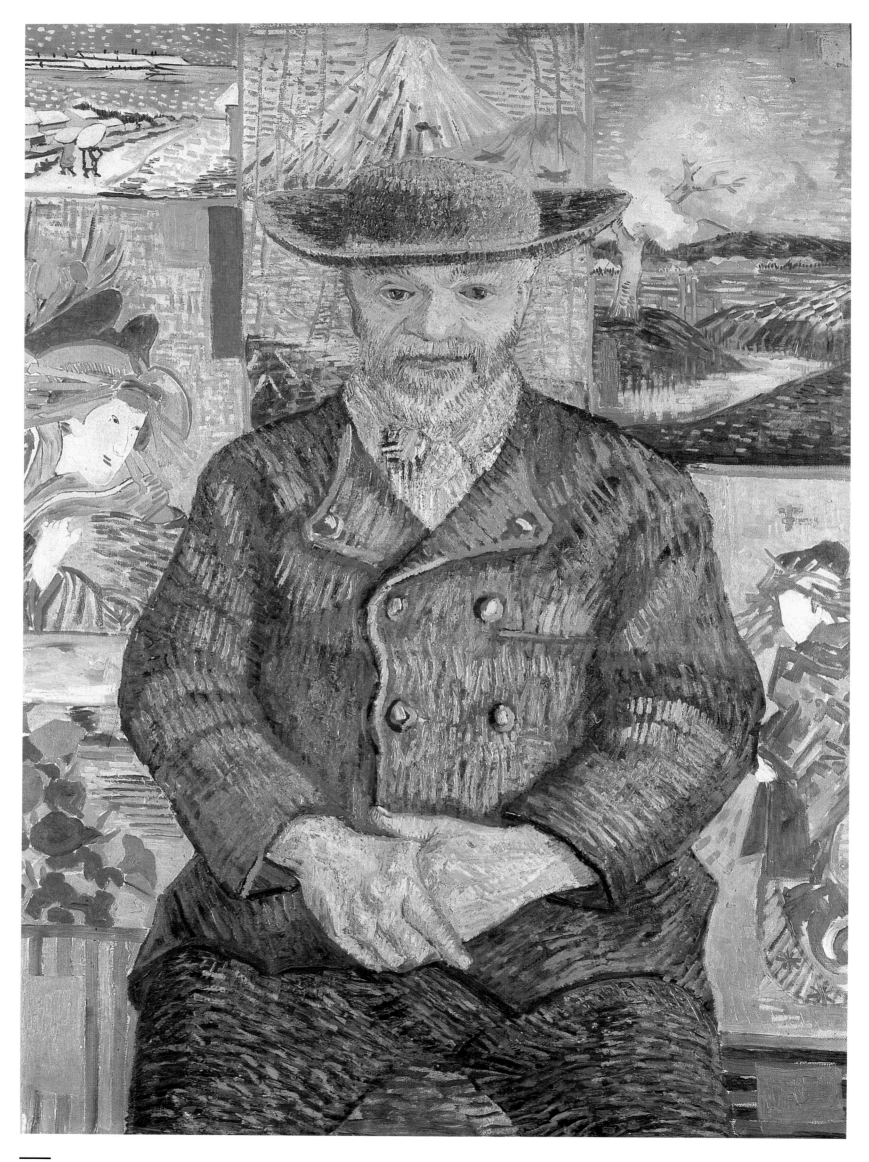

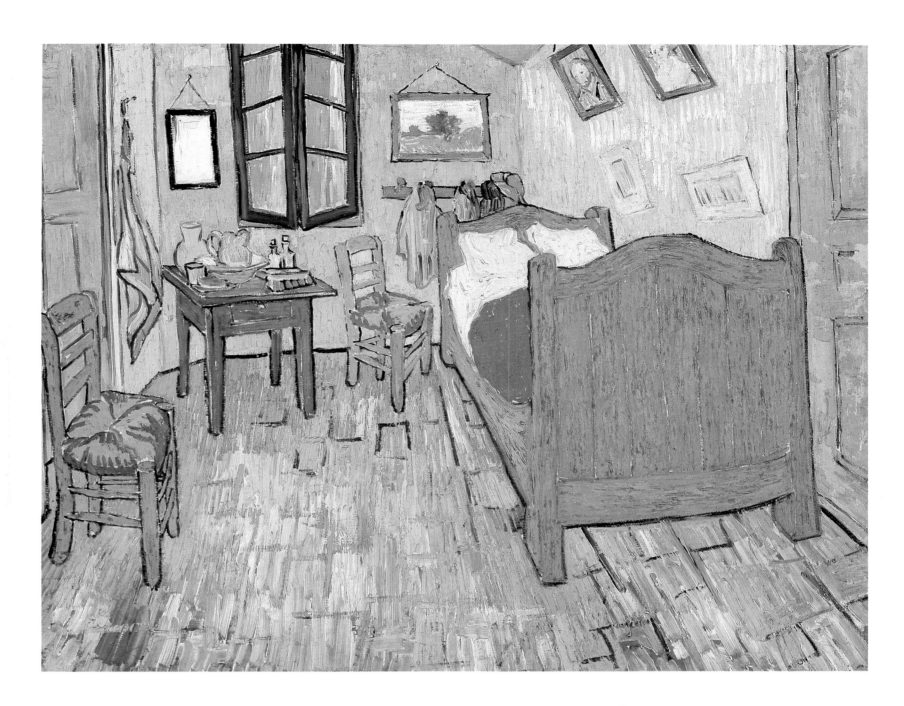

Portrait of Père Tanguy, 1887

Oil on canvas
25×19 inches (63×48 cm)
Paris, Musée Rodin

Toward the end of 1887, van Gogh painted two portraits of Père Tanguy. Van Gogh's portrait presents Tanguy as a solid, almost iconic figure. Indeed, he saw Tanguy as something of a contemporary saint who had devoted himself selflessly to the cause of art. Julien Tanguy was a color merchant and active supporter of the efforts of the painters of the *petits boulevards* (as van Gogh called them), agreeing to accept canvases in lieu of cash for his wares. His dark, cluttered shop in the rue Clauzel, Montmartre, which was almost the sole outlet for Cézanne's work in Paris in the 1880s, provided a haven for young experimental artists.

When he embarked on this portrait, van Gogh was working in close collaboration with Anquetin, Bernard, and Lautrec, all of whom were experimenting with a novel manner of painting consisting of a strong

outline, often almost caricatural in its stark simplicity, and flat unvariegated areas of color. When the critic Edouard Dujardin reviewed a group of such works at the Salon des Indépendants in 1888, he identified the style as a genuine attempt to break away from the *trompe l'oeil* or illusionistic goal of so much contemporary painting, Impressionism included, and to work in a symbolic rather than naturalistic vein. Confronting this new compartmentalized manner of painting for the first time, Dujardin borrowed a term from the techniques of enameling to describe it: 'cloisonnism.' In seeking precedents and parallels for the style, he pointed out the similarity of cloisonnism to the various decorative effects of popular woodblock images and Japanese prints.

The background to *Portrait of Père Tanguy* is made up of a collage of different Japanese prints, many of them works from van Gogh's collection. He valued the prints not only for their color, simplicity, and vitality but also for the different perspective on life they offered, their harmonious images of humankind working in nature.

Bedroom at Arles, 1888

Oil on canvas
29×36 inches (74×92 cm)
Chicago, Art Institute

From May 1888 van Gogh rented a house in Arles where he could establish his studio, the so-called 'Yellow House.' He was anxious that the house should make a favorable impression on Gauguin who had, somewhat reluctantly, accepted an invitation to visit Vincent in the 'Studio of the South.' In mid October, while still awaiting Gauguin's arrival, he painted his bedroom.

Although some of today's viewers find the distortions of perspective disturbing, for most the image unquestionably has a wholesome and comforting appeal. This is as van Gogh wished. The picture bespeaks the artist's pride in his new abode, his first real home. On the walls by the bed one can make out several of van Gogh's paintings, including a self-portrait. It was also, in a sense, symbolic of his feelings of exhaustion at the end of a period of intense work, of his need for tranquillity and calm.

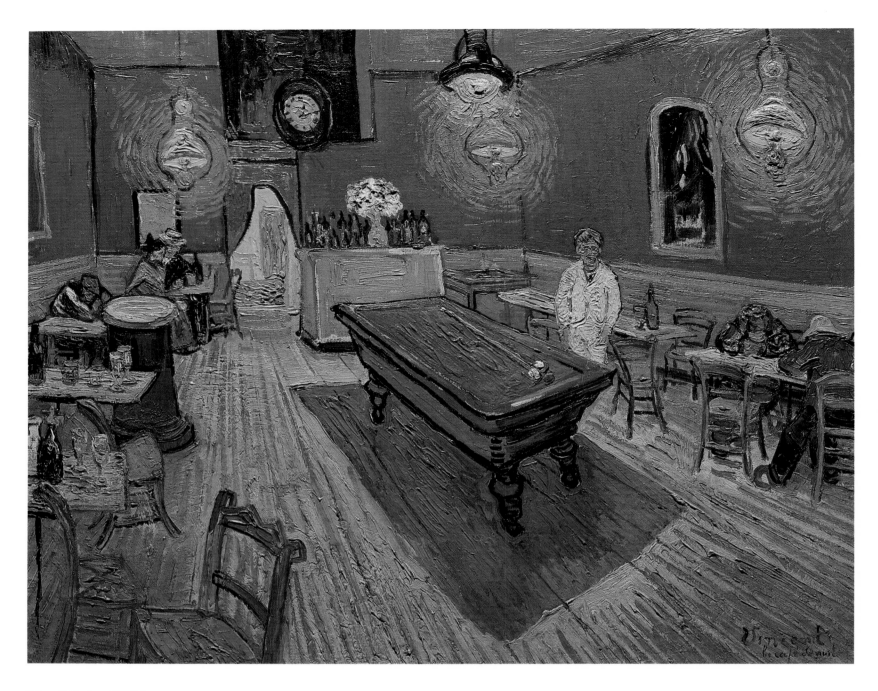

The Night Café, 1888

Oil on canvas
28½×36¼ inches (72×92 cm)
New Haven, Yale University Art Gallery

In February 1888, van Gogh left the bitter cold of Paris and traveled south to Arles. He went to Provence in search of warmth and sun to restore his impaired health; for his work, too, he longed for the country again, for new scenery, and for a rural way of life that he hoped would be like that of Japan. He was not disappointed in the flat expanse of the Rhône valley, with its varied agriculture – wheatfields, orchards, vineyards, and olive groves. Its busy waterways and drawbridges bore an uncanny resemblance to his native Holland.

Although much of van Gogh's output during the summer of 1888 was concerned with exploring the artistic potential of the Provençal landscape in a relatively traditional range of rural motifs, van Gogh also tackled a number of townscapes and interiors in Arles that recorded the appearance of this ancient yet rapidly changing southern town through the eyes

of an isolated stranger. *The Night Café* essentially describes the place where van Gogh took his meals. When not actually painting, van Gogh was an *habitué* of cafés and seedy restaurants; in Paris he painted several views of those he frequented. In Arles it was in the Café de la Gare that he found hospitality and companionship of a kind. He stayed there from May to September 1888, painting this picture at the end of his period of residence. Van Gogh had difficulty adjusting to the local cuisine; although in the south he abused his health less with tobacco and alcohol than before, in letters to his brother he complained frequently of the meals he was getting and their effect on his weakened stomach.

In his painting, van Gogh used an exaggerated perspective in the steeply receding plane of the floor, inspired perhaps by a similar effect seen in Herkomer's *Old Age – a study at the Westminster Union*, an engraving which he admired. He also deliberately heightened the clashes and contrasts of color, setting the blood red of the walls against the virulent greens of the billiard table and ceiling. He explained that

in doing so he aimed to 'express the terrible passions of humanity.' Certainly, the stifled, tetchy atmosphere of the all-night café, with its shifting clientele of thugs and prostitutes, an atmosphere in which at any moment a fight might break out, is conveyed most effectively. Thus while the work looks back, in emotional and humanitarian appeal, to the Victorian realist artists he so admired, van Gogh's exaggerated use of color and brushwork and his preoccupation with such modern symptoms as isolation and angst were forward-looking. Van Gogh played an important role in the formation of Expressionist styles in the early years of this century.

One of van Gogh's best-known works, *The Night Café* itself is much traveled; having once belonged to the noted Russian collector Morosoff, it found its way in the 1920s to the United States where it has remained ever since.

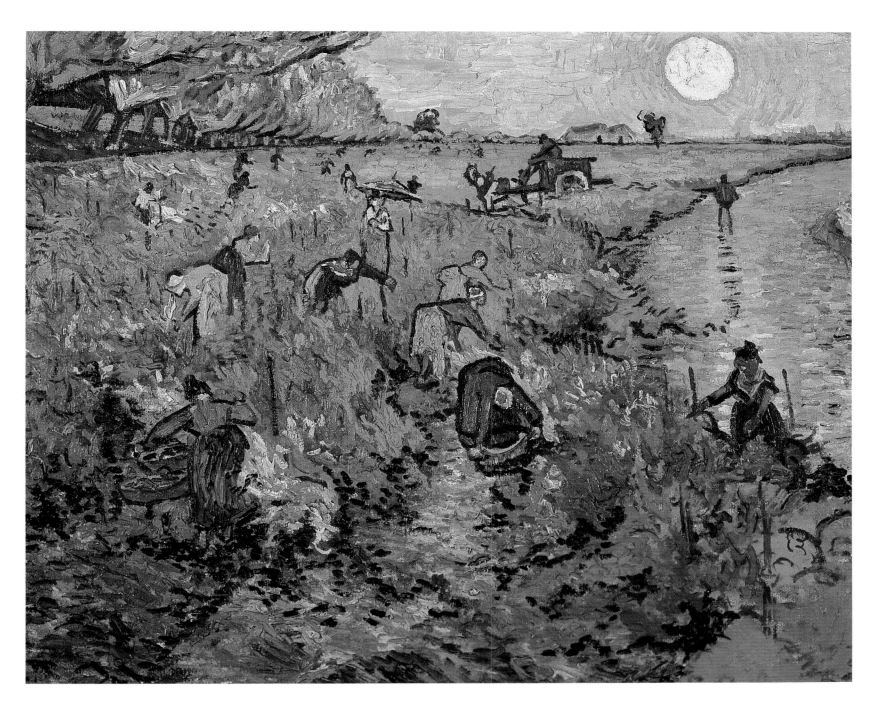

The Red Vineyard, Montmajour, Arles, 1888

Oil on canvas
29×36 inches (74×91 cm)
Moscow, Pushkin Museum of Fine Art

Van Gogh painted *The Red Vineyard* in early November 1888, during Gauguin's stay. On an evening walk, they had been struck by the brilliance of a sunset effect, after a rainstorm, on the red vines. In his turn, Gauguin tackled the subject, but produced a very different and more abstracted version of the theme, complicated by the intrusion of his own personal symbolism.

The *vendanges,* or grape harvest, was a picturesque Provençal ritual that was bound to appeal to van Gogh: he had already painted numerous agricultural scenes early in the year, and this painting served as a companion piece for *The Green Vineyard* painted the previous month. Presumably it is the tail end of the grape harvest that is still taking place, when the leaves of the vines have already turned to the brilliant autumnal reds and golds we see in the canvas. He offsets these hot colors with the blues and blacks of the women's costumes, their awkward stooping poses and gestures reminiscent of some of his earlier studies of peasants in the Lowlands, but also of the diminutive working figures in Japanese prints.

One of the strongest characteristics of van Gogh's style is the emphatic impasto of his brushwork, and in this painting his vigor and energy are clearly evident on the canvas surface. His extravagant use of paint and love of rough textures set his work apart from the Japanese art he so admired and from his close contemporaries, notably Gauguin, who favored a much less emphatic treatment of the surface. A key source for the heavy use of impasto was Adolphe Monticelli, a Provençal painter whom van Gogh idolized. When van Gogh had completed his *Red Vineyard* to his satisfaction, he wrote to his brother, 'I think that you will be able to put this canvas beside some of Monticelli's landscapes.' Today, when Monticelli is chiefly remembered for his importance to van Gogh, the artist's claim seems a modest one; for van Gogh, however, this readiness to measure his work against that of his hero was a mark of confidence.

Van Gogh was not to live long enough to see his work generally accepted by collectors – the ultimate validation of an artist's faith in himself. For many years, *The Red Vineyard* was thought to have been the only painting he succeeded in selling during his lifetime. Certainly, it was exhibited in early 1890 at the independent show of the XX group in Brussels and one of van Gogh's canvases was acquired there for 400 francs by the Belgian Symbolist painter Anna Boch, the sister of an artist van Gogh had met in Arles, Eugène Boch. However, it now seems probable that *The Red Vineyard* was not the picture Anna Boch bought, and that she acquired it on some other occasion after the artist's death. Like *The Night Café* it subsequently entered the collection of the Russian industrialist Morosoff and, in this case, remains in Moscow.

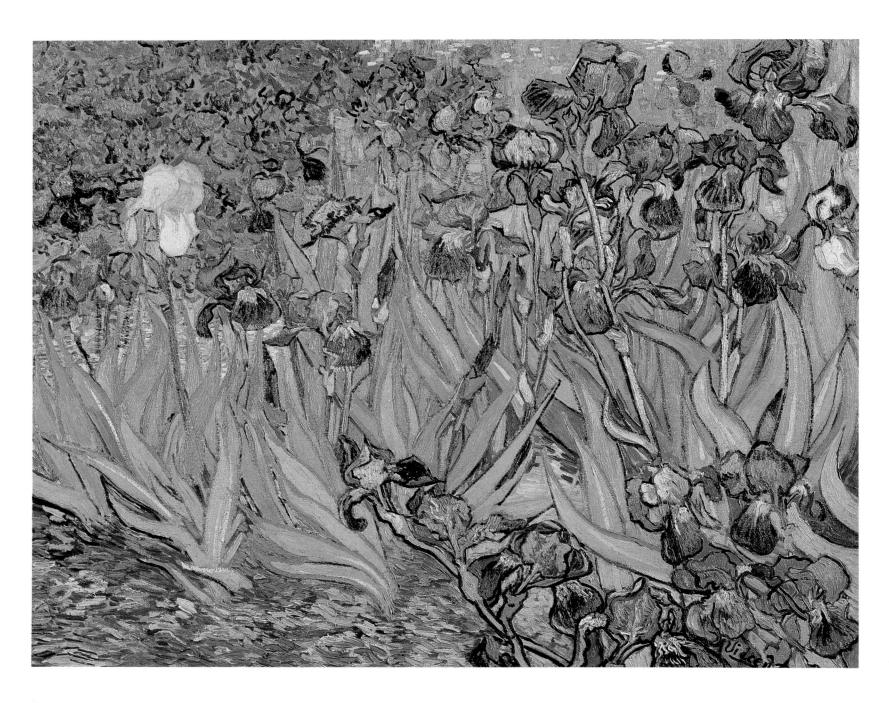

Irises, 1889

Oil on canvas
28×37 inches (71×94 cm)
New York, Sotheby's

The enormous prices van Gogh's paintings fetch at auction today are baffling. In 1987, all records were broken by the sums paid for two of his flower paintings, *Irises* and *Sunflowers,* both sold to private collectors, the latter to a collector from Japan. (Given van Gogh's special feeling for Japan, he would doubtless have rejoiced in the fact that his work was appreciated there.) Ironically, within the traditional hierarchy of genres, a hierarchy that continued to hold some sway at least until the mid nineteenth century, flower painting occupied a lowly status, on a level with domestic still life; accordingly, flower painters expected to command substantially lower prices than their contemporaries who specialized in history or portrait painting. It is a measure of the radical upturning of that hierarchy, brought about in some degree by the Impressionists but also by van Gogh's remarkable contribution to the genre, that it

should now be possible for 'mere' flower paintings to break all world records.

Van Gogh aspired to communicating with and touching the hearts of ordinary people through his work. That his ambition has been achieved today is evident not so much in the determination of a few wealthy private individuals to secure a van Gogh for their collection as in the familiarity of a wide audience with his works, both through their widespread reproduction and their availability in public collections.

Van Gogh's several paintings of sunflowers arranged artlessly in a pot have for many years held a universal appeal. His paintings of irises were until recently relatively less known. In this painting, a magnificent cluster of spiky blooms, still firmly rooted in the earth, is observed at close quarters. The color and frieze-like design are extraordinarily strong and decorative. The example of a Japanese printmaker, Hokusai, was probably in van Gogh's mind as he tackled this particular flower painting: among the large, detailed sheets of flower studies by the Japanese artist, one finds a study of irises. Van Gogh embarked

upon the painting in May 1889, shortly after arriving at the mental hospital at Saint-Rémy where he would live, off and on, for the best part of a year. He drew and painted a number of comparable subjects in the hospital's walled garden before being allowed to venture farther into the surrounding landscape. Although van Gogh considered this version of *Irises* more of a study from nature than a carefully considered picture, it was one of two paintings Theo submitted on his brother's behalf to the Salon des Indépendants of 1889 where it attracted the admiration of the critic Fénéon.

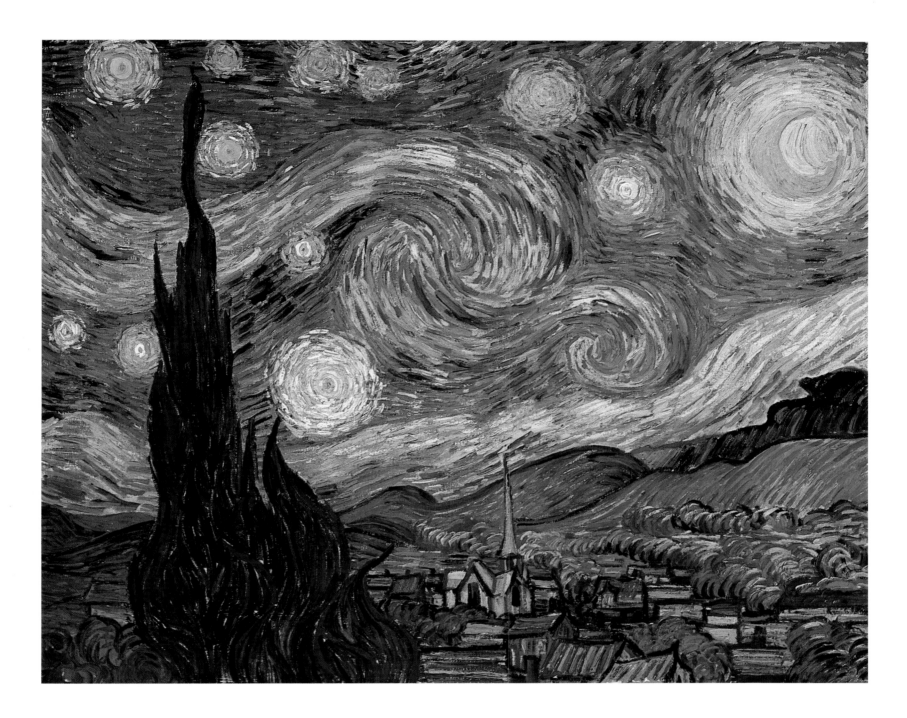

Starry Night, 1889

Oil on canvas
29×36¼ inches (74×92 cm)
New York, Museum of Modern Art

This extraordinary canvas was painted in Saint-Rémy during the month of June. Since first attempting a nocturnal picture in Arles the year before, inspired by the sight of brilliant stars reflected in the River Rhône, van Gogh had had in mind to try the difficult subject of night again. Although for his earlier painting he had made a point of working outside under the stars, he painted *Starry Night* in his studio, from where he had a restricted view of the walled garden. Van Gogh was thus thrown on his own resources.

Starry Night is essentially an imaginary image, produced by amalgamating elements from two of the recently completed landscapes that happened to be in the artist's studio: the cypresses come from one, the outline of the Alpilles from another. The slender spire of the church was nowhere to be found in the actual village of Saint-Rémy. Rather it stood as a reminder of van Gogh's native northern landscapes of which he spoke nostalgically at this time in letters. This active use of memory, a method used by the Symbolists and recommended to van Gogh by Gauguin, makes *Starry Night* a synthesis of present and past experience. Indeed, van Gogh felt certain that the painting must correspond in feeling to the recent work of his friends Gauguin and Bernard.

Van Gogh was enthralled by the patterns and rich coloring of the cypresses that grew around the grounds of the Saint-Rémy asylum. Traditionally planted in cemeteries, their symbolic association with death does not seem to have prevented van Gogh from infusing them with a linear and decorative life force that was appropriately compared, by the critic Albert Aurier, with upwardly shooting flames. Van Gogh allows that restless linear force to sweep through the sky, tracing dramatic spirals and swirls around the stars and moon which stand as symbols of eternity.

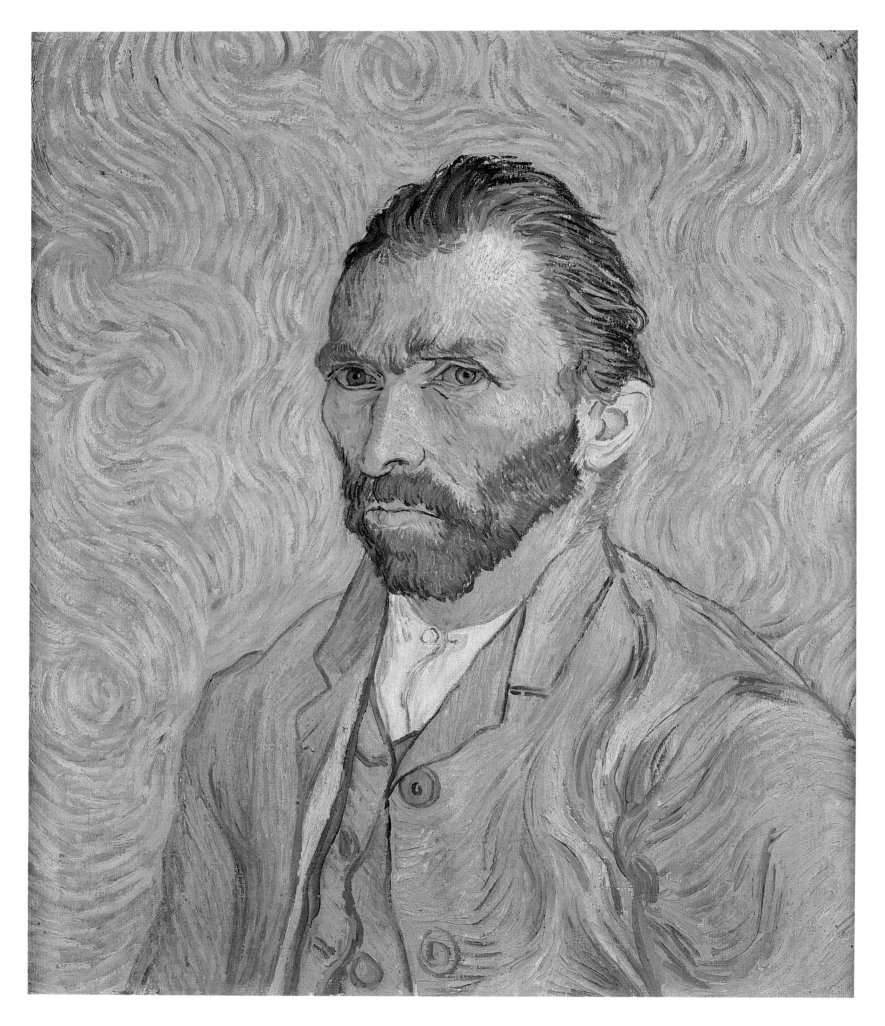

Self-Portrait, 1889
Oil on canvas
26×18 inches (66×46 cm)
Paris, Musée d'Orsay

Van Gogh painted some thirty-seven self-portraits during his brief career; a similarly large number was painted by his contemporary Gauguin. In both cases, the shortage of models was often the main spur to the artist's turning to his own features. However, whereas Gauguin used the genre self-consciously, to play up a variety of different roles or disguises, tackling each in an entirely different way, for van Gogh the practice involved intense psychological self-examination, almost a laying bare of the soul, and carried associations with the self-portraiture of Rembrandt.

Van Gogh's self-portraits tend to repeat a simple compositional formula. He places

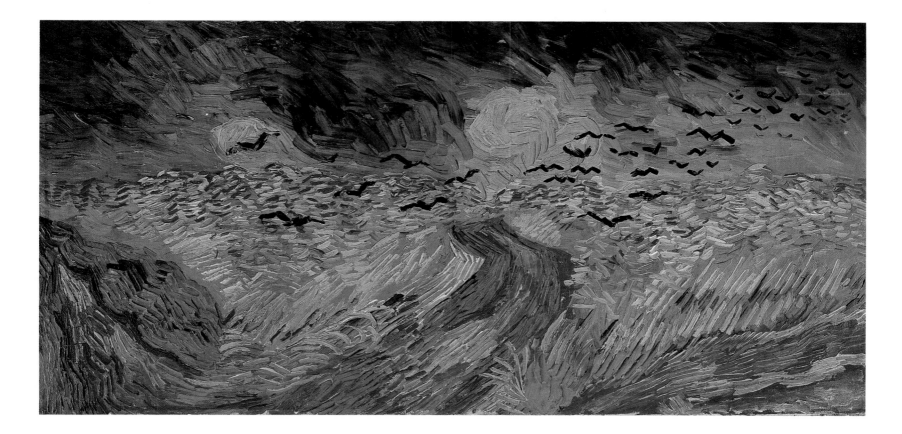

himself centrally within the canvas, shows only his head and shoulders, sets himself at a slight angle to the picture plane, usually with his right, painting arm farthest away. Preoccupied as he was during his last years by the vicissitudes of his health, both mental and physical, the successive self-portraits, particularly those produced in the hospital at Saint-Rémy, served him and those who cared for him as bulletins of his current state of mind as well as records of his physical appearance.

When he sent this self-portrait to Theo in September 1889, he explained that it was the second of two images of himself painted simultaneously.

I am sending you my own portrait today, you must look at it for some time; you will see, I hope, that my face is much calmer, though it seems to me that my look is vaguer than before. I have another one which is an attempt made when I was ill, but I think this will please you more, and I have tried to make it simple.

The image is certainly simple in coloring. Not long before, van Gogh had stated his intention of painting in gray tones again, as he had done early in his career; apart from the reddy brown of his hair, eyebrows, and beard, he confines his palette to a cool bluey gray, which he uses both for his suit and for the background, modulating through the full tonal range to white in the shirt and highlights of the face. To enliven what might have seemed an unduly sober color scheme, he makes emphatic use of brushmarks, emphasizing the folds of the jacket and repeating a swirling linear pattern in the background, so producing a decorative texture similar to that used in the cypresses and sky of *Starry Night*.

Crows in the Wheatfield, 1890

Oil on canvas
20×40 inches (51×102 cm)
Amsterdam, Rijksmuseum Vincent van Gogh

Crows in the Wheatfield was painted during the summer of 1890, when van Gogh had returned north to Auvers, a picturesque town long associated with artists, notably Daubigny, Pissarro, and Cézanne, whose *House of the Hanged Man* was painted here. After a spell at an inn, van Gogh was given lodging by Dr Gachet, an amateur artist and friend of Pissarro. Gachet had undertaken to supervise van Gogh's day-to-day living and to give him the space and calm atmosphere in which he could get on with his work.

Its dramatic composition, highly simplified bold colors, and almost violent rhythmic brushwork combine to make *Crows in the Wheatfield* one of van Gogh's most memorable landscapes. An unusual feature is its horizontal format, a double square, exactly twice as wide as it is tall. Hitherto consistent and unadventurous in his choice of canvas sizes, van Gogh's decision to embark on a series of tall or horizontal canvases in the summer of 1890 seems to have been prompted by seeing a display of Japanese prints during a brief stay in Paris on his way to Auvers.

Although produced just before the artist's suicide, there is no evidence to show that this was van Gogh's last painting. Scholarly opinion is divided as to whether the painting should be read as an image of despair or of hope; although the wheatfield is seen here under a stormy, lowering sky, for some commentators the three paths leading into the wheat suggest the Christian trinity. The birds are alternatively seen as flying away, in an uplifting trajectory, or as flying toward the spectator in a threatening manner. Van Gogh's own remarks about the effect of these wide open plains and fields of wheat on his state of mind appear contradictory and have contributed to the confusions surrounding the painting's interpretation. Describing this and another similarly horizontal landscape, *Wheatfield under Cloudy Sky* (Rijksmuseum Vincent van Gogh, Amsterdam), he wrote to his brother, 'I did not need to go out of my way to try to express sadness and extreme loneliness. I hope you will see them soon . . . I almost think that these canvases will tell you what I cannot say in words, the health and restorative forces that I see in the country.'

Armand Guillaumin

F r e n c h 1 8 4 1 - 1 9 2 7

Les Quais de Bercy, 1881

Oil on canvas
22×28 inches (55×71 cm)
Geneva, Musée du Petit Palais

In contrast to his Impressionist colleagues who, in the 1870s, made such a study of the western suburbs of Argenteuil and Chatou where Parisians could be seen enjoying their leisure on the river, Guillaumin's paintings explored the working riverbanks of the eastern suburbs, hitherto neglected aspects of the city, whose beauty and significance would be more fully acknowledged by writers and painters in the 1880s.

In *Les Quais de Bercy*, Guillaumin adopts the broad panoramic viewpoint traditional in topographical paintings and keeps his figures small in scale. Nothing interrupts the immediate foreground, but in the middle distance we see the piles of sand, the hauliers' carthorses, the barges, jetties, and pontoons. Incongruously, against this workaday setting, he sets the distinctive profile of a fashionable Parisienne of the 1880s, with her bustle and parasol. The strong blue of the water contrasts with the pinkish tone of the unmade-up bank, and a few touches of brighter color draw attention to the motley collection of buildings to the right of the panorama, so different from the ordered and elegant façades of central Paris.

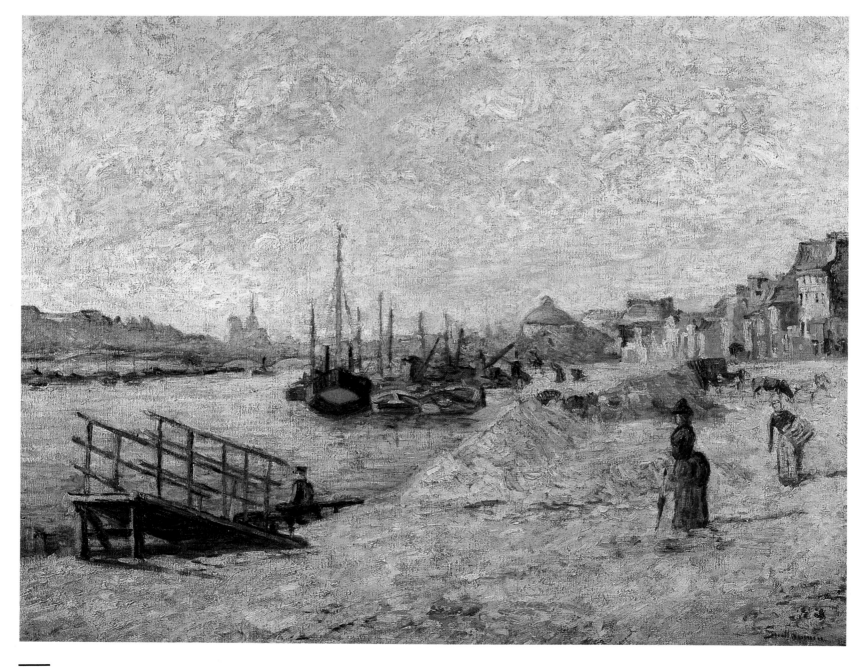

Johann Barthold Jongkind

D u t c h 1 8 1 9 - 9 1

Entrance of the Port of Honfleur (Windy Day), 1864

Oil on canvas
17×22 inches (42×56 cm)
Chicago, Art Institute

Of an older generation than the Impressionists, the Dutchman Jongkind was acknowledged by many of them to have been the main progenitor of the Impressionist landscape school. When he pro-

duced this characteristic seascape in the small but busy seaport of Honfleur, Jongkind was recognized as offering an important new direction in natural landscape painting. His admirers included the critic Castagnary, who wrote, 'I find in him a true and rare sensibility, and in him everything finds refuge in the impression.'

For all the apparent freshness of his vision, it is important to recognize that Jongkind was not in the habit of painting out of doors in oils. *Entrance of the Port of*

Honfleur, as a finished exhibition canvas, would have been executed in the studio. Despite Jongkind's considerable commercial success, his work remained on the edge of official acceptability. In 1873, after several years of acceptances, his work was rejected and he resolved never to submit his work to the Salon again. It may have been his disenchantment with exhibitions that prevented Jongkind from joining forces with the Impressionists in 1874, despite his support for their endeavors.

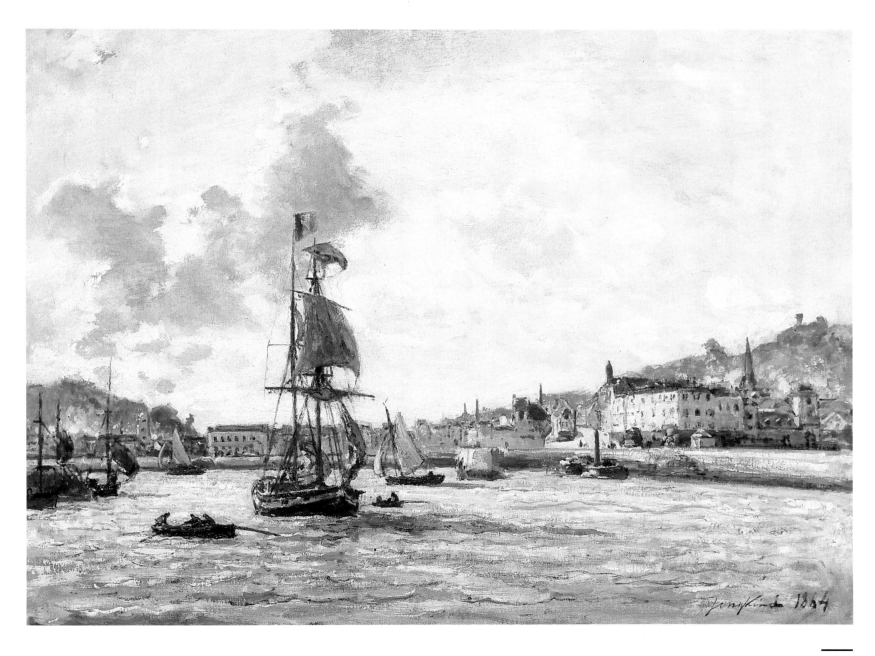

Édouard Manet

F r e n c h 1 8 3 2 - 1 8 8 3

Music in the Tuileries Gardens,

1862
Oil on canvas
30×46 inches (76×117 cm)
London, National Gallery

The influence of Manet's friend, the poet-critic Charles Baudelaire, permeates this painting – for almost twenty years Baudelaire had been calling for a painter capable of capturing the particular qualities of contemporary life.

His first Salon review of 1845 concludes with this now famous plea:

To the wind that blows no one pays any attention; and yet the heroism of modern life surrounds us and presses upon us. . . The painter, the true painter for whom we are looking, will be he who can snatch its epic quality from the life of today and can make us see and understand, with brush or with pencil, how great and poetic we are in our cravats and patent-leather boots.

One year later in his Salon review he renewed the call:

Our principal and essential problem is to discover whether we possess a specific beauty intrinsic to our new emotions. I observe that the majority of artists who have attacked modern life have contented themselves with public and official subjects – with our victories and our political heroism. . . The life of our city is rich in poetic and marvelous subjects. We are enveloped and steeped in an atmosphere of the marvelous; but we do not notice it.

In this painting, Manet has chosen a quintessentially modern subject, the gathering together of the cream of Parisian intellectual and artistic society under the trees of the Tuileries Gardens. Dressed in the height of contemporary fashion, they wait in relaxed and casual attitudes for the military band to begin playing.

Manet has depicted himself on the extreme left of the painting surrounded by his friends, among them Baudelaire and the critic, poet, and man of letters, Théophile Gautier. Also present are Manet's brother Eugène (center, leaning, in a black top hat), who also features in *Le Déjeuner sur l'herbe*, the Realist critic Champfleury, and the artist Fantin-Latour. Glimpsed to the center-right is the bespectacled composer Jacques Offenbach (center, seated behind Eugène), the doyen of the music world of the Second Empire and subsequent composer of the operettas *La Belle Hélène* (1864) and *La Vie Parisienne* (1867).

The painting is a concerted and conscious attempt to capture the specific quality of modern life in a deliberately modern way. Artists had painted cityscapes before, but none had ever caught the fragmentary and transitory nature of urban living. These are not the aristocrats of old, but the *haute-bourgeoisie*, the rulers of the modern world. In representing them, Manet has ignored traditional methods of composition, perspective, drawing, and coloration; instead, sharply focused details are placed next to ones that are only summarily indicated. Manet's brother Eugène, for example, makes conversation with something that is little more than a gray patch of paint. Manet causes the eye of the spectator to leap from person to person, from detail to detail, constantly refocusing as would be the case in real life. By his choice of subject matter and in his treatment of it, Manet has created an analogy for the visual experience of standing before the bandstand scanning the assembled crowd. The painting demands active participation from the viewer, a process that encourages the development of a sense of actuality that is the keynote not only of Manet's work, but also that of the Impressionists as a whole.

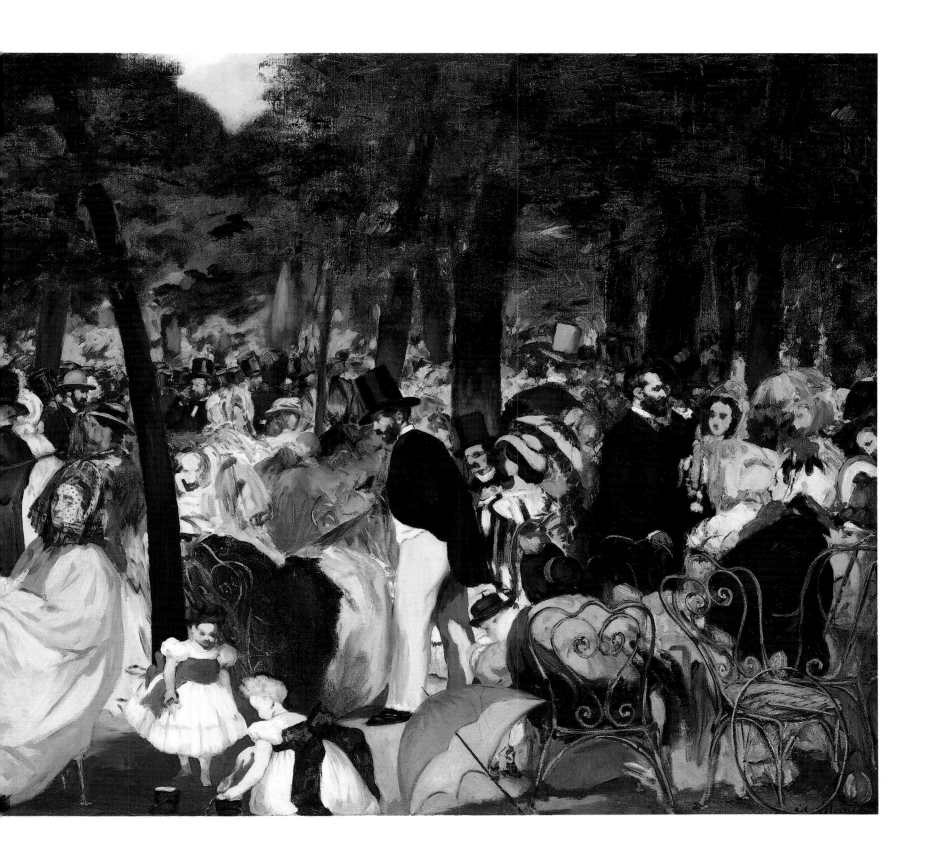

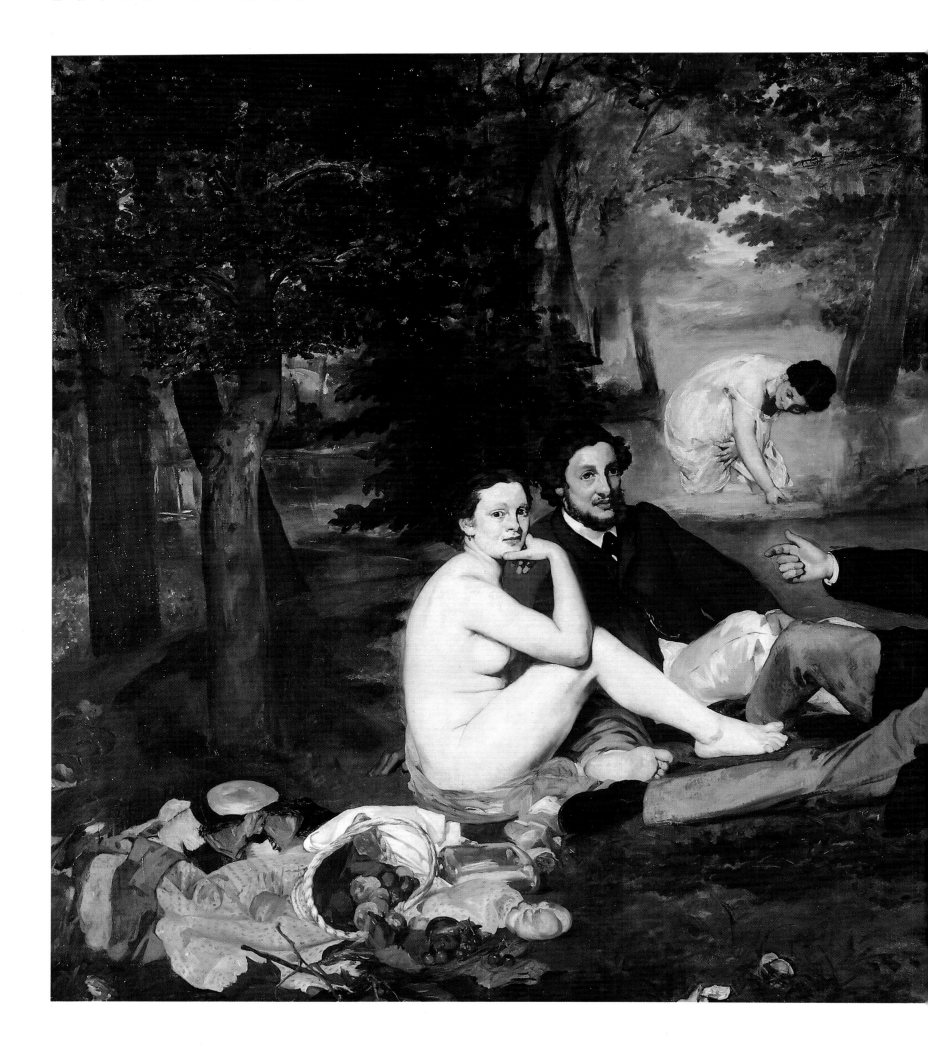

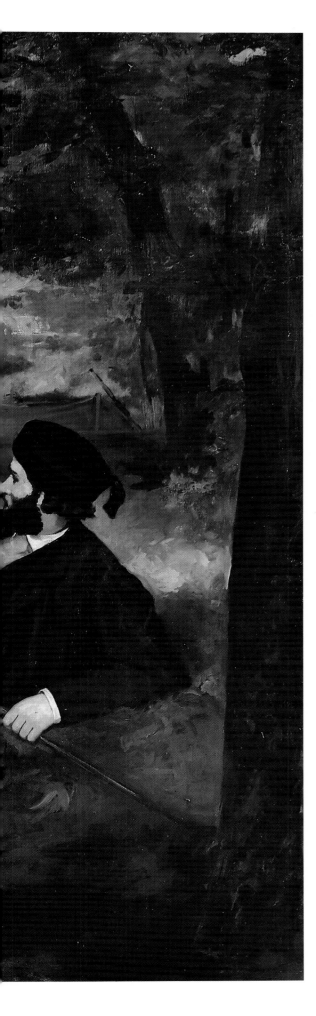

Le Déjeuner sur l'herbe, 1862

Oil on canvas
82×104 inches (208×264 cm)
Paris, Musée d'Orsay

Manet's *Le Déjeuner sur l'herbe* is one of the most familiar and enigmatic images of the nineteenth century. It was among the 4000 pictures that had been rejected from the 1863 Salon and became the main focus of criticism when it was exhibited at the Salon des Refusés held in halls adjacent to the official venue. This exhibition, instigated by the Emperor Napoleon III, was meant to give the public the opportunity to decide the merits or deficiencies of the judgment of the jury. Painters such as Manet, Cézanne, and Whistler hoped for a vindication of their efforts and a popular condemnation of the jury's prejudice – unfortunately, primed by the press, the public came not to judge, but to laugh.

Something of the difficulty the critics and public encountered in trying to understand Manet's painting, which received the brunt of the attacks in the press, may be illustrated by an extract from a review by Louis Etienne:

A commonplace woman of the *demi-monde,* as naked as can be, shamelessly lolls between two dandies dressed to the teeth. These latter have the air of schoolboys on vacation, perpetrating some outrage to play the man, and I search in vain for the meaning of this puzzle. . . This is a young man's practical joke. . .

It was not a joke, but a seriously considered comment upon the problems of creating an art for his own time. Only one critic recognized the reference to Raphael within the painting, which is central to an understanding of it. Its original title was *Le Bain,* and the naked woman looking out of the canvas was the artist's favorite model of the period, Victorine Meurent; she is seated opposite Manet's brother Eugène, who was later to become the husband of Berthe Morisot. These figures strike up poses mirroring exactly those in an engraving after Raphael by Marcantonio Raymondi. The borrowing is so complete that Eugène Manet, portrayed here as the figure holding a cane, is a modern substitute for the naked river god holding a palm leaf. Manet's friend Antoine Proust recalled in his account of the artist's life that the inspiration for the painting came from Manet's own experience. In 1862, Manet had observed two women bathing in the Seine at Argenteuil and, already having copied Giorgione's celebrated painting *Fête champêtre* in his student days, he now wished to do it again in a 'transparent atmosphere,' populated by figures from the present age. Manet has followed his idea precisely, removing the image from a timeless arcadian setting and, instead, situating it in the prosaic setting of a leafy glade by a river. Two male figures in contemporary dress are in the company of two women. One of the women is naked and turns away from the company to look out at the viewer; the other, dressed in some kind of chemise, is apparently in the process of washing herself in the water of the river close to the boat which transported them to their picnic site.

It is a peculiar and unforgettable painting. Art historians and critics have pondered it endlessly and painters have continued to develop Manet's ideas by producing their own reworkings of the subject. Picasso, in particular, was obsessed by it and, in the latter part of his career, produced many highly personalized versions of the painting.

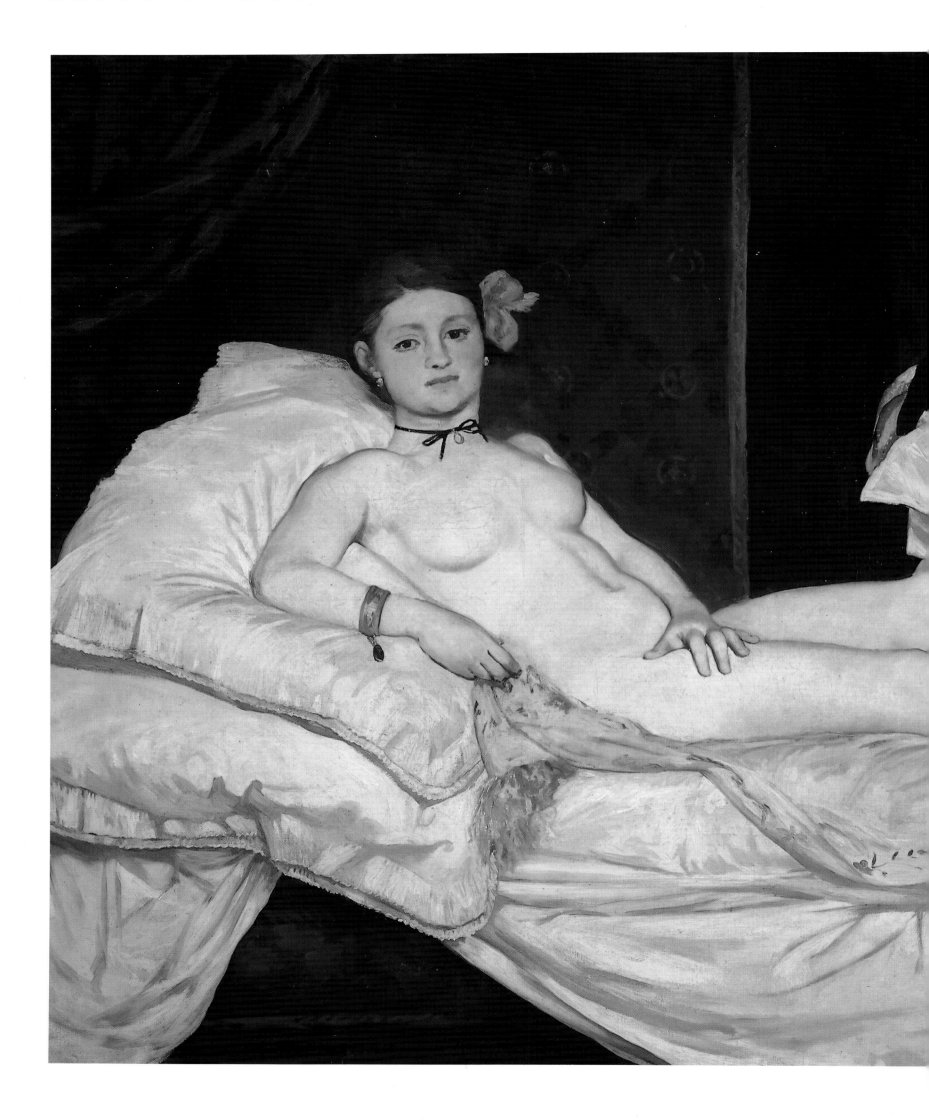

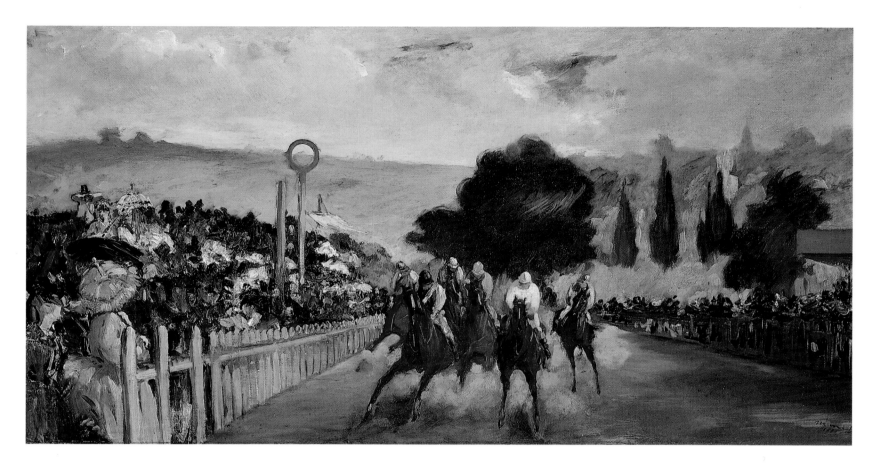

Race Track near Paris (Courses à Longchamp), *c.* 1867

Oil on canvas
17×32 inches (43×81 cm)
Chicago, Art Institute

Although horseracing had long been popular in England, it only became a really fashionable activity in France during the Second Empire. The racecourse at Longchamp was opened in 1857 and was situated in the Bois de Boulogne, to the west of Paris, looking out toward the hills of Saint-Cloud. The spectacle attracted people from every walk of life and soon became a center of social activity. It was a perfect place for an artist or writer to study the varied aspects of Parisian life.

The painting is a fragment of *la vie moderne*, an interpretation of a new social phenomenon; Manet had worked on a larger canvas of the same subject, which is now lost, from as early as 1864, but in this painting he would appear to have repeated the right-hand side of that composition, known today by a watercolor in the Fogg Art Museum. In the painting reproduced here, Manet has concentrated on attaining the effects of immediacy and movement.

In 1821 Théodore Géricault had painted *The Horserace at Epsom*, and, influenced by the English sporting prints, he depicted the horses galloping across the picture, each one with all four legs off the ground in an attempt to suggest the speed of the horse. Manet was aware of this convention and has adopted the same means of expression, but has used the dust raised by the horses' hooves to mask any resulting awkwardness. In a letter to Berthe Morisot he confessed, 'Not being in the habit of painting horses, I copied mine from those who know best how to do them.' But instead of the usual lateral view, found in the English sporting prints, Manet has pictured the horses and their riders thundering toward the viewer, giving the impression that the horsemen are about to spill out of the canvas into the viewer's own space. It was not until after 1878 when Eadweard Muybridge came to Paris to show his sequential photographs of horses in movement that artists began to question the accepted conventions of depicting horses in movement.

Following his usual practice, Manet made sketches from real life, but painted the final work in the studio. The tense atmosphere of the event is perfectly caught; the apparent speed with which the bold areas of color are thrown onto the canvas and the impressionistic indication of forms perfectly capture the tense atmosphere of the races. The spectators are pushed to either side of the canvas; a solitary figure holding a pair of binoculars stands above the forest of open parasols watching the jockeys as they hurtle from the center of the canvas to pass the finishing post in a single pack beneath the brilliant mauve of the sky.

Portrait of Émile Zola, 1868

Oil on canvas
57×57 inches (145×145 cm)
Paris, Musée d'Orsay

The portrait of Émile Zola was conceived as an act of thanks from a beleaguered artist to a supportive critic. Zola had written a review of the Salon of 1866 defending Manet in the face of much hostile criticism. The reaction of the outraged readers was so intense that Zola was forced to stop writing art criticism for the journal.

On 1 January of the next year, Zola published a booklet for Manet's one-man show at the Place d'Alma. When Zola posed for his portrait in February 1868, the little catalogue was given pride of place on his desk, serving as a background for Manet's signature and to show clearly Manet's debt to the writer.

As well as being a striking likeness of the writer, it is also an emblematic collection of Manet's various artistic interests. Contained in the frame to the top right of the picture is a collection of images pertinent to Manet's painterly concerns: a photograph of his *Olympia* who does not look implacably out at the spectator as in the original, but instead gives a sidelong glance to her protector. Partially obscured by *Olympia* is Goya's etching after *Los Barrachos* by Velázquez, and on the left of the frame is placed a contemporary Japanese print of a sumo wrestler. The composition is reminiscent of Dutch seventeenth-century painting which, at the time, was being reevaluated by the realist circle as a possible model which could be used for depictions of contemporary life.

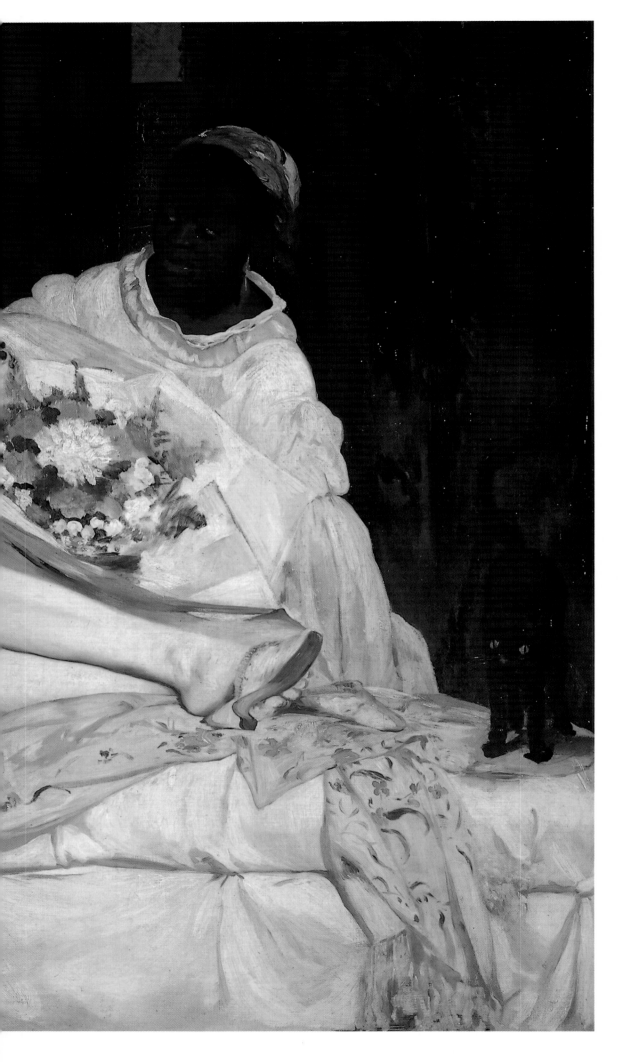

Olympia, 1863

Oil on canvas
51×75 inches (130×190 cm)
Paris, Musée d'Orsay

Olympia was painted in the same year as *Le Déjeuner sur l'herbe* and features the same model, Victorine Meurent. Perhaps Manet sensed that it was too radical an image to present with *Déjeuner*, and he kept it in his studio until 1865, when it was shown at the Salon of that year. The critical reaction equaled in hostility and banality that which had greeted his work in 1863.

Manet's painting conformed neither in style nor subject matter to the accepted norms of Salon nudes. The year 1865 was a boom one for the subject, and Cabanel's painting *The Birth of Venus* was bought by the Emperor for the sum of 40,000 francs, and the already much honored artist received a *grande médaille d'honneur*.

What was wrong with *Olympia*? To begin with, she was naked, not nude, and could not be interpreted in a hypocritically dispassionate way as a piece of 'High Art,' like the Cabanel; instead, she demands by her persistent stare to be properly accounted for. Once the viewer is engaged by this stare, he (for we must, as artists would have done at that time, presume a male audience) becomes part of the painting's meaning. And in this case, he becomes the client of this ordinary prostitute. It is he who has just walked into this woman's boudoir, frightening the black cat at the bottom of the bed, and it is he who has brought these flowers, presented to Olympia by her black maid and received without a trace of acknowledgment. Unlike Cabanel's Venus, who obeys all the conventions of the pinup, Manet's *Olympia* places the viewer in a very uncomfortable position, refusing to adopt a seductive pose. This is a commercial transaction and not a romantic encounter. It is a repetition of the ploy that we have previously met in *Déjeuner*. The painting is based upon one of the most famous nudes in the history of art, Titian's *Venus of Urbino*, but Manet has translated an image of fecundity.

With *Le Déjeuner sur l'herbe* and *Olympia*, the two daring subversions of traditional art practice, Manet once more made the age-old theme of the nude a matter of contemporary significance and prepared the way for future artists to continue his attempts to find a manner of painting suitable to the modern age and compatible with the great works of the past.

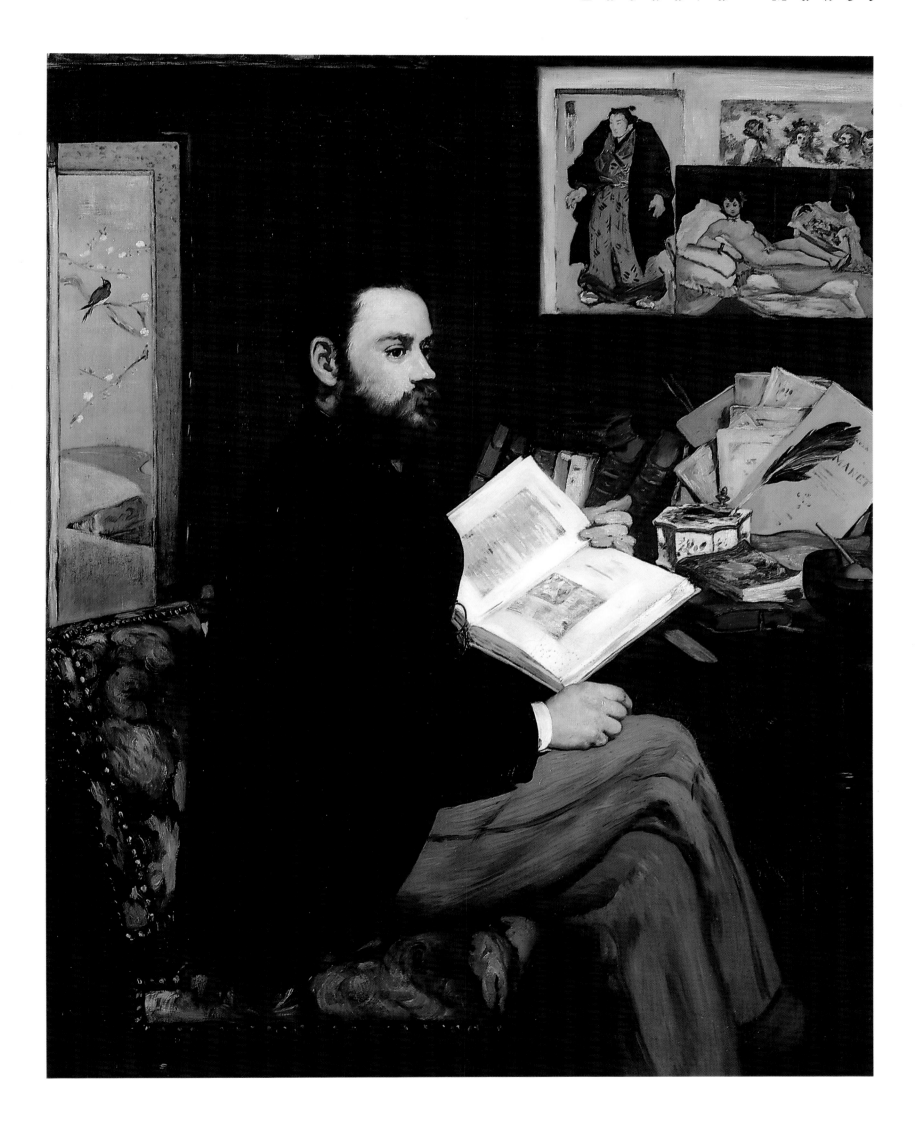

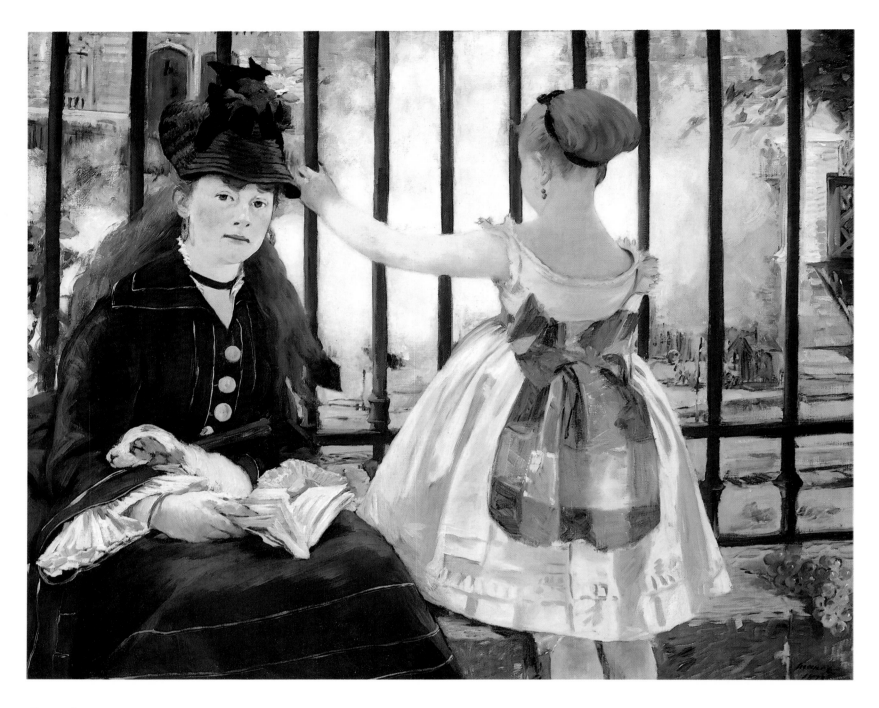

Gare Saint-Lazare, 1873

Oil on canvas
36¾×45 inches (93×114 cm)
Washington D.C., National Gallery of Art

The critic Philippe Burty wrote in the autumn of 1872 that Manet '. . . has not quite finished a double portrait that he sketched out in the open sunlight. A young woman dressed in the blue that has been in fashion up until autumn. Movement, the sun, the reflections, everything gives the impression of nature, but nature seized by a delicate sensibility and translated by one of refined taste.'

Manet was the first of his circle to depict the Gare Saint-Lazare, and he did so in a characteristically oblique fashion. At first sight, it appears to be a study of two figures rather than a painting of the station of Saint-Lazare. Manet has not depicted the mighty representatives of the steam age but instead has contrasted the soft ephemerality of the steam rushing from an obscured locomotive with the uncompromising geometric rigidity of the cast-iron railings.

The figure in blue who looks up from her book at the viewer is Victorine Meurent who, ten years previously, had modeled for *Olympia*, and the little girl is the daughter of the artist Adolphe Hirsch, from whose garden the scene was painted. This was the largest painting to date on which Manet had worked either wholly or in part *en plein air*. The painting was accepted at the Salon of 1873, but its unusual image and composition made it an easy target for contemporary caricaturists. Their remarks are not memorable for their subtlety: 'Two incurable madwomen suffering from monomania watch the trains pass from between the bars of their cell.'

Victorine, still faithful to her black choker, recalls with her steady gaze the figure of *Olympia*. The little dog asleep on her lap suggests the cat from the painting of 1863, and is perhaps a reference to the sleeping dog in Titian's *Venus of Urbino*, the original model for *Olympia*. The crude repetitive geometry of the grill behind the main figures stresses the flatness of the composition, and makes a startling con-

trast with the soft human shapes in their summer dresses. The painting is cool, ironical, and detached. The specific identities of these people are unimportant – as in real life, we have made a momentary contact, exchanged disinterested looks, and walked on. The woman will return to her book; but we will never forget her upturned face.

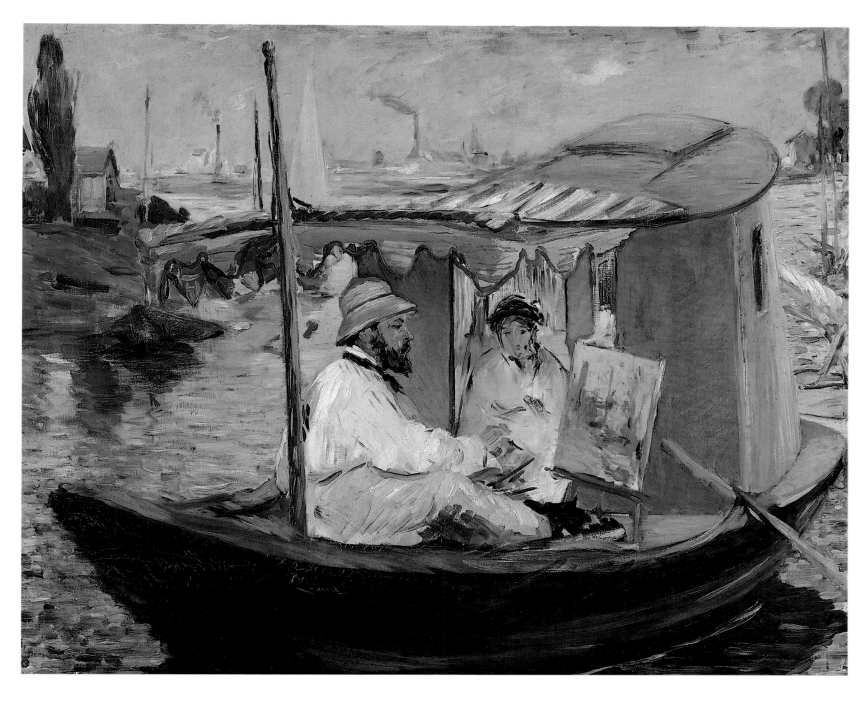

The Barque (Claude Monet in his Floating Studio), 1874

Oil on canvas
33×40 inches (83×101 cm)
Munich, Neue Pinakothek

Influenced by his Impressionist friends, Manet began to paint out of doors in the 1870s. He painted this picture while he was working with Monet and Renoir in 1874. Instead of using what Degas called his 'wonderful prune-juice,' that is, his dark, Velázquez-inspired manner of free and lyrical use of the brush, dramatic contrasts of clearly defined shapes, and rejection of halftones, Manet has been seduced here into using the lighter palette and staccato brushwork of his friends.

Monet is shown with his wife Camille seated in his floating studio painting the riverside landscape beyond the canvas edge. It was probably the Barbizon painter Daubigny who introduced Monet to the idea of using a floating studio; Daubigny called his boat *le Botin* and, following its launch in 1857, he explored and painted the rivers Seine, Marne, and Oise. Manet's painting, as well as being an image of husband and wife, records the view downriver to the south and west complete with the factory chimneys punctuating the horizon. Monet later looked back with obvious affection on those:

. . . wonderful hours I spent with Manet on that little boat! He did my portrait there. I did his wife's and his. Those wonderful moments with their illusions, their enthusiasm, their fervor, ought never to end.

The double portrait of husband and wife is wittily conceived. Monet is seen in profile concentrating upon his painting; while, framed by the cabin doorway, Camille looks out in a rather bored manner at the viewer. The image is laid down rapidly with a free, sweeping series of long gestural strokes, although the handling of the water in the lower left-hand corner is not too dissimilar to Monet's own. The rest of the painting is treated in a much more fluid manner; Manet never wholly abandoned the use of dark tones, and in this painting he has used them to secure the major axes of the composition. The subject may be as informal and intimate as a snapshot, and it makes a very marked contrast with Seurat's later painting *Bathers at Asnières*, but this casualness has been arrived at in a very deliberate manner. The mast of Monet's studio-boat finds echoes throughout the painting; the horizontals and verticals it sets off across the picture hold together what would otherwise have been a very loose and eccentric composition.

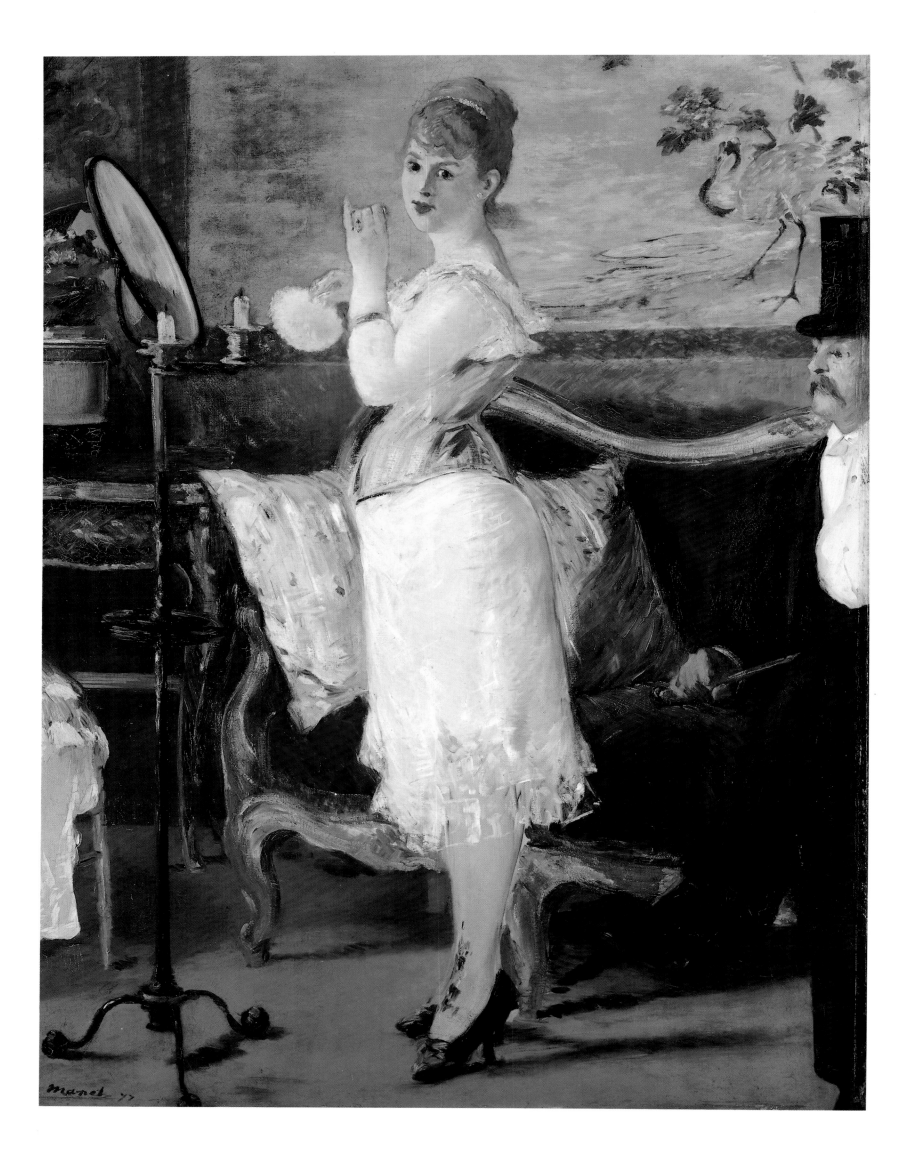

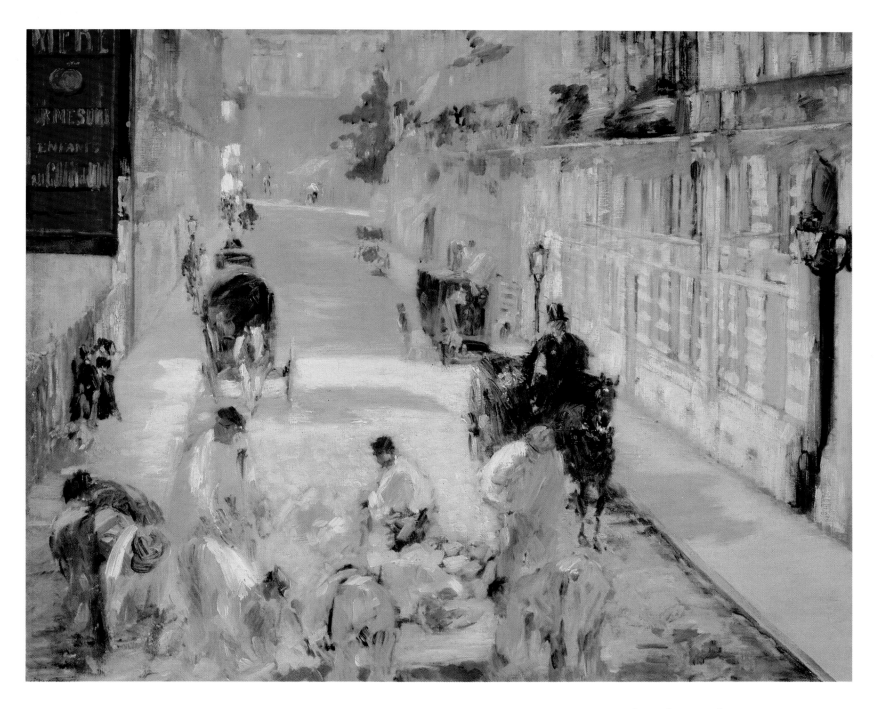

Nana, 1877

Oil on canvas
61×45 inches (155×114 cm)
Hamburg, Kunsthalle

The subject for Manet's painting was a character in Émile Zola's novels, *L'Assommoir* and *Nana*. The obvious connection between Manet's painting and Zola's work was commented upon by many contemporaries. The unseemly subject matter of the painting for contemporary viewers may well have been the reason for its rejection from the Salon of 1877.

The painting features a professional model, Henriette Hauser, a prominent member of the *demi-monde*, who, due to her association with the Prince of Orange, was better known by the nickname 'Citron.' Her profession links the picture with *Olympia* of twelve years earlier, although in this case no overt references to the art of the past are incorporated into the image. The Nana of the painting is not yet the all-consuming *femme fatale* of Zola's novel of the same name, but rather the fun-loving *cocotte* of *L'Assommoir*, a type featured in many of the caricatures of the time. Although rejected from the 1877 Salon, it was exhibited in the shop window of Giroux at 43, boulevard des Capucines, where it attracted much attention. Not until the later work of Forain, Degas, and Toulouse-Lautrec would such controversial scenes be treated in such a direct and uncompromising fashion.

The body of the courtesan is echoed curve-for-curve by the well-upholstered, gilt-edged sofa. Balancing the rhythms created by the furniture is laid a taut exchange of horizontals and verticals which cross at the looking-glass. This essential piece of boudoir equipment counterpoints the pert figure of Nana balancing on her high-heeled shoes. We return her covert glance and look with sympathy at the man in evening dress, his mind elsewhere, who seems unaware of our presence. The detail of the client, daringly cropped by the picture edge, was added at a later date and adds a more complex note to this simple painting.

Roadworks on the rue Mosnier, 1878

Oil on canvas
25¾×32¼ inches (65×82 cm)
Private collection

By 1878, Manet has assimilated many of the ideas of his younger friends, and in this painting is perhaps the closest he ever came to producing a *plein-air* painting in the Impressionist manner. As usual, however, the effect of spontaneity is the result of much forethought and the painting is probably a studio work. Manet has lightened his palette considerably and has introduced a range of brighter colors. His composition seems to emphasize the ordinariness of the street. There is no central incident, nor can the painting be read as a statement praising the heroic ennobling value of physical labor. Instead, it is merely a slice of modern life, caught in full sunlight, viewed from the detached standpoint of an apartment window.

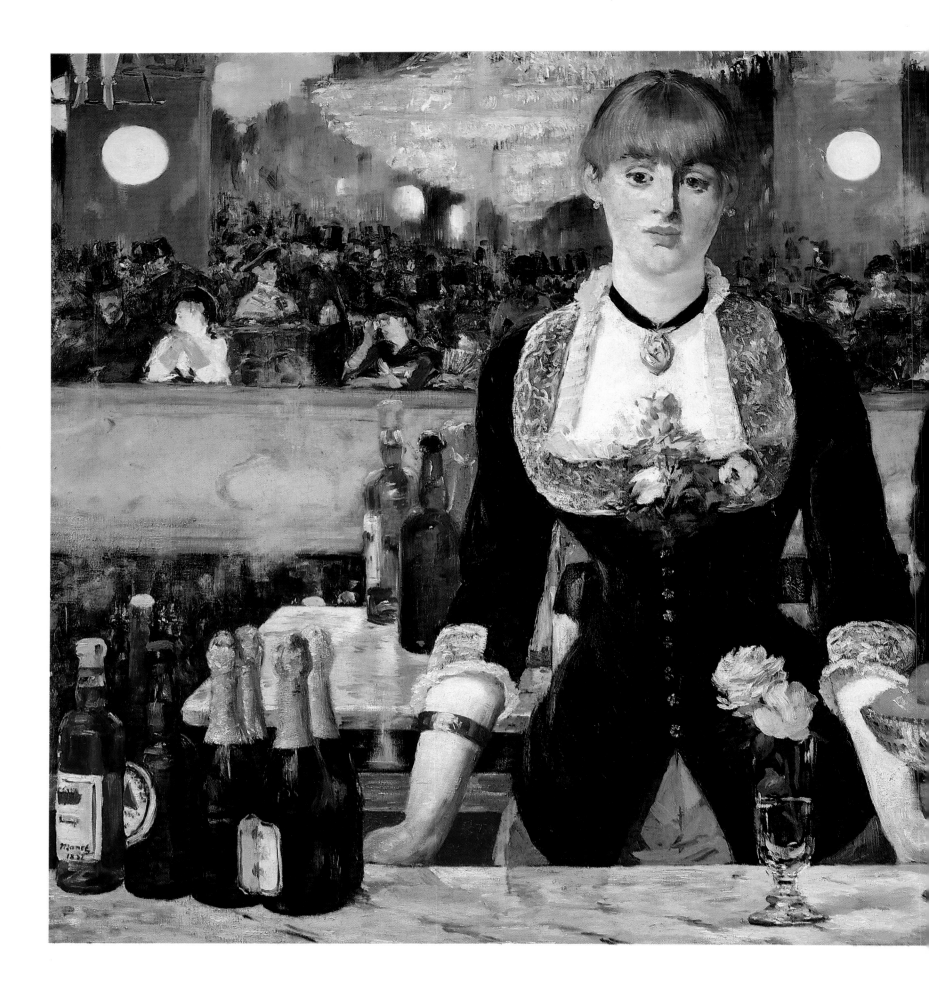

Bar at the Folies-Bergère, 1881-82

Oil on canvas
38×51 inches (97×130 cm)
London, Courtauld Institute Galleries

Manet's final masterpiece was probably conceived from the first as a last statement. Manet was gravely ill when he began it and may well have realized that he had little time to live. He died a year later, aged fifty-one. The painting may be seen as a drawing together of images and ideas that had concerned him throughout his working life. A deliberately ordinary manifestation of contemporary life inspired him to create a modern-day equivalent to the traditional academic paintings of the official Salon. Instead of a goddess set in an idealized landscape, he chose to depict an ordinary waitress at work in an urban place of vulgar entertainment. In place of a traditional, perspectively based composition that would situate his figures in an easily comprehensible and secure space, Manet's painting presents us with a catalogue of spatial ambiguities caused by his inclusion of a large mirror behind the waitress. Was Manet perhaps making an analogy between the reflective surface of the mirror and the idea of a painting as a reflection of society? The Folies-Bergère was no ordinary place of entertainment; in 1878, J-K Huysmans had written:

It is ugly and it is superb, it is of an outrageous yet exquisite taste: it is incomplete like something which could be really beautiful . . . This theater, with a playhouse whose faded red and dirty gold clashes with the spanking luxury of the sham garden, is the only place in Paris which reeks as exquisitely of the makeup of paid love and the bark of wearied corruptions.

Manet went to endless trouble in preparation for the painting; he had one of the several small bars around the side upper level of the Folies-Bergère reconstructed in his studio. His model stood on a platform behind the counter as she would have done in the bar itself.

Despite the painting's sense of vivid immediacy, it was, in fact, the product of lengthy consideration. Manet subjected the work to constant revision. X-rays of the work have shown that the reflection of the barmaid in the mirror was moved from its rational position to the extreme right of the picture. By making the relationships of the objects on the counter to their reflected counterparts deliberately eccentric, Manet has created a pictorial space as ambiguous as that which we inhabit. As in *Olympia*, *Le Déjeuner sur l'herbe*, and *Nana*, the viewer is directly accosted by the gaze of the central female figure in the painting. It is this rapport between the viewer and the painted barmaid that gives the painting much of its impact – the reflection to the figure soliciting the barmaid can only be read as a metaphor for the viewer, and as many of the women in her position supplemented their meager earnings by part-time prostitution, the relationship here portrayed between the man and woman is doubly ambiguous.

Manet has included his friends Méry Laurent, Jeanne Demarcey, and Gaston Latouche, glimpsed in the mirror reflection among the crowd on the opposite side of the balcony. The presence of a trapeze artist is established by the witty inclusion of a pair of lime-green-shod feet at the top left of the painting. The whole scene is bathed in the powerful radiance of bright light, which banishes the shadows from the heavily fringed face of the girl behind the bar. This alone would not make the painting the masterpiece it is. Manet has presented us with a particular study of one member of Parisian society, at a particular time and place, with such force that we feel the years that separate the painted image from the modern viewer fall away. The artist has caught the weariness, the boredom, and the depersonalization common to serving jobs of any description. The barmaid is resting her weight on the counter, relieving her feet from the burden they have supported for hours past. With the stillness and gravity of a latter-day Madonna, she looks out from behind her marble-topped counter, separated from the world and yet part of it. Our attention is divided between her superbly impassive face and the brilliantly painted corsage pinned on to the front of her black dress. We are completely convinced by her reality, yet when we look closer at the painting we realize that the flowers of her corsage are the product of a few cursive brushmarks on, and surrounded by, the bare canvas. In typical fashion, the master painter reveals and conceals his art at one and the same time.

Claude Monet

F r e n c h 1 8 4 0 - 1 9 2 6

The Bridge at Argenteuil, 1874

Oil on canvas
24×32 inches (60×80 cm)
Paris, Musée d'Orsay

Monet's painting of *The Bridge at Argenteuil* is one of the most magical of all Impressionist paintings. It is at once a completely convincing illusion of actuality and an extraordinarily richly textured weave of color laid on to a flat canvas. We are seduced into believing that we are looking through a window at the river beyond, only to realize, in the next instant, that this illusion has been created with daubs of pigment brushed onto a piece of linen stretched on four pieces of wood. Claude Monet returned to Paris with his family in the autumn of 1871, ending their self-imposed exile in England. In December of the same year they left Paris for Argenteuil, situated a little over 6 miles (10 km) away from the capital on the banks of the River Seine. He stayed there for six years and depicted the rapidly developing town and its environs no less than 170 times. The bridge, opened only eleven years before, was the perfect vehicle for Monet's ambitions to paint the modern landscape.

The bridge is presented with an almost prosaic directness, without a trace of the picturesque. In itself a sign of the encroachment of the city on the countryside, the bearer of noisy locomotives from Paris, it is featured here, fittingly, without a trace of ornament, a powerful symbol of the new materialist age. Monet has gloried in the very ordinariness of the scene. At first sight, the composition seems a matter-of-fact depiction of the iron and concrete structure of the bridge, the yachts moored in midstream set against the managed, suburbanized nature of Argenteuil.

But the interplay of horizontals and verticals gives the painting a geometric rigor rare in Monet's work. A relatively limited number of colors describes the scene, each one occurring several times through the painting to balance and to harmonize its composition. The yellow ocher of the sail-boats is used again in the building and foliage and then, in turn, is reflected in the water. This subtle structuring contains one of Monet's most dazzling displays of virtuoso painting. He captures the movement of the water, from the stillness of the stretch near the shore reflecting the fleecy clouds above to the middle distance where the current affects the surface, distorting the reflections of the bridge and foliage.

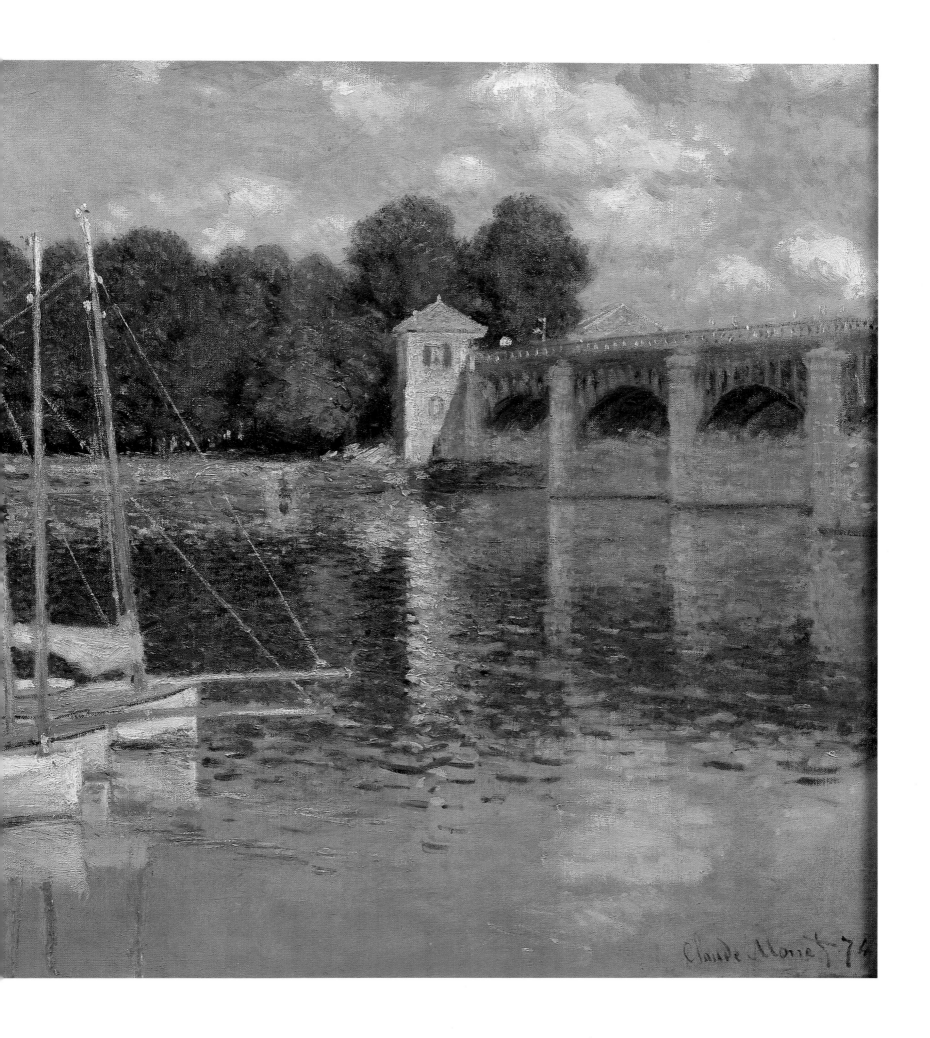

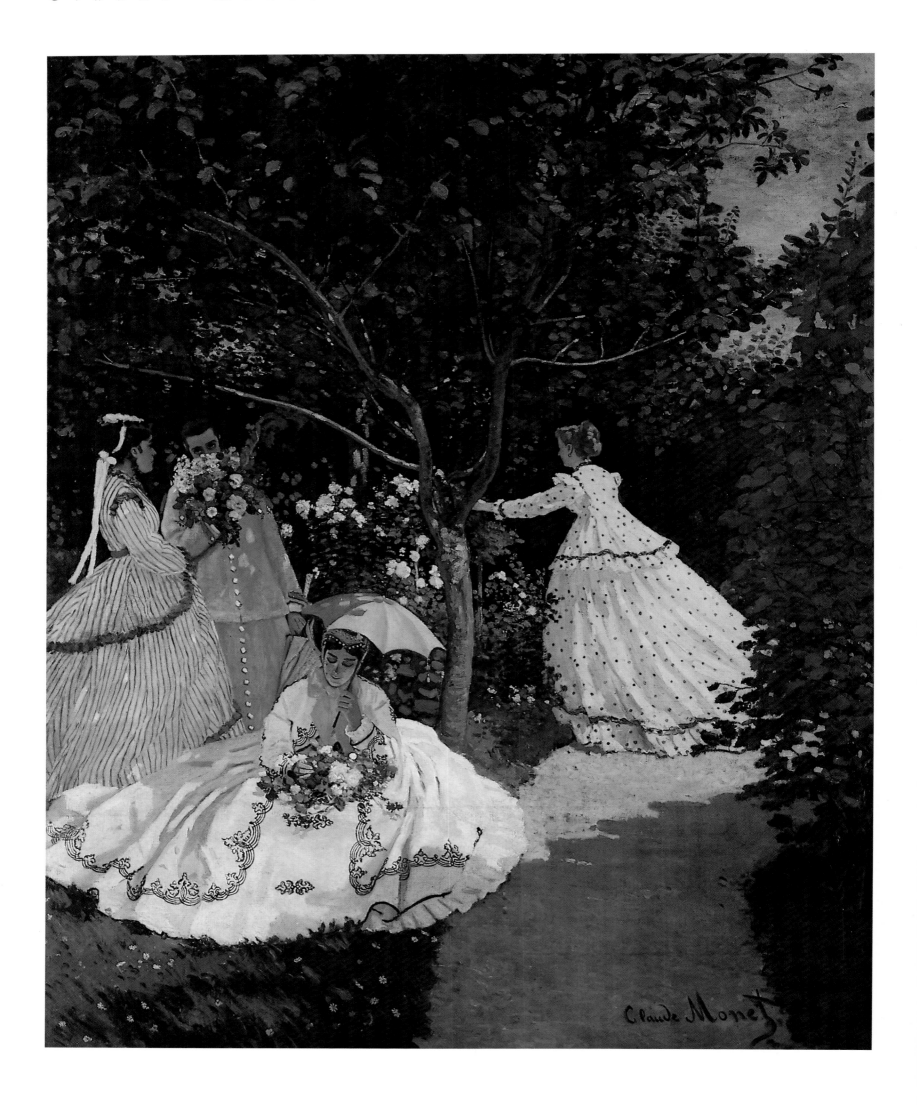

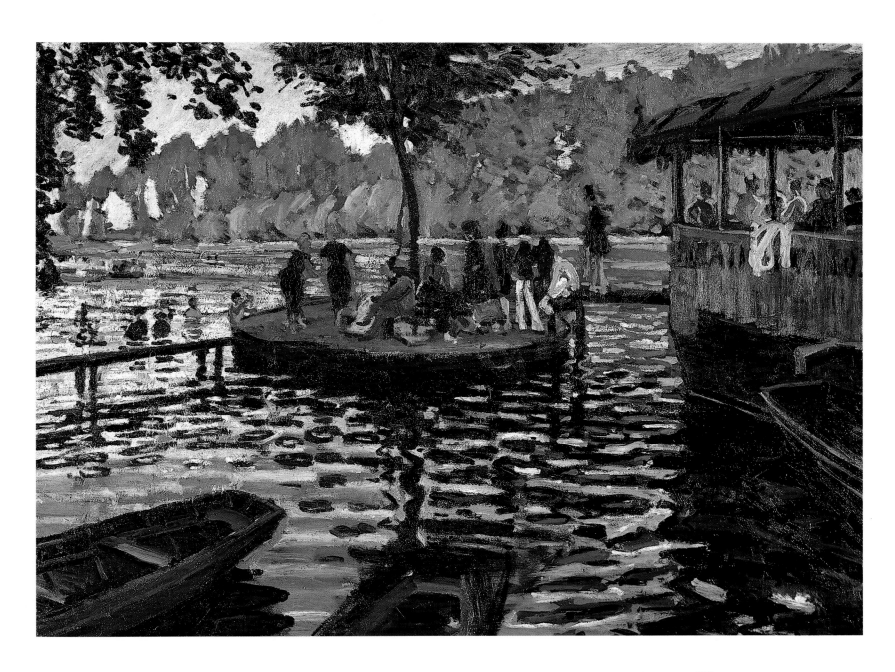

Women in the Garden, 1866-67

Oil on canvas,
100×81 inches (254×206 cm)
Paris, Musée d'Orsay

To avoid the complications involved in a large group-painting Monet has concentrated upon four separate figures (three of whom are based on his companion, later to be his wife Camille) posing in a garden of a house he had rented close to the station of Ville d'Avray. The size of the painting suggests the importance attached to it by the young and as-yet-unknown artist, who obviously wished to produce a work that would capture the attention of the critics and the public.

Instead of following the traditional practice of using sketches and studies made in the open air as the basis for a painting created in the studio, Monet decided to sketch in the entire work onto the canvas out of doors. The size of the painting presented the artist with a formidable set of problems. Not least of these was how to paint the picture from the model when the canvas itself was so large as to hinder all possibility of seeing her. Monet solved this

problem in part by digging a large trench into which the canvas was placed, thereby enabling him to work with relative ease on the otherwise inaccessible areas. Under the circumstances, it is astounding that the composition works as well as it does. The slight awkwardness in the relationship between the figures may be due either to Monet's use of fashion plates or photographs or, just as likely, to the inherent problems of using only two models for a multifigure composition.

The style of the painting is loose and free; the paint is applied in thick, opaque slabs of pigment corresponding to patches of color perceived by the painter. The motif once chosen, the composition determined, Monet ignores his subject matter; his only concern is light. The sunlight falls in a diagonal from the top right-hand corner of the painting down to the lower left-hand side. In doing so, it passes over the figure in the foreground. As she is protected by a fashionable parasol, the sunlight does not fall directly upon her, but is reflected upward from her outspread dress and the flowers she has placed on her lap. This causes her features to be seen in a highly original and individualistic manner.

La Grenouillère, 1869

Oil on canvas
29¼×39¼ inches (74×100 cm)
New York, Metropolitan Museum of Art

In this painting Monet constructs an image almost tangible in its sensation of atmospheric unity. The viewer is presented with a space that is recognizable, inhabited by people we can feel at ease with. Monet is less interested in the social habits of the people he is painting and more concerned to express the mood of this particularly sunny day in the most direct and spontaneous way possible. He has chosen a small canvas, partly for ease of carrying and partly so as to be able to complete the work in a short period of time while the light effects remain constant and his concentration and involvement are at their most intense. To note down rapidly the effects of the light on that particular afternoon, he has used short, choppy brushmarks of pure color, laid adjacent to one another, resulting in a mesh of light and atmosphere which, for Monet, was the true subject of the painting. The Salon rejected this sketch; Monet's way lay outside the official art world.

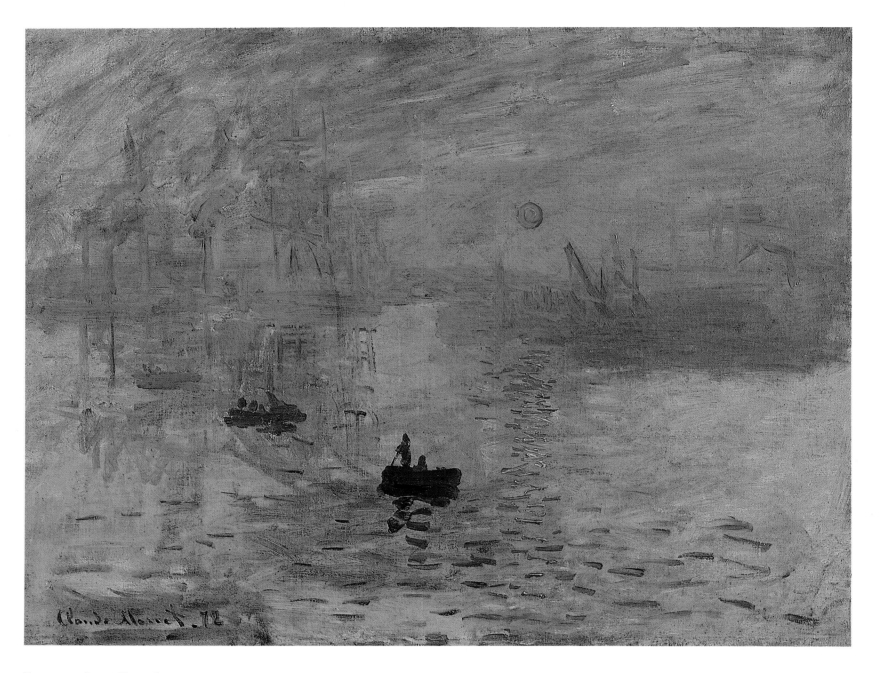

Impression, Sunrise, 1872

Oil on canvas
20×26 inches (51×66 cm)
Paris, Musée Marmottan

Late in life, Monet told the young painter Maurice Guillemot:

Landscape is nothing but an impression, and an instantaneous one, hence this label that was given us, by the way, because of me. I had sent a thing done in Le Havre, a view from a window, seen in the mist with a few masts sticking up in the foreground . . . They asked me for a title for the catalogue, it couldn't really be taken for a view of Le Havre, and I said, 'Put Impression.' From that came Impressionism, and the jokes blossomed.

This painting was almost certainly the one included in the famous exhibition at Nadar's photographic studios at 35, boulevard des Capucines, and the story that surrounds it is one of the most familiar in the history of art. Monet, Renoir, Bazille, and their friends exhibited their works from 15 April until 15 May 1874 under the title of *Société anonyme des artistes, peintres, sculpteurs, graveurs, etc.* The show was reviewed

by the critic of the *Charivari* on 25 April in an article entitled *L'Exposition des impressionistes*. His analysis of Monet's painting was deliberately derisive:

Impression, I was sure of it. I was just telling myself that since I was impressed, there had to be some impression in it . . . And what freedom, what sense of workmanship! Wallpaper in its embryonic state is more finished than that seascape.

The term caught the popular imagination although the Impressionists themselves were less than happy with it. The critic Castagnary gave a more perceptive account; since the 1850s he had been defending and promoting the realists and, therefore, was more sympathetic to their aims. 'They are *impressionists* in the sense that they paint not the landscape, but the sensation that the landscape produces.'

The painting itself features the former outer harbor, now the inner harbor, of the port of Le Havre, looking toward the southeast. Monet's friend and mentor Boudin painted the view many times. The sun, low in the sky, throws its brilliant reflection across the water, and the pervasive

mist causes the shipping to lose itself in ambiguous veils of color. In the middle of the harbor, smaller boats, only summarily sketched in, move across the open water. It is rare to find a work by Monet left in this rudimentary state and he may have been influenced by the American James McNeill Whistler, whose paintings of night scenes he may have seen exhibited at Durand-Ruel's gallery.

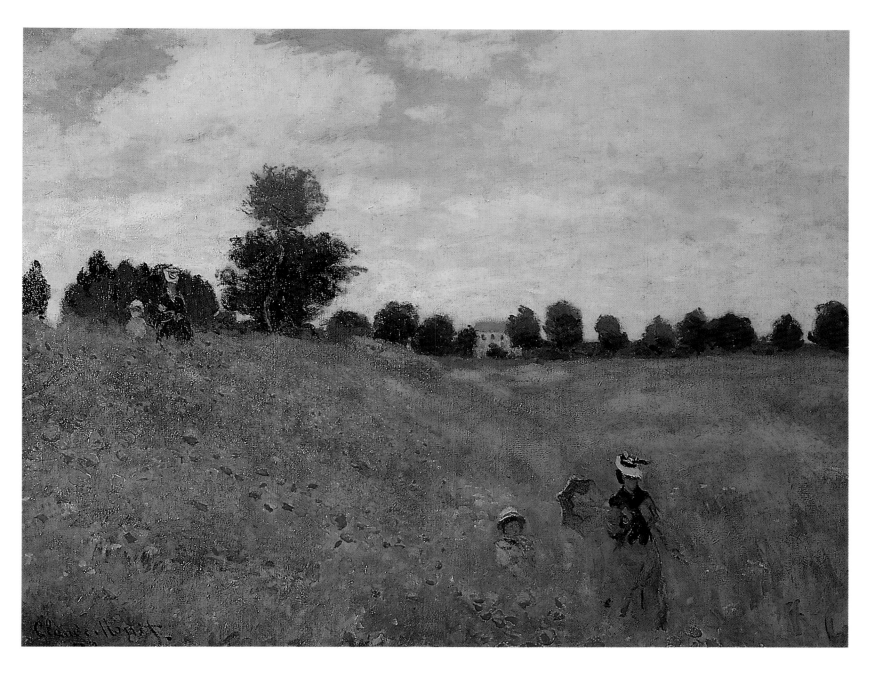

Wild Poppies, 1873

Oil on canvas
20×26 inches (51×66 cm)
Paris, Musée d'Orsay

Perhaps because of their use of family and friends as models, many of the Impressionist paintings have a wonderful air of intimacy about them, even when the figures within them are small or indistinct. This painting of a field ablaze with poppies is one of the most familiar of all Impressionist scenes. It was painted in the environs of Argenteuil and was probably shown at the First Impressionist exhibition. Monet's wife and son stand at the top of a small rise, silhouetted by the band of trees that stretches almost without break across the picture. The figures appear again at the lower right of the painting, having left behind them traces of their journey down the embankment in the tall, poppy-strewn grass. Their clothes and their deportment suggest that they are not residents of the countryside but only visitors come to idle away a sunny afternoon. This is not a grand landscape from Greek myth, nor even an evocation of some long-lost arcadia.

Instead of a ruined antique monument punctuating a classically inspired Italianate setting, Monet introduces a simple, anonymous red-roofed house. The inhabitants of this unpretentious corner of the French countryside are not nobility or Italian peasants but ordinary people, happy to be free, if only for a moment, from the pressures of city life.

The vibrant contrast between the blood red of the poppies and the verdant green of the meadow makes the painting spring to life. The loose, almost casual, sketchiness with which the picture is painted suggests an informality that is most attractive to the modern viewer.

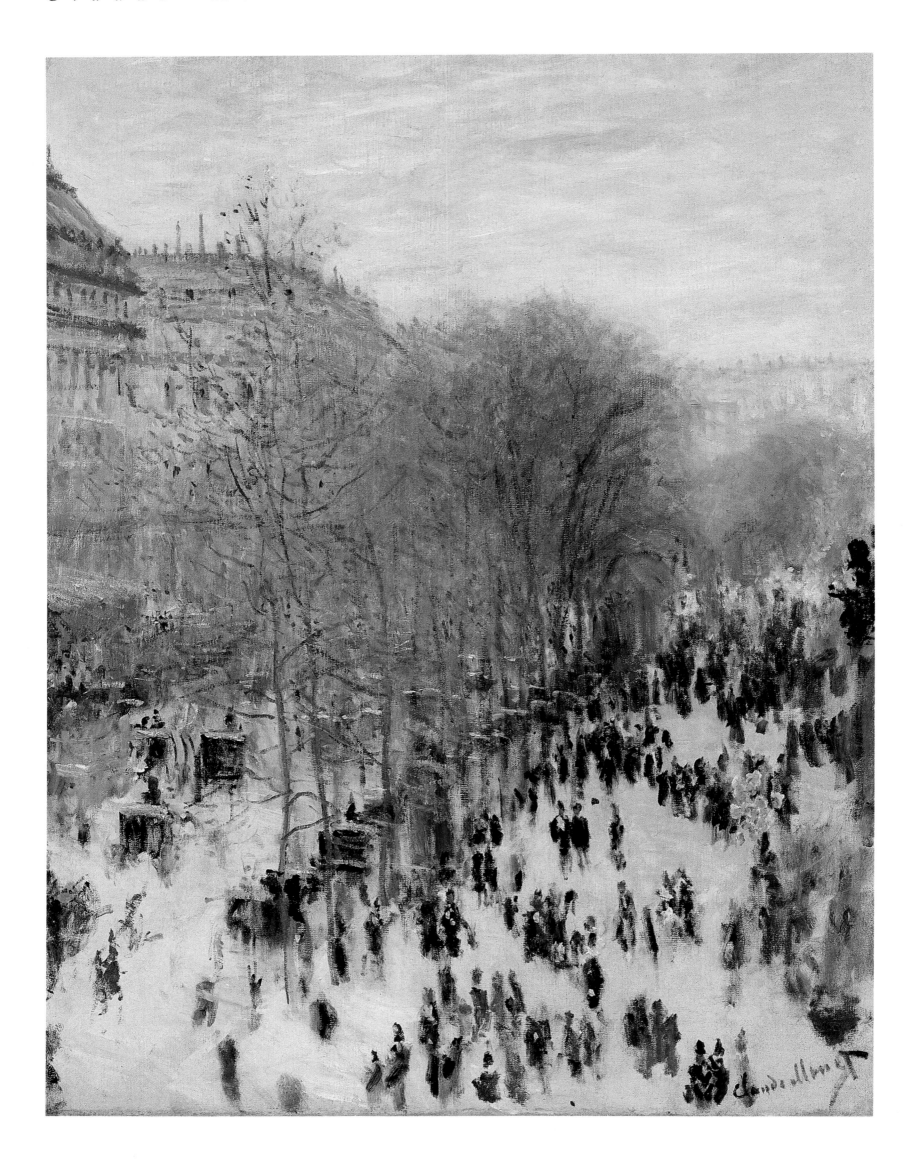

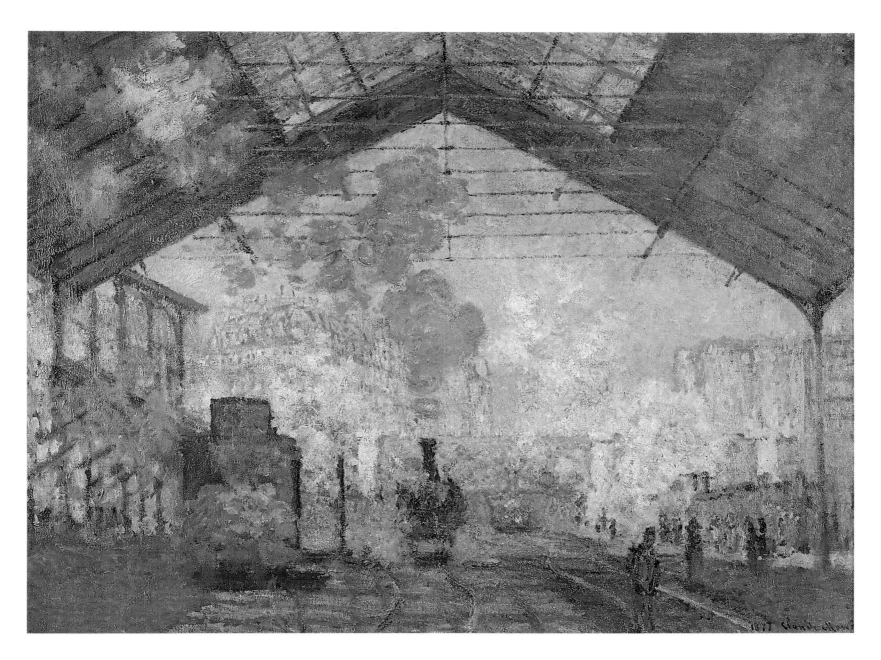

Boulevard des Capucines, 1873

Oil on canvas
31×23 inches (79×58 cm)
Kansas City, Missouri, Nelson-Atkins
Museum of Art

The Paris Monet and his friends painted was essentially the Paris that we know today, and the popular image of the capital has been to a large extent created from their works. To Monet's contemporaries, viewing the works in the 1870s when the vast program of rebuilding initiated by Baron Haussmann had been almost completed, this image of Paris must have looked brash and unromantic. The Impressionists were among the first to respond to this new environment, uncoated at that time with the nostalgia that the city evokes in present-day visitors.

The view seen here is from Nadar's photographic studio, looking out over the boulevard des Capucines, one of the chic new boulevards leading up to the Place de l'Opéra. It was in these rooms that the First Impressionist exhibition was held in 1874.

Monet painted two versions of the scene, one of which was exhibited at the 1874 show. The oil in the Pushkin Museum in

Moscow has a horizontal format; the one reproduced here uses a vertical format which accentuates the novelty of the high viewpoint. The trees smudge into indistinctness in the late afternoon light, and the pearly tones of the foreground merge imperceptibly into the milky blue of the far distance. Two top-hatted figures on a neighboring balcony share the spectacle with the viewer, and compensate for the unusual character of the composition by acting as mediators between the scene depicted and our comprehension of it. From such a vantage point, individual characteristics would be lost in the continual flow of the crowd, reducing the human form to a blurred, anonymous shape. No doubt Monet was influenced by similar effects in contemporary photography; his very choice of a high viewpoint owes much to photographic examples. He was, after all, painting in a photographer's studio, and seems to have tried to be as faithful as a camera to his visual impression of the scene below.

La Gare Saint-Lazare, 1877

Oil on canvas
29½×41 inches (75 x 104 cm)
Paris, Musée d'Orsay

The Gare Saint-Lazare presented Monet with a novel subject possessing evocative atmospheric effects. In this painting Monet does not concentrate upon the technological splendor of the bridge, the locomotives, or the architecture, but studies the effects of sunlight filtering down into the steam-filled station area instead. The scene is studied in full sunlight, the refractions of light through the moisture-filled atmosphere causing spectacular coloristic effects that Monet has exploited to the full. The paint is applied directly onto the canvas, the brushwork weaving a rich scumble. The originality of Monet's technique and the novelty of his subject matter confounded the critics, who found this style impersonal: 'No inner feeling, no subtlety of impression, no personal vision, no choice of subjects to show you something of the artist. Behind his eye and hand, one looks in vain for a mind and a soul.'

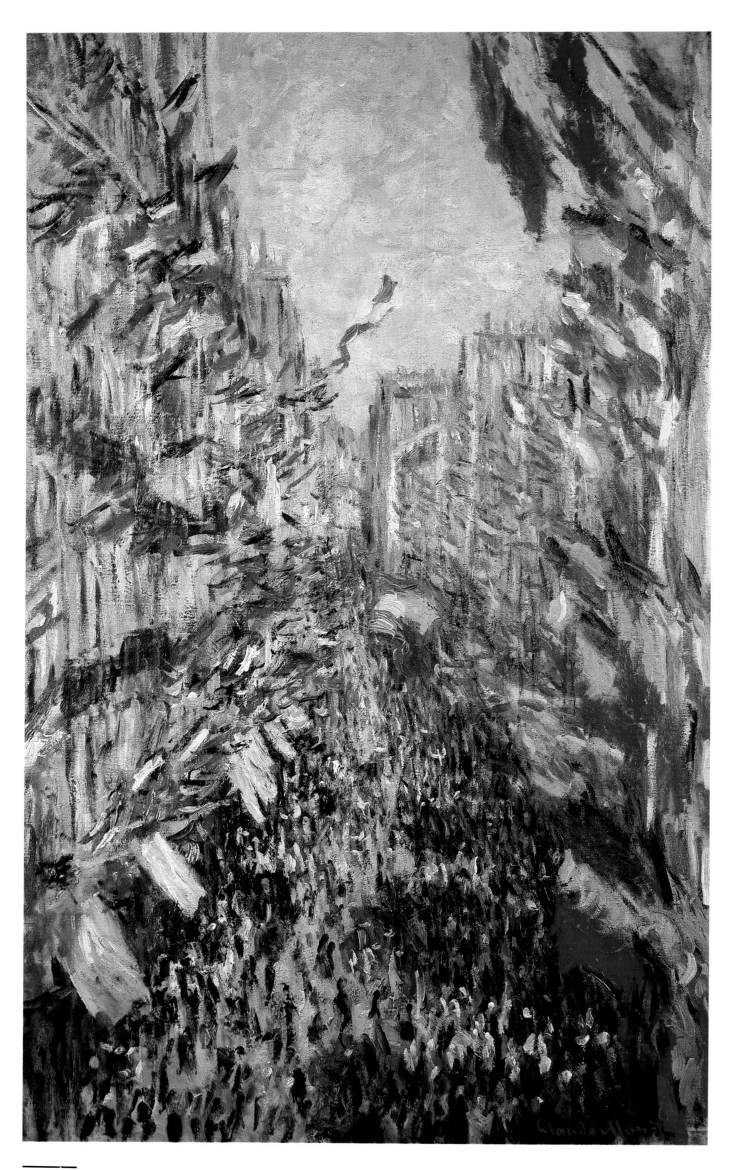

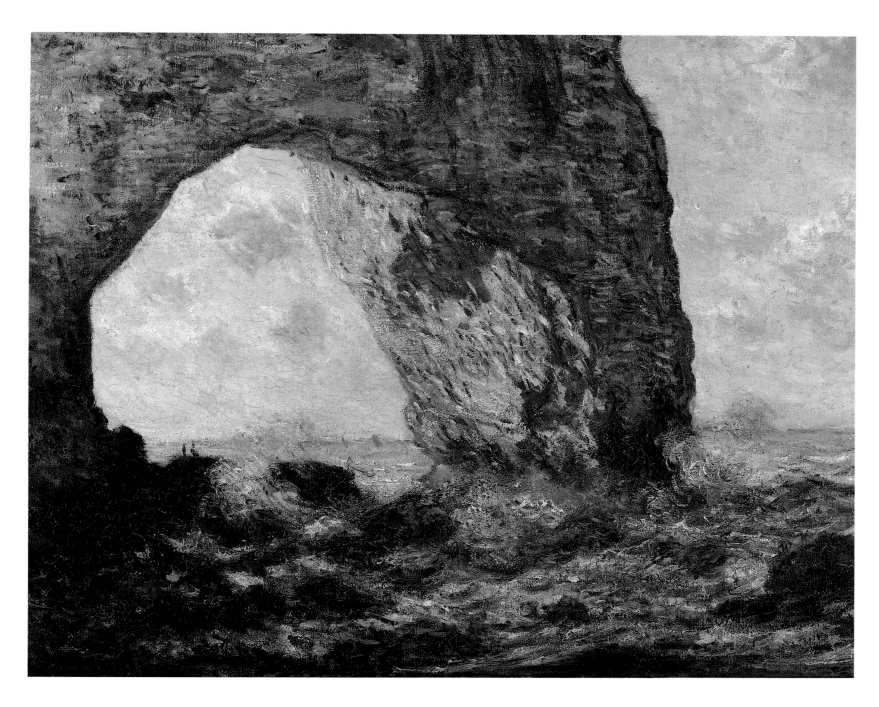

La rue Montorgueil, Fête of 30 June 1878, 1878

Oil on canvas
31×20 inches (80×50 cm)
Paris, Musée d'Orsay

At first sight, it would be easy to mistake this painting for a Manet. It echoes the work of that master in subject matter and in style. The painting is a bravura performance, animated by the vividness of the tricolor, surely the most paintable of all flags. Countless numbers of them float on the wind from the anonymous apartments that line the rue Montorgueil, hung there to celebrate the opening of the 1878 Exposition Universelle. Monet surveyed the scene from a balcony, capturing the festive mood in a rapid descriptive shorthand, and using the narrow format of the canvas to accentuate the verticality of the scene. The street narrows to a vanishing point in the absolute center of the picture. The vitality of the painting comes from the chromatic force of the red, white, and blue of the flags trans-

lated with the minimum of means into a dazzling display of light and color. The excitement is suggested not so much by the scene depicted, as by the quality of the painting itself. For all its seeming exactness of visual truth, Monet has treated the traditional rules of perspective in a cavalier manner. The flag near the apex of the triangle formed by the diminution of the street is rendered as large as those closer to the viewer. The Parisians throng the pavements below, their identities as individuals lost in the crowd that swarms into the ever-narrowing perspective. People are given no more attention than the architecture, itself half hidden by the flags flickering in the sunlight. This was not some great military victory to be commemorated by massive allegorical figures but the celebration of a civic, republican, even commercial, event by the ordinary citizens of Paris immersed in the very fabric of their city.

The Manneporte, Étretat, 1883

Oil on canvas
25¾×32 inches (65×80 cm)
New York, Metropolitan Museum of Art

This painting is one of the many he painted of the cliffs and beaches of Étretat and may be seen as an attempt by Monet to challenge the versions of the same scene that Courbet had painted in the late 1860s. To be able to paint this spectacular view, Monet would have had to walk about half a mile along the cliff to the beach beyond the Manneporte itself. He has chosen to close in on the great chalk archway, allowing its peculiar shape to function as the only compositional motif of the painting. The horizon and any sense of distance are thereby played down in favor of creating a compositional effect which is at once both immediate and powerful. The enveloping presence of the atmosphere, combined with the massiveness of the rock, and the might of the sea, together fill the painting to the exclusion of all else.

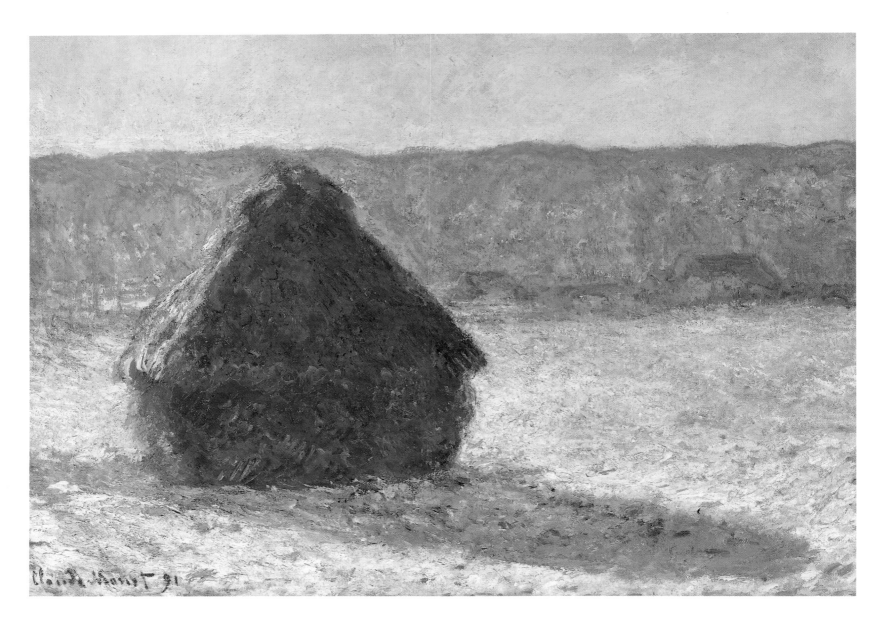

Haystack in Winter, 1891

Oil on canvas
25¾×36¼ inches (65×92 cm)
Boston, Museum of Fine Arts

Monet is recorded as saying:

When I began I was like the others. I thought that two canvases were sufficient, one for overcast conditions and one for sunny days. I then painted two stacks which impressed me and made a lovely group, two steps away from here; one day, I saw that the light [had] changed. I said to my stepdaughter, 'Go to the house, if you would be so kind, and bring me another canvas.' She brought it, but a little later things were again different. Another! and yet another! And I worked on each only when the effect was right, and that's all there is to it. It's not difficult to understand.

By the late 1880s, when he had settled in a house in Giverny, Monet's finances were sufficiently secure to enable him to follow his own ideas. Between the years 1888 and 1891, he painted at least thirty different versions of a group of what are now thought to have been grainstacks that were situated a few minutes away in a field to the west of his house.

So excited was he by the opportunities

they offered him that he arranged to have them left there beyond their due season so that he would be able to continue using them as motifs for his paintings. Despite his comments quoted above, we know that Monet continued to revise his paintings in the studio. They are not, therefore, direct results of his confrontation with nature, but rather prolonged meditations on the nature of sight and the means by which paint may be used to express the artist's sensations. On 11 October 1890, he wrote to his friend Gustave Geffroy, 'Finally, I am more and more exasperated by the need to realize what I feel, and I vow not to be weak, because it seems to me that I am making progress.'

Fourteen of these paintings made up the centerpiece of his one-man show at Durand-Ruel's gallery at 11, rue Pelletier, in 1891, and bear witness to his increasing preoccupation with the rendering of visual experience. Like his paintings of the Gare Saint-Lazare at the Third Impressionist show of 1877, they were meant to be seen together as a series of related images. He told a visitor to the exhibition that the grainstacks only acquired their full value when seen in comparison with each other and as a complete series of successive paintings. He has denied any agricultural,

social, and topographical significance these objects might have had and has concentrated instead on exploring them as instants of vision presented simultaneously to the viewer. For Monet's contemporaries, seeing the paintings on the same subject grouped together in a small room must indeed have been an extraordinary and memorable experience.

Monet's grainstacks entered the folklore of modern art. In 1913, Wassily Kandinsky, the pioneering abstract painter, published his *Reminiscences,* in which he recalled the impact of seeing one of these canvases in Moscow at the French Impressionist exhibition in about 1895:

Previously I had known only realistic art . . . Suddenly, for the first time, I saw a 'painting.' The catalogue informed that it was a Haystack. I could not recognize it. This non-recognition was painful to me. I considered that the painter had no right to paint indistinctly. I dully felt that the object of the picture was missing . . . but what was entirely clear to me now was the unsuspected power of the palette, which had up to now been hidden from me, and which surpassed all my dreams. Painting acquired a fairytale power and splendor. And unconsciously the object was discredited as an indispensable element of the picture.

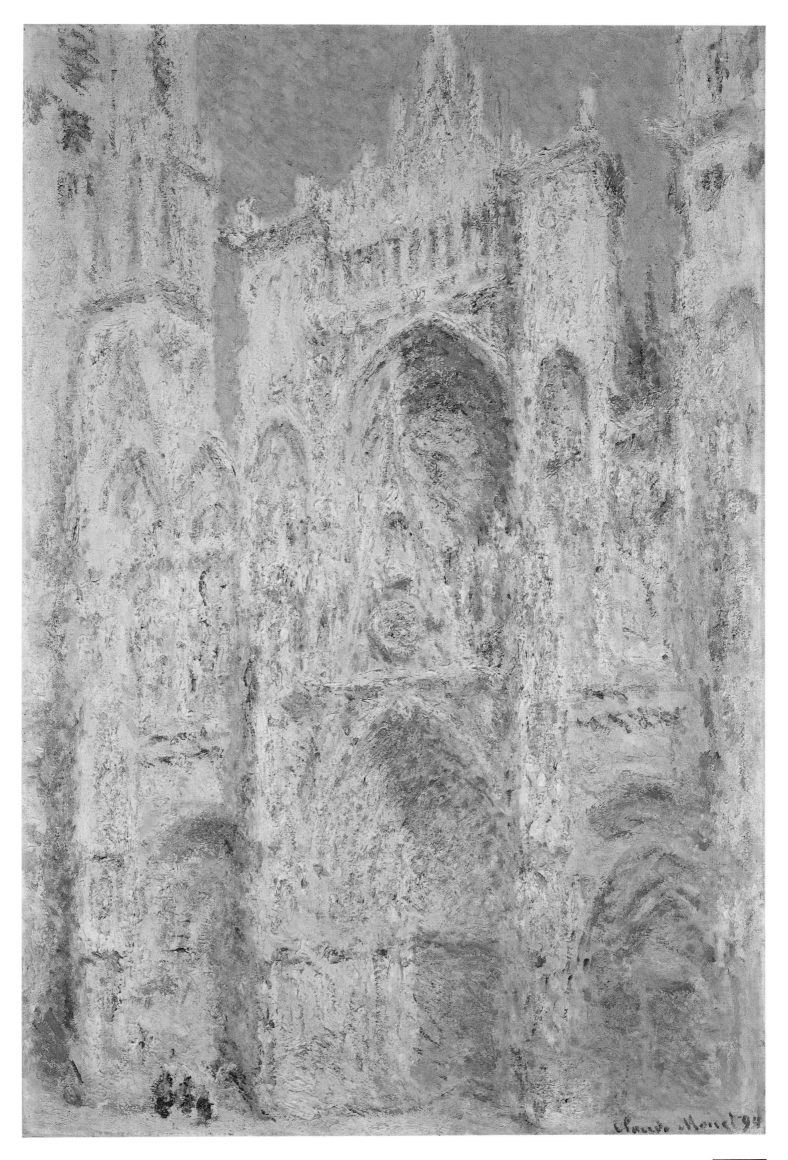

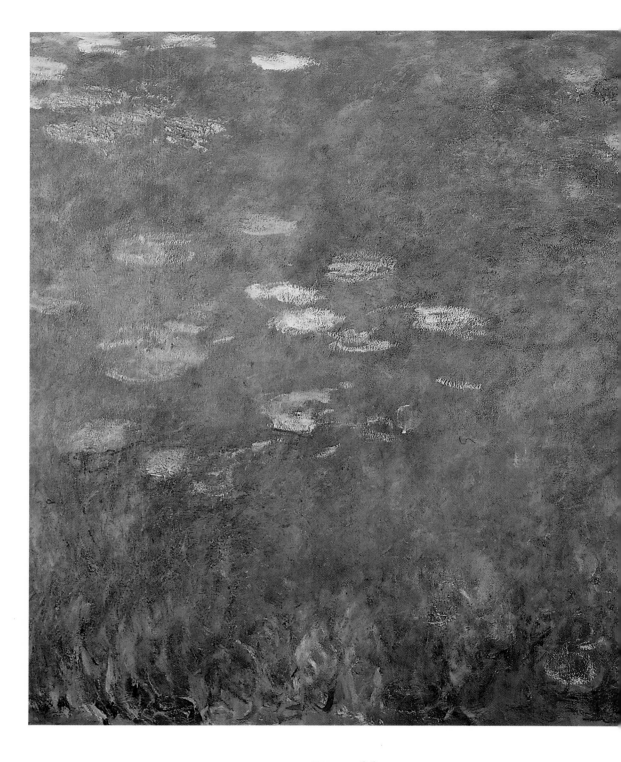

Rouen Cathedral, West Façade, Sunlight, 1894

Oil on canvas
39½×26 inches (100×66 cm)
Washington D.C., National Gallery of Art

In 1892 Monet rented a room in a building opposite the great west front of Rouen Cathedral. He was given permission to make certain modifications to the structure of the room to accommodate the large number of canvases that would be necessary to capture the effects of the constantly changing light as it fell on the massive façade. He worked on the series for two years and, at the end of that time, exhibited a number of the canvases as an ensemble at Durand-Ruel's gallery.

From the many statements that Monet made, it was obviously important to him that these paintings were seen in relationship with each other and not so much as single canvases. This implies that the artist wished to suggest in his work that things do not have their being in a single, fixed state, as in a photograph, but are subject to change, '. . . by their surroundings, by air, and light which vary considerably,' and, he might have added, by the sensibility, mood, and interests of the person observing them.

For is not a twelfth-century Gothic cathedral an odd choice of subject for an Impressionist painter? Monet no longer needed an obviously contemporary subject to express his modern sensibility and wished to concentrate all his energies on the problem of expressing the effect of visual experience.

The reviewers stressed the secular nature of these paintings and it is difficult to see any element of Christian faith being worked into the image. Instead, the cathedral is used as an unchanging sculptural mass against which the variables of light and atmosphere are examined. The paintings record the effect of light falling, reflecting off and sinking into the carved stone of the cathedral façade.

But these are not rapidly painted sketches capturing separate instants of experience; it is clear from their exalted color and the thick, reworked surface that Monet must also have worked on them away from the motif, using his memory and the great experience he had gained as a landscape painter to weld the separate paintings into a homogeneous group.

Monet has rejected the traditional method of setting the cathedral in a perspectival setting which would render its architectural structure immediately legible. He has also abandoned the academic practice of using an almost mathematical series of tones ranging from dark to light. Instead, he visualizes the cathedral as a natural phenomenon, like a great Normandy cliff-face, and fills the whole canvas area with the rugged façade rendered in spectacularly intense and unexpected color harmonies.

Fellow artist Camille Pissarro wrote to his son Lucien that he was '. . . very excited by this extraordinary mastery . . . the cathedrals are much argued over and also much praised by Degas, me, Renoir and others . . .' He wrote again the day after the exhibition had closed, '. . . I would have so much wanted you to see it in its ensemble, because I find in it a superb quality . . . that I have so often sought . . .'

Waterlilies, *c.* 1919-26

Oil on canvas
79×167½ inches (201×425 cm)
Cleveland, Museum of Art

Monet, like Titian, Rembrandt, and Matisse, lived long enough to present the world with the flowers of a lifetime's research. For the last thirty years of his life, Monet dedicated himself almost exclusively to painting works related to the gardens around his property at Giverny. In 1893, he caused a narrow stream to be diverted and opened up to form a small waterlily pond; modifications continued until, by 1910, he needed the service of six full-time gardeners to supervise his gardens. His first painting of the original lily pond with its Japanese footbridge dates from 1895, and rapidly it became the focus for his continuing explorations of the ever-changing nature of light. All his life, the

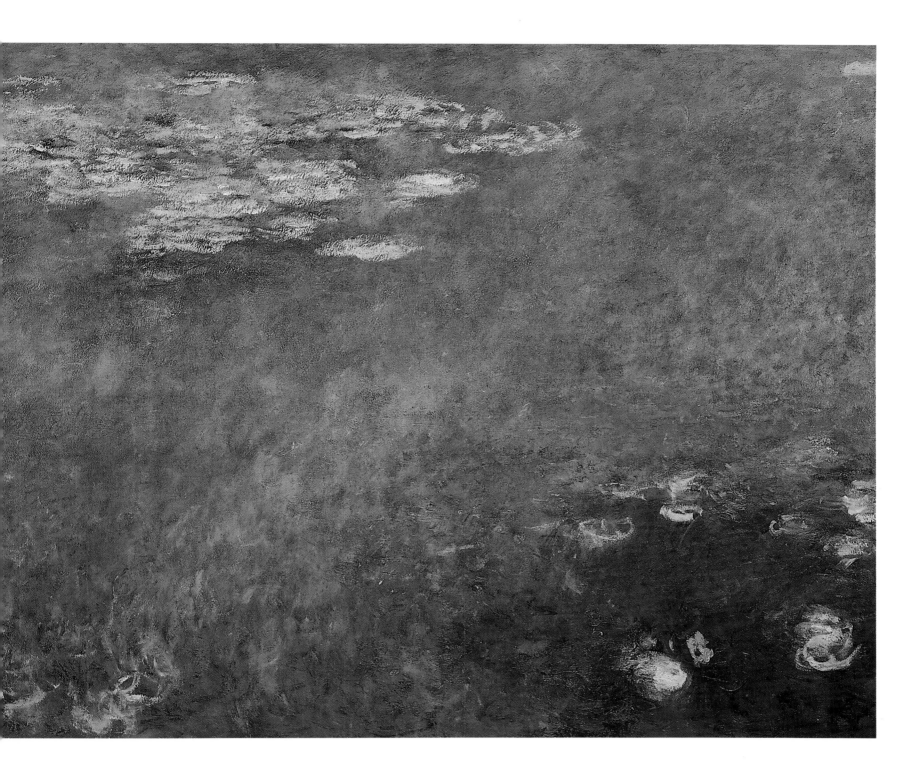

reflective properties of water had been a central concern; his last works are meditations sparked off by light hitting, passing through, and reflecting off the unstable surface of water.

Monet had massive studios built on his estate so that he could work on a decorative ensemble, the data for which would be gleaned from his paintings produced in the garden itself. Beginning from a rapid lay-in produced before the motif, Monet would continue to work and rework these canvases in the studio, building up with his distinctive cursive brushwork a rich, grainy surface of opaque paint across which further layers of paint were laid until the canvas was finished. Even more than his *Haystacks* or his images of Rouen Cathedral, these paintings cannot be seen to refer to any one particular moment, but seem rather to capture the flux of time itself. The subjects of his canvases become progressively more difficult to make out as

he eliminates all elements of the landscape to concentrate upon the surface of the water. The sky and the overhanging trees are present only as reflections in the surface of the water which expands to fill the entire canvas area. In so doing, Monet presents himself with new problems of recession and perspective; and the sensation for the viewer is one of startling closeness to the motif allied to a strong awareness of the compositional or decorative unity that the work possesses.

Because we are used to conventional ways of seeing the world represented, these paintings can take some time to decipher, but once we trust to our own experience they become quite legible. Monet spent his whole life exploring the nature of visual perception and expression. By focusing all his creative powers on the transference to the canvas of his experience of light, he allowed others to see afresh the ever-changing richness of the natural world.

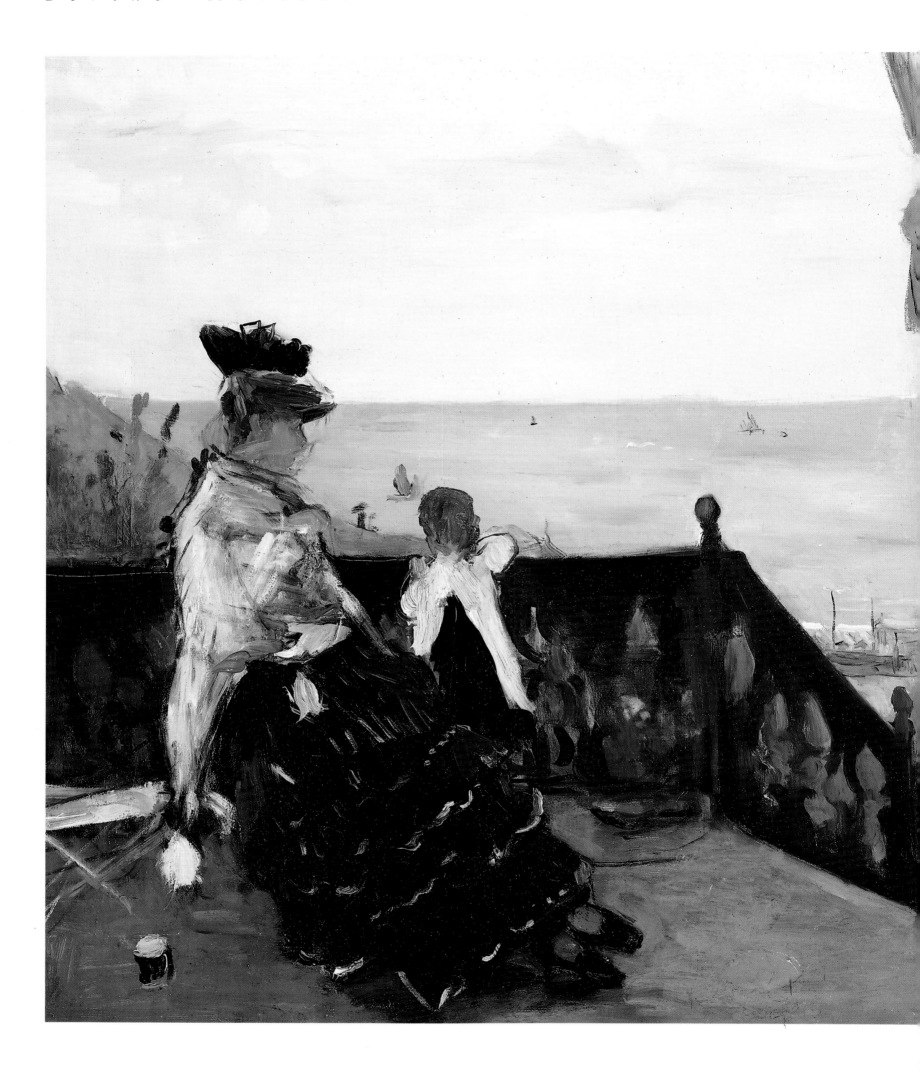

Berthe Morisot

F r e n c h 1 8 4 1 - 9 5

In a Villa at the Seaside, 1874
Oil on canvas
19¾×24 inches (50×61 cm)
Pasadena, Norton Simon Art Foundation

This fresh, silvery toned seascape was painted at Fécamp on the Normandy coast where the Morisot and Manet families spent a holiday together in 1874. It was during this holiday that Berthe Morisot accepted the proposal of marriage of Eugène Manet, the younger brother of the painter. It has been suggested that the Impressionist style evolved as a response to the changeable skies and soft light-effects of northern France. Certainly, Morisot was much more readily inspired by the soft, translucent light of the Normandy Channel than by the harsh colors of Saint-Jean-de-Luz, near the Spanish border, on the Atlantic coast where she had stayed the previous year.

On the veranda of this seaside villa are seated a woman and child watching the activity on the beach below. This compositional device of placing figures in a raised foreground plane – such as a balcony or some other vantage point – and using their gaze to lead the spectator into the deeper distance was one that Morisot adopted on several occasions. The thin application of paint and the quirky carved balustrade and pillars set against the milky turquoise slab of the sea beyond remind one of the Japanese-inspired seascapes of Whistler, whom Morisot admired.

The following year, honeymooning on the Isle of Wight, she complained of the difficulty such paintings involved: 'Views from above are almost always incomprehensible; . . . I miss the babies as models; one could make lovely pictures with them on the balcony.' In this picture, as has been aptly pointed out, the placement of the figures performs more than a structural function: it also reflects the essentially safe, closed domestic experience of bourgeois women and children, such as Berthe Morisot and her sisters.

The painting was included in the sale of Impressionist works at the Hôtel Drouot in 1875, where it was bought for 230 francs by Henri Rouart, an engineer and amateur painter who had exhibited at the First Impressionist exhibition. Berthe Morisot's decision to participate in this sale alongside Monet, Renoir, and Sisley, and to ride out the considerable and harsh criticism it provoked, confirmed her position as a central member of the new Impressionist group. The sale took place at a difficult time and poor prices were reached in general. For a small easel painting, 230 francs was not a bad price compared with those fetched by her colleagues; in fact, the highest price reached – 480 francs – was earned by another of Morisot's paintings.

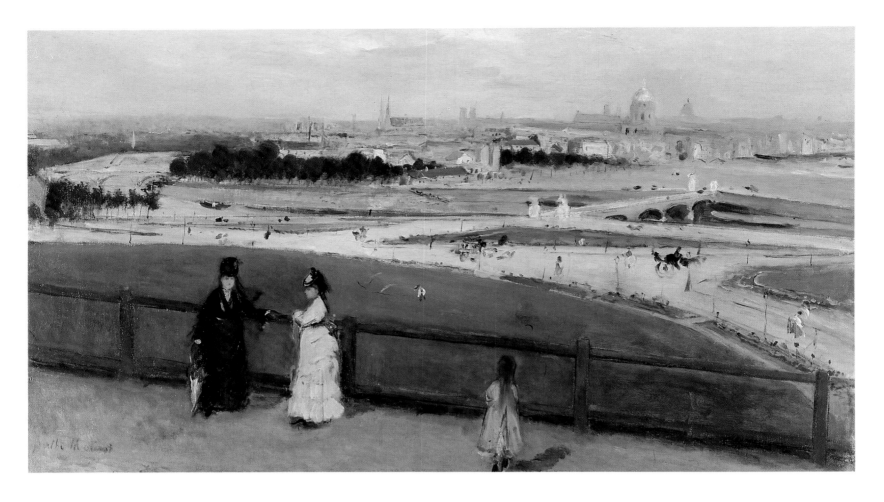

View of Paris from the Trocadéro, 1872

Oil on canvas
27¾×41¾ inches (70×106 cm)
Santa Barbara, Museum of Art

The two younger Morisot sisters, Edma and Berthe, were both taught painting by a reputed Lyonnais Salon artist, Guichard, who recognized their potential to become serious painters and warned their mother of the consequences. They later benefited from the advice of Corot, who is supposed to have found Edma the more biddable pupil. Their first exhibited paintings, shown at the Salon of 1864, were landscapes in the vein of Corot and Daubigny.

When Berthe Morisot painted her panoramic vista of Paris from the heights of the Trocadéro, her viewpoint was very near her parents' house in the rue Franklin. The models for the elegantly dressed women in the foreground, who both gaze away from the view, were her two sisters Edma Pontillon and Yves Gobillard, while the little girl is probably Yves' daughter. The hill of the Trocadéro afforded one of the best vantage points from which to survey the city's topography, and several key landmarks can be seen in Morisot's painting. More or less centrally, on the horizon, are the twin, squared-off towers of Notre-Dame. To the left of them, a little nearer, one sees the pointed Gothic towers of Sainte-Clotilde. The most prominent dome, gilded and catching the light, is that of the Chapel of Saint-Louis des Invalides,

and to the right again, farther away, is the dome of the Panthéon.

The most obvious precedent for tackling such a view was Édouard Manet, to whom Berthe Morisot was particularly close in the early 1870s when she posed for a number of his pictures. When Manet had painted a view of Paris from almost the identical location in 1867, a large and ambitious painting that Berthe Morisot would certainly have known, he had been concerned to record a particular historic event – the Exposition Universelle – and the temporary hive of activity it had brought to the scene. As a cityscape, the painting had a somewhat clumsy and unconvincing air.

Berthe Morisot advisedly gives her figures less importance, keeping the foreground of the Trocadéro hill, as yet undeveloped, and the wide open space of the Champ-de-Mars on the other side of the river free of distracting or anecdotal activity, so smoothing the transition from her vantage point to the distant cityscape of densely packed buildings. The balance of the composition and the broad tonal handling, which competently cope with the problems of aerial perspective, demonstrate how much Berthe Morisot had learned from her teacher Corot. In fact, hers must have been one of the last artistic records of this uncluttered panorama before it was altered irrevocably; a few years later, the site was given over to another phase of urban development as the Palais du Trocadéro and its gardens were laid out for the Exposition Universelle of 1878.

The Cradle, 1872

Oil on canvas
22×18 inches (56×46 cm)
Paris, Musée d'Orsay

Most of Berthe Morisot's subjects were taken from her immediate environment and domestic circle. In late nineteenth-century Paris, although painting and drawing were thought fit and suitable accomplishments for a well-brought-up young woman of the *haute bourgeoisie* and played a significant role in her education, the obstacles placed in the way of a woman wishing to pursue art as a professional career were considerable. Denied access to nude models, women artists found difficulty in acquiring the anatomical skills expected of the figure painter and tended to opt for less challenging genres such as still life and flower painting. It was impossible for a young woman to wander the streets of Paris alone, unchaperoned, sampling the spectacle of the changing city.

In *The Cradle*, one of the group of works – landscapes, portraits, and figure paintings – that Berthe Morisot showed at the First Impressionist exhibition in 1874, her sister Edma is shown seated by the cradle of her firstborn child, Jeanne, whose tiny features are glimpsed through the transparent voile of the curtains. Following her marriage to a young naval officer in 1869, Edma abandoned all ambition for an artistic career. This painting marked the beginnings for Morisot of a series of paintings of mothers and children – a subject that

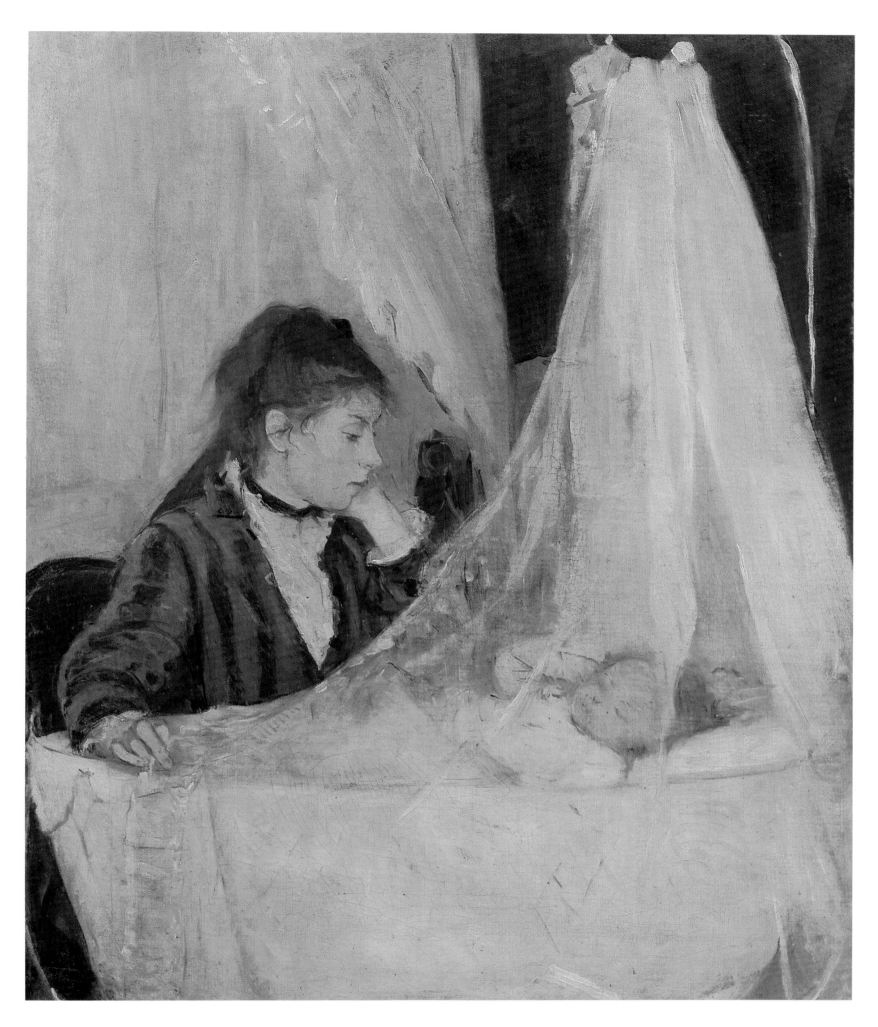

she would pursue throughout her career.

The Cradle is distinct from the conventional and widely popular images of mother and child current at the time, most of which derived in one way or another from the iconography of the Madonna. Rather than cradling her baby in her arms, the new mother looks on in wonderment at this enigma of her own creation, psychologically perhaps not yet quite attuned to the child. Morisot's image is not only a true expression of those first weeks of discovery, but also reflects something of the physical detachment a bourgeois mother had from her offspring in an era when wetnursing was the norm. Some years later, after she had given birth herself, Morisot did not shrink from representing her baby daughter Julie being suckled in an orchard by an anonymous, country-bred, and ample-bosomed wetnurse.

Winter (Woman with a Muff),

1880
Oil on canvas
29×23 inches (74×58 cm)
Dallas, Museum of Art

In the Dining Room, 1886

Oil on canvas
24×19¾ inches (61×50 cm)
Washington D.C., National Gallery of Art

In this painting of an attractive and fashionably dressed young woman, Berthe Morisot departs from the strict, down-to-earth realism usually associated with the Impressionists. Various devices differentiate this from her more modern genre subjects and portraits: the halflength format, which Berthe Morisot seems to have favored; the use of a neutral background; and, above all, the allegorical title show that she wished to produce a more generalized, timeless image. Both in the background and in the treatment of the dress, fur hat, and muff, the lively flecks of the brush are left undisguised. Even the face is rendered with the minimum of fuss, a few bold and judiciously placed brushstrokes defining nostril, lips, and chin.

Allegorical evocations of the seasons,

using fashionably dressed young Parisiennes, were the stock-in-trade of Morisot's contemporary and friend, Alfred Stevens, an immensely successful Belgian painter. Manet was to adopt the same device, possibly following the example of his sister-in-law, two years later. Modern life served up in such traditional, allegorical form was readily acceptable to the bourgeois public. But in terms of handling, Morisot's painting makes no concession to the contemporary taste for detail and polish; rather, it harks back to the brilliant bravura sketchiness of the rococo masters of the eighteenth century for whom she had a great admiration. Fragonard was, in fact, one of her forebears, and she seems to have consciously emulated the hasty spontaneous handling he had used in his 'fancy pictures,' a category which could equally be used to describe Morisot's *Winter*. The 'Fragonardian refinement' of her use of color was mentioned approvingly by the critic Paul Mantz, who appreciated the loose, sketchy qualities as well as the delicacy of Berthe Morisot's work.

This delightful painting was one of those Berthe Morisot exhibited at the final Impressionist show, held in 1886, under the title *The Little Serving Girl*. Her works that year were seen alongside some stiff competition: Degas' important group of pastels of women bathing, a group of Cassatts, and the works of Seurat and Signac, who were demonstrating their new, meticulous, and highly resolved pointillist technique for the first time. In the context of that exhibition of innovation and splinter movements, the sketchy, unfinished aspect of Morisot's work was more than usually apparent. Her brushwork struck critics as a sort of hasty telegraphese and she was generally dismissed, as a representative of the old school of Impressionism. By male critics, Morisot was frequently judged to be 'more feminine' than Cassatt, who practiced a more robust, and therefore manly, drawing style. Indeed, there were some disparaging parallels drawn between what were seen as the essential characteristics of Impressionism – its instability, fluency, and delicacy, its attachment to the ephemeral, to the shifts of light, and to the surface of things – and the very notion of femininity itself.

The cool palette used for *In the Dining Room* is dominated by opalescent blues, grays, and whites, a subdued range particularly favored by Morisot. The artist made a point of including in the composition objects with shiny surfaces – the glass globe and chimney of the gas-lamp, the glass doors of the dresser, the flask on the highly polished table – all of which catch and reflect the shafts of sunlight that filter in through the windows. The setting for the painting was the dining room of the house where she and her family had recently moved. Morisot seems to have arranged the decoration of her new abode to suit her artistic tastes. She kept the rooms light, with white stucco, fabrics, and mirrors, and commissioned Monet to paint a decorative panel. The exquisite environment she created and the reserved politeness with which she entertained some of the capital's most prominent artists, writers, and politicians recalled, for many visitors, the fashionable style of the salons during the eighteenth century.

Camille Pissarro

F r e n c h 1 8 3 0 - 1 9 0 3

The Côte du Jallais, Pontoise,
1867
Oil on canvas
34¼×45¼ inches (87×115 cm)
New York, Metropolitan Museum of Art

In 1866, Camille Pissarro settled in Pontoise where he worked until 1869. He completed a number of important landscapes during his first stay there, including this large horizontal painting, in which he typically favored a broad handling of areas of tone, creating sharp contrasts of light and dark, and in which he treated the buildings as blocky shapes. His palette displays a rich range of greens. These early landscapes remind one of Courbet, whose work was of great importance to Pissarro in the 1860s. A similar motif, looking down into the agricultural valley and sweeping up to a ridge beyond, can be found in a painting by Daubigny of the previous year. Daubigny's *Landscape at Pontoise* showed peasant figures harvesting in the fields, however, while Pissarro shows two apparently middle-class women out walking, against a backdrop of small farms. The picture seems to demonstrate the artist's awareness of the countryside, especially on the outskirts of a town, as simultaneously providing a living from the soil and a place for leisure for town dwellers.

Pontoise was an old market town some 15 miles (24 km) northwest of Paris, characterized by its medieval church and streets. Its attraction for Pissarro lay in its balance of the old and the new: contrasting with the medieval churches was the evidence of new industry springing up around the outskirts, and at such a short distance from the capital, Pontoise still had a rural character and could offer an abundance of landscape motifs. During his years there, Pissarro maintained an apartment in Paris so as to keep in touch with his artist friends, the art market, and exhibitions.

In Pissarro's landscape work of the late 1860s, most of it featuring Pontoise, one finds a polarity of motifs. He painted a number of townscapes – showing people on the quays of the Oise, with factories in the background – so establishing the commercial and modern character of the town. On the other hand, he favored more agrarian motifs such as this, being particularly drawn to the picturesque hamlet of l'Hermitage, a small community nestling among the hills, a location also explored by Cézanne in the 1870s.

The canvas was exhibited at the Salon of 1868 with another landscape of l'Hermitage; their acceptance was in large measure assisted by the support of Daubigny, who was on the selection jury. The painting was admired by a few naturalist critics such as Castagnary and Zola and, more surprisingly, by the young Odilon Redon.

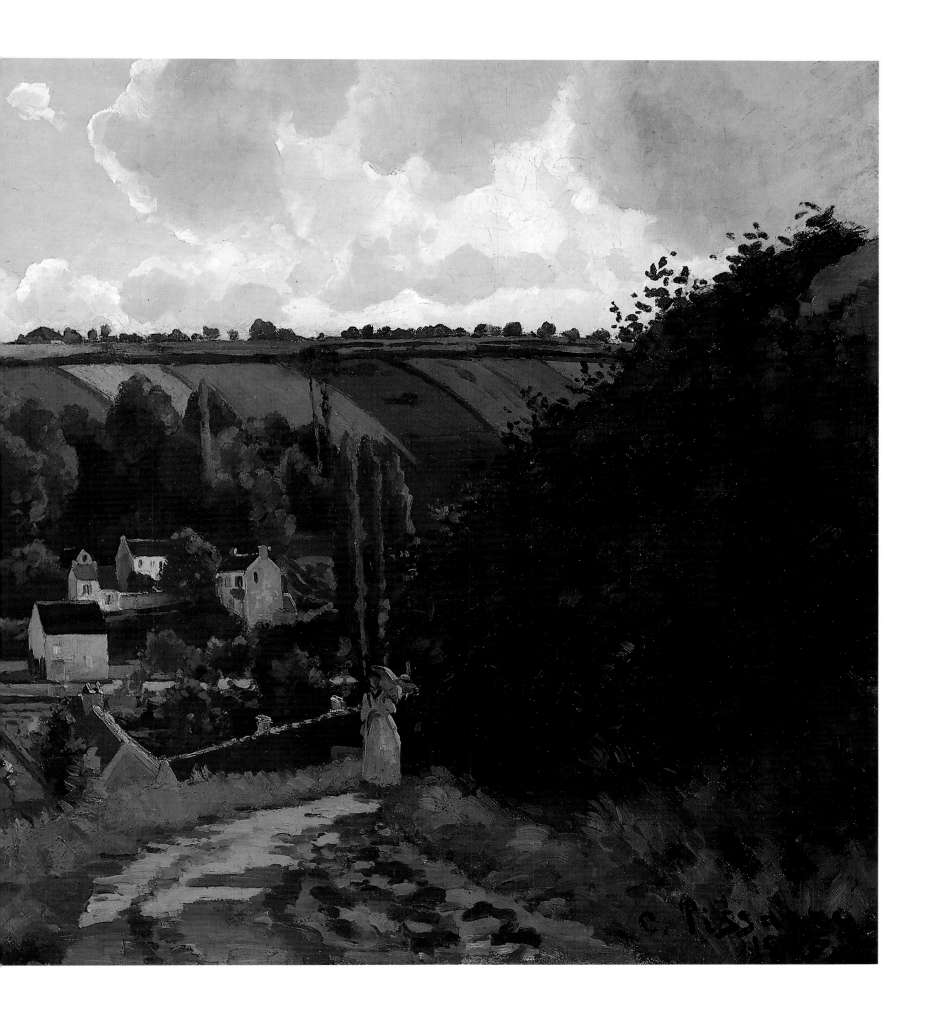

Hillside at l'Hermitage, Pontoise, Autumn, 1873

Oil on canvas
24×29 inches (61×74 cm)
Paris, Musée d'Orsay

After an enforced absence from France to avoid the hostilities – he spent the years of the Franco-Prussian War and the *Commune* in London – Pissarro returned to Pontoise in 1872 and remained based there for the next decade. Although only five or six years separate the two landscapes painted at l'Hermitage, an enormous distance has been traveled by the artist in the interim in terms of developing an independent radical style.

A crucial, but in reproduction far from obvious, distinction between this and his earlier landscape is the reduced scale. Following the debacle of the Franco-Prussian War, Pissarro, in common with his new colleagues Monet, Sisley, and Renoir, abandoned the large-scale canvases they had favored in the previous decade and which were essentially dictated by the need to make an impact at the Salon. Instead, during the 1870s, they confined themselves to smaller canvases, which involved less investment of time and effort and which, the artists believed, would be more saleable. This move was of practical importance in view of their by now almost exclusive practice of painting in the open air: small canvases were easier to handle and carry about. The blonder, more unified palette, from which the dark tones – blacks and earth colors – have been eliminated, also sets Pissarro's 1873 painting apart from his earlier landscape at l'Hermitage with its predilection for starkly dramatic tonal contrast; and this, too, was the direct consequence of working on such paintings out of doors where he could paint under natural light conditions.

A notable development in Pissarro's approach to composition seems to take place around 1872-73. Instead of adopting landscape motifs which involved a broad, uncluttered horizontal sweep, occasionally varied by a road leading the eye into the distance – devices typical of the classical tradition of landscape and particularly of Corot, one of Pissarro's great mentors in the genre – Pissarro began to view the motif from close quarters, bringing out its blocklike shapes with repeated marks, elsewhere using a more conventional brush so as to approximate the irregular character of the terrain. He avoids the temptation to arrange and to compose the site into a harmonious unity; the horizon line starts to creep up the canvas, and working figures, although still small in scale, assume more prominent and pivotal places within the structure of the whole. Interestingly, Pissarro painted exactly the same motif again, but under different light and climatic conditions (with a layer of winter snow), and this practice, shared with Sisley, was later to be taken to more extreme lengths by Monet in his famous series paintings, begun around 1890, of poplars, haystacks, and Rouen Cathedral.

The Red Roofs, a Corner of the Village, Winter, 1877

Oil on canvas
22×26 inches (54×66 cm)
Paris, Musée d'Orsay

In the late 1870s, Pissarro became increasingly interested in dense motifs, where the image is difficult to find and upon which the eye cannot easily focus. No longer using the simplified, broad handling of the mid decade, he had begun to work with a finer brush, in a tight, somewhat clogged manner. This change in technique, which is paralleled in Renoir's career at this time, makes it very clear that, even at this period of 'High Impressionism,' we cannot talk of a fixed style.

The Red Roofs is typical of this period. As in a number of other paintings and etchings of the late 1870s, Pissarro chose a view through trees to buildings, so his apparent focus of attention is partially masked. He also favored the inclusion of a high ridge to the rear, which allows the sky only a limited role and denies spatial depth. The overall effect is not exactly flat, but the eye tries with difficulty to read depth, especially as the foreground trees are executed with great vitality. The brushmarks are small and fussy with one layer of touches placed over another, and there are no strong contrasts of light and dark to give a sculptural effect. The style is close, in fact, to Cézanne, who had been working side-by-side with Pissarro in Pontoise; he too at this time was beginning to model forms not by contrasts of light and dark but by modulating warm and cool. All these factors, combined with the rough yet consistent surface which makes little or no attempt to correspond to the actual texture of the object it is describing, make *The Red Roofs* an important transitional work, and one of Pissarro's more intractable images. *The Red Roofs* may have been one of the exhibits at the 1877 Impressionist exhibition. If so, it would have shared in the abuse heaped on Pissarro's landscapes by a particularly disparaging critic, Léon de Lora. Of the paintings, he remarked, 'Seen up close, they are incomprehensible and hideous; seen from a distance they are hideous and incomprehensible.'

Unlike Renoir, Pissarro stubbornly refused to make any concessions to please the public, and this intractability, both in his choice of motifs and in his refusal to stick with a style for long, was acknowledged by contemporaries such as Théodore Duret, and by the artist himself, to be the reason for his delayed acceptance by the broader public. In recent years, however, particularly in the last decade since the major exhibition marking the 150th anniversary of his birth, Pissarro's status as one of the prime movers within the Impressionist circle, and his integrity in remaining true to himself rather than to the demands of the market, have at last been fully acknowledged.

The Warren at Pontoise, Snow,
1879
Oil on canvas
23¼×28½ inches (59×72 cm)
Chicago, Art Institute

The winter of 1879 was exceptionally harsh, and a number of the Impressionists braved the elements to produce snow scenes that year. In this composition, Pissarro takes his viewpoint from some high ground, looking down through the skeletal trees of the warren to the roofscape below. As in *The Red Roofs*, he avoids giving the eye a focus of attention, forcing the spectator to sort out the pattern of surface marks into a legible whole. The solitary and anonymous male figure is casually offset to the right and turned away, as though to inhibit our attention or curiosity about this lone figure.

The composition and treatment of this picture, which in part harks back to the snowy landscapes produced by Courbet late in his career, make an instructive comparison with Gauguin's snow scenes of the same year such as *Winter Landscape* now in Budapest, Hungary. The two painters could almost have been working side-by-side, Gauguin eager to assimilate every nuance of Pissarro's informal teaching and example. While Pissarro was generous with his advice and time, his own work was at a transitional stage and he seems to have passed on to his pupil a number of his own doubts and uncertainties about Impressionism. He experimented with how best to organize a composition, how to approximate the variety and variability of nature while still giving a canvas textural and coloristic unity.

In the next decade, Pissarro would introduce some marked changes both to his subject matter and to his technique, with a view to overcoming some of these difficulties. Gauguin, for his part, was to break more radically from the fundamental aim of Impressionism – that of reproducing one's sensation before nature – and in the process drew farther and farther apart from his old friend and mentor.

The Little Country Maid, 1882
Oil on canvas
25×21 inches (64×53 cm)
London, Tate Gallery

Although Pissarro regularly drew and painted portraits of his large family, he rarely painted interiors. In this painting Pissarro shows his maidservant busy sweeping up, apparently unconscious that she is observed by the artist, while a child seated at the table, probably identifiable as Pissarro's youngest son at the time, Ludovic-Rodo, finishes his meal.

The picture makes an interesting comparison with Berthe Morisot's painting of 1886 of a serving girl in the dining room of her smart new Paris apartment. With his large family, Pissarro was at times on the verge of poverty, and his modest means are exemplified by his servant, who looks like a local peasant girl from the village of Osny. On the other hand, Berthe Morisot, the daughter of a senior civil servant, was a member of the *haute bourgeoisie*, and her housemaid has the more elegant style of

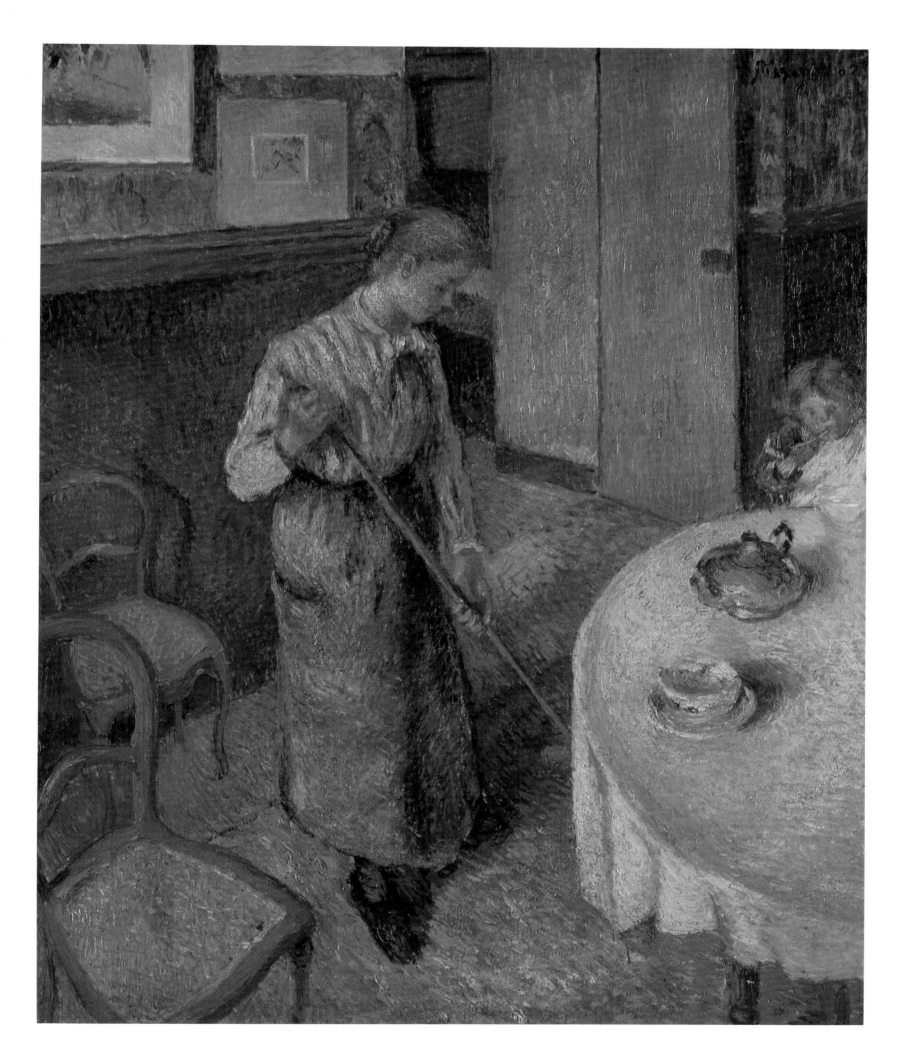

the Parisienne, as she pauses to pose.

A comparison of the different approaches to composition is also instructive. Where Morisot's figure is centrally placed and looks directly at the spectator, Pissarro's is seen from above. Pissarro adopts a plunging viewpoint, tilting up the table top and chair seats toward the picture surface and setting off the curve with angular straight lines in a carefully interlocking pattern. Pissarro's small, even touches betray a steady, labored approach as he struggled to find a way to deal with the shifting flux of light sensations. His painting and the palette he uses is altogether more sober and considered, and recalls the interiors depicted by the Dutch Masters of the seventeenth century.

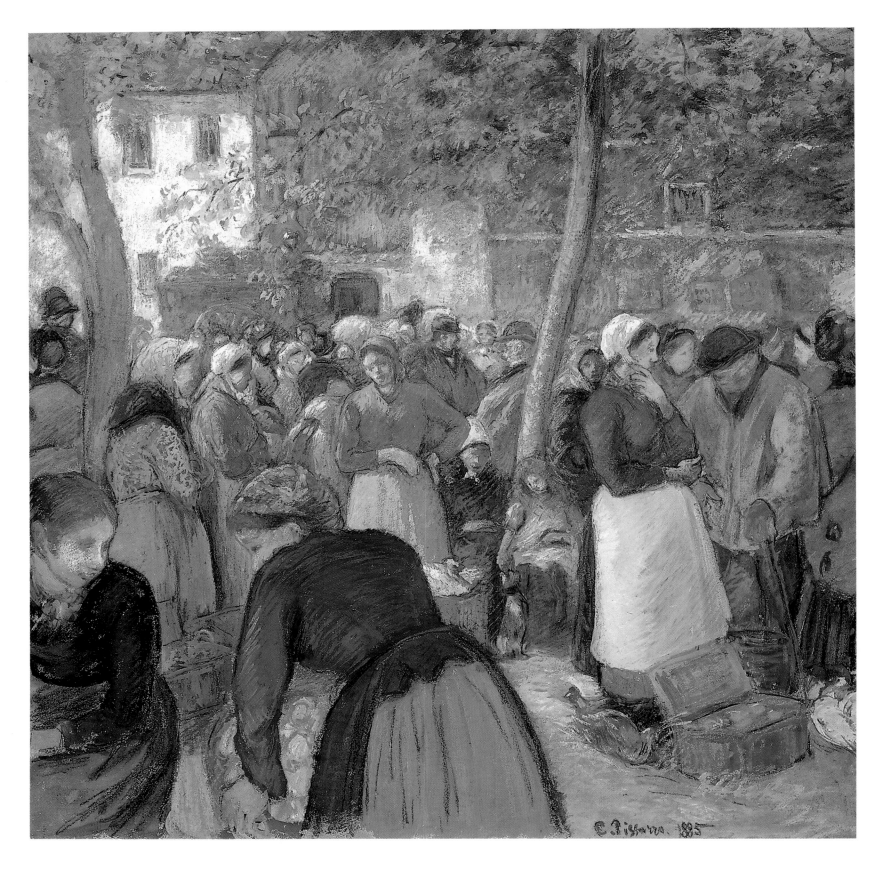

Poultry Market at Gisors, 1885

Gouache and black chalk on paper
mounted on canvas
32¼×32¼ inches (82×82 cm)
Boston, Museum of Fine Arts

In 1883 Pissarro and his family moved to the village of Eragny, in the valley of the Epte. His new interest in the figure and in drawing had led him, in the early 1880s, to tackle a number of views of the market at Pontoise. Here he shows the busy scene in the poultry market at Gisors, the nearest market town to Eragny. The market, where peasant farmers from the surrounding vil-lages would present their produce for sale, represented the end of the chain of agricul-tural production, every stage of which is represented in Pissarro's work. His fond-ness for this theme can be compared to the interest shown by his contemporaries in scenes of urban work, and bears out Degas' observation about the essential difference between Pissarro and his predecessor Mil-let: 'Millet's peasants work for mankind, Pissarro's work for a living.' Rather as in Degas, from whose example Pissarro learned a great deal at this stage of his career, Pissarro creates a sense of the momentary by avoiding a conventional balanced composition. Instead, he fills much of the foreground with the two women in conversation, one seen in mid movement from behind as she lifts a heavy basket, both cut off by the canvas edge.

The work is painted in gouache, a water-color paint which has a chalky, opaque appearance, on an unusual square canvas, a format Pissarro used again the following year. The composition is complex but care-fully ordered and relates to a number of other drawings and paintings. It was in all likelihood done in the studio rather than in the market itself. The brushwork consists of small, short touches, rather like strokes of pastel, less heavy and dense than in *The Little Country Maid* of three years before.

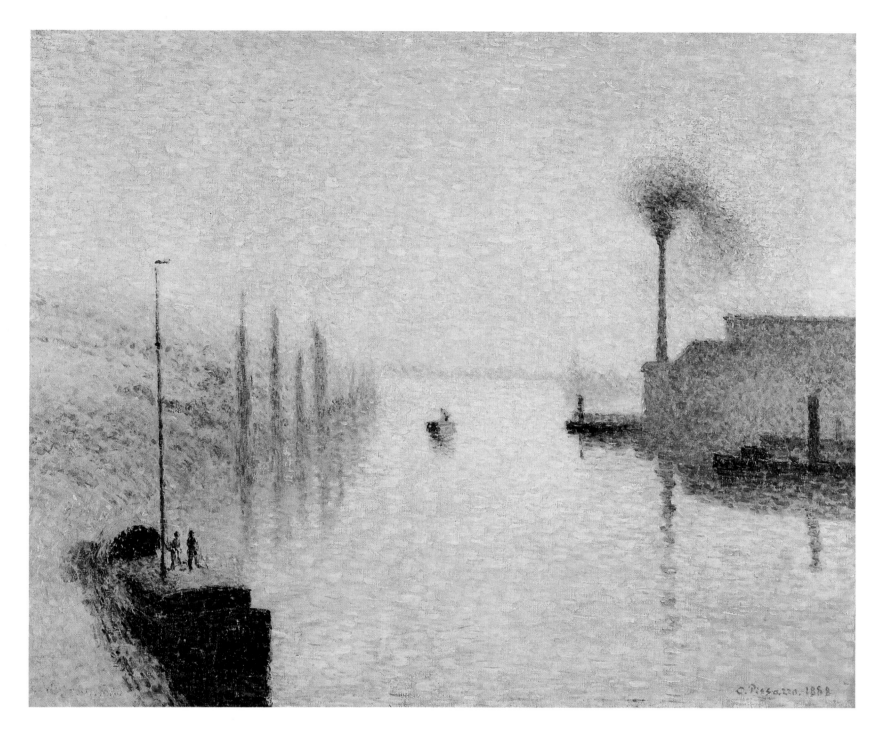

River – Early Morning (Île Lacroix, Rouen), 1888

Oil on canvas
17×23 inches (43×58 cm)
Philadelphia, Museum of Art

River – Early Morning is one of Pissarro's finest pointillist paintings. After his meeting in late 1885 with Seurat and Signac, Pissarro's painting had taken a new direction. He had been greatly impressed by the new initiatives they were pioneering, their creation of a unified image by painting with a regular dotted touch, blocking out the composition into simple shapes and areas, and coordinating color by systematic complementary contrasts to give a greater sense of luminosity and vibration. Such was his admiration for their results that, although thirty years older than they, he courageously adopted the new procedure himself. The three artists, with Pissarro's eldest son Lucien, had hung their

pictures together at the 1886 Impressionist show and had earned themselves the title 'the Neo-Impressionists.'

Pissarro first visited Rouen on a painting campaign in 1883, when he stayed for several weeks in the autumn. Several paintings and a number of etchings had resulted from this visit. These show his interest in the variety of motifs Rouen could provide: picturesque narrow streets and medieval houses, traffic on the streets and views of the industrialized riverside quays. One of the etchings made in 1883 shows exactly the view taken up some years later in oil, and possibly worked on intermittently between 1886 and 1888. The view looks eastward down the Seine and shows on the right the island of Lacroix.

Pissarro appears to have made no further working visit to Rouen when he took up this view again. The fact that it was executed in the studio and not from direct observation meant Pissarro had to rely on memory and on earlier images which may

have assisted him in producing this highly simplified image. The misty dawn moment also helps to reduce the details to a minimum, the pearly gray tones creating a shimmering veil of opaque light which drapes the lazy river.

He did not pursue the Neo-Impressionist procedure of systematic color division for long. As he explained to the Belgian Neo-Impressionist Van de Velde in 1890, he had found it '. . . impossible to follow my sensations, and consequently to give a sense of life and movement, impossible to follow the effects of nature, so fugitive and so admirable, impossible to give my drawing an individual character. . .' Such were the practical difficulties underlying the seemingly effortless harmony of *River – Early Morning*.

The Gleaners, 1889

Oil on canvas
26×32 inches (66×81 cm)
Basel, Dreyfus Foundation

As a subject for painting, women gleaning carried strong associations with Millet, whose famous painting of the same theme would certainly have been known by Pissarro. Like Millet, Pissarro chose to group his figures close to the spectator, and to lay out the vast expanse of cornfield behind them. But, whereas Millet's workers were shown in rhythmic stooping pose, anonymous under their scarves, an image that suggested their fatalistic acceptance of their burden of toil, Pissarro's use of more varied poses allows his peasant women greater individual identity. That Pissarro intended to underline the fact and hardship of their work is clear from his treatment of the women themselves, with their awkward stances and movements, heavy limbs, and strong physique. They are a far cry from the prettified peasant harvesters so appreciated by Salon audiences. Yet the impression of harshness is counteracted by the evening light which casts a rosy aura of harmonious radiance over the scene, and by the unifying effect of Pissarro's small, broken brushstrokes, although he had abandoned the systematic divisionism and pointillism of the previous two years.

Pissarro was a frequent witness of the harvest at Eragny; these gently sloping fields, which he drew and painted at different times of year, were within easy walking distance of his home. Gleaning, the practice of gathering up the sheaves and ears of corn that remained after the harvest was over, was a backbreaking task usually performed by women. To glean at the end of the day had been the traditional right of the poor in rural communities but this right was threatened with abolition in the industrial age.

For an elaborate composition of this kind, Pissarro would work in the studio instead of *en plein air*. He would assemble the drawings of the figures and perhaps watercolor sketches made of the landscape, using them as documents to aid his memory without the distractions of the changeability of the weather and time of day. Pissarro's anarchist views and his bitter experience of making a living as a painter in Paris combined to make him acutely aware of differences between life in the city and life in the country. Although Pissarro's rural paintings have no overt

moralistic aims, the series of idyllic harvesting scenes to which his *Gleaners* belongs seems to express an optimism not present in his earlier work. Around 1889-90, much discussion focused in Paris on the new aesthetic of Symbolism and the new watchword was 'synthesis.' *The Gleaners* was exhibited at a one-man show at Boussod and Valadon in 1890, one of the last exhibitions organized by Theo van Gogh, and again two years later at Durand-Ruel's. Pissarro was hailed by younger critics of the time as going beyond material reality and physical sensations before nature, as having produced a more generalized synthetic image. Although at this time Pissarro's attitude to Gauguin's calculating adoption of a synthetic style was generally cynical and disparaging, he too, in seeking, as he claimed, a unified poetic vision, was in his way responding to the changing criteria of art criticism.

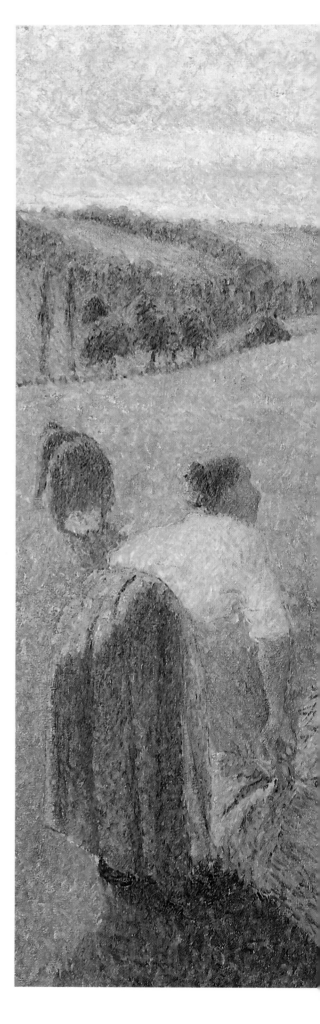

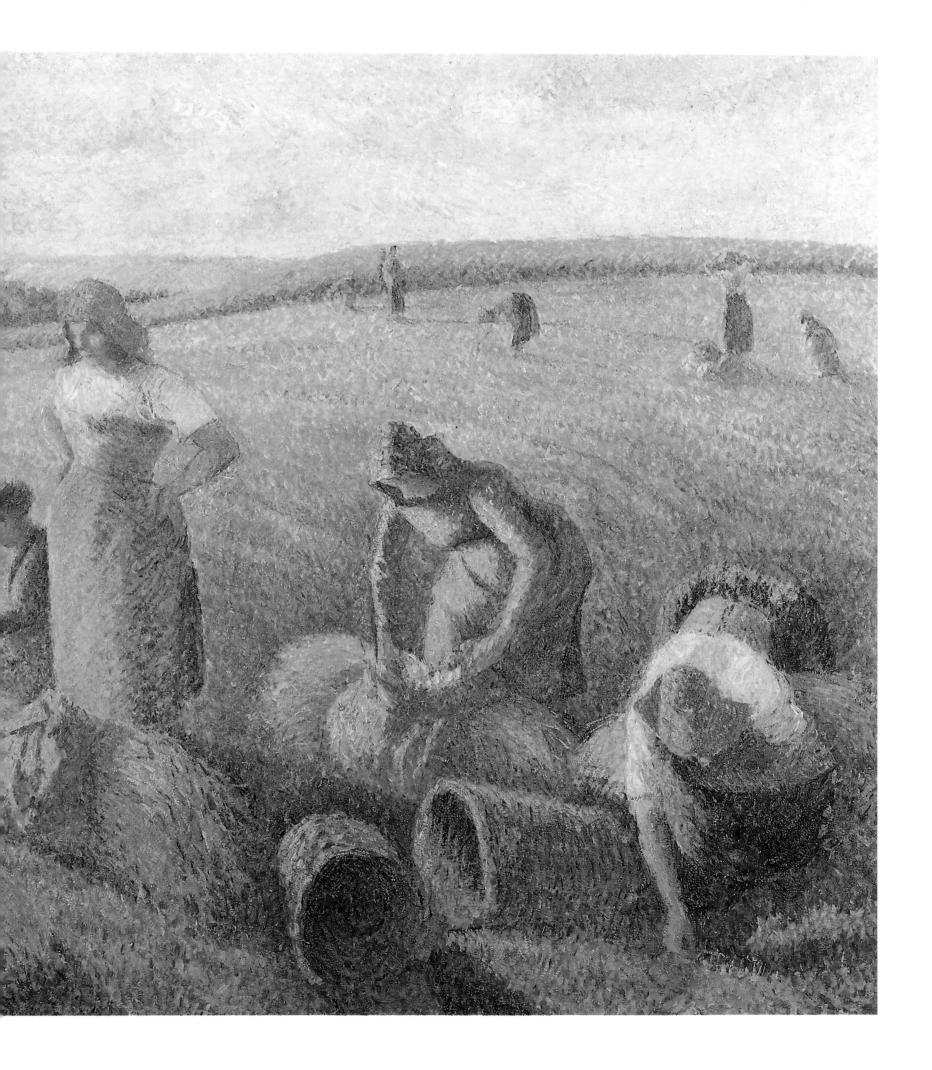

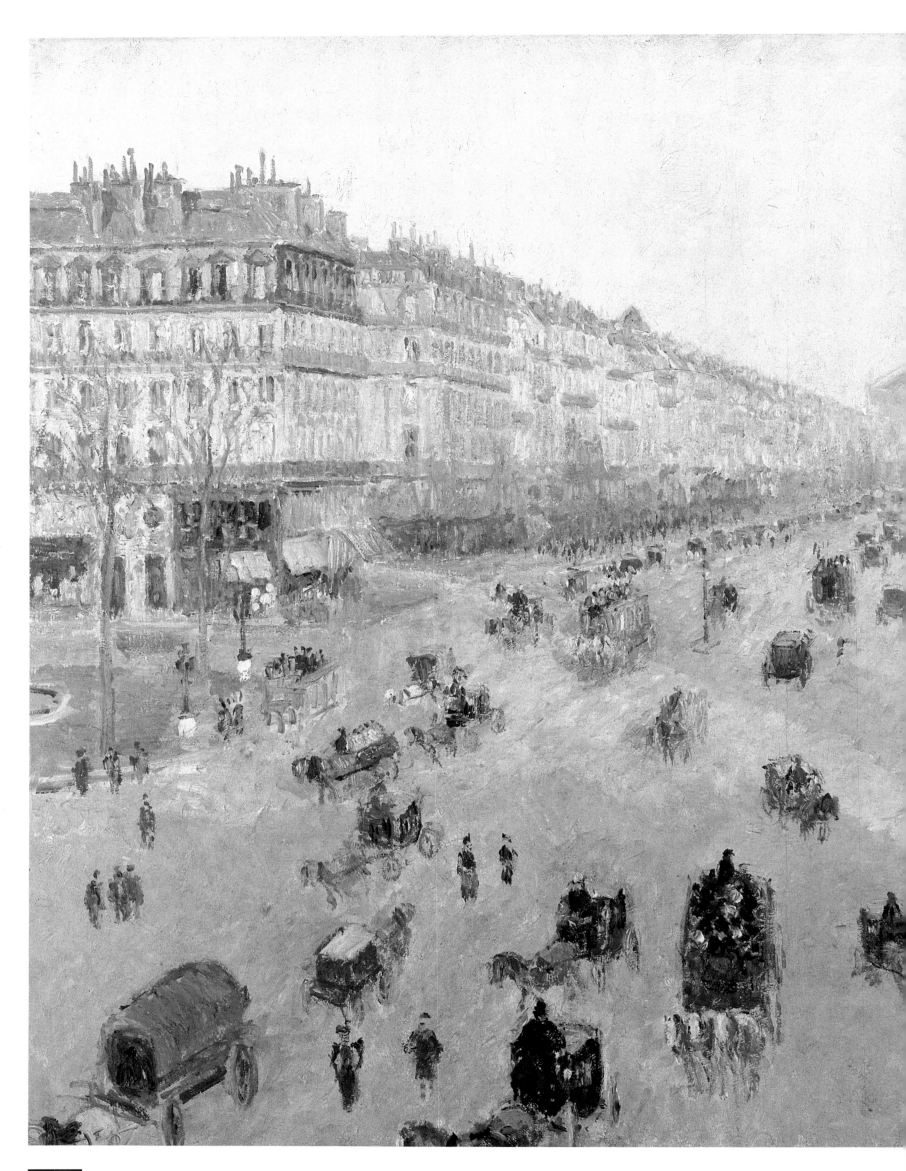

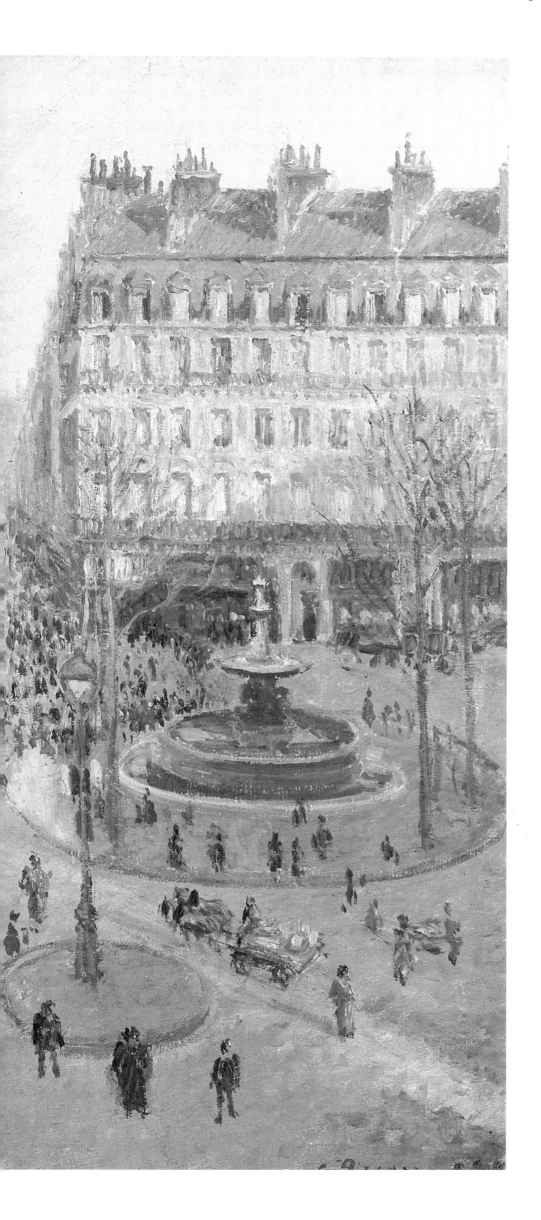

The Avenue de l'Opéra, Sun on a Winter Morning, 1898
Oil on canvas
29×36 inches (74×92 cm)
Reims, Musée Saint-Denis

Unable to paint out of doors any longer because of eye trouble, in late 1897 Pissarro found a room in the Grand Hôtel du Louvre, right in the center of Paris, which allowed him a view northwestward up the avenue de l'Opéra. Over the next few months, he painted a series of pictures, both looking up the avenue and also looking down on the Place du Théâtre Français to the lower right of this picture. This canvas was bought and exhibited with others of the series by Durand-Ruel in May 1898.

Pissarro was attracted to the way in which winter weather both blurred and defined the outlines of the city. Charles Garnier's eyecatching Opéra (started in the early 1860s and opened in 1875), which was intended as the focal point of the avenue, is scarcely visible in Pissarro's painting. Pissarro's motif has a stable quality to it: the long funneling perspective of the avenue, the spacious crossroads, the circular fountain in the Place, the regular height of the buildings and the consistent sandy gray of their stonework.

This regularity had been one of Baron Haussmann's aims when he undertook the major scheme of improvements to the city during Napoleon III's autocratic Second Empire. The avenue de l'Opéra itself was constructed between 1876 and 1877. The scene is dissolved by Pissarro's broad yet light brushwork, which catches the crisp morning light of winter, casting long blue shadows which serve to define the composition as much as the urban structures themselves do.

The series of Paris street views belongs, with Pissarro's port scenes of Dieppe, Rouen, and Le Havre, to a campaign of cityscapes produced in the last decade of his career. As a group, they form a marked contrast to his equally important group of rural images which continue his long-established interest in the image of the country. The message of Pissarro's city paintings is ambiguous; he seems to enjoy the spectacle of the modern city from the safe distance of his hotel room, focusing, on the one hand, on the bustling metropolis with its novel modes of transport, on the other, as in this painting, on the calm, light-filled, ordered spaces of the new city.

Pierre-Auguste Renoir

French 1841-1919

La Grenouillère, 1869

Oil on canvas
32×26 inches (81×66 cm)
Stockholm, National Gallery

It is with the paintings of *La Grenouillère* by Monet and Renoir that we see for the first time the hallmarks of 'Impressionism.' They were painted as open-air sketches for larger, more finished pictures that would be sent to the Salon. By the 1860s such practice was commonplace; what was revolutionary about these paintings was that they were eventually considered by their creators as completely finished works in their own right and by implication the equal of any studio-based academic paintings that filled the walls of the Salon. Ambitious and desiring to paint a modern, rather risqué subject, the two painters had set up their easels at a popular bathing spot known as La Grenouillère, which translates as 'the Frog pool.' The reference to the Parisian slang word for a woman of easy virtue leaves one in no doubt as to the rather shady reputation of the place. It was within easy reach of the capital, situated between Bougival and Chatou on the banks of the River Seine, and was an ideal place for a day out. Under the shade of the trees one could eat, bathe, go boating, or indulge in '*les affaires du coeur.*' Renoir and Monet painted several versions of this scene and, although sometimes their easels must have been only feet apart, their versions are very different.

Unlike his friend Monet, Renoir's central concern throughout his life was people, particularly women, and because of this he has not been able to avoid giving his figures a certain amount of delicate, yet precise, definition. Like the figures in Manet's *Music in the Tuileries Gardens* Renoir's figures are sketchily painted but they are closely observed; their particularities and relationships are caught in a few deft strokes of the brush which situate each person exactly in the crowd, the women in their crinolines, the men in their casual, ready-made clothes leisurely enjoying a perfect summer's day as the midday sun reflects off the water. The brushwork is feathery and soft, the scene hazily focused as if seen through half-closed eyes, and the figures fuse into their surroundings. Instead of being a privilege only of the aristocrats, it is now the turn of the ordinary people of Paris to enjoy the delights of free time. Despite its deliberately modern and casual subject matter, the painting is, in fact, a homage to Renoir's beloved artists of the eighteenth century. He was especially fond of Watteau's *L'Embarquement pour Cythère*, then as now to be seen in the Louvre, Paris, and Renoir's painting has caught something of the refined elegance of that work.

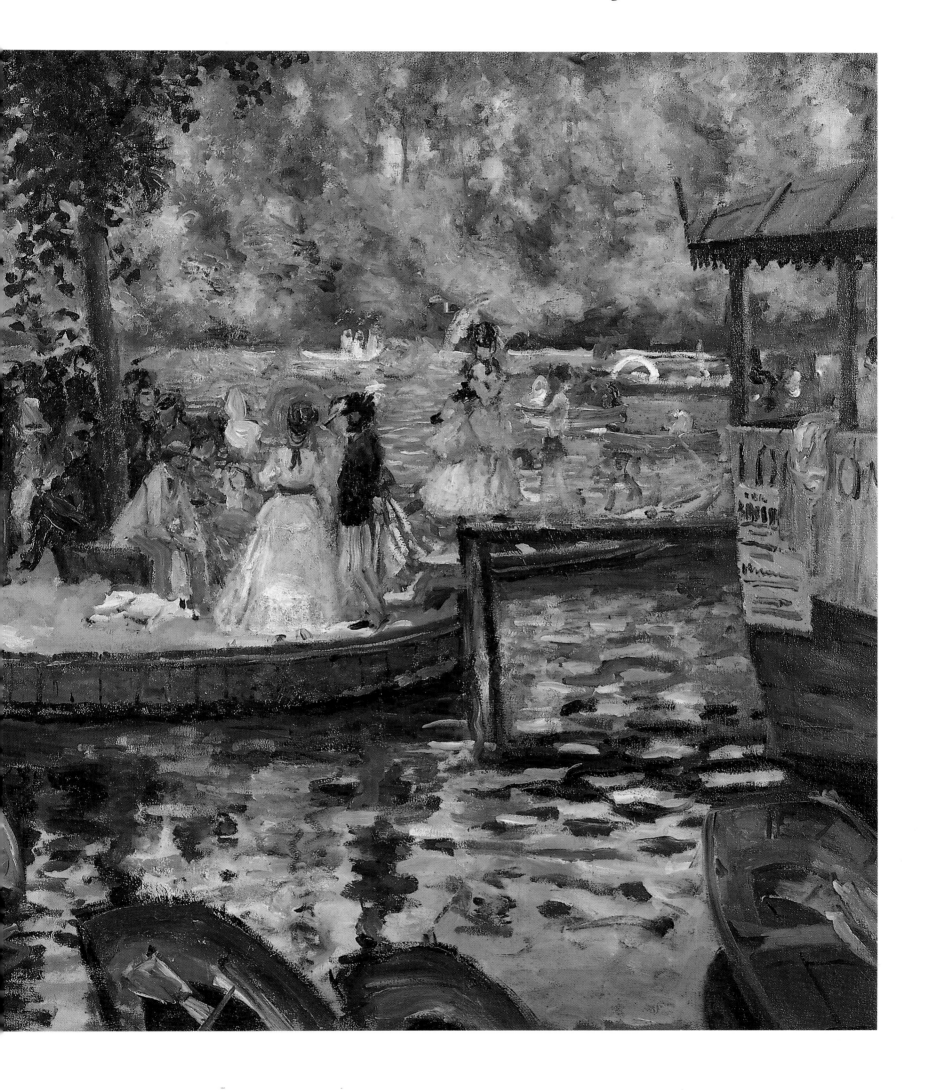

Pont Neuf, Paris, 1872

Oil on canvas
29¾×37 inches (76×94 cm)
Washington D.C., National Gallery of Art

The scene has changed very little since it was painted over 100 years ago. Indeed, it is from such works that the popular image of Paris has been culled and, subsequently, it is difficult to believe that there was ever a time when the paintings of the Impressionists were not highly valued. Three years after this painting was completed, however, Renoir, Manet, Sisley, and Berthe Morisot held an auction of seventy-three of their works at the Hôtel Drouot. The entire stock only realized 2000 francs. Renoir had placed twenty of his canvases at the auction. The sale was a disaster, the police had to be called to maintain order, and ten of Renoir's works did not even reach 100 francs apiece. A certain M. Hazard paid 300 francs for this painting. Nearly fifty years later, in 1919, it changed hands for nearly 100,000 francs. John Rewald records Renoir's brother Edmond's account of the genesis of the painting:

We established our quarters at the entresol of a little café at the corner of the quai du Louvre, but much nearer the Seine than are the present buildings. For our two coffees, at ten centimes each, we could stay at the café for hours. From here Auguste overlooked the bridge and took pleasure, after having outlined the ground, the parapets, the houses in the distance, the place Dauphine, and the statue of Henri IV, in sketching the passersby, vehicles, and groups. Meanwhile I scribbled, except when he asked me to go on the bridge and speak with passersby to make them stop for a minute.

The intense light of a summer's day beats down, reflecting off the buildings and isolating the people in a glare of light. Each is caught in a distinctively awkward pose familiar to us through our exposure to the split seconds of frozen time in contemporary photography.

Similar subjects by Pissarro and Monet show how much attention Renoir gave to his figures, which despite the brevity of their handling retain their identities as individuals.

Gust of Wind, 1872

Oil on canvas
20×32 inches (51×81 cm)
Cambridge, England, Fitzwilliam
Museum

The subject of the painting is a gust of wind, swirling through a very ordinary landscape in the Île de France. The long grass sways in counterpoint to the blustery clouds moving overhead. Renoir's feathery brushstroke has moved lightly across the canvas surface, sometimes fully charged with paint, sometimes painted so thinly as to leave the bare canvas visible. The surface of the canvas is flecked with separate touches of color sprinkled through the landscape, perhaps tracing the path of the wind. Its invisible progress animates the scene from the right-hand side of the painting, where the cloud mass, the house, and the poplar tree converge, down the hill to where we meet the cross rhythm of the diagonal formed by the bank of trees and bushes across the canvas from left to right. No figures or implied narrative distract us from this vibrant evocation of the transitory passage of a gust of wind glimpsed for a brief moment by the artist over a hundred years ago.

This painting was included in the auction of 1875 held at the Hôtel Drouot under the title *High Wind*, and sold for the small sum of only 55 francs.

La Loge, 1874

Oil on canvas
32×25 inches (81×64 cm)
London, Courtauld Institute Galleries

The models for this painting were Edmond Renoir, the artist's brother, and Nini, known as *Gueule-de-Raie*, which translates (rather surprisingly, given her undeniable beauty) as 'Fish-face.' Georges Rivière records that:

Between 1874 and 1880 Renoir's usual model was a pretty blonde girl called Nini. She was the ideal model; punctual, serious, and discreet, she took up no more room than a cat. We used to find her there when we arrived; she seemed happy there, and appeared in no hurry to leave when the sitting was over, or to abandon the armchair where she sat over a piece of needlework, or a novel picked up out of some corner – just as one sees her, in fact, in many of Renoir's studies.

The subject parallels work by Manet and Degas and is strongly reminiscent of the prints of Daumier and especially of Gavarni, whose work was highly regarded in the Impressionist circle. Its very familiarity may in fact blind us to its technical brilliance.

Renoir subtly engages the interest and involvement of even the most casual of viewers. As if looking through a pair of opera glasses, we are privileged to view this dazzling close-up of a beautiful woman, dressed to kill. Her companion, lover, or husband, preoccupied with whatever he can see through his glasses, does not hinder our almost indiscreet examination of her person. We are not encouraged to question our position vis-à-vis this box, so absorbed are we in the gaze of the woman, who bears a kinship, however distant, with Manet's barmaid of the Folies-Bergère.

Despite the tighter handling of the face and the power of this gaze, no single part of the painting disturbs the exquisite balance of black and mother of pearl. The dress, her jewels, and the flowers in her hair all create a rich sensuous surface.

The painting was first shown at the First group exhibition in April 1874 and was exhibited in London in March the following year. It was sold to Père Martin for 425 francs, and sold again in 1899 to Durand-Ruel for 7500 francs. It is now one of the jewels in the crown of the Courtauld Institute Galleries, London.

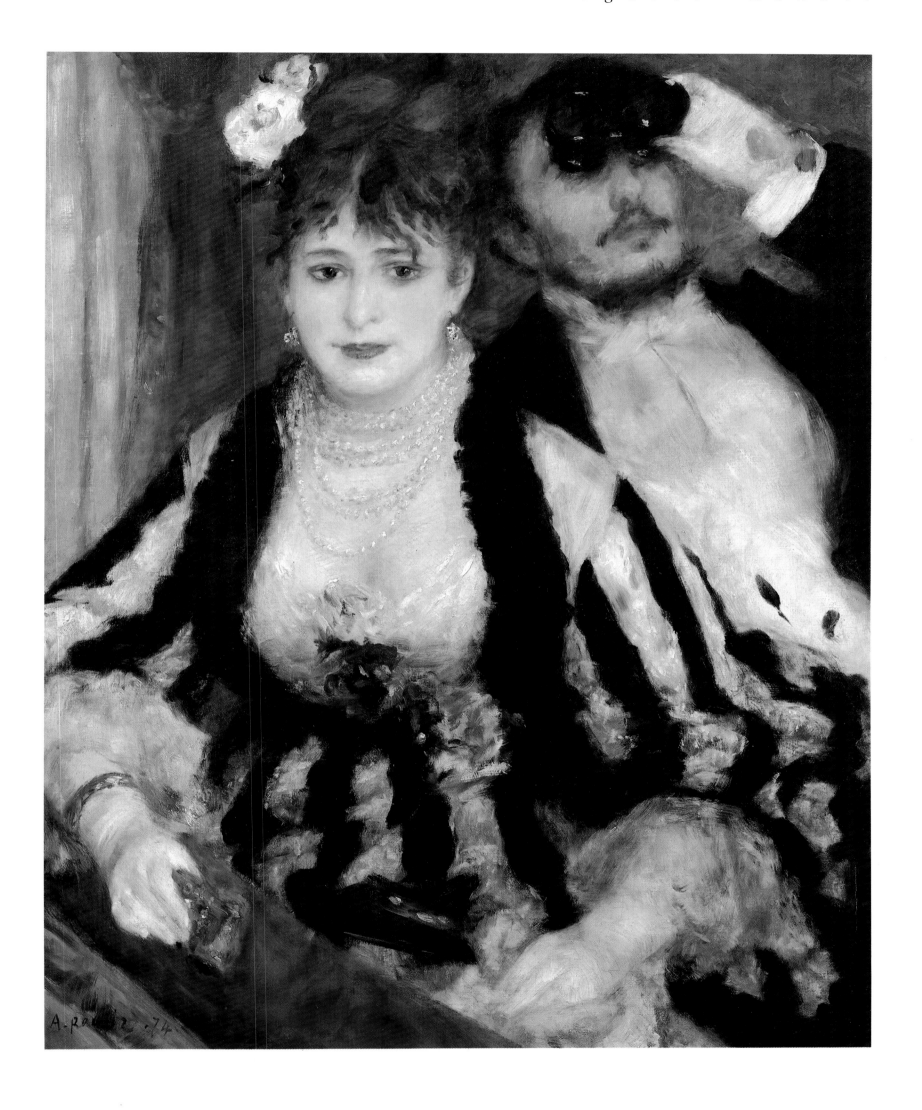

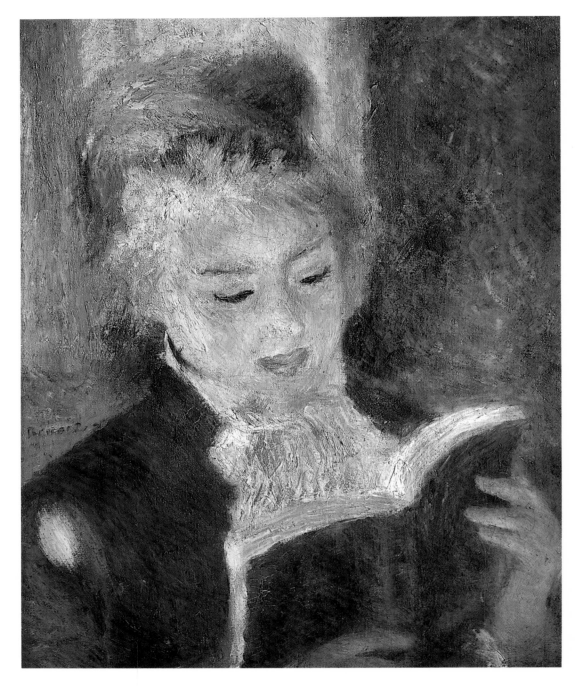

Woman Reading, 1874-76

Oil on canvas
18×15 inches (46×38 cm)
Paris, Musée d'Orsay

The light reflected from the pages of the open book illuminates the face of this elegant reader with an inner radiance. In its lightness of touch and intimacy of subject, the painting is yet another example of Renoir's deep regard for the painters of the eighteenth century, and in this case the works of Fragonard spring to mind. The intangible sense of intimacy comes in part from Renoir's composition. He has focused only upon the woman's face and hands, which implies that the viewer and artist are in close physical proximity to the model who, undisturbed by our presence, reads on, coquettishly aware of the enchanting way the reflected light illuminates her features. Renoir may have had little regard for the intellectual abilities of the female sex but he knew how to instill a canvas with the pulsebeat of a living being.

Nude Woman in the Sunlight,

1876
Oil on canvas
36×25 inches (81×65 cm)
Paris, Musée d'Orsay

Renoir always affirmed his love of the female figure and gave it a central place in his work. Despite his interest in landscape painting, his *oeuvre* may be considered a continuation of the figure paintings of Rubens, Fragonard, and Delacroix. In this painting, the model is posed in an almost liquid landscape bathed in dappled sunlight which falls upon her, causing a pattern of reflections and highlights which the artist has transposed directly on to her body. Late in life Renoir told the art historian Walter Pach, 'When looking at a nude figure I see myriads of little shades, and what I have got to do is to select those which, on my canvas, will make that flesh a living quivering thing.' It was Renoir's directness of approach, his rejection of the conventional means of describing light and shade in favor of a method that is much closer to our visual experience, that was to awaken the critics' wrath. He exhibited the painting in the Second Impressionist show, where it elicited this response from Albert Wolff, the conservative art critic of *Le Figaro*:

Would someone kindly explain to M. Renoir that a woman's torso is not a mass of decomposing flesh with green and purplish blotches that indicate a state of complete putrefaction in a corpse. . .

His model was Anna Leboeuf, who figures in many of Renoir's paintings and, like so many nudes in Western art, has been given a passive, almost somnambulant, expression; her averted eyes suggest that she is unaware of the painter's analytical gaze as he examines and records every nuance of light that falls on her perfect skin.

The painting was among those bought by Gustave Caillebotte and left, on his death in 1894, to the French nation.

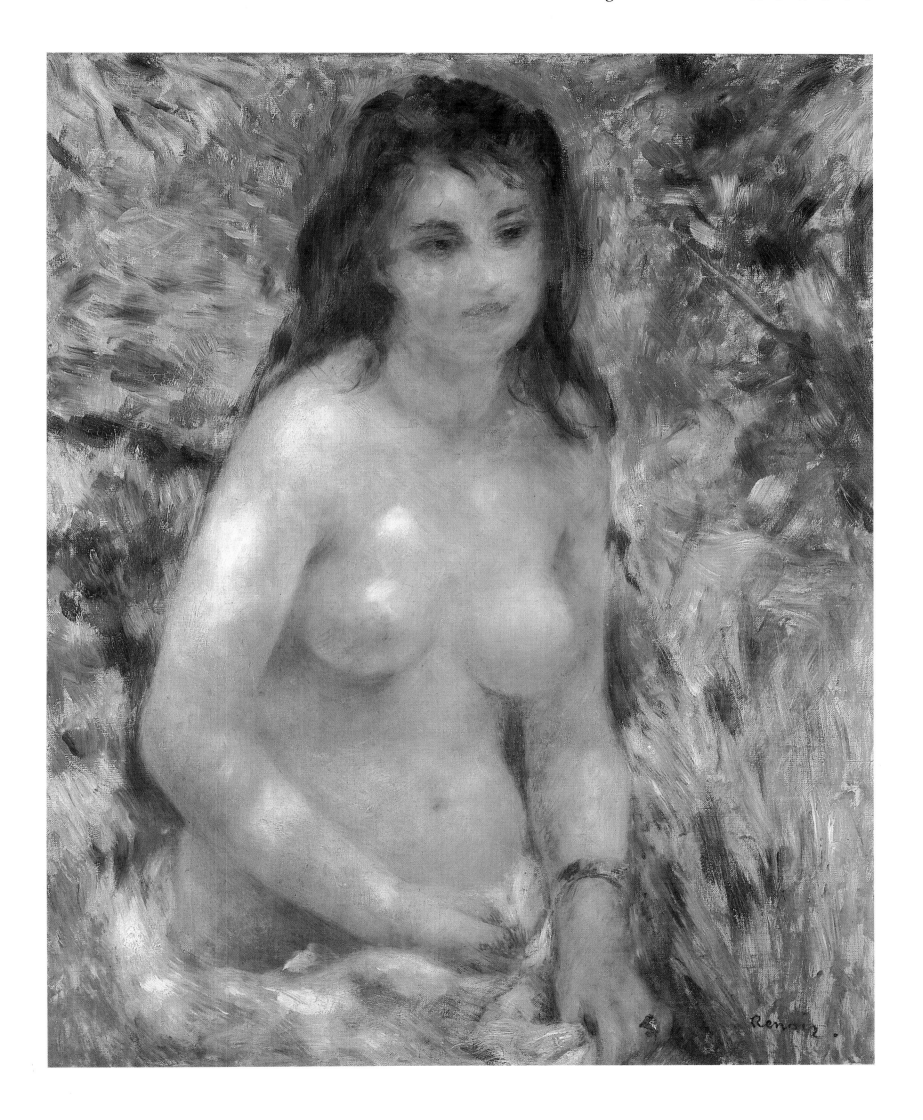

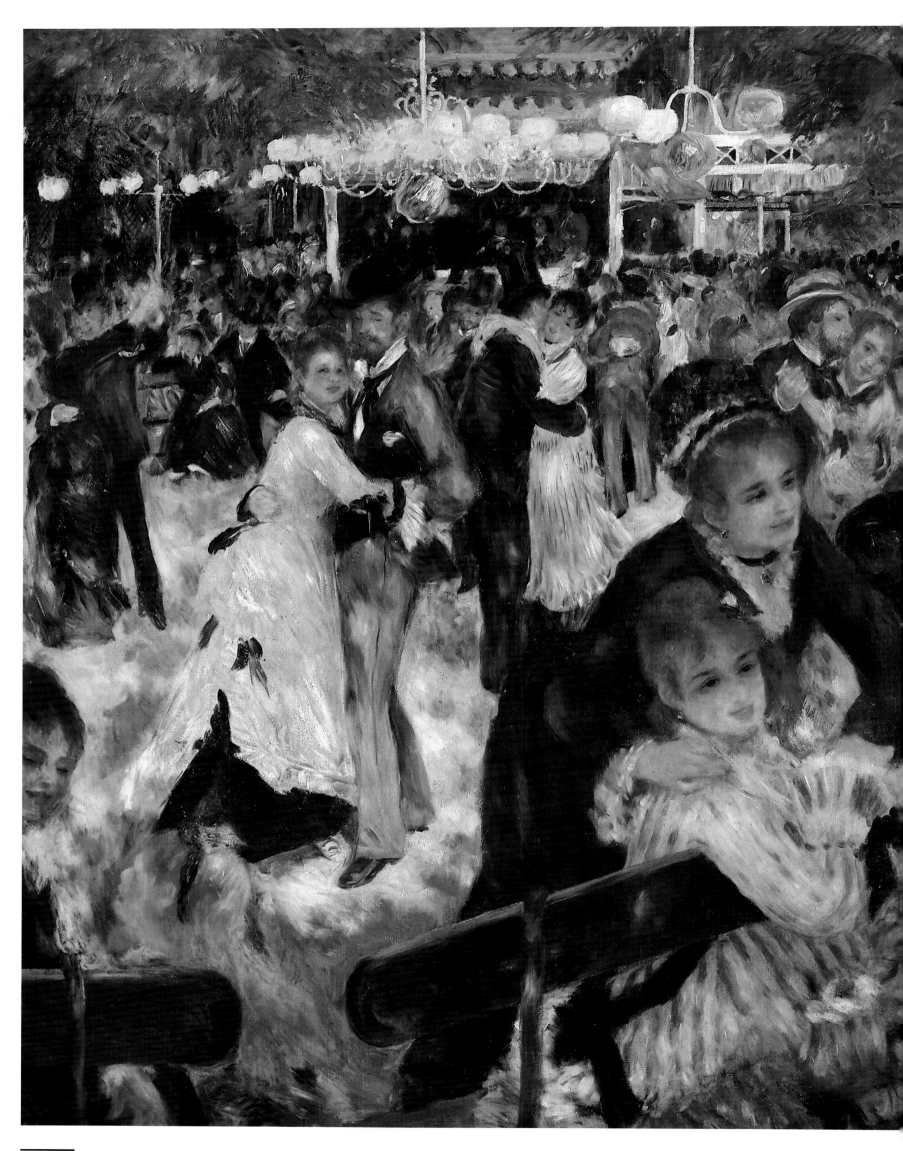

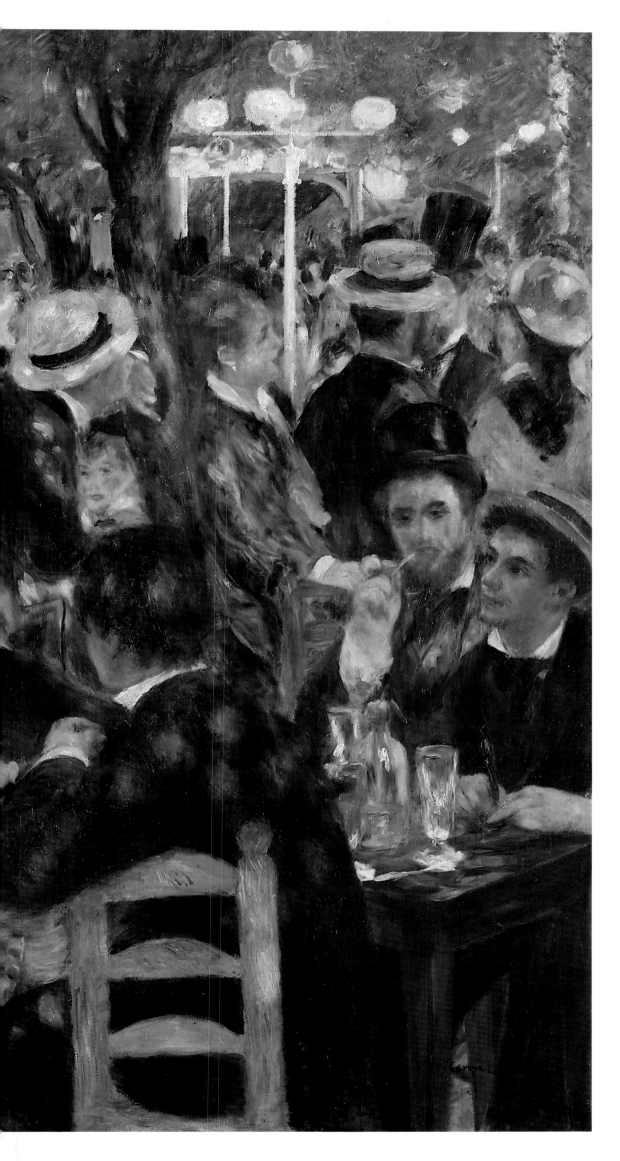

The Ball at the Moulin de la Galette, 1876

Oil on canvas
52×69 inches (131×175 cm)
Paris, Musée d'Orsay

This perfect evocation of people enjoying themselves transcends the specific nature of its subject to speak to us all. Rarely has the informality of a social moment been so cunningly caught. The painting creates a sense of movement, of social intercourse, of music and light so convincingly that it seems we are not looking at a painting at all, but that rather we have been magically transported to the very place in question.

Our entry into the picture is by way of the group talking to one another on the right. They are obviously friends chatting and looking around them as if in expectation of the imminent arrival of others. Renoir has left an empty space at the bottom right, as if to invite the viewer to join the group. Once at the table, one is part of a spiral leading around to the standing figures and across to the couples on the dance floor. Each stage of the dance is shown; the asking, the boy attempting to attract the attention of the girl leaning on the trunk of the tree, the dance itself, and, in the couple seated below the bandstand, the inevitable lovers' tiff.

Renoir places each couple on different planes of the picture area; in the foreground, the middle distance, and at the rear of the dancing space. Each is shown in a different attitude to suggest the various aspects of the dance. The spectator is led to imitate the movement of the dance as the eye leaps, or waltzes, from group to group, and the lights and posts regulate the rhythm of the viewer's gaze across the expanse of the painting.

The leitmotif of the painting is the light falling through the trees on to the people below. There are hardly any sharply defined edges; light, shade, and color are caught in a sequence of delicately brushed separate strokes fused into one another. Shown in 1877 at the Third Impressionist exhibition, it received some favorable reviews, among them one by the improbably named 'Ch Flor O'Squarr': 'The painter has perfectly captured the raucous and somewhat bohemian atmosphere of this open-air dance hall . . . the joyful light fills every corner of the canvas and even the shadows reflect it . . . The whole painting shimmers like a rainbow. . .'

Madame Charpentier and Her Children, 1878

Oil on canvas
60½×75 inches (154×190 cm)
New York, Metropolitan Museum of Art

Renoir did not participate in the Fourth Impressionist show of 1878; instead, he exhibited this portrait at the Salon of 1879 and, in doing so, braved the displeasure of the other members of the Impressionist group. 'There are scarcely fifteen art collectors in Paris capable of liking a painter without the backing of the Salon,' he wrote in a letter to Durand-Ruel. 'I sent my portrait to the Salon for purely commercial reasons.' Renoir's decision to exhibit at the Salon may also have been due to the high social position of his sitter, Madame Charpentier. Her husband was the influential and notorious publisher, Georges Charpentier, the editor of the works of Émile Zola and Guy de Maupassant.

One of the foremost literary hostesses of her day, Madame Charpentier was able to ensure that the work would be well exhibited, and most critics praised the portrait, although many admonished the painter for sloppy draughtsmanship. One critic complained that it was '. . . a very incomplete sketch done in accurate tones . . . a slack transparent sketch, which seems to have been executed with different colored balls of cotton wool.' Certainly it was more acceptable in style and subject matter than any of his previous works. The influential critic Castagnary thought the painting:

. . . a most interesting work . . . the palette is extremely rich . . . not the least trace of conventionality in either arrangement or handling. The observation is exact as the execution is free and spontaneous. It has the elements of a lively art whose future development we await with confidence.

Camille Pissarro wrote, 'Renoir is a great success at the Salon; I think he is "launched." All the better! It's a hard life being poor!'

The work is an icon of the *haut-bourgeois* life of the period. The interior is arranged in the latest Japanese taste, the gown is designed by Worth, the exclusive couturier; even the children are exquisite exemplars of style. Renoir has artfully exploited their attractive casualness. The six-year-old Georgette is seated on Porto, the Newfoundland family dog, and at the heart of the family group is the three-year-old Paul, sometimes referred to, mistakenly, as 'a girl' on account of his ringlets and blue dress. Domestic bliss, order, and high luxury are represented by Renoir in this picture as something almost naturally achieved, as beautiful and exquisite as the still life which completes the composition.

Edmond Renoir noted that '. . . none of the furniture was moved from its usual place and nothing was prearranged to emphasize one part rather than another.' The painting reveals Renoir's increasing dissatisfaction with the looseness of the Impressionist approach, his continued awareness of the work of the Salon portraitists. His return to a more detailed and finished way of working may be seen in the hands and faces of the figures. Delightful though the painting is, and however interesting it has become as a historical document of the period, it lacks the psychological probity of Degas' work.

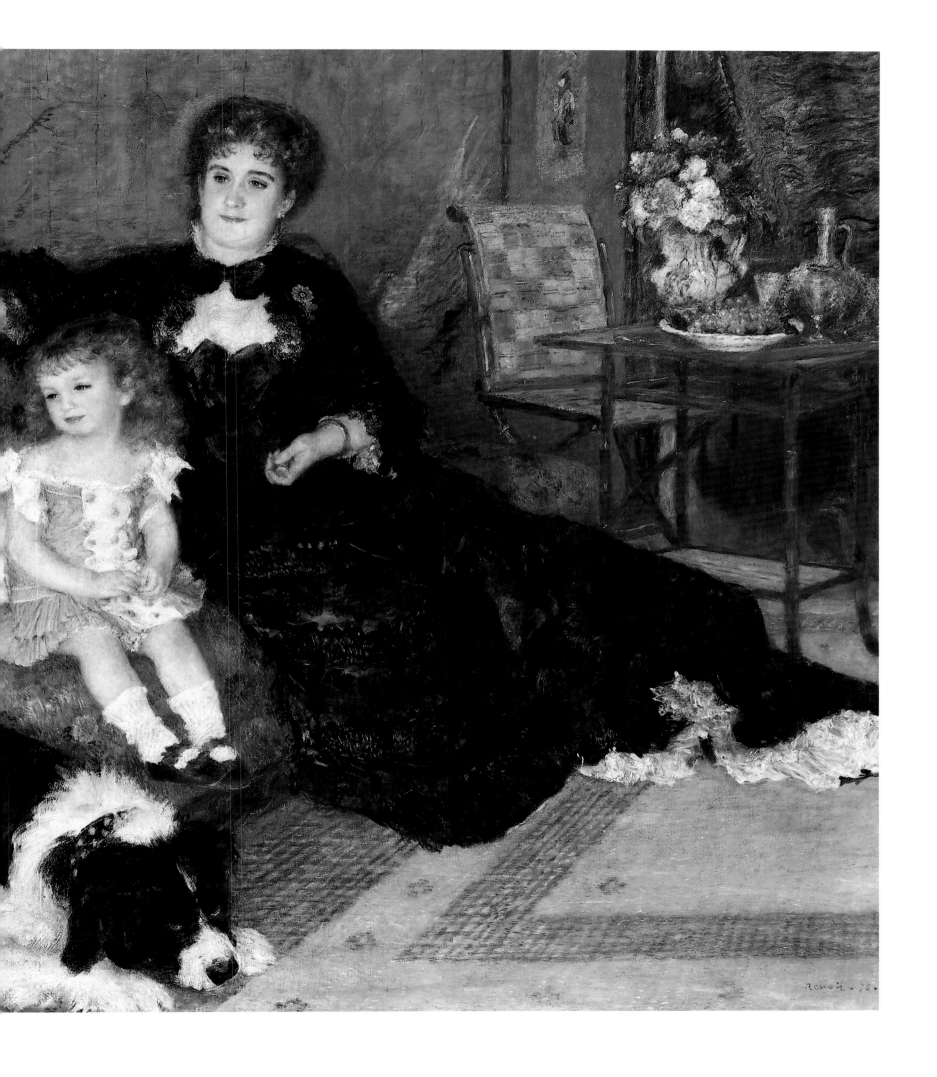

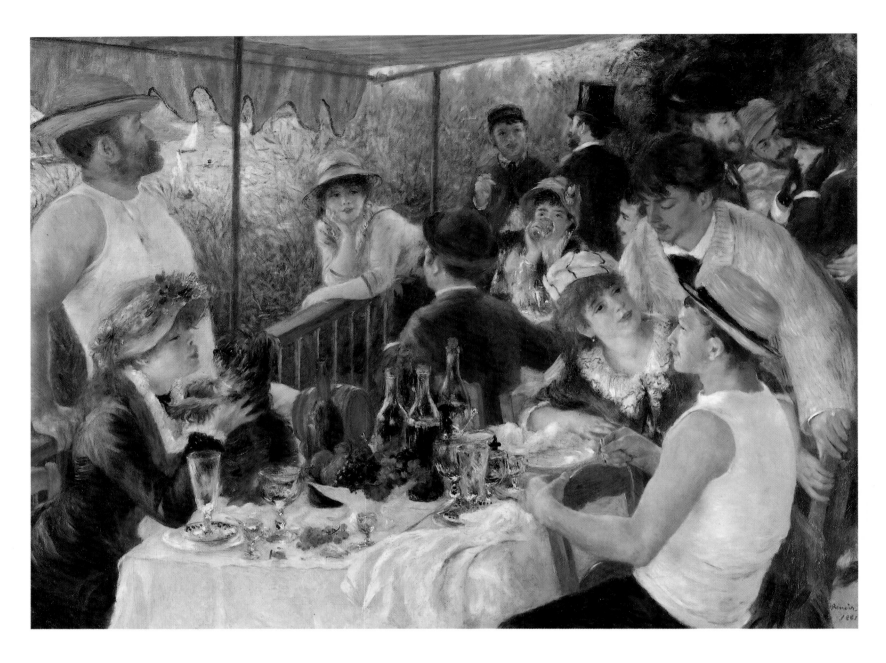

Luncheon of the Boating Party,
1881

Oil on canvas
51×68 inches (130×173 cm)
Washington D.C., Phillips Collection

The setting for this painting is Pére Fournaise's restaurant at Chatou, on the Île de la Chausée, facing the left bank of the River Seine between Bougival and Rueil. During the 1880s, the vogue for *canotage*, or boating, was at its height, and Renoir responded by producing a number of works related to this theme.

He began work on the painting in the summer of 1880 and sold the work to his dealer, Durand-Ruel, early in 1881. It was listed in the stockbook as *Déjeuner Champêtre*, exhibited at the Seventh Impressionist show as *Un Déjeuner à Bougival*; later still, at his one-man show of 1883, it was given the title *Noces à Bougival*. All very confusing. It may be seen as a pendant to his *Ball at the Moulin de la Galette*, as, once again, it is a celebration of Renoir's own leisure activities and records his growing dissatisfaction with the landscape bias of Impressionist paintings.

Luncheon of the Boating Party is a perfect illustration of Renoir's seemingly effortless power of composition. The picture is packed full of incident and detail and yet the viewer's gaze flows from group to group. The still life resting on the brilliant white tablecloth anticipates the encrusted, color-drenched canvases of Bonnard. Straw hats presented an excellent opportunity to introduce the otherwise rare color yellow into a painting and it is surprising how many straw hats we encounter in the work of the Impressionist painters and their associates. The figure in the center of the composition has his back turned to us and leads us to the subject of his attention, the pretty girl leaning on the balcony whose languid form is framed by the asymmetrical pattern formed by the support structure of the awning.

Luncheon of the Boating Party is an open, artfully casual composition that allows us to explore at our leisure the many delightful relationships envisaged by the painter. With the exception of the two men at the far end of the balcony, everyone in the painting seems to be engaged in some kind of flirtatious dialogue, even if it is only with a lapdog held on the table.

Place Clichy, 1881

Oil on canvas
26×22 inches (66×56 cm)
Cambridge, England, Fitzwilliam Museum

Painted in the same year as *Luncheon of the Boating Party*, this small painting is one of the most delightful of all the Impressionist canvases.

Renoir has caught a bird on the wing. Drawing apart from the swirling bustle of the Parisian crowd, a young woman pauses, as if to cross the road. Behind her, in soft focus, the rush of the day continues, regardless of her presence. The precision of modeling of the Parisienne's face and the rococo-like handling of her feathered and beribboned hat are firmly contrasted with the rest of the scene.

As our eyes move up the diagonal of the curbside toward the omnibus in the top left-hand corner, our attention is neatly arrested by a touch of pure vermilion. This, the only strong color in the painting, describes the closed umbrella held close to her by another young woman who seems to be passing the time of day in the com-

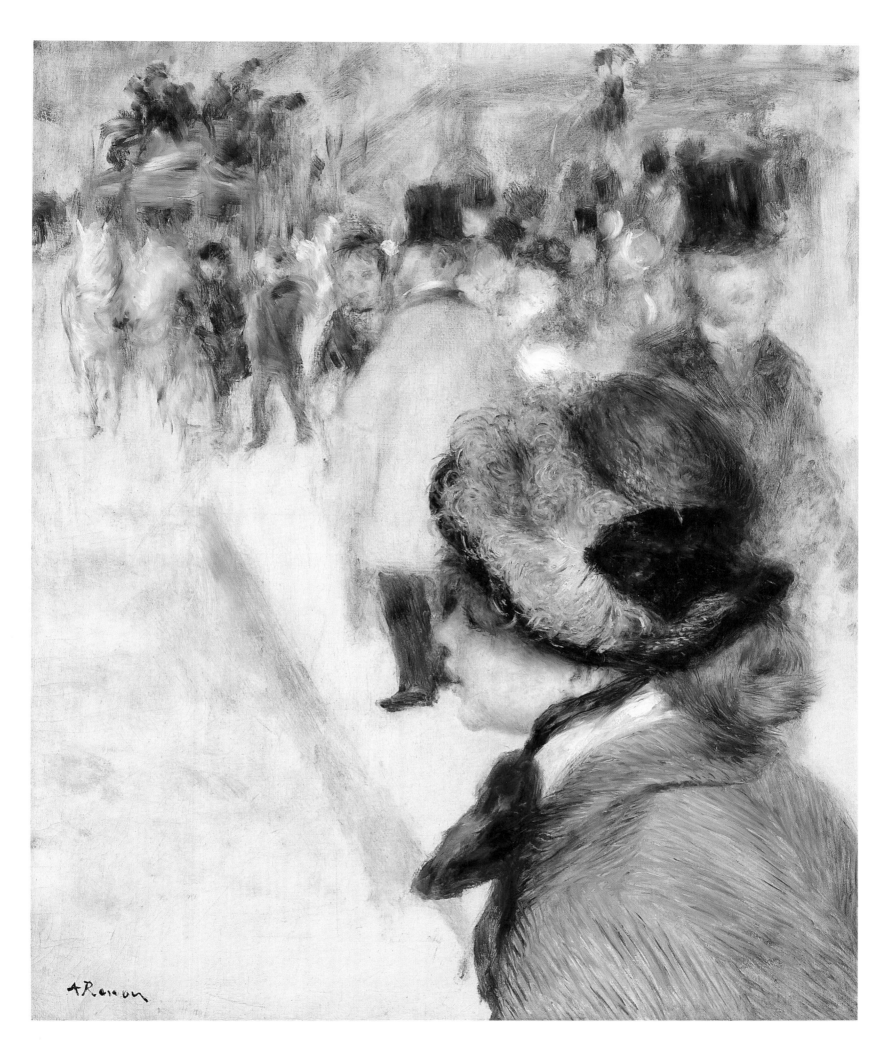

pany of a smartly dressed city gent.

In comparison with the street scenes by the other Impressionist painters, and in particular with those of Gustave Caillebotte, *Place Clichy* is very much a saccharine version of city life.

The painting represents the state of Renoir's art just before the tightening up of his style that is evident in his works of the mid 1880s and best represented in his *Bathers* of 1887. Perhaps in the delineation of the young girl and the separately treated, sketchlike background, Renoir has already begun the move away from the Impressionist tenet of the enveloping atmosphere, ideal for things viewed in the middle distance but problematic when one wishes to treat objects close at hand.

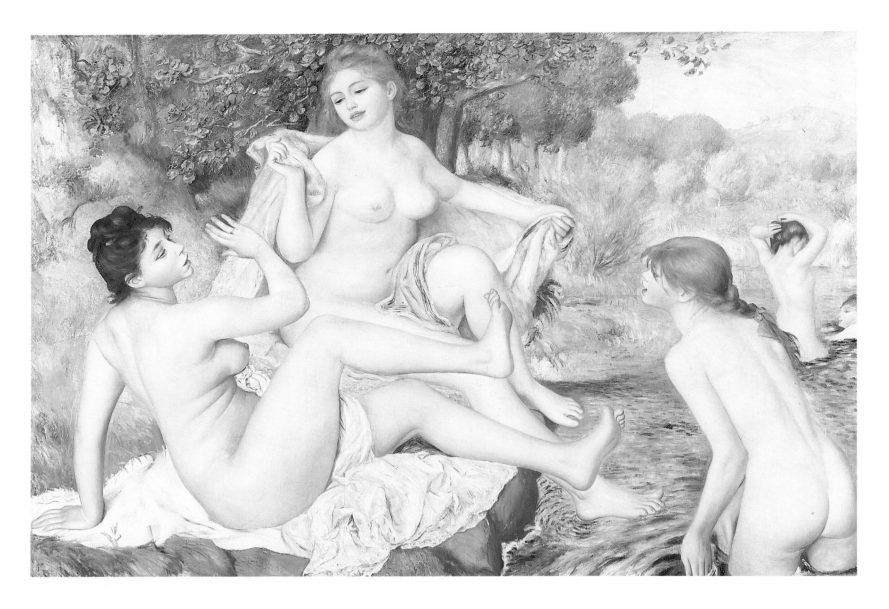

The Bathers, 1887

Oil on canvas
46¼×67¼ inches (117×171 cm)
Philadelphia, Museum of Art

'I wanted to tell you,' Renoir told his dealer Vollard, 'that in about 1883 there occurred a kind of break in my work. I had got to the end of "Impressionism," and I had come to the conclusion that I didn't know how either to paint or draw. In short I had come to a dead end.' For Renoir, technically a very gifted artist, such a statement comes as something of a surprise.

The 1880s saw many of the artists associated with the Impressionist group express dissatisfaction with their work of the previous decade. In the portrait of *Madame Charpentier and Her Children*, Renoir had shown that he could work in a firmer, grander style than that of his *confrères*. He had always been attracted to what he referred to as the art of the museums, and it is therefore not surprising that in *The Bathers*, one sees him returning to traditional sources of inspiration.

A far cry from the bathers of *La Grenouillère*, dressed in their modest bathing costumes, *The Bathers* represents an idyll, an erotic dream of young women amusing themselves on the banks of a river. The location could be France, Italy, or even Greece, the participants could be village girls or latterday waternymphs. Renoir's love of women and his lack of inhibition contrast markedly with Cézanne's attempts at the same subject.

This carefully planned work is the result of nearly four years' painstaking labor. *The Bathers* is the masterpiece of what the artist himself terms his 'sour period,' his *manière aigre*. It can be seen partly as a response to his journey to Italy, where he was stunned by the work of Raphael in the Vatican and the Farnesina. It is interesting to note that many years later Picasso was equally impressed by the calm grandeur of the murals at Pompeii.

The immediate source for the painting was the bas-relief at Versailles by the seventeenth-century sculptor François Girardon, but perhaps Renoir's main inspiration was that charmingly decorative masterpiece of seductive art, Boucher's *Diana Getting Out of her Bath*, which had been acquired by the Louvre during the period that Renoir was a student.

The sour period was a short-lived phase in Renoir's career, but from this ground sprang the softer race of creatures that populates his later work, where bodies can be seen pulsating with the bright warm radiance of the Mediterranean sun.

Bather Drying Her Leg, c.1910

Oil on canvas
33×26 inches (83×66 cm)
São Paulo, Museum of Art

In this painting dating from *c.* 1910, Renoir has closed in on the model, allowing her form to fill most of the canvas area. As usual in his work, his model keeps her head averted and her eye downcast, concentrating, not too convincingly, on the task in hand. In drying her leg, the model at once reveals and conceals her body, in this way adding to the allure of an already seductive picture.

Renoir's color has blossomed out from the restricted palette of his *manière aigre* to a range of tones encompassing the entire spectrum. The modeling of the nude in licks of thinned-down paint builds up the nuances of reflected light and shade that suggest not only the strong indications of her sculptural form but also the texture of her skin.

The qualities of strength and softness that she personifies are the product of his subtly generalized draughtsmanship and his understated use of ivory black. Renoir had never really given up his use of black, and in this painting, mixed in with the other colors, it gives his modeling of the flesh a firm yet luminous hue.

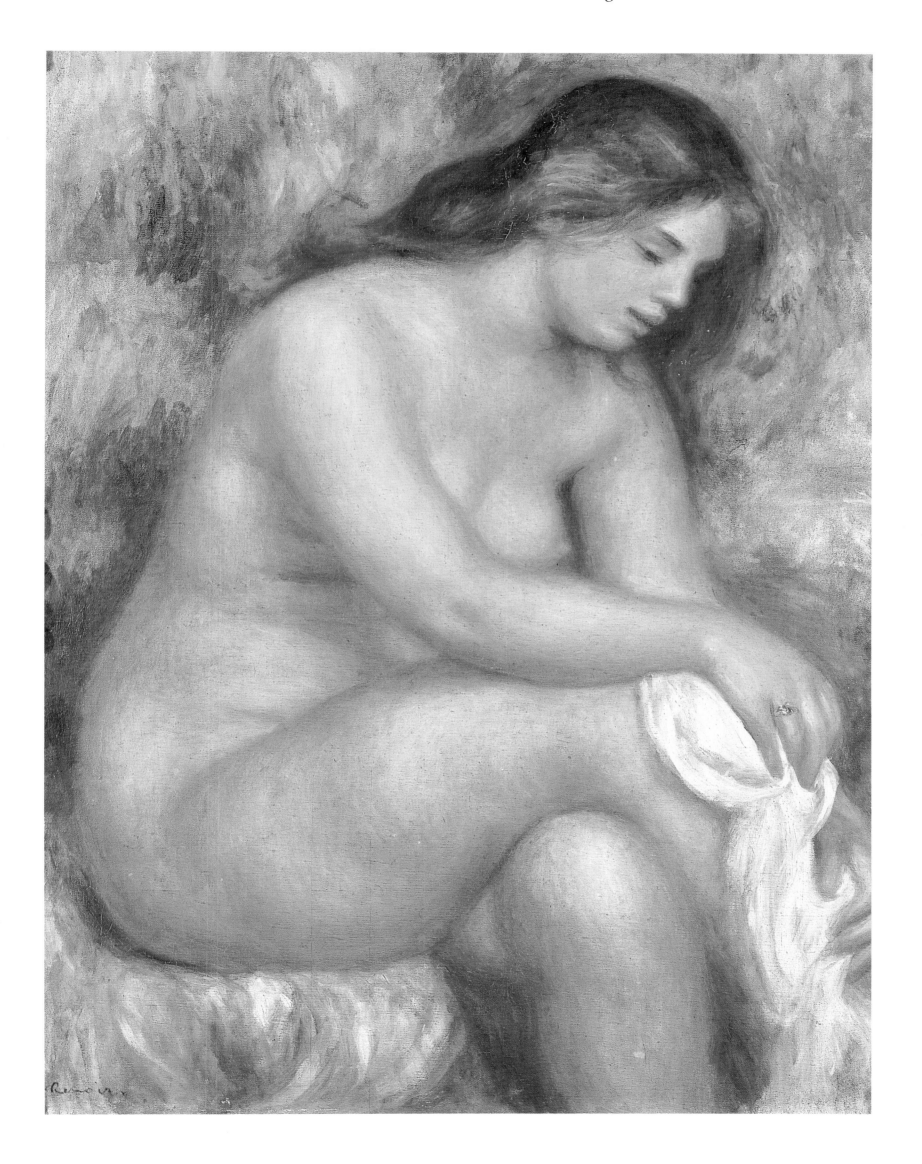

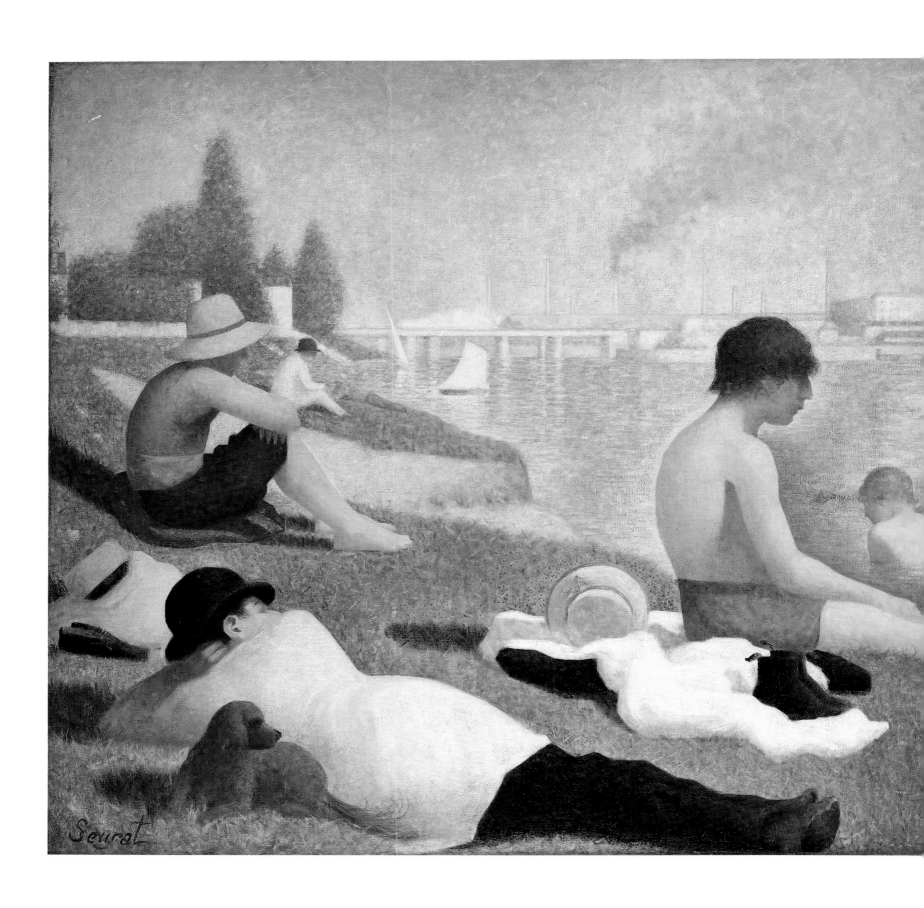

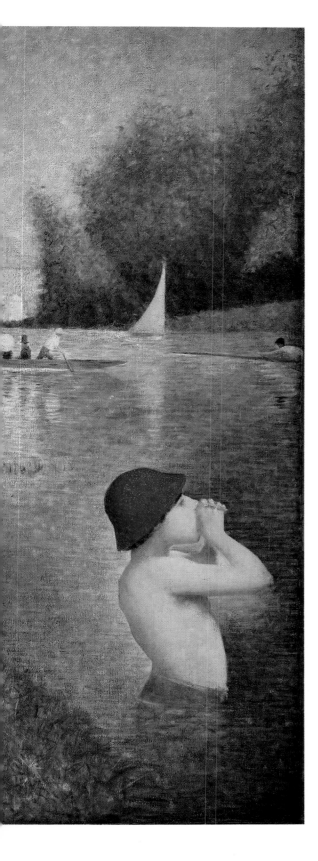

Georges Seurat

F r e n c h 1 8 5 9 - 9 1

Bathers at Asnières, 1883-84

Oil on canvas
79×118 inches (201×300 cm)
London, National Gallery

Although it was rejected at the official Salon, *Bathers at Asnières* was the picture that first brought Georges Seurat to the attention of the Paris public when it was displayed, in 1884, at the newly founded Salon des Indépendants. Two years later, exhibiting with the Impressionists, the artist was hailed as the new leader of the avant-garde and the originator of the first distinctively new style to develop out of Impressionism. The superficial similarities, at the level of subject matter, between this canvas and those of the Impressionists are misleading, however. Not only is Seurat's scene of urban leisure painted on a much larger canvas than those usually associated with the Impressionists but also it differs in terms of composition and handling. It is a carefully balanced and structured composition, the product of Seurat's exhaustive training at the École des Beaux-Arts, and its classical image of harmony, pervaded by a curious overall stillness, is quite at odds with the river scenes of Monet's generation, who set out to capture in paint the fleeting moment, the instantaneous impression, the movement of ripples and trees by means of lively, undisguised brushstrokes. Even if Seurat's color range is broadly comparable to that of Monet, his brushwork is less emphatic and is much more consciously disciplined.

The suburb of Asnières, like Argenteuil, where Monet had painted so many canvases in the 1870s, offered boating, fishing, and other riverside entertainments for the city-dweller. Being closer to the center of Paris and to the industrial zone of Clichy, its character was less that of a rural idyll than of an in-between territory, an area in which industry and its effects on the environment could not be forgotten. The figures seated on the riverbank seem to have snatched brief periods of leisure from their workplaces – probably the factories, workshops, and shops of the locality – because they are dressed in, or have temporarily discarded, their working clothes. But whereas the choice of theme, and particularly details such as the shoes, suggests a naturalist approach, the ordered style elevates the image to a higher classical plane. One notices, for instance, the use of profile poses for all the figures, and their studied stillness; even the boy in the water, his hands cupped to call, seems frozen. Such an unorthodox combination of form and content was a calculated move on the part of its author.

The painting's quality of monumental stillness was unmistakably derived from the work of the major mural painter of the day, Puvis de Chavannes, as more than one critic was keen to point out. Puvis's graceful forms and controlled arcadian vision were to exert a powerful influence over the younger generation of Symbolist artists who came to the fore in the later 1880s.

Sunday Afternoon on the Island of la Grande Jatte, 1884-86

Oil on canvas
82×121 inches (208×308 cm)
Chicago, Art Institute

Sunday Afternoon on the Island of la Grande Jatte was Seurat's second monumental composition on the theme of Parisians at leisure, again painted at Asnières, on the island in the middle of the Seine known as la Grande Jatte. The painting was executed between the exhibition of *Bathers* and the spring of 1885, and Seurat made over thirty related drawings and oil sketches in which he studied the details as well as the overall composition. There was no opportunity that spring to show the new work, however. After a summer spent on the Normandy coast, during which Seurat developed a smaller, flecked touch, he retouched certain passages, dividing tones into small separate dots of pure color. The notion was that these would coalesce, through 'optical mixture,' to constitute the correct tone in the eye of the spectator without the color losing any of its freshness and luminosity.

Sunday Afternoon on the Island of la Grande Jatte was the centerpiece of the group of pointillist works, all with similarly dotted or flecked surfaces, that was shown at the Eighth Impressionist exhibition in 1886 by Seurat, Signac, Pissarro, and his eldest son, Lucien. So extraordinary was the impact of this new 'scientific' development from Impressionism that the critic Félix Fénéon devoted a substantial section of his review to explaining the method and to analyzing this painting in particular. Fénéon's description is worth repeating:

. . . beneath a canicular sky, at four o'clock, the island, boats flowing by at its side, stirring with a dominical and fortuitous population enjoying the fresh air among the trees; and these forty-odd people are caught in a hieratic and summarizing drawing style, rigorously handled, either from the back or fullface or in profile, some seated at right angles, others stretched out horizontally, others standing rigidly; as though by a modernizing Puvis.

He went on to explain the systematic division of color. On the level both of subject and of technique, Seurat's painting was seen as breaking new ground.

Many viewers were puzzled by his stiff, puppetlike figures whose rigidly controlled movements seemed so at odds with

the setting and the idea of leisure. The social range they represented was wide and played on the contemporary audience's familiarity with certain recognizable 'types' from city and popular imagery: the

soldier, the nursemaid, the bourgeois *canotier*, and the self-satisfied man-about-town who flaunts his mistress on his arm. In effect, Seurat has reduced each of his figures to its essentials, almost to its

geometric components. The composition is ordered into a pattern of repeated verticals, horizontals, and arcs, occasionally intersected by diagonals. The tacit intention behind such elaborate maneuvers was without doubt to construct a masterpiece that would convey a message, perhaps an ironic message about the artifice of urban forms of leisure and the class mixture that took place on this crowded island.

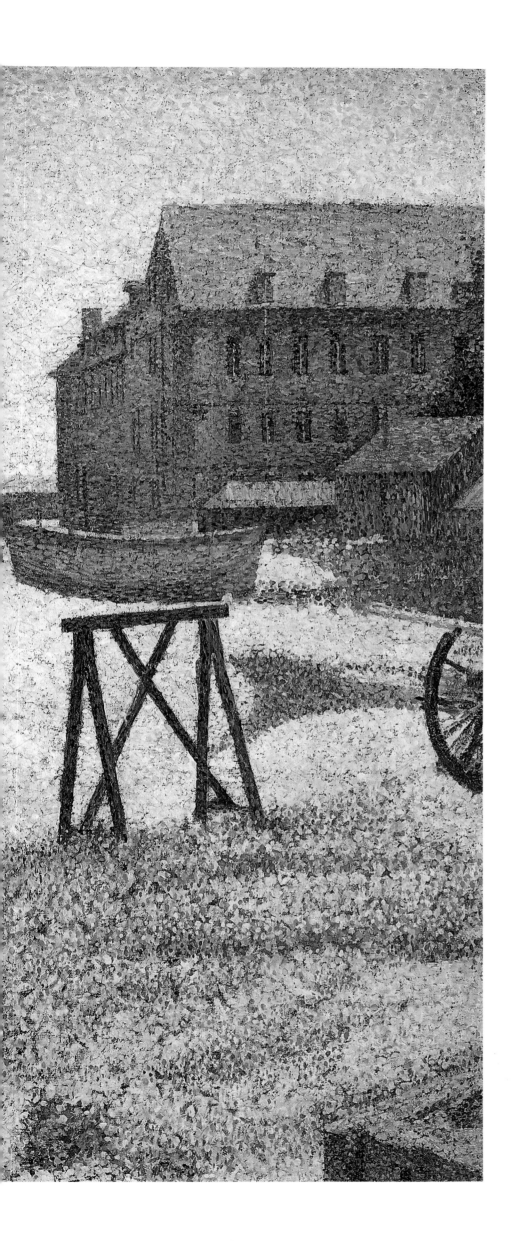

The Lighthouse at Honfleur, 1886
Oil on canvas
26¼×32¼ inches (67×82 cm)
Washington D.C., National Gallery of Art

Marine painting was an important aspect of Seurat's work, balancing his concentration on urban motifs. From 1885, he usually spent his summers on the Channel coast and brought back a clutch of marine works. From the outset of his career, Seurat had shown a considerable talent as a landscape painter and, like many artists, he no doubt welcomed the chance to escape from Paris in the summer months and to tackle more restful subjects such as this. He chose to base himself in Honfleur in the summer of 1886, shortly after the first showing of his pointillist works in Paris.

These campaigns of marine painting were important in terms of Seurat's technical evolution. The trip to Grandcamp in 1885 had enabled him to develop the small surface touch of dots and dashes, with which he retouched *Sunday Afternoon on the Island of la Grande Jatte*. *The Lighthouse at Honfleur* was one of seven canvases executed at Honfleur and, like several of these, was worked up from an oil sketch following traditional, rather than Impressionist, landscape procedure. The works in the Honfleur group were the first to be painted from start to finish in the new Neo-Impressionist technique, but this particular marine is not entirely dotted; the beach is treated in crisscross, the sea in horizontal, strokes. The overall effect is decidedly blond, giving the sense of a warm summer's day. The verticals and horizontals, carefully balanced, and the placement of the lighthouse just off center, suggest that the composition was deliberately contrived to convey a mood of calm reflection. Indeed, its evocation of mood through form is more aptly described as Symbolist than Impressionist.

As a location, Honfleur had attracted a number of landscapists in the nineteenth century. Indeed, this exact site had been painted in the 1860s by Boudin, Jongkind, Lépine, and Monet. But Seurat was not concerned with conveying a holiday atmosphere nor with naturalistic representations of transitory weather effects, bustle or movement. He strips the scene of human activity, using the broad lines and inanimate elements of the composition to enhance the atmosphere.

Les Poseuses (small version), 1887-88

Oil on canvas
16×19 inches (41×48 cm)
Private collection

Seurat embarked upon *Les Poseuses*, a major study of nudes, in late 1886. His first figure composition to be executed entirely in dots, it served to prove to the skeptics that his new pointillist technique could adapt itself equally well to the nuances of flesh tones as to the vibrant atmosphere of a sunny day. In keeping with his naturalist approach to subject matter, he chose his own studio as the most plausible setting for a study of modern nudes. Yet, for all the naturalism of the setting and the matter-of-fact inclusion of his own monumental canvas *Sunday Afternoon on the Island of la Grande Jatte* hanging, unsold, on the wall, Seurat gives a richer, somewhat unreal, dimension to the mundane subject. He shows the three models in three logical stages: one preparing herself to pose; another standing facing the artist (as though he were weighing up her suitability); a third dressing again. He also arranges their poses symmetrically into a pyramidal form so that we have a profile, a full face, and a back view within the same picture. Juxtaposing them with the stiff artifice of the population of la Grande Jatte was surely not a fortuitous act on Seurat's part; indeed, the stylish bonnets and parasols that are so much a theme of the outdoor scene crop up again among the discarded clothing of *Les Poseuses*, as though the artist intended to make an ironic comment on the states of dress and undress.

Seurat was evidently dissatisfied with the first large canvas; he seems to have had problems with the prepared gesso ground, which caused the dots to discolor. Despite their intense admiration, Signac and others felt he had used too small and finicky a touch for the size of the canvas. These two factors may have led Seurat to paint this smaller replica of *Les Poseuses*, probably some time after the first picture had been exhibited at the Indépendants in 1888. Here the color has remained remarkably fresh and delicate, and the touch is freer. The composition has a perfectly ordered, classical construction, suggesting a similar seeking after perfection to that found in the work of Ingres though with none of the earlier master's sensual enjoyment of the woman's body.

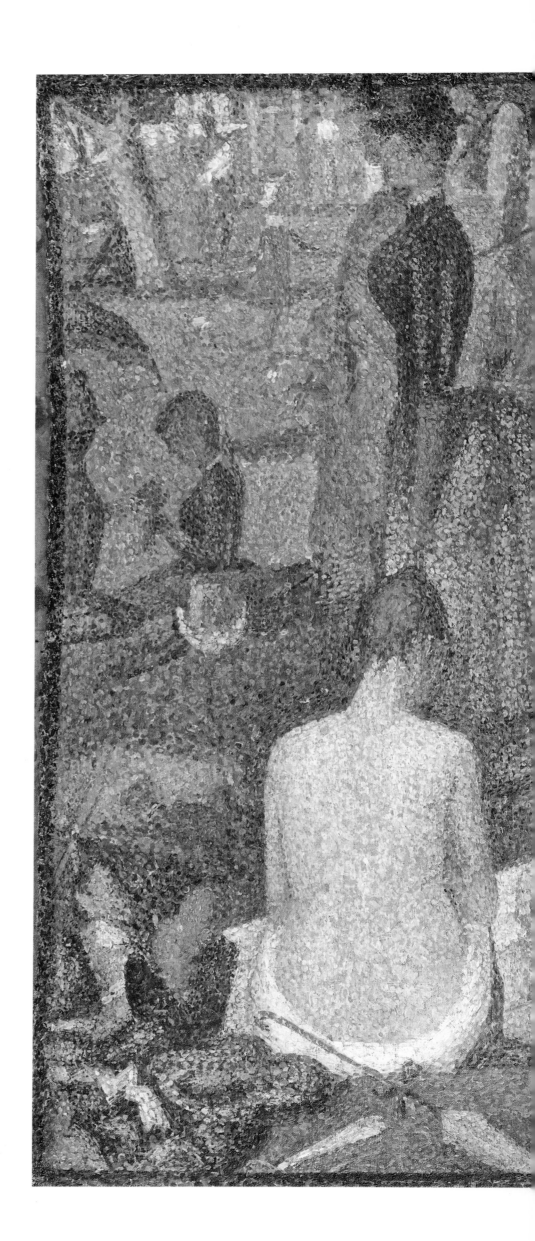

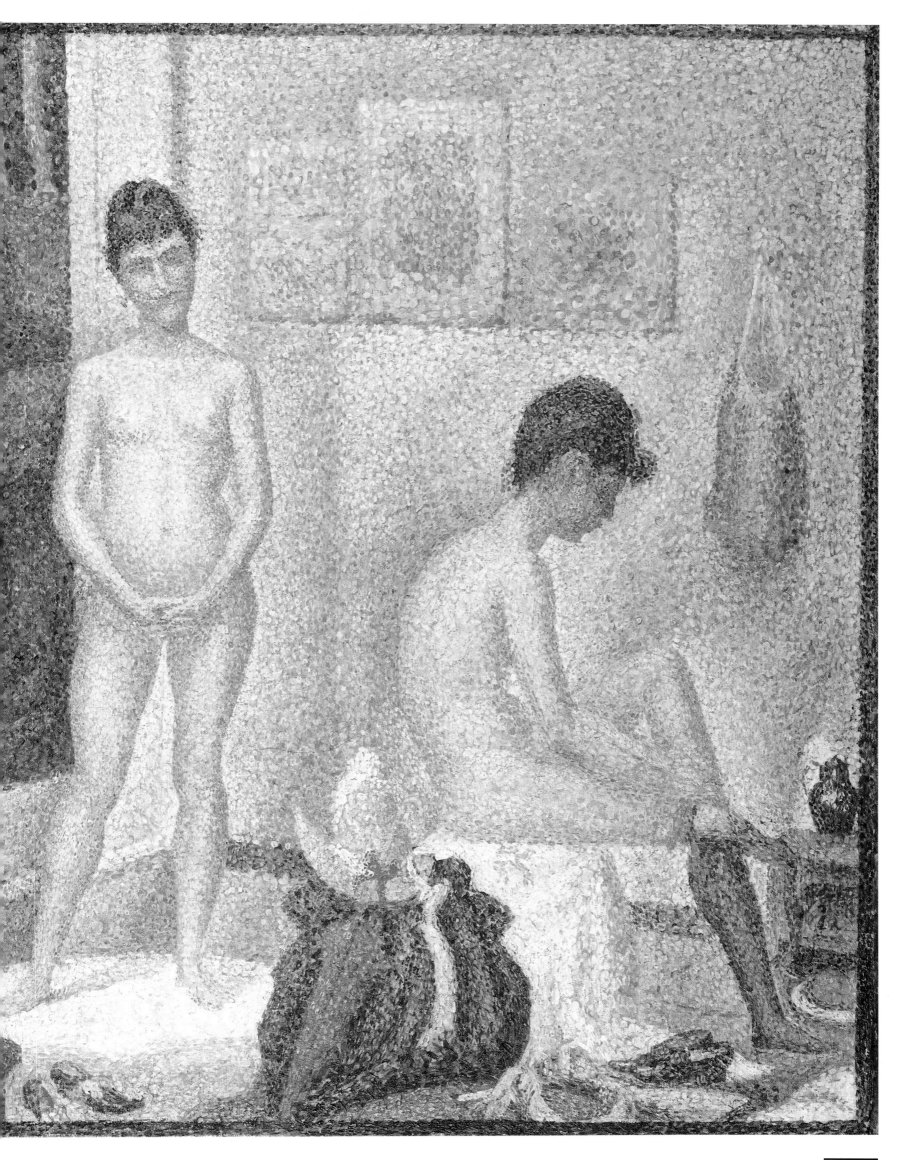

Young Woman Powdering Herself, 1889-90

Oil on canvas
37×31 inches (94×79 cm)
London, Courtauld Institute Galleries

The taciturn Seurat seems to have taken up with Madeleine Knoblock about 1888. She bore him a son in February 1890, but he kept his liaison secret from his parents until a few days before his sudden death in March 1891. He was equally secretive about this painting, which he exhibited under the unspecific title given here, alongside *Chahut*, at the Salon des Indépendants in 1890. In the inventory of the artist's work drawn up after Seurat's death, however, Madeleine Knoblock referred to it as 'my portrait.'

The painting clearly had a very personal significance for the artist. X-rays have shown that there was once a head in the picture frame, possibly a self-portrait, which was removed on grounds of discretion. The woman is plump, sensuous, and self-absorbed; the fact that it is a likeness of a particular person gives this work a different character from most of Seurat's paintings in which the figures are treated as generalized types rather than as individuals. Nevertheless, the painting is made to obey Seurat's stylistic concerns. In accordance with the theories of Charles Henry and others, Seurat had come to believe the directions of lines and the relative warmth or coolness of colors to be analogous with key changes and rhythmic patterns in music, that is, capable of conveying mood. The mood to be expressed in this case being happiness – appropriately enough given the painting's subject matter – Seurat uses a gay, rococo color range of warm yellows, pinks, and pale blues and also deploys a regular pattern of upwardly tending lines in the wallpaper. With its swirling decorative pattern of dots, the painting can scarcely be described as naturalistic. And there is more than a suggestion of caricatural popular imagery in the way that the woman's pudgy body snugly fits into its constricting corset. One might go so far as to suggest an element of self-deprecatory irony on Seurat's part: the rice powder swathed evenly over the woman's body can be seen as a metaphor for Seurat's own method of applying paint with a dusting of regular dots, both contemporary artifices devised with the aim of producing a smooth harmonious surface.

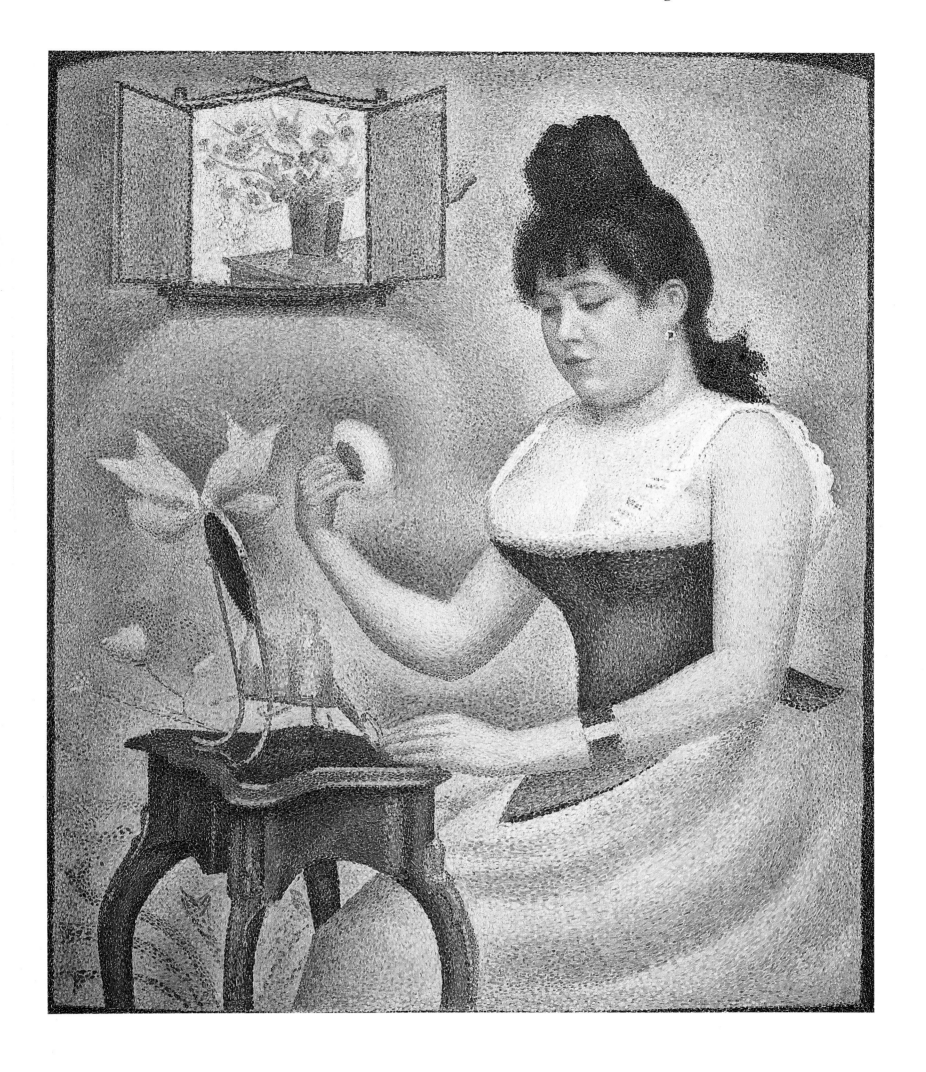

Paul Signac

French 1863-1935

Gas Tanks at Clichy, 1886

Oil on canvas
26×32 inches (65×81 cm)
Melbourne, National Gallery of Victoria

This painting was one of the group of works Signac exhibited at the Eighth Impressionist exhibition in 1886 alongside those of Seurat. Paul Signac had been working for some time in an Impressionistic manner loosely based on Monet, an artist he greatly admired, when he first encountered Seurat in 1884. Thereafter, in close parallel with Seurat, he developed a tight drawing style and a controlled, flecked brushstroke. Signac's anarchist-socialist convictions colored his approach to modern urban subject matter which was less complex and ambiguous than Seurat's; it is more comparable with other like-minded artists of his immediate circle such as Pissarro, van Gogh, and Maximilien Luce. In 1886-87, he painted a sequence of urban landscapes in and around the industrial suburb of Clichy (whose chimneys are visible in the background of Seurat's earlier *Bathers*) in which the emphasis is less on the people who lived and worked there than on the buildings. In his predilection for such unprepossessing motifs – in *Gas Tanks at Clichy* there would seem to be nothing of an immediately picturesque character to attract the attention of a landscape artist – Signac built on that tendency toward the banal and workaday already identifiable within Impressionism.

The painting's composition is simplified into three distinct zones: the foreground is a barren wasteground; the merest suggestion of a cart track leads the eye up to the line of gas tanks and other excrescences of the industrialized city that form a band of bright color across the center of the composition; above these runs the uniform blue of the sky. The possible focus of attention is the modest little worker's villa in the center, cheerfully domestic with its pink shutters and washing hanging over the palisade fence. Given the uncompromising proximity of the gas tanks, this incongruous dwelling takes on almost an emblematic quality, a symbol of human resilience and endurance. Signac's engagement with the anarchist cause may have alerted him to such anomalies. He was committed to bearing witness, through his art, to the visible symptoms of the rapid change within the industrialized city and to the 'great social struggle now entered into between the workers and capitalism.'

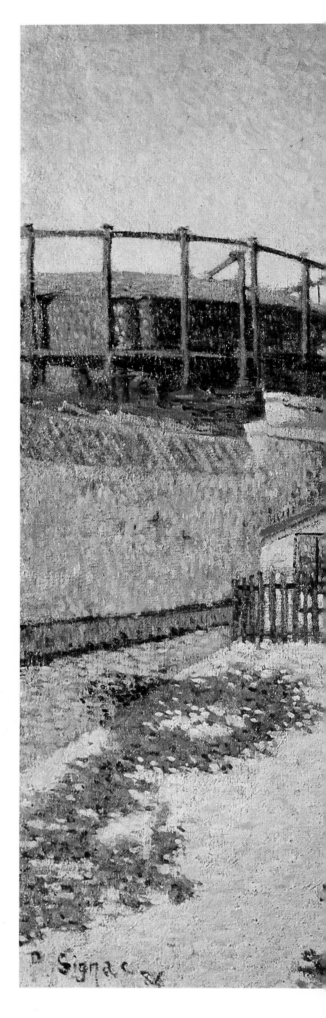

Sunset at Herblay, 1889-90

Oil on canvas
22½×35½ inches (57×90 cm)
Glasgow, Art Gallery and Museum

This extraordinarily calm, ordered image of a sunset on the River Seine was begun by Signac in September 1889, but completed, signed, dated, and inscribed with the Opus number 206 in 1890. Signac's practice of cultivating musical analogies, using opus numbers for his paintings and frequently adding musical titles to his marines (Adagio, Presto, etc.), indicate the new more Symbolist direction his art was taking at the turn of the decade. From this date on he temporarily abandoned the working, suburban subjects he had so fearlessly tackled in the mid-1880s, preferring to evoke mood through more timeless landscapes and harbor scenes. Images of harmony and tranquillity, in which he sometimes included figures of an allegorical rather than modern character, dominate his output during the 1890s and were, so Signac felt, an alternative means of projecting the ideals of an anarchist utopia.

The subject tackled here is similar to a number of riverscapes by Monet. At Herblay, situated just to the north-west of Argenteuil, the River Seine broadens out and the artist's viewpoint can only have been an island or a 'studio-boat' anchored midstream. It was a viewpoint that allowed the artist to create a perfectly symmetrical image, with the horizon line bisecting the composition and the three groups of trees reflected in the calm water rhythmically balancing one another. The orange glow of the setting sun, offset and systematically diffused by the complementary blues of the sky and water, produces a band of warm color across an otherwise cool image. Smooth expanses of sky and water, and the long fragile waves characteristic of rivers, were well conveyed by the subtleties of the pointillist technique, as the critic Pierre Olin observed in his review of the Indépendants' exhibition of 1891, where Signac exhibited this painting alongside seven other river and seascapes. Writing in a vein that accorded with the Symbolist tendencies so prevalent at the time, Olin was struck by 'all the melancholy of memories in front of this oh so suggestive canvas.' Appropriately enough, the painting's first owner was Comte de la Rochefoucauld, a rich collector, amateur painter and promoter of Symbolist ideas.

Alfred Sisley

E n g l i s h 1 8 3 9 - 9 9

Snow at Louveciennes, 1874

Oil on canvas
22×18 inches (56×46 cm)
Washington D.C., Phillips Collection

An archetypal Impressionist scene, its title informs the viewer that the subject of the painting is not the nondescript architecture of a sleepy French village but rather the study of a particular atmospheric effect. It was painted at Louveciennes, to the west of Paris, where the artist lived with his family between 1872 and 1874. He had moved there originally to escape the dangers of the siege of Paris and, like Renoir, who lived nearby, he found the gentle rural charm of the local landscape particularly captivating. Under the influence of Monet, Sisley had evolved from his earlier style based on Corot to a more forceful and abbreviated manner of rendering the landscape. Sisley shared with Monet the idea of making a series of paintings of the same subject over a period of time and under different climatic conditions. He had painted the same scene in the summer of the previous year, in a work that emphasized the warmth and greenness of that season. In this famous version, Sisley presents the viewer with the cosy feeling of being indoors looking out on the chilly stillness of a snowy winter's day.

The colors in the painting are restrained and suitably subdued. The overall blond tonalities suggesting the snow-filled atmosphere form a rich contrast against the green of the garden gate and the rust of the upper windows of the house. The snow lies across the scene like a blanket, revealing the structures of the trees and simplifying the architecture of the houses, their geometric lines softened by the thick layer of snow.

All the elements of the picture lead the eye quietly but inevitably to the anonymous figure of the woman with the umbrella, placed with complete sureness at the anchor point of this modest composition. Around her, the wintry atmosphere gives all things a common harmony, the relative starkness of the trees and fence fades into a more generally indicated distance. No element could be removed without compromising the perfection of this exquisite and evocative picture.

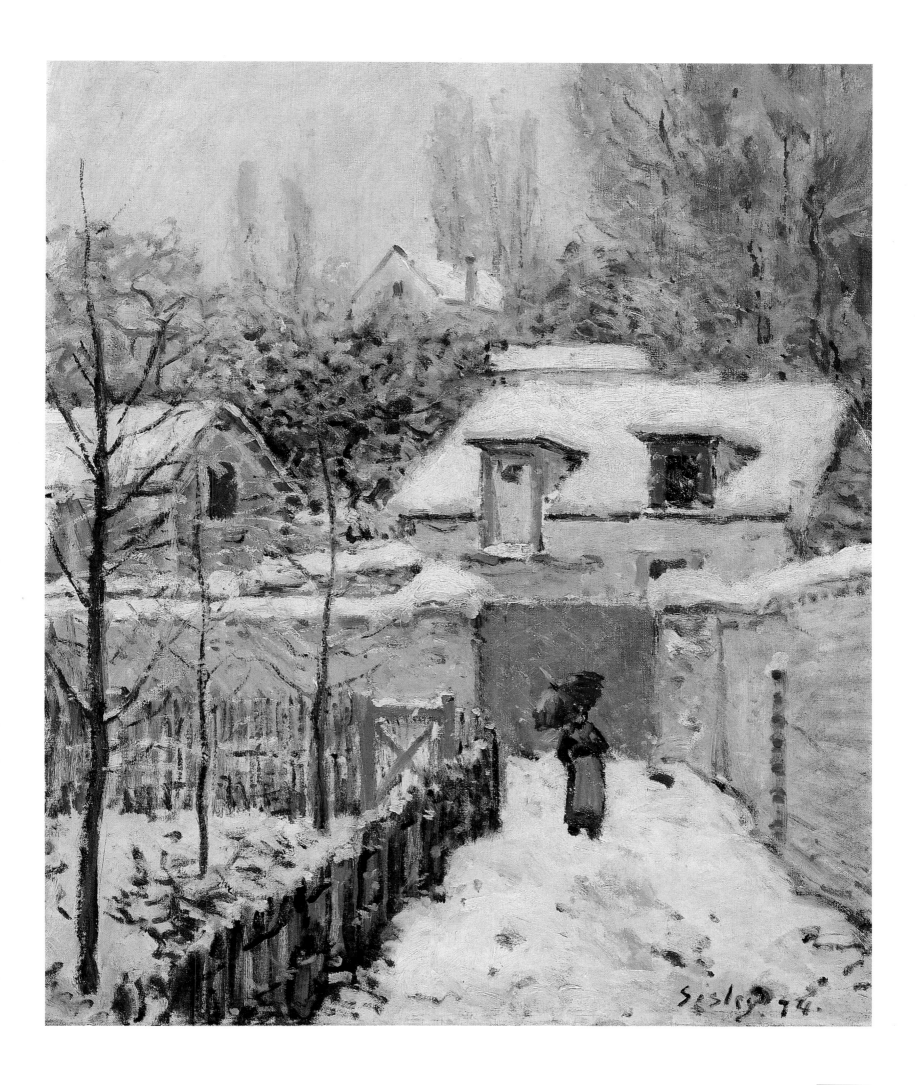

The Weir at Molesey near Hampton Bridge, Morning Effect,
1874

Oil on canvas
20×28 inches (51×71 cm)
Edinburgh, National Gallery of Scotland

Sisley exhibited five paintings at the First Impressionist exhibition; all remained unsold. In the company and at the expense of the opera singer and collector of Impressionist paintings, Jean-Baptiste Faure, he arrived in England in July 1874. He remained for four months, during which time he painted some of his most radiant works. Except for a small but spectacular view of the capital, he concentrated upon the immediate environs of the then small village near Hampton Court. Here on the banks of the River Thames he recorded his explorations of the ever-changing harmonies of sky and water in a series of rapidly painted, luminous canvases.

His painting of the weir at the nearby village of Molesey is one of the most stunning works from this period. The heavy mauves and lilacs of a cloud-laden sky dominate more than half the canvas area, contrasting dramatically with the rush of the clean, blue water over the weir. Against these forces of nature stands the still, restraining structure of the weir itself, perceived as two dynamic diagonals, one acute, the other oblique. Sisley rarely wrote anything about his ideas on art; but some time after its completion he wrote to his friend, the art critic Adolphe Tavernier:

Although the landscape painter must always be the master of his brush and his subject, the manner of painting must always be capable of expressing the emotions of the artist. You see I am in favor of differing techniques within the same picture. This is not the general opinion at present, but I think I am right, especially when it is a question of light.

The sunlight in softening the outlines of one part of a scene will exalt others and these effects of light which seem nearly material in a landscape ought to be interpreted in a material way on the canvas.

Sisley's work owes much to the example of his friend Monet, and there are obvious similarities in their choice of motifs and in the way in which they both often take as subjects solid structures affected by atmospheric conditions; but Sisley's work is distinctive for a subtle grace and delicacy unique to himself.

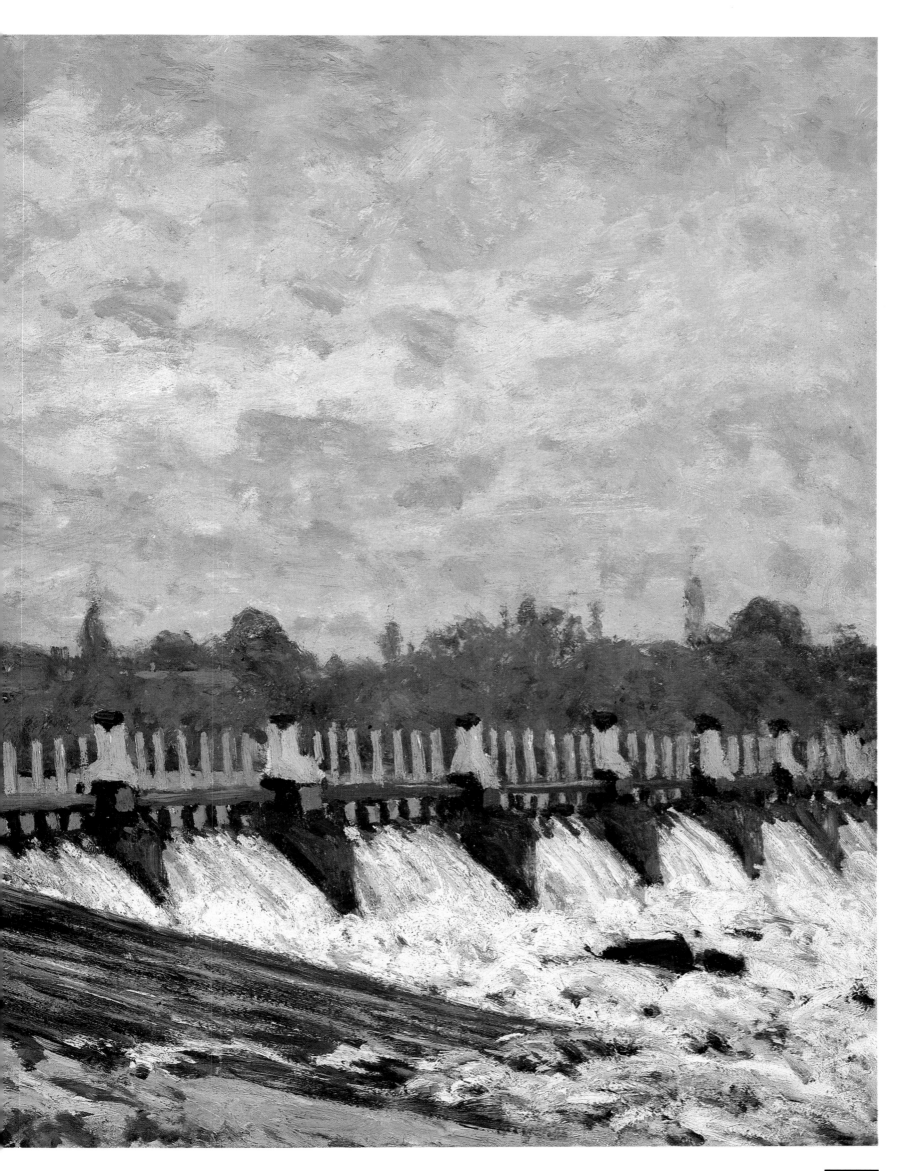

Flood at Port Marly, 1876

Oil on canvas
24×32 inches (60×81 cm)
Paris, Musée d'Orsay

All of Sisley's paintings exhibit a deep love for the countryside, and especially for the Seine valley. His preferred landscape was one enlivened by the real or suggested presence of people. As a young man he had lived in England and he was familiar with the paintings of the Dutch landscapists, especially those of Hobbema, which depend for their effect upon a closely knit alliance between the earth and the sky. In 1876 Sisley was living at Marly-le-Roi on the outskirts of Paris, and a flood he witnessed there served as inspiration for a group of three canvases. Camille Pissarro saw them after the artist's death, and wrote to his son Lucien that he felt Sisley to be 'an artist equal to any of the greats.'

It was shown at the Second Impressionist exhibition of 1876. In Sisley's painting, the flood is not seen as a tragedy; if anything, the disruption caused by the flood is underplayed as the painter carefully notes down the colors, tones, and harmonies of the light playing on the water and reflecting on the façade of the Saint Nicolas inn. It is an exact and sensitive capturing of a particular moment. The reflections of the inn mirrored on the choppy water are perfectly caught in a weave of short rhythmic brushstrokes. The low clouds of the overcast sky create an exquisite balance of blue-grays across the composition. It is a quiet, subtle painting, with nothing of the melodramatic, an evocation of silence and a meditation on the quality of light falling through a layer of cloud and reflected up from the surface of the water. Although the picture gives the immediate impression of a scene spontaneously recorded in paint its apparent simplicity is the result of a careful ordering of compositional elements.

The masses of the inn are beautifully constructed and colored in bands of delicately flecked paint; its windows, roofs, doors, and even the sign of the saint all contrast markedly with the emptiness caused by the newly risen waters. The low viewpoint leads the eye out directly across the brilliantly lit sheet of flood water. Space is evoked by the upright posts in the right foreground of the picture which function as a foil for the posts in the distance and contrast with the more solid forms of the buildings.

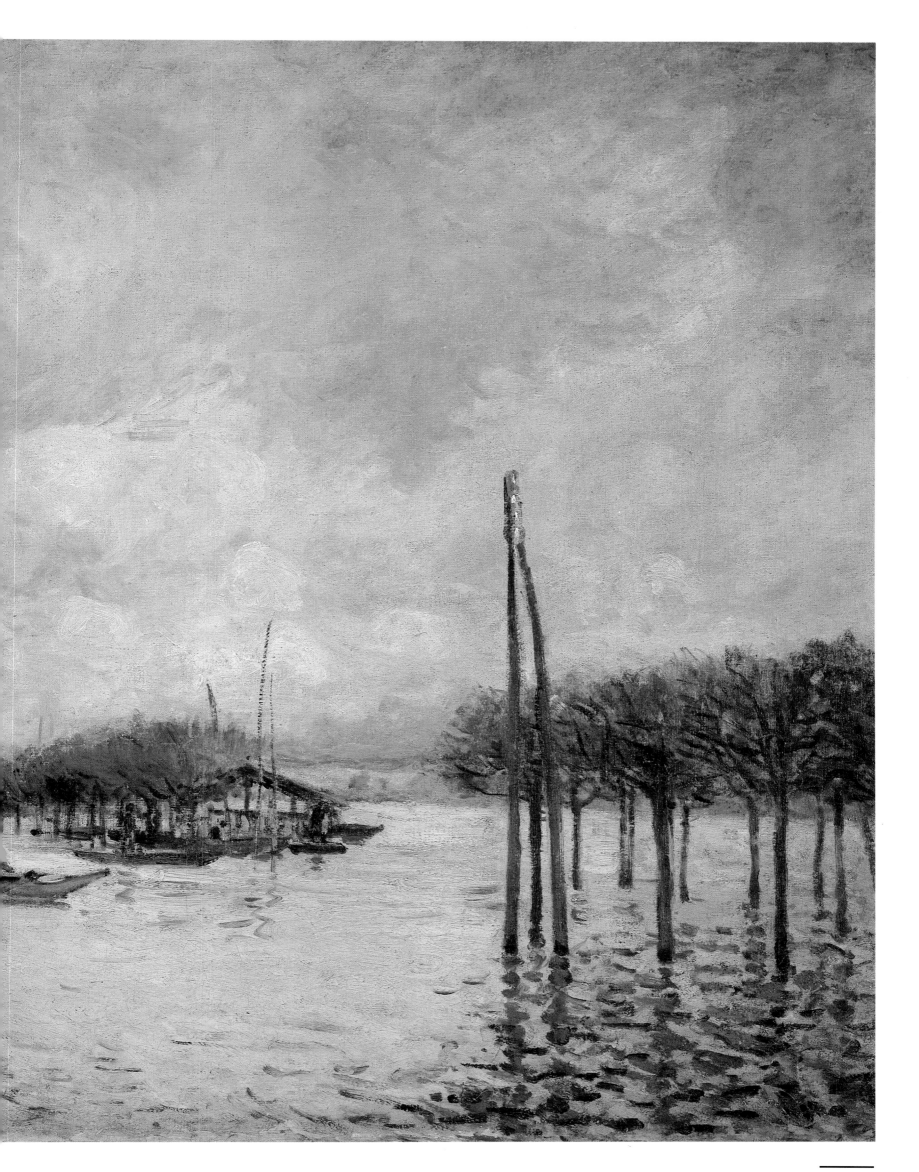

Overcast Day at Saint-Mammès,

*c.*1880
Oil on canvas
21¾×29 inches (55×74 cm)
Boston, Museum of Fine Arts

Saint-Mammès is a village situated close to the confluence of the rivers Loing and Seine. Sisley and his family had moved to Veneux-Nadon, near Moret-sur-Loing, in 1880 and lived there until September 1883. The countryside of that picturesque area, which included the forest of Fontaine-bleau, and its qualities of light, had been a source of attraction to many of the painters Sisley most admired – Corot and the Barbi-zon painters, Courbet and Monet. Sisley was to stay in this region painting its villages and charming landscapes until his death in 1899.

This painting is typical of his middle period and counteracts the often-expressed opinion that Sisley's work deteriorated in the last years of his life. It has a grandeur and evocation of place that bears comparison with any of his earlier paintings. All the elements of the composition converge on a single vanishing point, just out of sight beyond the distant bridge and hidden behind the trees that cluster at the matrix of the composition. The low horizon line allows the loosely painted sky to dominate the landscape below and create the atmospheric mood of the painting. As in the case of the Dutch painters he admired so much and of many of his Impressionist colleagues, the close study of the sky is the key to Sisley's paintings. He wrote to his friend Adolphe Tavernier:

The sky is not simply a background: its planes give depth (for the sky has planes as well as solid ground), and the shapes of clouds give movement to a picture. What is more beautiful than the summer sky, with its wispy clouds floating idly across the blue? What movement and grace! Don't you agree? They are like waves on the sea; one is uplifted and carried away.

The sky is the real subject of the painting; its richly handled surface of broken comma-like brushmarks gives a convincing impression of the transience of light-effects, even on an overcast day. The brushwork of that area reacts strongly against the smaller, dablike strokes that are used in the rest of the painting. The overall effect is one of great vividness with the small, but significant, touches of reds lift-ing the russet tones and contrasting mark-edly with the green of the landscape. Cradled between the houses and the river is a group of men husbanding trees, adding a small but important mark of human activity to the scene.

The Church at Moret, 1893

Oil on canvas
25½×36 inches (66×91 cm)
Rouen, Musée des Beaux Arts

In October 1883 Sisley moved to the little town of Moret-sur-Loing, about 8 miles (13 km) from Fontainebleau. Several years later he moved to a small house, standing in the shadow of the church, situated on the corner of rue du Château and rue de Montmartre. In the last years of his life, he produced no less than twelve canvases, all of which take the church as their central subject.

Inevitably these pictures call for comparison with Monet's celebrated paintings of Rouen Cathedral. Monet had begun his cycle of paintings in 1892, and they must have inspired Sisley to begin his own series. He was seriously ill at this time and in a great deal of pain, and yet, as ever in his art, nothing of his personal suffering is evident from the paintings. Whereas Monet's cathedral paintings show more concern for the recording of a series of moments within

the same painting, thereby presenting a generalized effect, Sisley presents the church as seen in precise weather conditions and at specific times of the day as if caught in a single moment. In his paintings, the church keeps its integrity as an architectural structure solidly wrought from chiseled stone and set firmly in the heart of the village community. Despite its scale and massiveness, the church does not have an oppressive presence; the inclusion of ordinary people, busy about their everyday affairs, gives the scene a pleasing human touch. This quality is reinforced by the proximity of the well and market hall to the church. The features of its architecture are generalized but strongly indicated with a lack of finicky detail that adds a simple dignity to the building. Sisley uses white to mix with his blues and ochers to create a subtle range of coloristic effects. His brushwork creates a solid weave of bold and vigorous directional marks which describe the scene with acute perception and wit, adding to the powerful effect of the composition.

Henri de Toulouse-Lautrec

F r e n c h 1 8 6 4 - 1 9 0 1

Le Moulin de la Galette, 1889
Oil thinned with turpentine on canvas
35×40 inches (88×101 cm)
Chicago, Art Institute

Although the same dance-hall provided the setting for this painting as for Renoir's archetypal Impressionist masterpiece of some thirteen years earlier, there is a yawning gap between Renoir's radiant image and the more acerbic representation of leisure in the modern city by the aristocrat and man-about-town, Henri de Toulouse-Lautrec. The mixed bohemian and lower-class crowd drawn to the Moulin de la Galette had been idealized by Renoir in 1876. The more cynical Lautrec presents a harder, more uncompromising view.

Lautrec had joined forces with the younger Parisian avant-garde in 1886-87. Of all the artists in the Impressionist circle, Lautrec was closest to the draughtsmen Degas and Forain. His brushmarks are graphic rather than painterly, revealing a close kinship with the styles of contemporary painter-illustrators such as Steinlen and Raffaëlli. Lautrec's technique of painting, using oil thinned with turpentine on canvas that has been primed with a buff tone – later he favored cardboard as his support – is a far cry from the luminous brushwork of Renoir, which sought to approximate the shimmering play of light. Lautrec was clearly more interested in the individual characters who fetched up in such a nightspot than in its overall atmosphere. The painting is remarkably made – whole areas of the composition have thin washes of drab color laid on and counterpointed with odd touches of red, as in the shock of dyed auburn hair just to the right of center. The image is enlivened by the brilliantly telling portraits: the man with the hawkish profile leaning forward to the right and the two women in the center and lower left, whose expressions and pallid, heavily made-up features reveal the boredom of waiting night after night for a possible pickup.

Far from seeking to emulate Renoir's image of sociability and fun, Lautrec seems bent on pointing up the lack of real human warmth, the pervasive isolation of the urban crowd. The dancers are, for the most part, dark, ill-defined shapes, and the composition, instead of sweeping one up in their rhythmic movements, places a barrier between us and the dance floor in the form of the crude wooden balustrade and table-top. As spectators we are encouraged to join the other four figures on the sidelines, seated with their backs toward us in the foreground. Although they have evidently won the artist's sympathies they seem as oblivious of him as of each other.

The contrast between the two images also reveals how times had moved on in the world of Parisian entertainment. In 1889, the year this picture was first exhibited at the Salon des Indépendants, the Moulin de la Galette gained a rival of higher status nearby in the form of the Moulin Rouge, a new and highly commercialized dance-hall able to offer a variety of star attractions. The socially mixed clientele of Lautrec's *Moulin de la Galette* has a seedy look as compared with the youthful *joie de vivre* expressed by the figures in Renoir's painting. The women make little display of finery; those that have no male partners take to the floor in couples. Many of the men appear to be passing through and retain their overcoats; those in top hats can perhaps be identified as voyeuristic bourgeois, one of whom is confronted by an apparently argumentative off-duty soldier; the bowler hats probably belong to *petit-bourgeois* employees, spending their wages on a night out with a girl.

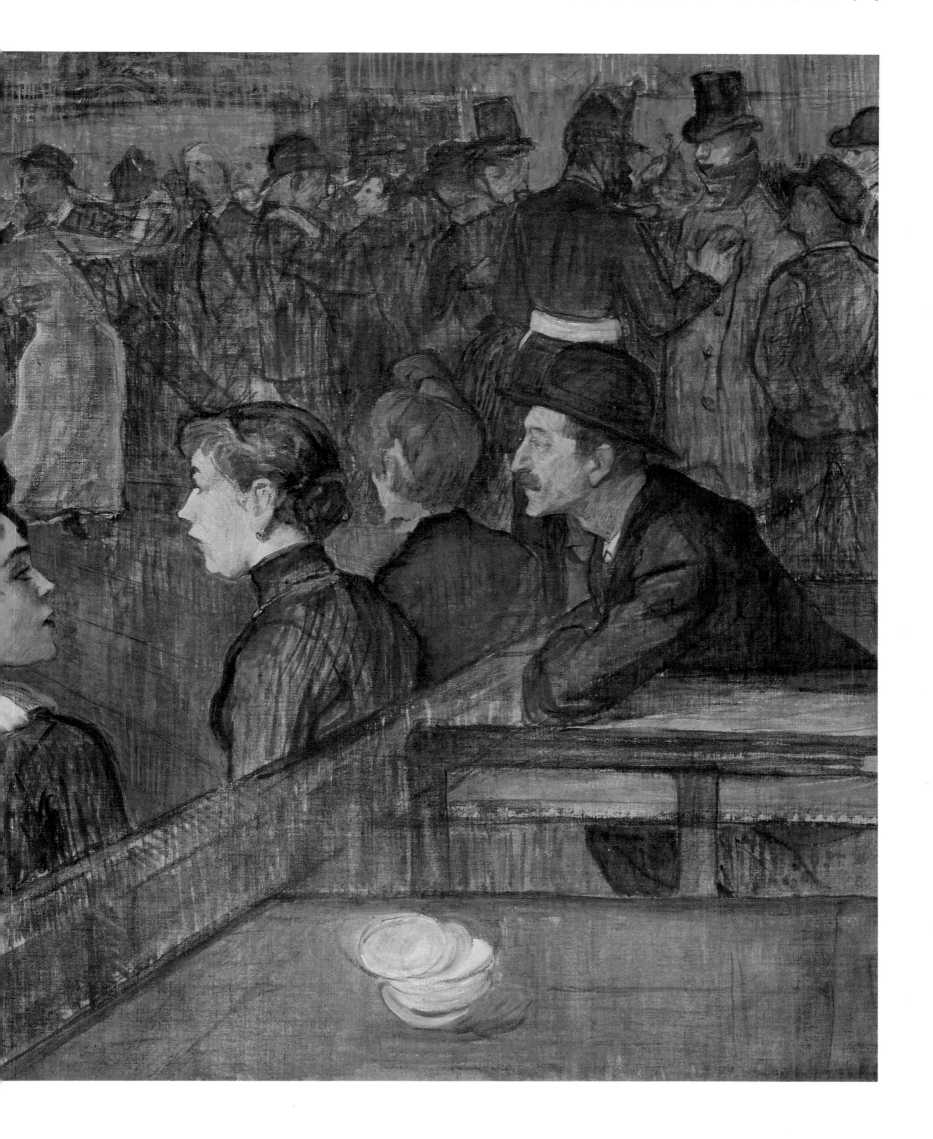

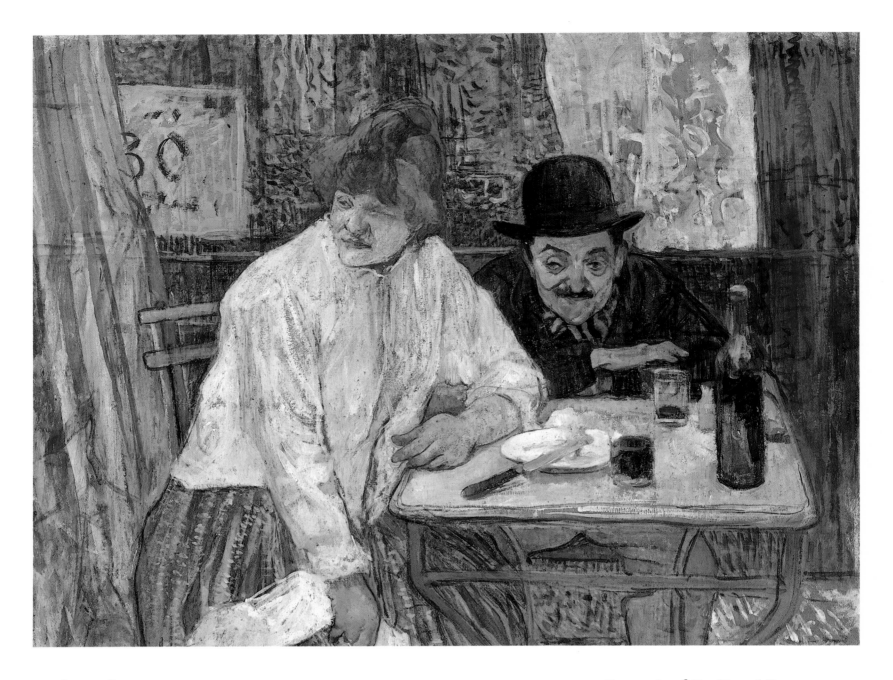

At the Café La Mie, 1891

Watercolor and gouache on paper
mounted on panel
21×26¾ inches (53×68 cm)
Boston, Museum of Fine Arts

Lautrec had been interested in bar and café
scenes since the mid 1880s. *At the Café La
Mie* was his first important exhibited work
showing a down-at-heel wine shop similar
to the one featured by Zola in *L'Assommoir*
(1876), though here the suggested location
is in the industrial suburbs. The painting
was shown at the Salon des Indépendants
in early 1891 along with *Portrait of Dr Henri
Bourges*. The two works made an interest-
ing contrast of high-life and low-life,
reflecting the polarities of Lautrec's own
existence. The man in *At the Café La Mie* is
Maurice Guibert, a champagne salesman
and dissolute, a friend of Lautrec's, and the
unknown woman was probably posed by
one of Guibert's many mistresses. For Lau-
trec's purposes, they acted out the roles of
a seedy proletarian couple; he also had
photographs taken as an *aide-mémoire*
from which he developed the composition.

The general design was common among
modern life painters at this period. One
finds a similar pair of drinkers in Degas'
L'Absinthe, although closer still to Lau-
trec's painting in subject and approach was
Raffaëlli's *Absinthe Drinkers*. Although
Lautrec would have been too young to see
the Raffaëlli – another frontal image of a
run-down wine shop – when it was first
shown at the Impressionist exhibition in
1881, he would have seen it when it was re-
exhibited at the Salon of 1889.

It is not known whether an actual bar
existed with the curious name 'La Mie'
(The Crumb). The title may have been an
invention to stress the degradation of
people caught in the downward spiral of
alcoholism and poverty. Toulouse-Lautrec
may have made this powerful but rather
unusual attempt at social realism as a
homage to Raffaëlli, for whom he had some
admiration, or simply as a frivolous excuse
to exaggerate Guibert's bohemian personal
style. Certainly, more than one critic in
1891 referred to Lautrec's work as 'humo-
ristique,' while general appreciation was
voiced for his acute and unsentimental
powers of observation.

Portrait of Dr Henri Bourges, 1891

Oil on cardboard mounted on panel
31×20 inches (79×51 cm)
Pittsburgh, Carnegie Museum of Art

At the Salon des Indépendants in early
1891, Toulouse-Lautrec, unannounced in
the catalogue, showed at the last minute
not only *At the Café La Mie* but also three
portraits of male friends.

This animated full-length portrait shows
Henri Bourges pulling on his gloves as he
prepares to go out. Bourges' gesture
reminds one how close Toulouse-Lautrec
was to naturalist conventions, for the doc-
tor is seen performing a characteristic,
banal action in a specific place, the artist's
studio. The emphasis is on costume, pose,
and physiognomy, the intention being to
give a portrait of a man in society.

Lautrec may well have exhibited these
upper-class images alongside the down-at-
heel characters of his *At the Café La Mie* to
show his mastery of Parisian types.

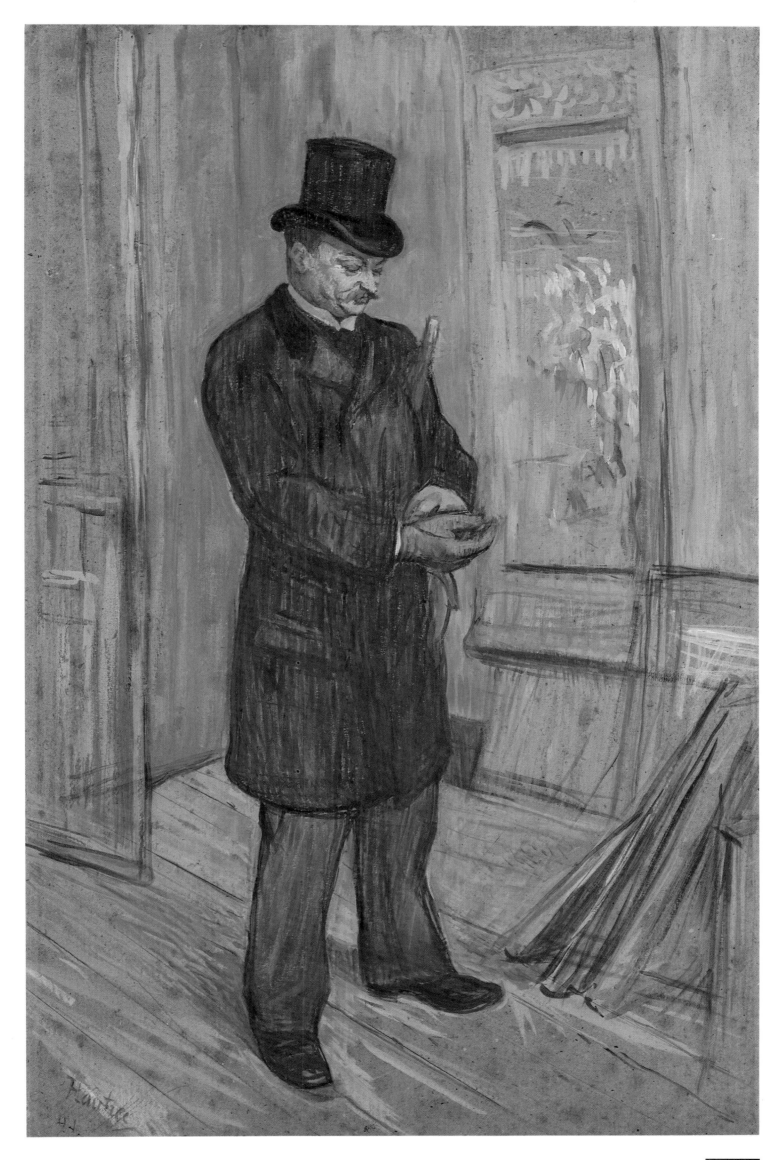

At the Moulin Rouge, *c.1894-95*

Oil on canvas
48×56 inches (123×141 cm)
Chicago, Art Institute

This painting stands as Lautrec's last major work based on the subject of the dance-halls, which had interested him for a decade. When the Moulin Rouge had first opened in 1889, Lautrec had been quick to paint its interior, dancers, and audience. His first poster, designed in 1891, was commissioned to advertise the star dancer at the Moulin Rouge, La Goulue. *At the Moulin Rouge*, which he executed *c.* 1894-95, is a masterly summation of an intensive period of work.

As so often with Toulouse-Lautrec, autobiographical elements are strong, particularly in the choice of models. He features his cronies and women friends in the Moulin Rouge and does not show any aspect of the performance. The bearded man to the left is the writer Edouard Dujardin; the woman with the pasty face, La Macarona; the man with the mustache is the photographer Paul Sescau; and the other seated man is probably Maurice Guibert, who had also posed for *At the Café La Mie.* The woman seated with her back to us, her fashionable red hair arranged in an elaborate coiffure that makes a vivid contrast with her striking plumed hat, may be Jane Avril, another dance-hall star and frequent model of Lautrec's. The woman fixing her hair in the glass is La Goulue herself, accompanied by La Mome Fromage (Cheese Tart). In the center, behind the group at the table, the artist represents his own diminutive figure, absurdly sent up by the exceptionally tall figure of his companion, the degenerate medical student Tapié de Celeyran, who was Lautrec's cousin. Such self-parody was characteristic of Lautrec, both in his life and his art. The figure dashing out to the lower right of the composition is the English dancer, café-concert singer, and notorious lesbian, May Milton. In the picture she appears to be ostracized by the seated figures, and this may be a reference to her actual departure from the Paris entertainment world in 1895 for the United States. It used to be thought that she was incorporated into the composition as an afterthought, necessitating the addition of a vertical strip of canvas to the right. It now appears, on the contrary, that the picture was cut down some time after the artist's death so as to remove her disturbing, mask-like image and leave a more balanced and conventional composition, and later had to be reassembled.

As usual with Lautrec's work, except in the area of the faces, the paint is thinly applied. The composition is reminiscent of Japanese prints; the sharp diagonal of the balustrade tips up the perspective and seems to tilt this seedy world toward us. The colors have an eerie quality – the rusty golds, browns, and blacks contrasting oddly with the green, a color favored by Lautrec, of the mirrors and the shadows of May Milton's face. Perhaps he intended these clashes to serve as equivalents for the exaggerated contrasts produced by the electric lighting which effectively reduced people to caricatural silhouettes.

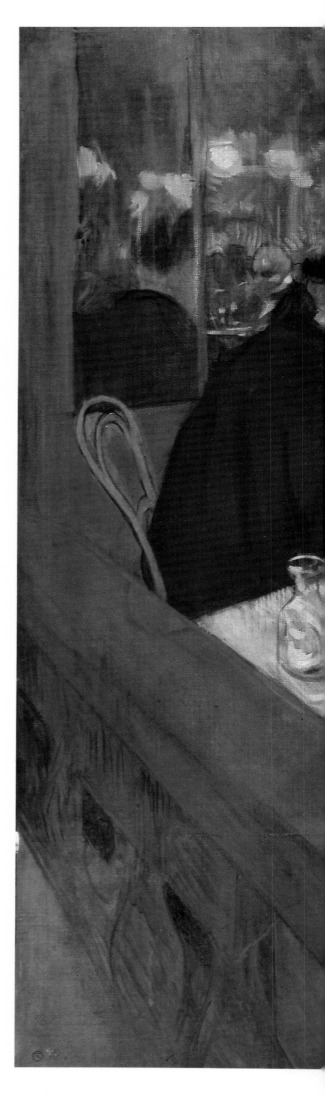

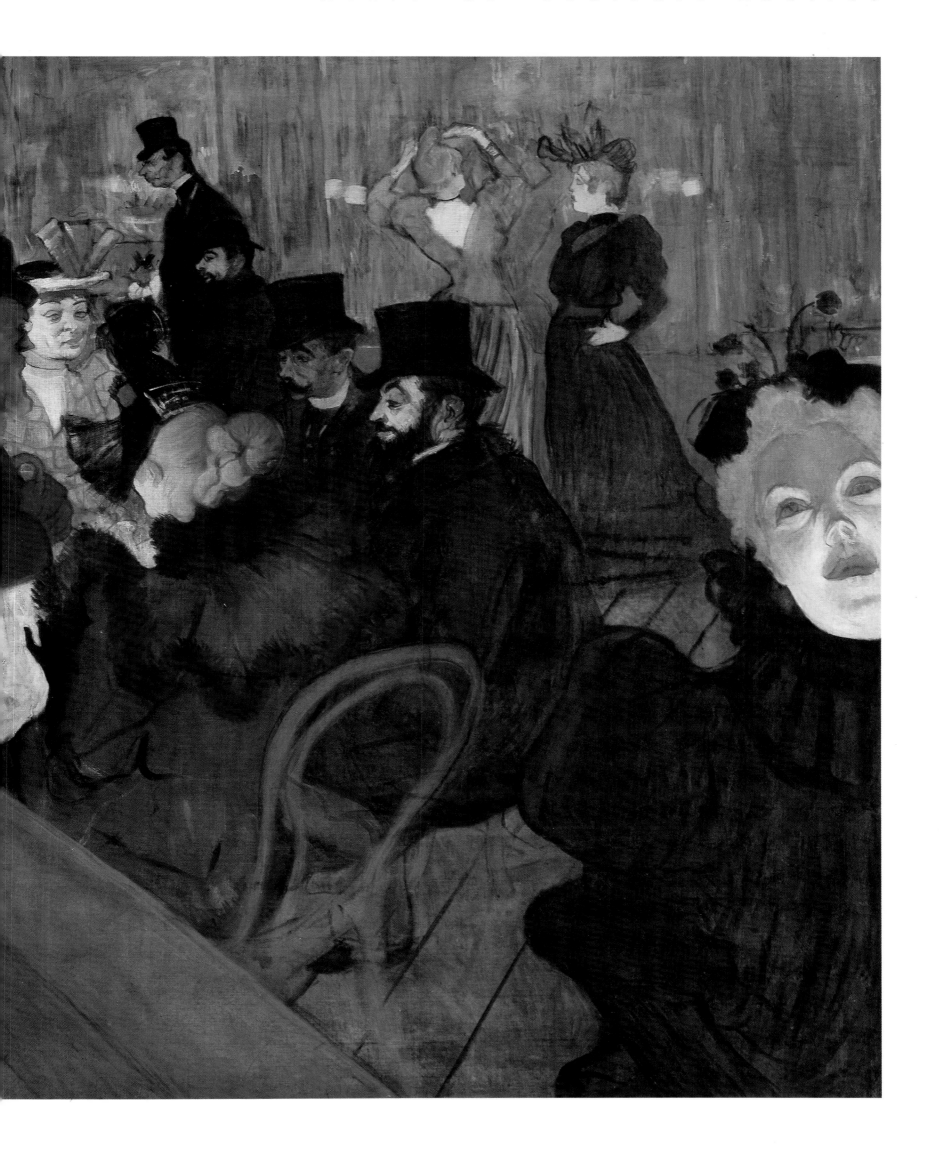

The Two Friends, 1894
Oil on cardboard
18¾×13½ inches (48×34 cm)
London, Tate Gallery

Toulouse-Lautrec's fascination with the subject of the brothel, frequently explained as a symptom of the decadence of the times or of his own debauchery, was one that he shared with several of his direct literary and artistic contemporaries. Like van Gogh, Lautrec seems to have looked on the prostitute with sympathy, as an emblematic figure of modern society, whose dignity, if destroyed by her work, deserved to be retrieved by the artist. In order to study her at close quarters, in 1893-94 Toulouse-Lautrec lodged for weeks at a time in one of the state-regulated brothels in the rue des Moulins, taking his meals with the women who worked there and sharing, as a courteous observer and listener, their daily lives. It may be that Lautrec's physical oddity as well as his voluntary position as a social *déclassé*, enabled him to win the prostitutes' confidence and with their co-operation he was able to satisfy his curiosity and pursue his artistic project unhindered.

Unlike the women in Degas' brothel images, rarely do Lautrec's prostitutes appear naked; they are usually shown, as here, during their private moments of relaxation and intimacy, wearing loose dressing gowns. There is no unseemly titillation, rather a cosiness and domesticity which avoids the sensational or erotic. Yet in tackling the theme of lesbian love, Lautrec challenged another taboo; the subject was one that aroused much prurient curiosity during the *fin de siècle*.

The lines of the prostitutes' abused bodies, although in no sense idealized, nevertheless draw graceful intertwined arabesques. The bare buff-colored cardboard of the support, only sketchily painted in many areas, is used by Lautrec as an active part of his color scheme and, with the plums and reds that describe the brothel's plush furnishings, it serves as an effective foil for the chalky tones of the women's flesh and shifts. The two women are seen as completely self-absorbed, impervious to the gaze of the artist. The woman in profile in the foreground, her features closed and inward-looking, her exhausted body slumped on the broad cushions, seems mutely unresponsive to the affectionate gesture of her companion.

La Conquête de Passage, 1896
Black chalk and oil on paper
41×26 inches (104×66 cm)
Toulouse, Musée des Augustins

In 1896 Toulouse-Lautrec produced a series of eleven color lithographs entitled *Elles*, an album which again dealt with the life of prostitutes. Some of these lithographs, like Toulouse-Lautrec's brothel paintings, show the unglamorous, tedious regularity of such a woman's existence; snoozing, having breakfast in bed, getting washed or fixing hair. Indeed, the prints are generally in soft yellows, pinks, and browns – sensuous but ironically pretty colors given their seedy subject.

Only one of *Elles*, the ninth in the series, is explicitly concerned with the business of prostitution. *La Conquête de Passage* (the oil study seen here and the print are almost identical) shows a woman attaching her corset while her client looks on. The painting reveals how scrupulously Toulouse-Lautrec prepared his album of prints, using energetically drawn and hastily colored oil sketches as well as pencil studies. In this painting, he used his typical pallid turquoise to enliven the crisp blacks and whites with which he has established the composition.

Édouard Vuillard

French 1868-1940

Public Gardens, 1894

Two panels from a decorative scheme
Distemper on canvas
Left panel: 7 feet×34½ inches (2.145
m×88 cm)
Right panel: 7 feet×36 inches (2.145
m×92 cm)
Paris, Musée d'Orsay

Vuillard, like Bonnard, was a generation younger than the Impressionists. He belonged to the Nabi group, a secret artistic brotherhood that was formed in 1888 at the Académie Julian by a group of adventurous young students. Admiring the Impressionists and holding lofty aspirations for their art, the members rebelled against the style of photographic naturalism being disseminated by their art teachers. The first practical demonstrations of a new, Symbolist, style of art, by Gauguin, Bernard, and their associates from Pont-Aven, added to their determination to venture outside the canon of academic taste and look for inspiration instead to primitive and decorative art forms: Egyptian reliefs and early Italian frescoes as well as the Japanese print and stained glass were among the sources of the Nabi style.

Vuillard was already proficient in the rudiments of naturalist painting when he joined the Nabis in 1889-90. For the first few years, his experiments with color and line – in which he sought to distance himself from the motif and to exploit the decorative two-dimensional essence of the picture surface – resulted in small and exquisite studies but only a few finished, exhibitable works. Like the other Nabis, he was closely involved with the birth of the Symbolist theater, and his experience of painting stage sets was particularly beneficial when he received his first commissions to paint large-scale decorations, such as this one, for private apartments. *Public Gardens* was destined to adorn the dining-room of Alexandre Natanson, a wealthy patron of the arts and joint editor of the key artistic journal of the 1890s, *La Revue*

Blanche. The scheme consisted of nine large panels, five of which are now in the Musée d'Orsay, the remainder having been dispersed across Europe and America. He painted the panels in distemper, a medium whose matt, quick-drying properties Vuillard had discovered in his theater work. The charm of the subject matter, with children playing in and out of the clumps of bushes and trees and nannies gossiping on park seats, has an immediate and lasting appeal, and captures a characteristic aspect of Parisian life. Vuillard's concern to observe the light-effects of a bright summer's day carries echoes of his Impressionist predecessors, notably such works as Monet's *Women in the Garden*. In Vuillard's case, however, the composition was not so much an impression as a distillation of numerous observations, in the Tuileries and the Bois de Boulogne, and cannot be tied down to a particular day or place. Vuillard was more attuned to the decorative qualities of the subject, more arbitrary in the way he could exploit the patterning effects of the foliage and the cast shadows while eliminating modeling elsewhere, reducing his figures to flat, simplified silhouettes. A typical Nabi refinement, in this pair of panels he uses muted secondary tones for the figures' stylish costumes – salmon pink, rusty red, gold, and dusty plum – to enliven his composition with rare and exquisite color accents.

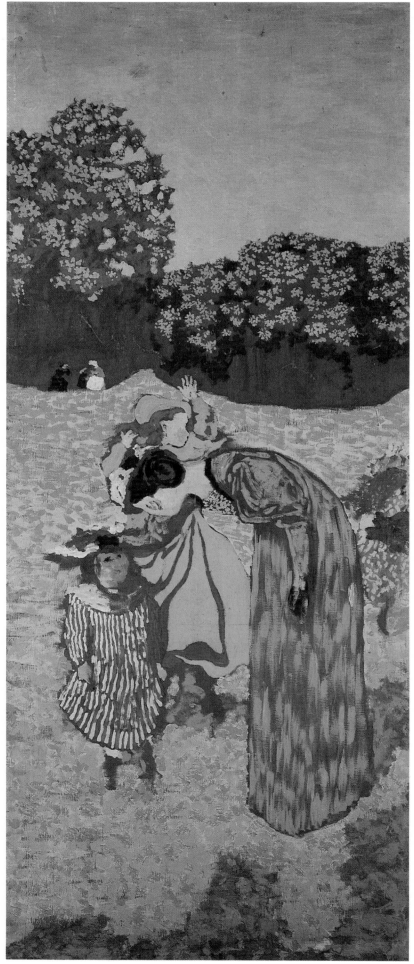

Acknowledgments

The publisher would like to thank Martin Bristow, who designed this book; Melanie Earnshaw and Moira Dykes, the picture researchers; and Wendy Sacks, the editor. We would also like to thank the following institutions, agencies and individuals for permission to reproduce the illustrations:

Albright Knox Art Gallery/The Bridgeman Art Library: page 82

Art Institute of Chicago: page 36 (Charles & Mary F S Worcester Fund, 1964.336); 41 (Robert Waller Fund, 1910.2); 89 (Helen Birch Bartlett Memorial Collection, 1926.417); 97 (Louise B & Frank H Woods Purchase Fund [in honor of the Art Institute of Chicago's Diamond Jubilee] 1968.614); 104 (Potter Palmer Collection, 1922.424); 136 (Gift of Marshall Field, 1964.200); 162-3 (Helen Birch Bartlett Memorial Collection, 1926.224); 183 (Mr and Mrs Lewis Larned Coburn Memorial Collection, 1933.458); 187 (Helen Birch Bartlett Memorial Collection, 1928.610)

Ashmolean Museum, Oxford: page 17(top)

The Burrell Collection, Glasgow Museums and Art Galleries: pages 49, 67

Calouste Gulbenkian Foundation Museum: page 18

Carnegie Museum of Art, Acquired through the generosity of the Sarah Mellon Scaife family, 1966: page 185

Christie's, London: page 109

Cleveland Museum of Art, John L Severance Fund, CMA 60.81: pages 124-5

Courtauld Institute Galleries, London (Courtauld Collection): pages 53, 149, 169

Courtauld Institute Galleries, London/The Bridgeman Art Library: pages 110-11

Dallas Museum of Art, gift of the Meadows Foundation Incorporated: page 131

Dreyfus Foundation, Basel/Colorphoto Hans Hinz: pages 140-41

Église de Saint Sulpice, Paris/Bulloz: page 12(below)

Fitzwilliam Museum, Cambridge: pages 148, 157

Foundation E G Bührle Collection, Zurich: page 86

Glasgow Art Gallery and Museum: pages 172-3

Hamburger Kunsthalle /Kleinhempel: page 108

Harvard University Art Museums, Fogg Art Gift, Mr and Mrs F Meynier de Salinelles: page 26

Laing Art Gallery, Newcastle, Reproduced by permission of Tyne & Wear Museums Service: page 80

Louvre, Cabinet des Dessins/Musées Nationaux: pages 21, 22

Metropolitan Museum of Art: pages 20 (Bequest of Edith H Proskauer, 1975); 59 (Bequest of Mrs H O Havemeyer, 1929. The H O Havemeyer Collection); 60-61 (Gift of Horace Havemeyer. The Horace Havemeyer Collection); 69 (Bequest of Mrs H O Havemeyer, 1929. The H O Havemeyer Collection); 15 (Bequest of Mrs H O Havemeyer, 1929. The H O Havemeyer Collection) 121 (Bequest of William Church Osborn, 1951); 132-3 (Bequest of William Church Osborn, 1951); 154-5 (Wolfe Fund, 1907. Catharine Lorillard Wolfe Collection)

Milwaukee Art Museum, Gift of the Milwaukee Journal Company in Honor of Miss Faye McBeath: page 37

Musée des Augustins de Toulouse/Jean Dieuzaide: page 189

Musée des Beaux Arts, Lyon: page 63

Musée des Beaux Arts, Rouen/Giraudon: page 181

Musée Fabre, Montpellier/Bulloz: page 25

Musée Marmottan/Studio Lourmel: page 116

Musée d'Orsay, Paris/The Bridgeman Art Library: pages 2-3, 62, 71, 117, 134, 191(both) [© DACS 1988]

Musée d'Orsay, Paris/The Bridgeman Art Library, Lauros-Giraudon: page 13(below), 14(below)

Musée d'Orsay, Paris/Giraudon-Art Resource: pages 46, 66, 150

Musée d'Orsay, Paris/Musées Nationaux: pages 8, 9, 12, 15, 19, 29, [© DACS 1988], 47, 56, 94, 100, 102-3, 105, 113, 114, 119, 120, 129, 135, 151, 152-3, 178-9

Musée du Petit Palais, Geneva: pages 34, 96 (Oscar Ghez Foundation)

Musée Rodin, Paris/Bruno Jarret: page 88 [© ADAGP, Paris/DACS, London 1988]

Musée Saint-Denis, Reims/Robert Meulle: pages 142-3

Museum of Fine Arts, Boston: pages 40, 84-5, 122, 138, 180, 184

Museum of Modern Art, New York. Acquired through the Lillie P Bliss Bequest: page 93

National Gallery of Art, Washington: pages 13(top) (Rosenwald Collection); 32 (Ailsa Mellon Bruce Collection); 42-3 (Chester Dale Collection); 72 (Chester Dale Collection); 106 (Gift of Horace Havemeyer in memory of his mother, Louisine W Havemeyer); 123 (Chester Dale Collection); 130 (Chester Dale Collection); 146-7 (Ailsa Mellon Bruce Collection); 164-5 (Collection of Mr and Mrs Paul Mellon)

National Gallery, London (Courtesy of the Trustees): pages 54, 64-5, 68, 98-9, 160

National Gallery of Scotland, Edinburgh: pages 81, 176-7

National Gallery of Victoria, Melbourne (Felton Bequest 1948): page 171

National Museum, Stockholm: pages 144-5

National Museum of Wales, Cardiff/The Bridgeman Art Library: pages 50-51

Richard Natkiel (map): page 8(top)

Nelson-Atkins Museum of Art (Acquired through the Kenneth A and Helen F Spencer Foundation Acquisition Fund): page 118

Neue Pinakothek, Munich/Artothek: pages 1, 78-9, 107

Norton Simon Art Foundation, Pasadena: pages 126-7

The Ny Carlsberg Glyptotek, Copenhagen: pages 48, 77

Petit Palais, Paris/Bulloz: page 52

Philadelphia Museum of Art: pages 39 (Given by Margaret Sargent McKean); 44 [Purchased W P Wilstach Collection]; 55 George W Elkins Collection); 139 (The John G Johnson Collection of Philadelphia); 158 (Mr and Mrs Carroll S Tyson Collection)

Phillips Collection, Washington: pages 156, 175

Private Collection/E T Archive: page 74

Private Collection, location unknown (print supplied by Phaidon Press): page 6

Private Collection/Musée Nationaux: page 16(top)

Private Collection, Switzerland: pages 166-7

Pushkin Fine Arts Museum, Moscow/Colorphoto Hans Hinz: page 91

Pushkin Fine Arts Museum, Moscow/Novosti Press: page 14(top)

Roger-Viollet: pages 7, 11(left and right)

Rudolf Staechelin Foundation Basel/Colorphoto Hans Hinz: page 83

Santa Barbara Museum of Art (Gift of Mrs Hugh N Kirkland): page 128

Sao Paulo Museum of Art/The Bridgeman Art Library, Giraudon: page 159

Sotheby's London: page 17 (below left)

Sotheby's New York Inc: page 92

Tate Gallery, London: pages 137, 188

Vincent van Gogh Foundation/National Museum Vincent van Gogh, Amsterdam: pages 23(top & below), 95

Wadsworth Atheneum, Hartford (Bequest of Anne Parrish Titzell): page 10

Wallraf-Richartz Museum, Cologne/The Bridgeman Art Library: page 16(below)

Weidenfeld Archive: page 15(top), 17 (below right)

Yale University Art Gallery: pages 30 (Gift of Walter Bareiss, BA 1940 [© ADAGP, Paris/ DACS, London 1988]), 90 (Bequest of Stephen Carlton Clark, BA 1903)